Fashion AFRICA

by Jacqueline Shaw

a visual overview of contemporary African fashion

JACARANDA

First published in Great Britain 2011
by AFG Publishing

This second edition published in 2013 by
Jacaranda Books Art Music Ltd
98b Sumatra Road,
West Hampstead
London NW6 1PP
www.jacarandabooksartmusic.co.uk

A CIP catalogue record for this book
is available from the British Library.

ISBN: 978 1 90976 200 8

Designed in Great Britain by
Nicola Erdpresser www.designcreateinnovate.co.uk

Printed and bound in Spain by Graficas Estella

To Mum,
For all your encouragement.
In memory of your Mum and Dad,
Clarise and Cecil, and
the Maroon tribe, which we come from.

contents

❮ *Endpapers and Designer Opener image,*
courtesty of Chichia

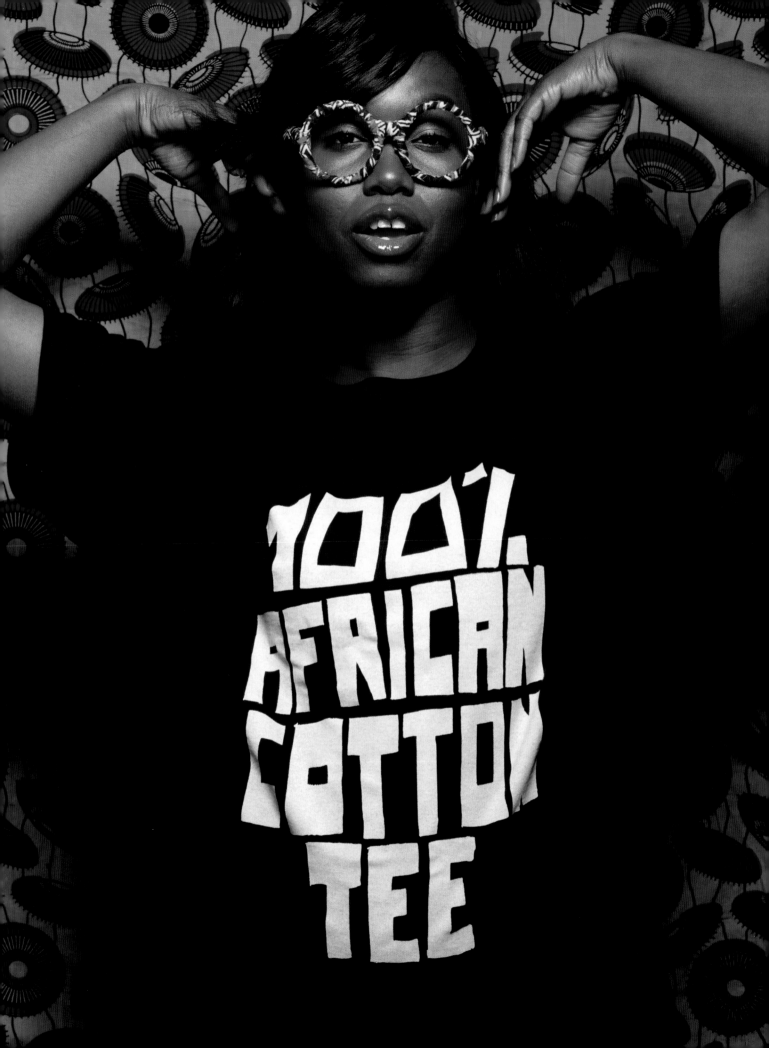

Introduction by Jacqueline Shaw

Mo Ibrahim, African billionaire and entrepreneur said *"There is a wide gap between our perceptions of Africa and the reality on the ground."*

Being born to Jamaican parents in London, England in the year that the late Margaret Thatcher became the first female UK Prime Minister, has always felt of some significance to me. My parents are descendants of the powerful Maroon people of Jamaica and this fact combined with what has been referred to by others as my "Iron Lady" mentality have proved to be the underpinning for my subsequent successes in the world of fashion. Through my interest in African and Caribbean history throughout the African Diaspora, I have pursued my dream against the odds and with a strong desire to influence, impact and perhaps even change lives in the process. Africa is a great signifier for me in everything I do and inspired by Mahatma Gandhi's eloquent call to "be the change you want to see" in the world, the focus on my work in Africa has been the great passion of my life.

I was drawn to fashion as an ideal outlet for my many and varied passions. It was a tough road to travel in an industry not only over-populated with many dreamers, aspiring to be the next big thing, but also filled with many influencers who ultimately determine the fate (good or bad) of many a young dreamer. I became increasingly frustrated with the industry and didn't always like what I saw. I felt this multi-billion dollar industry could do much more for the people who worked so tirelessly in it for very little reward or payment. Although I was working in fashion as a professional designer in the UK, Turkey, Germany, USA and China, I needed and wanted to do more in this field for others.

I realized that to be successful in any way in this industry I would have to fight my way through, not take things personally and most importantly never give up. Undertaking further studies with an MA in Ethical Fashion (2009- 2011), I placed a direct focus on Africa and ultimately I birthed my social enterprise and sourcing business Africa Fashion Guide (AFG). AFG is an information-based platform and one-stop shop for fashion professionals, fashion students, retailers, magazines, bloggers, and all those interested in African fashion and textiles. It acts as a voice for the promotion of the fashion industry and functions as a bridge between Africa and Europe. Its sourcing consultancy creates vital links between African designers, craftspeople, manufacturers and textile designers as well as with fashion design companies.

❮ *"100% African Cotton Tee" from the Africa Fashion Guide African Cotton Campaign 2012* (MODEL NANA AFUA ANTWI; PHOTOGRAPHER ABI OSHODI OF AO PHOTOGRAPHY)

The Current State of African Fashion

Today a new appreciation of Africa has emerged which looks past its history, its culture and age-old traditions and beyond its significant role as the birthplace of humanity. This present-day perception of a New Africa is an evolving one, and the continent is being recognized as an important market, especially within the fashion industry.

In the last ten years, there has been significant growth in Africa in mobile technology, energy, and agricultural markets. The World Economic Forum tells us that:

"Africa is on the brink of a major transformation... the outlook for the region remains bright at a time when the rest of the world is facing major political and economic challenges."

The Economist magazine online report on growing economies states that:

"...Over the ten years to 2010, no fewer than six of the world's ten fastest-growing economies were in Sub-Saharan Africa Angola, Nigeria, Ethiopia, Chad, Mozambique and Rwanda, all with annual growth rates of around 8% or more."

The textile industry is just one of these economic markets where growth results in change and thus provides a better impact on communities.

The number of Africa Fashion Weeks in Africa and around the world in New York, London, Barcelona, Los Angeles and Toronto, all highlight the growing influence and burgeoning significance of fashion and textiles in Africa.

Presently there are at least nine African countries (including Kenya, Tanzania, South Africa, Botswana and Zimbabwe) presenting fashion shows and industry events. The question is always about the impact of these shows and how they generate trade.

One impact appears to be the flurry of new design collections showing at the international catwalks from the likes of Burberry, Gwen Stefani's L.A.M.B. label, Louis Vuitton, Diane von Furstenberg, Junya Watanabe and more, all displaying distinctive designs directly inspired by Africa's vibrant colours, textiles and prints which differ from the more familiar safari ranges often seen on the catwalk.

Simultaneously, there has been a noticeable increase in the number of international fashion collections created locally in Africa. Popular UK online retailer ASOS (previously known as As Seen On Screen) seasonally produces their ASOS Africa apparel collection with the SOKO workshop in Kenya. ASOS also invests in SOKO financially through their ASOS Foundation, providing support for the workforce who can in turn support their families financially.

The collaboration between urban street brand Diesel and the Edun brand, owned by music star Bono and wife Ali Hewson, includes denim and jersey pieces sourced and produced in Africa using African cotton.

A lot of publicity has focused on the United Nations' International Trade Centre (ITC) division and their Ethical Fashion Africa project collaborations with various international designers, most notably Vivienne Westwood. Westwood's project with the ITC resulted in the production of a collection of bags manufactured in workshops in Kenya staffed by the local community and working to fair trade standards.

These are just a few of the many new success stories of the recognition from the wider fashion industry of the great potential on this vast continent. In 2012, the International Herald Tribune held its Luxury conference in Rome, with a focus on "The Promise of Africa, the Power of the Mediterranean". The conference, curated by Suzy Menkes, presented Africa as a land of both consumers and producers of luxury goods. It highlighted positive aspects of the quality of production in Africa and suggested that there is great potential for African-focused brands

❯ **LEFT** *Batik print fabric at the Choolips workshop, Ghana*
❯ **RIGHT** *Sindiso Khumalo SS13 collection at the Styled by Africa launch party*

to join the luxury market, but that the challenge is also for these brands to market themselves internationally.

The huge increase in bloggers focusing on African fashion, style, music and culture, such as Haute Fashion Africa, One Nigerian Boy, Shadders, Ciaafrique, Heritage 1960 and Style House Files, of digital and print magazines such as Arise, POP Africana, New African Woman and FAB Magazine, has presented an opportunity to bring African fashion and culture to more mainstream markets worldwide.

Africans as consumers

There has been significant growth in the African Middle Class over the last 5-10 years. According to the African Development Bank (AfDB) Africa's middle class had risen to 313 million people in 2010, 34% of the continent's population – compared with 111 million (26%) in 1980, 151 million (27%) in 1990. The bank's report defined middle class as people who spend the equivalent of $2-$20 (£1.30-£13) a day,

saying this is appropriate given the cost of living for Africa's near 1 billion people.

South Africa is the biggest economy in Africa and many more Africans living in the Diaspora have returned home. Nigerians are the 4th biggest group of shoppers for tax-free goods in London. With all of these developments and trends, Africa is now seen as a new market for consumers, for business expansion, and for economic growth. International retailers are recognizing this, too. Spanish retailers Zara, owned by the Inditex group, as well as Mango, Gap, Walmart, Converse and more are opening retail outlets on the continent. From Nigeria to Kenya, Morocco to South Africa, the continent has become the new playing field for fashion retailers.

Challenges and the Issue of Aid

Although there are a variety of new opportunities we must acknowledge that there are also challenges. With amazing growth prediction rates

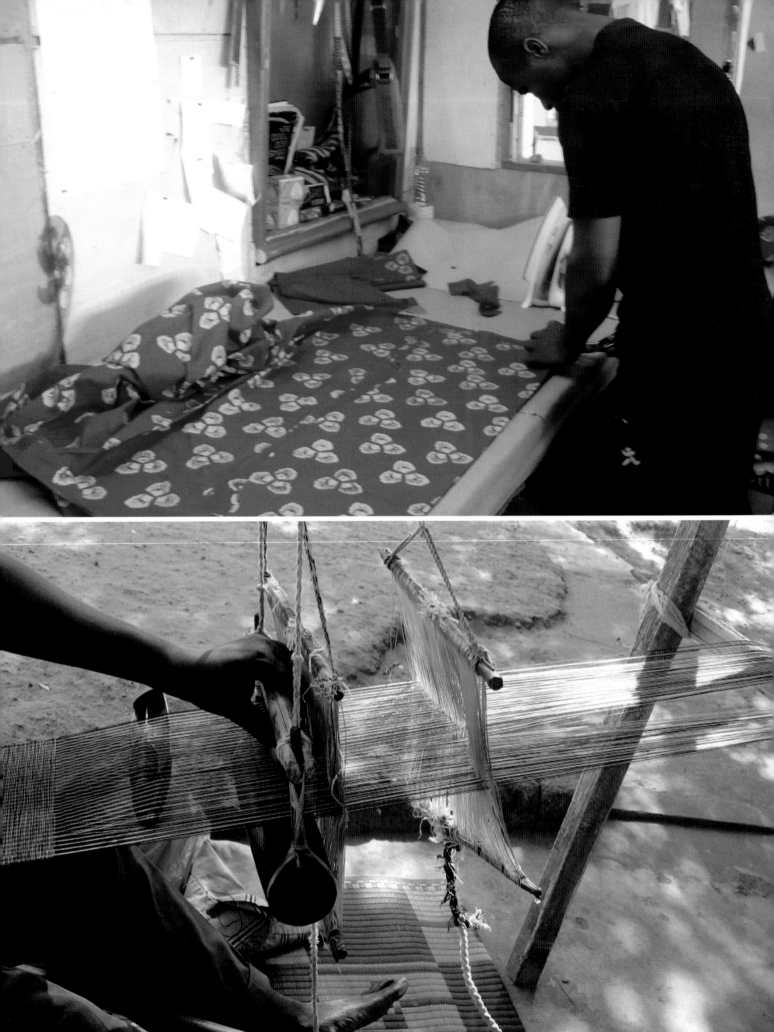

forecasted up to 2050 there is a need for political stability and the strengthening of Africa's leaders to deal with challenges such as unemployment, and food and water scarcities.

The lack of skills and the need to employ foreign workers to do the technical work; the lack of equipment and materials; the impact of secondhand clothing sent to Africa; the threat of China's influence and impact on trade in Africa; the issue of African intra-continent trade vs. international trade are all crucial issues to be addressed. Within this discussion we include and highlight relevant policy factors such as 'trade not aid', Fairtrade policies, labour laws, and working conditions such as those within SA8000 International Labour standards which are imperative in fashion manufacturing generally, but especially with regard to the cost of living and living wages for the producer countries.

There is a vital need for large business investment to drive economies in Africa's frontier markets. Zambian-born writer Dambiso Moyo in her book 'Dead Aid – Why Aid is Not Working and How There is Another Way for Africa' presents a good argument against aid and provides a summary of the history and impact (or in this case lack of impact) of aid in Africa.

'Study, after study…have shown that, after many decades and many millions of dollars, aid has had no appreciable impact on development.' (p46)

COTTON

Although Africa grows 12% of the world's cotton, over 95% of the cotton grown on the continent is exported in its raw form, which means that all the true value of cotton leaves the continent. The ITC backs this up in their Analysis of EAC Textiles Sector - The African Textiles Industry under Siege by adding that

"Having established the two markets, the raw material and the finished good markets…this is a long-standing issue in Africa – the attempt to diversify away from raw material exports to value-added goods. This is a similar situation for many African countries – the export of raw material with no value added and the import of finished goods."

Recent research showed that only around 1 million spindles exist in continental Africa. Without the tools to add value to the raw material cotton, one of Africa's largest exports, must then be imported back to Africa in its fabric form.

MANUFACTURING

All types of textile as well as garment manufacturing exists in Africa but the lack of mills and factories for processing is dire and causes Africa to have difficulty competing with the Asian giants in this industry.

For example in the 1990s Ghana had a textile industry that employed over 25000 people, today this has shrunk to 3000. In comparison Nigeria in the 1970s and 80s had over 250 textile manufacturing units, which have been reduced to less than 25 units today. South Africa continues to deal with labour rights in its textile industry where small clothing factories are unable to pay their workers the minimum wage, which is due to larger retailers demanding cheaper manufacturing rates.

African Pride and the rise of Afropolitanism

The idea of a 'new' or 'contemporary' African fashion is in many ways a misconception. African fashion has been influencing fashion trends for generations, and it derives from the existence of African dress formed from the early traditions and cultures of Africa. Fashion today is an expression of both past and present as it reflects and speaks of an African identity

❮ **TOP** *Tailor at the Choolips workshop, Ghana* ❮ **BOTTOM** *master weaver, The Gambia* (PHOTOGRAPHER JACQUELINE SHAW)

crafted from a heritage that spans thousands of years. Today, designers of African descent who are directly inspired by their heritage express this in a fusion of traditional and modern techniques.

In the area of retail, Africans on the continent and in the Diaspora are opening increasing numbers of online boutiques to showcase and sell garments made in Africa using African materials, boutiques such as Kisua, and Le Tabouret D'Or. Coupled with the rise of new high street stores such as that by Christie Brown, and Bow Boutique by Sika Designs, these retail outlets demonstrate the support for African designers from their local African markets.

An important demonstration of this support for African fashion is the 'Buy Nigerian' campaign in 2010 set up by Omoyemi Akerele, the founder of creative development agency Style House Files. She used the campaign to emphasize the importance of both retailers and consumers buying African fashion products in order to advance the Nigerian and African fashion industry.

There is an increased level of pride in being an African. It has become 'cool' to be African and to be a part of this new movement and appreciation for African contemporary culture. Part of this new trend is the rise of the Afropolitan.

In 2011 when I was ready to 'birth' my business Africa Fashion Guide, the V&A held a Friday Lates event entitled "Afropolitan" and within the many talks, fashion shows and discussions was a lecture on what it meant to be an Afropolitan. Panel member, Minna Salami, founder and blogger of Ms Afropolitan, says:

"Afropolitan… is about an awareness in Africa – politically, culturally …you don't have to be an African to be an Afropolitan…"

The term Afropolitan first appeared in a 2005 magazine article by Nigerian/Ghanaian writer Taiye Selasi who is said to have coined this term. She stated that Afropolitans are "Africans of the world." I feel this sums up African fashion. So I encourage you once more to delve in, have a read, continue your research and become yourself a signifier in the new renaissance that is happening in Africa.

Many designers in this book believe that Africa has a lot of 'untapped and hidden resources' and equally a lot of 'untapped potential'. Though there are still 'charitable' and typically 'ethnic' perspectives of Africa, they also agree that having a fair trade and ethical story attached to your brand can be a great advantage, one that is definitely achieving the goal of 'helping the development of the industry'.

I curated this book to highlight the strengths, challenges and misperceptions of Africa within the global textile industry. Logistics as they relate to the transportation and distribution of goods, timing (changing the perception and reality of chronically late suppliers), and poor infrastructure with unreliable energy sources resulting in power outages, provide an indomitable disincentive to players in the fashion world. Production and sourcing in Africa, as defined by a lack of availability of trims and textiles, lack of technically trained and experienced people in Africa and a lack of specific machinery adds one more degree of difficulty to an already highly charged situation; but there is still a lot of hope.

I wanted the book 'Fashion Africa' to showcase the level of strong entrepreneurship in Africa, but also for its readers to look at fashion in Africa from a business perspective and for the actors involved in the system there to move away from the workshop mentality. As a result, I have also set up international yearly conferences under the same title to bring together those involved in this industry to develop solutions, connect likeminded

people and make a difference. It is important when discussing African fashion to look at the full supply chain and encourage others to consider how the Diaspora can engage with this and develop and implement change for the future.

This book does not claim to have the final word in the business of textiles and fashion in Africa, nor does it claim to be the only directory in this field, rather it aims to present an unbiased overview. I selected an extensive group of emerging and established design companies, based in Africa and the Diaspora, specifically choosing a variety of companies who are not all African-owned but who do all have a relationship to Africa (via sourcing and/or production) and asked questions relating to the whole supply chain and incorporated modern, beautiful commissioned illustrations. This book showcases a new aesthetic of African fashion and textiles and displays them in a contemporary way. The designers' responses to the questions met the objective to highlight the challenges, but to also give an understanding of what is actually realistic.

This book aims to be a resource for fashion designers, manufacturers, fashion retailers, design education institutes, and more, as a way of sharing knowledge and understanding of what Africa has to offer. Like the website www.Africafashionguide.com it acts also aims to give retailers, educational intuitions, designers and textile organizations another option to the overused and overstretched global textile industry by highlighting the possibility of Africa as a new sourcing destination, creating the opportunity for African sourced materials and projects to bring money to the continent.

So I encourage you to delve in, take a look, have a read and learn and share about a small curated part of African fashion and its future in the global fashion and textile industry today.

Jacqueline Shaw

Africa Eco Symbols Table

'When we speak of "African Fashion" there's no one definition of what this truly means'.

ENYINNE OWUNWANNE (CREATIVE DIRECTOR OF HERITAGE 1960, ONLINE AFRICAN FASHION BOUTIQUE)

The Coming of Age of African Fashion by Chris Spring

Africa is a vast and richly diverse continent populated by an amazing variety of peoples occupying the continent's mountains, deserts, rain forests – and, of course, it's great and rapidly expanding cities, from Cairo to Cape Town and from Lagos to Addis Ababa. Above all, Africa is a global phenomenon affecting in one way or another, the lives of people in every part of the planet – and none moreso than in the area of textiles, dress and fashion. Few people today are aware that Yves Saint Laurent, the founder of the Saint Laurent label, one of the world's leading fashion brands, was an African born in Algeria. Or that Enid Marx, legendary designer of London Transport's distinctive upholstery in the 1930s, drew her inspiration from the exquisite kente cloth of the Asante people of Ghana.

When Enyinne Owunwanne made her comments to journalist, author and curator Hannah Pool, at the Africa Utopia fashion panel debates (D'ACCORD Issue 5 2013), she was not being negative in suggesting that in one sense there is no such thing as 'African Fashion'. Instead she was simply pointing out that, in common with 'African Art' or 'African Writing', 'African Fashion' must be seen as a vast, dynamic, and global phenomenon which has deep historical roots on the continent but is at the same time very much 'of the moment' both in Africa and around the world.

In recent years what can only be described as a *tsunami* of African creativity has engulfed the world. A tidal wave of talented artists, architects, photographers and fashion designers of African heritage are questioning the old order and *status quo* on many different fronts. In the world of fashion, the established hegemony of Paris, Milan, New York and London is being challenged, and although Johannesburg, Lagos, Nairobi and Casablanca may not be quite ready to take over, Fashion Weeks have become established in many African countries over the past decade. Today, African fashion designers are leading the world in the variety and imaginative breadth of their creations, yet top designers such as Oumou Sy of Senegal proudly maintain their African identity and help to inspire the rapidly growing fashion industry in various parts of the continent. Alternatively, a visit to the Malcolm Shabazz Harlem Market in New York will give an inkling of how many designs and fashions for peoples of African descent around the world find their roots in the textile traditions of Africa.

❮ *Wearing kanga in a style known as Ushungi* (PHOTO CHRIS SPRING)

Eastern Africa

In the late nineteenth century the exotic island of Zanzibar, was known as the 'Paris of eastern Africa'. The women of Zanzibar dressed in machine-printed textiles, brightly coloured rectangular wraps known as *kanga* in Tanzania and *leso* in Kenya, after the Portuguese word *lenço* meaning 'handkerchief'. Today the Kenya/South Africa eco fashion label LaLesso draws its name from this tradition of printed cloth.

Today the conventional form of the *kanga* is found mainly in Tanzania and Kenya, where those which are not imported from India or China are designed and printed in textile mills such as Rivatex at Eldoret in Kenya, and the Urafiki and Karibu textile companies in Dar Es Salaam.

Southern Africa

Textiles of eastern and southern Africa very much reflect changing times, fashions and tastes, providing a detailed chronology of the social, political, religious, emotional, sexual and economic concerns of those who wear them. One reason the 'Paisley' pattern on textiles, particularly in Mozambique, became so immensely popular was because of its similarity to the shape of the cashew nut, a major source of income in eastern and southern Africa.

In southern Africa, a complex history lies behind the discharge-printed indigo cloth, commonly known as *shweshwe*, named after the nineteenth century King Moshoeshoe I (c.1786-1870). Today, local designers create small masterpieces with *shweshwe* cloth and it is also the textile of choice for many fashion labels.

Central Africa

The Brave New World of twentieth-century Europe brought to a terrible halt by the First World War, saw the worlds of fashion, design and fine art turning to Africa for inspiration – and they have been doing so ever since. The idea that 'fashion' and *haute couture* are purely European or Western inventions is nonsense. Many of the patterns of dress worn by fashionable women in New York and Paris of the 1920s and 30s – not to mention art deco furniture of the period – drew inspiration from the raffia palm leaf textiles of the Kuba and other peoples living along the southern tributaries of the great Congo River basin.

Northeast Africa

In the mid-nineteenth century Christian noblewomen of the central and northern highlands of Ethiopia wore tunics probably made of imported cotton sheeting (as likely as not manufactured in Manchester, UK), but which they embroidered around the neck and sleeves with complex and colourful patterns created from imported Chinese silk. Today, men and women all over the world, as a signifier of global Africa, wear factory-printed tunics and other garments using the same pattern.

❯ **TOP LEFT** *Two women of Zanzibar* (ZAN ARCHIVE) ❯ **TOP RIGHT** *Three women wearing kanga in Bagamoyo, Tanzania* (PHOTO CHRIS SPRING) ❯ **BOTTOM LEFT** *June Bam-Hutchison in an 'Ethiopian' patterned dress* (PHOTO CHRIS SPRING) ❯ **BOTTOM RIGHT** *Two women of Mozambique* (PHOTO CHRIS SPRING)

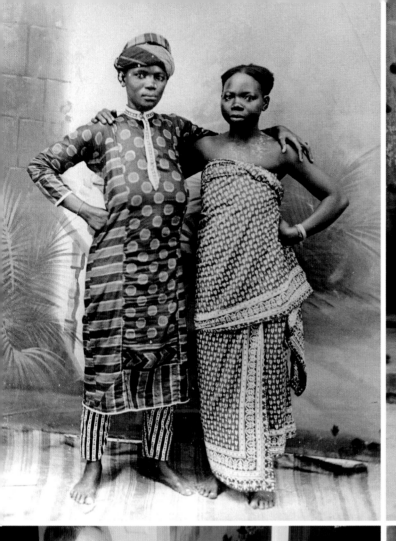
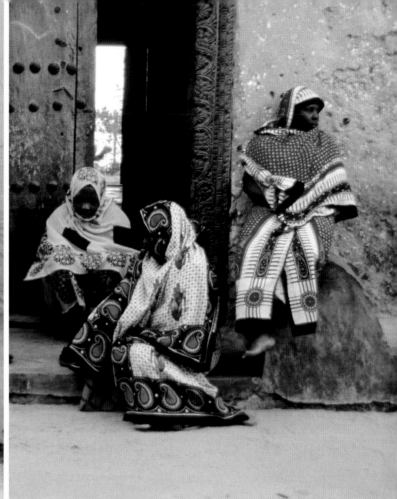

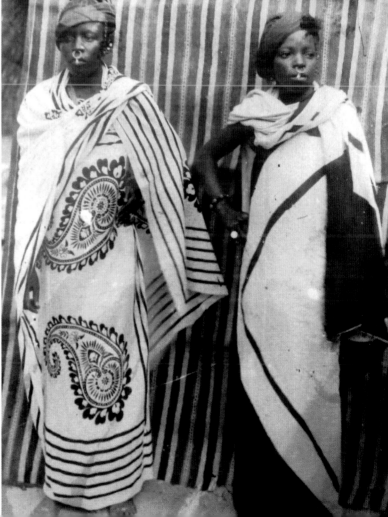

'The fabrics are not really authentically African the way people think; they prove to have a crossbred cultural background quite of their own. And it's the fallacy of that signification that I like'.

YINKA SHONIBARE MBE

‹ LEFT *Opening of* Fabric of a Nation *exhibition, Luton, UK, 2010* (PHOTO HEIDI CUTTS) **‹ RIGHT** *The distinctive flared headdress, decorated with badges and beaded ornaments, worn by a married Zulu woman at a festival near Durban, South Africa* (PHOTO DR KATESA SCHLOSSER)

West Africa

Yinka Shonibare, the celebrated artist of Nigerian descent, is of course referring to the factory-made 'wax' and 'fancy' prints which imitate Javanese batik resist-dyed cloths and were originally created in the early nineteenth century by the Dutch textile industry and later in the UK for export to Africa. During the post-colonial period, textile companies were established in various West African countries, including **Sotiba** in Senegal, **Afprints** in Nigeria, **Uniwax** in Ivory Coast and **GTMC** in Ghana, and became important producers of textiles not just for the African market but also, in Sotiba's case in particular, the leading producer of 'African print' fabrics in the USA.

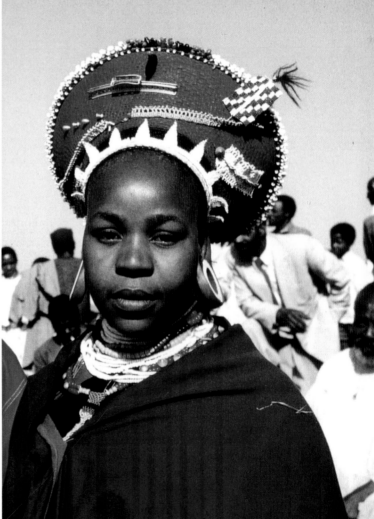

Hats and other accessories

In Africa, mainly men wear hats and caps, while women often wrap their heads with lengths of cloth or create elaborate hairstyles. Apart from protecting the head from the elements, hats, headdresses and 'jewellery' are a means of identifying personal rank, marital status, religious belief and ethnic and regional affiliation. They are also important personal accessories and, in common with all aspects of clothing today in Africa, they are subject to the scrutiny of the burgeoning contemporary fashion industry. There is probably no better indicator of culture change throughout the world than cloth and clothing, and in Africa the great diversity of textile traditions makes the continent a particularly sensitive barometer for such changes.

A married Zulu woman's traditional headdress consists of a circular coiffure created from the wearer's own hair dressed with red ochre, animal fat and stiffened with hoops of vegetable fibre. Other 'fashion' varieties of detachable headgear based on this pattern are today made from a variety of materials and are worn by Zulu women at parties and other celebrations.

❯ *Women at a wedding in Kampala, Uganda, wearing dresses known as 'Busuti' developed from early victorian styles of dress* (PHOTO CHRISTINE WANAMBA)

Fashion: Shapes lines & Colours of Tradition

Cloth and clothing in Africa represent means of displaying power, prestige, spiritual and material wealth (all familiar ingredients of *haute couture*), as well as means of protecting the wearer from the elements – though not necessarily at the same time. From the most elaborate gown or crown to everyday costume and headwear, dressing and adorning the head and body are essential elements of traditional clothing and act as important means of identifying particular facts about the wearer, such as rank and status, religious belief, ethnic and regional affiliation.

It is clear that in many parts of Africa these traditions are of great antiquity and that the importance of fine materials in the making of garments was paramount. In the late sixteenth century, Portuguese merchants described the vigorous trade in raffia (palm leaf) cloth taking place in the ancient Kingdom of Kongo at the mouth of the great Congo River system, the waterway which helped to make this trade possible:

'In this kingdom of Congo they make some cloth of palm trees with a surface (skin) like velvet and some worked like velvety satin, so beautiful that those made in Italy do not surpass them in workmanship.' D. Pacheco Pereira, c. 1506

Trade

The Portuguese were the first Europeans to navigate the African coast in the 15th century, though by then the great cultures and empires of Africa had traded with Europe, Arabia, India and the Far East for at least a thousand years. Everywhere the Portuguese went they found a thriving import and export trade in textiles. This trade included locally made cloth, cloth imported from other parts of Africa and, in some cases, cloth imported from different parts of the world. Textile patterns, materials and means of production may illuminate individual events in history, or they may chart the movements and migrations of people over a much longer period; they may also tell of the long engagement of Africa with other peoples of the Atlantic, Mediterranean and Indian Ocean worlds. Patterned textiles of essentially North African inspiration were traded across the Sahara for many centuries, so that even today many West African peoples have a taste for cloth of North African pattern, despite the sumptuous textiles which they themselves produce.

Changing Materials and Techniques

Although hand-woven, dyed and embroidered garments in Africa are produced in greater quantities than ever before, distinctively patterned machine-printed cloth has been extremely popular for more than a century. Once exclusively imported from Europe, India and the Far East, much of today's printed cloth is locally produced, though it is now once more under pressure from overseas manufacturers, China in particular. In West and central Africa wax 'fancy' prints are favoured, while in eastern Africa *kanga* is worn in matching pairs by women, particularly in Kenya and Tanzania, while other types of printed cloth are popular in countries further to the south such as Mozambique *(capulana)* and South Africa *(shweshwe)*. In eastern Africa, red, black and white cloth, once imported from the USA, is still known as *merikani* and is worn principally by women, though also by the *mganga* and their assistants, spirit healers and diviners who wear a combination of black, red and white *kaniki* which is both a uniform and a fashion statement.

> **TOP** *Women wearing kanga, Bagamoyo, Tanzania* (PHOTO CHRIS SPRING) > **BOTTOM** *Cloth market at Bouaké, Ivory Coast* (PHOTO DR KATESA SCHLOSSER)

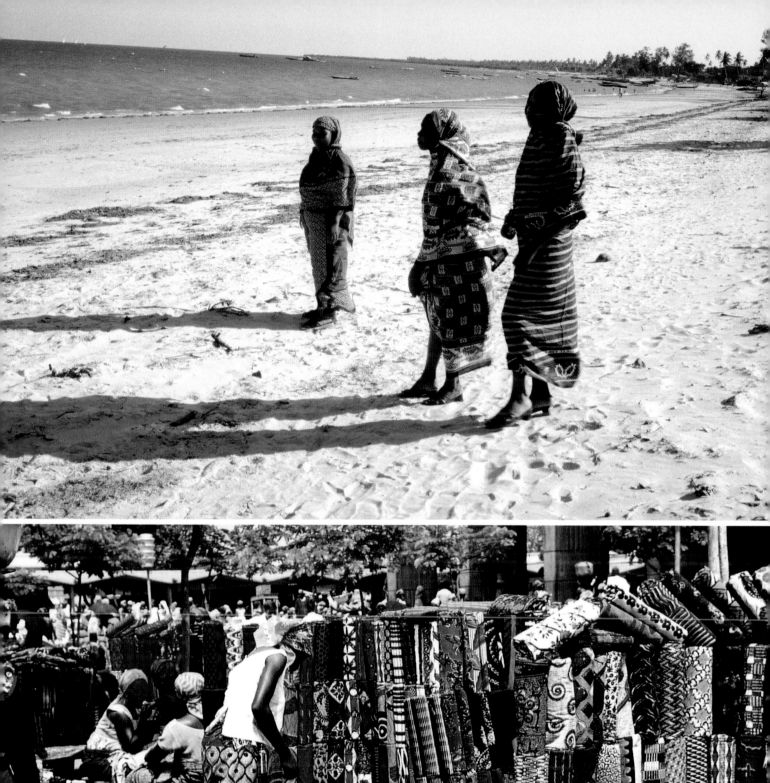
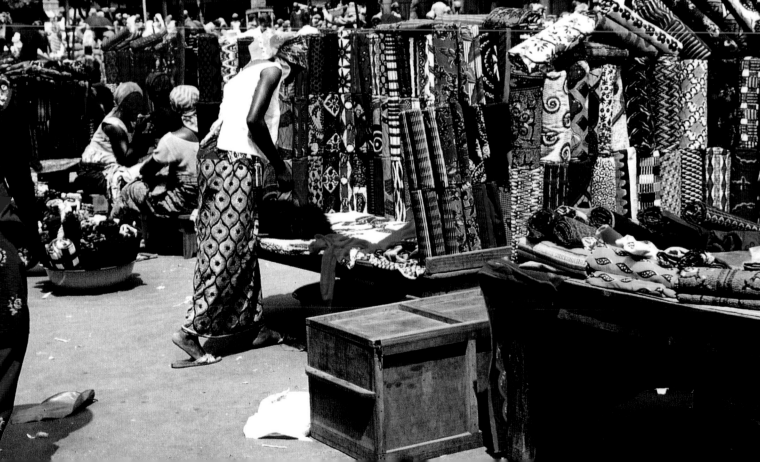

"At the heart of the company is the desire to make and produce fashion accessories which are beautiful and which showcase the amazing materials and quality of hand-made goods in Africa."

ADÈLE DEJAK, KENYA

Status, Pattern and Colour

Textiles, more than any other art form in Africa, represent a means of declaring status and of exercising leadership. Textiles in their many forms offer ways of defining, reinforcing and actively carrying out these roles in many of Africa's hugely diverse societies. Often colour plays a particularly important role in distinguishing certain kinds of spiritual and religious leadership, such as the red cloth worn by the mganga or spirit healer of eastern Africa, or the predominantly blue clothing of certain Zionist preachers of South Africa

FASHION: Influencing Factors

Heat and dust

Africa's extraordinarily varied climate is, to some extent, reflected in the dress and fashions of her peoples, though often in unexpected ways. Men and women of the Berber peoples of the High Atlas mountains of North Africa and the South Sotho peoples of the mountain kingdom of Lesotho in southern Africa both wear thick, woollen blankets on certain occasions, though not always to do with the prevailing climate.

Likewise the Tuareg and other peoples of the Sahara Desert and its fringes may wear equally voluminous clothing, though usually of cotton and sometimes flooded with indigo, including turbans and baggy pants. These garments not only protect them from the sun, facilitating the riding of horses and camels, but also express their status and religious belief.

Cotton, bark and silk

The materials used to produce cloth vary greatly within Africa. Cotton and a variety of synthetic yarns are widely used, but in eastern and southern Africa, where woven cloth was not so commonly produced, skins and bark-cloth often took the place of textiles until the widespread use of factory manufactured cloth from the mid-nineteenth century. In rural North Africa and the inland delta of the Niger in West Africa the main weaving material is sheep's wool, whereas in the Congo basin it was traditionally fibre stripped from the leaves of the raffia palm; raffia cloth was also used as a form of currency. Silk is a favoured material for prestigious textiles in parts of West Africa, urban North Africa, Ethiopia and Madagascar.

❮ TOP LEFT Mganga *spirit healers at Bagamoyo, Tanzania* (PHOTO CHRIS SPRING) ❮ TOP RIGHT *Sotho* seana marena *or 'king's blanket', Lesotho* (PHOTO CHRIS SPRING) ❮ BOTTOM *Zulu Zionists near Laduma's Homestead, South Africa* (PHOTO DR KATESA SCHLOSSER)

"Africa will continue to inspire the jaded western world with its amazing creativity and integrity of design."

MARIANNE FASSLER, SOUTH AFRICA.

Ways of Life

Apart from western style clothes, sometimes supplied by the burgeoning second-hand market, men and women in Africa favour fashions which reflect their economic circumstances, but which nonetheless tend to conform to particular accepted norms. Sometimes, 'traditional' dress may in fact be a fusion of European/western elements and indigenous dress. A classic example is the woman's three-piece wrapped and sewn ensemble known as the *kaba* in Ghana, though with variations elsewhere in West Africa. The male equivalent would be a voluminous gown, often embroidered around the neck, and worn with a variety of caps. In both cases such dress would be the focus of deeply considered fashion statements, though always the wealth and status of the wearer would be indicated by the richness of the materials used, the extent of the embroidery and the quality of the tailoring. In Dakar, Senegal, in the past, textiles with the 'gel capsule' pattern were all the rage.
The design confers an element of protection and may be understood as part of the great variety of patterns and amulets which, when attached to different forms of dress in Africa, contribute towards the wearer's well-being.

Hierarchy

The wearing of certain types of decorated barkcloth was the reserve of the Kabaka (king) and royal family of the ancient kingdom of Buganda, a centralised African state in Uganda. When not worn as dress, prestigious raffia 'cut-pile' embroidered cloth of the Kuba peoples of the southern Congo basin is accumulated as an indication of wealth.

The wearing of patterned silk cloth, *lamba akotofahana*, became a mark of status among the aristocracy of the Merina people of pre-colonial Madagascar. In recent years weavers have once more begun to weave patterns and colours emulating those of the 19th century.

Narrow-strip woven silk cloth was once a monopoly of the Asantehene (king) and royal lineage of the Asante of Ghana. Today 'kente' cloth is widely worn, but remains a symbol of African independence and culture throughout the world.

❯ **TOP LEFT** *Maria da Luz of Angola wearing a 'samakaka'* (PHOTO CHRIS SPRING) ❯ **TOP RIGHT** *Gel capsule cloth, Senegal* (PHOTO CHRIS SPRING)
❯ **MIDDLE RIGHT** *Merina woman weaving on a single heddle loom* (FROM A PAINTING BY THE MALAGASY ARTIST RAINIMAHAROSA, 1907)
❯ **BOTTOM** *Young Zulu girls of the Shembe Church wearing tartan skirts* (PHOTO DR KATESA SCHLOSSER)

21st century enterprise

Most people in the West still only perceive Africa through the stories and images presented by the media. Instead of a vast, diverse, global phenomenon, Africa becomes a single sub-Saharan country, either beset by war, famine and disease, or a place of drumming, dancing, colourful market places and elephants wandering across the Serengeti at sunset. However, in recent years more

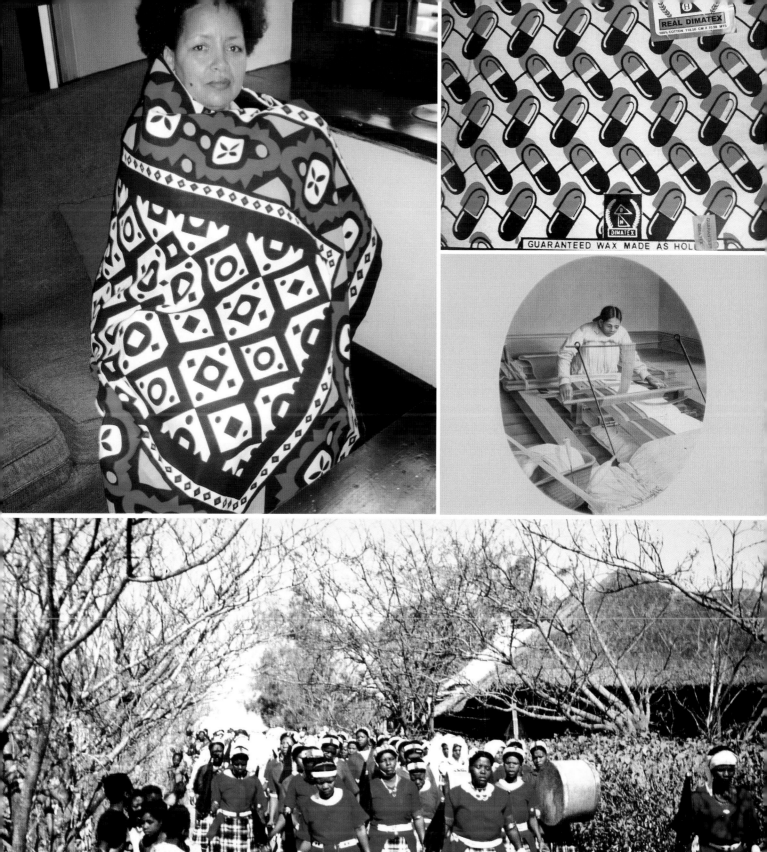

GUARANTEED WAX MADE AS HOLL

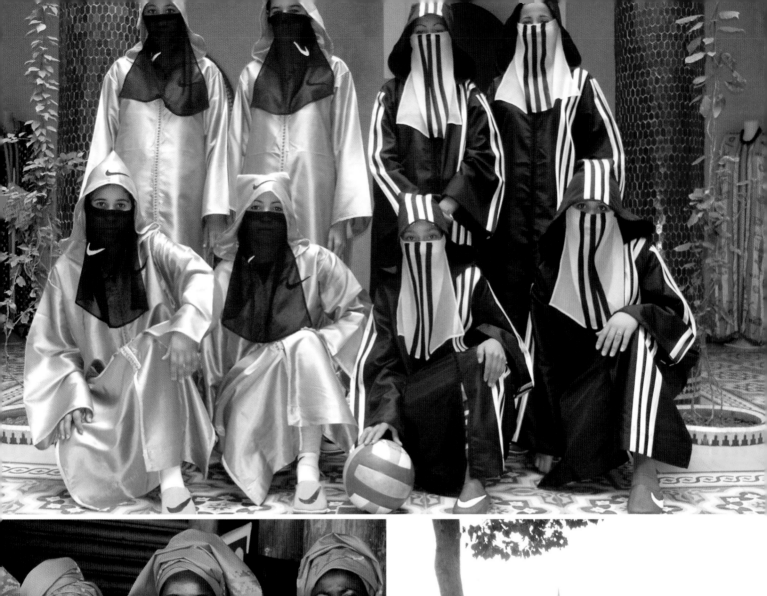

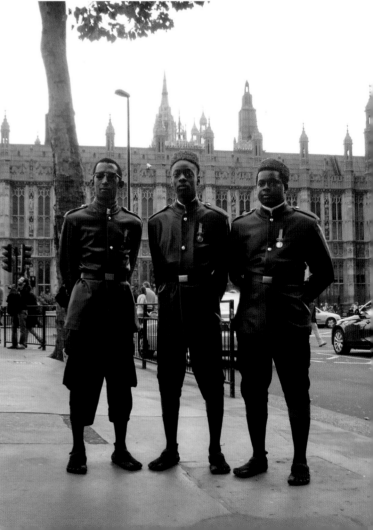

"Africa is fast becoming the new hub
for fashion... It's like we just became
the new buzz..."

Lanre Da Silva Ajayi, Nigeria

positive images of Africa have gained ground, with African writers exploring new boundaries in fiction and African talent emerging in football, fashion, contemporary art and in the political arena with the likes of environmentalist Wangari Maathai of Kenya.

Using 'the universal language of sport', Hassan Hajjaj looks at stereotypical notions of Morocco and North Africa, which have their roots in European Orientalist images of the nineteenth century, bringing them up to date with a combination of his own skill as a designer and photographer. He creates his own versions of the hooded gowns *(djellaba)* and face-veils *(niqab)*, so often demonized in the West, and playfully appropriates the branding of Nike and Adidas to dress his models.

We have seen how African fashion and long-established traditions of dress have been adopted by the West and incorporated into *haute couture*. By the same token, many materials and fashions from other parts of the world have been assimilated and re-interpreted by African tastes and fashion. As the Nigerian fashion journalist and cultural commentator Toyin Odulate observed:

'It appears Nigeria, and many parts of fashion-savvy Africa, have taken over other people's inventions [fabrics], improved on them and re-presented them to the world.'

For example, industrially produced 'lace' embroideries, initially from the Austrian province of Vorarlberg and from Switzerland, became extremely popular in post-independence southern Nigeria and may be seen as a very Nigerian expression of a tradition from another part of the world.

Throughout Africa, trade has been a primary factor in driving innovation in existing traditions and in initiating new ones. Tartan cloth was introduced by Scottish missionaries, soldiers and traders and is now part of the 'traditional' dress of peoples as diverse as the Maasai of eastern Africa and the Zulu of South Africa.

Today fashion designers such as Noxolo Dyobiso, a Xhosa designer from South Africa, has been instrumental in transforming traditions such as *shweshwe*, from its roots in Germany and Switzerland, into her distinctly southern African fashion statements.

Many contemporary artists of African heritage are also fashion designers in their own right.
In *'The Long March of Displacement'* by Leo Asemota, 2009, the artist Leo Asemota (left) and two assistants pose in front of the Houses of Parliament, London, as the 'Agents of the Union'. Their 'uniforms' were carefully designed by Asemota to suggest not only the African colonial troops of the Gold Coast Protectorate (now Ghana) who took part in the operation and in the capture of the Oba (king) of Benin, but also elements of Benin royal regalia.

❮ TOP *Hassan Hajjaj 'Nike v Adidas', 2010*
❮ BOTTOM LEFT *Women at a wedding in Benin City, Nigeria, dressed in ensembles of imported lace fabric* (PHOTO BARBARA PLANKENSTEINER) ❮ BOTTOM RIGHT *'The Long March of Displacement' by Leo Asemota* (PHOTO CHRIS SPRING)

DESIGNERS

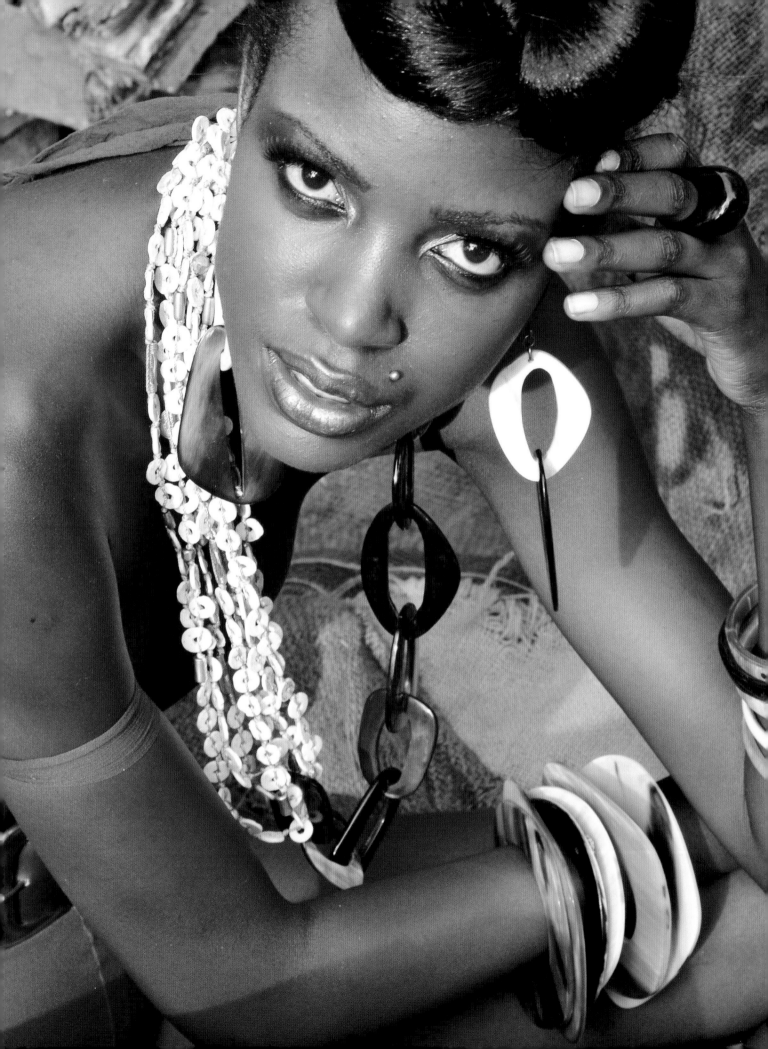

ADÈLE DEJAK

FACT FILE

LOCATED: KIAMBU (ON THE OUTSKIRTS OF NAIROBI), KENYA
WEBSITE: WWW.ADELEDEJAK.COM
FOUNDED: 2008

The ADÈLE DEJAK brand of luxury fashion accessories are designed and handmade in East Africa using reclaimed and recycled materials from Kenya, Uganda, Democratic Republic of Congo and Rwanda, emphasising sustainablility and engagement with the local communities.

The Adèle Dejak label began as a small home-based business and quickly grew from a just two beaders to a team of twenty-eight people. Based in Kenya, the majority of staff and artisans work in Kiambu on the outskirts of Nairobi. The company places emphasis on sustainability through engagement with local communities working closely with refugee camps in northern Kenya. The brand is an inspiring combination of strong African style and materials and European designs. Each unique piece is intimately connected to the cultural environment in which it is produced and from where its materials are sourced.

‹ *Rogo Collection 2012, Rani Ostrich Necklace, Ruma Earrings, Remi Bangles, Ayana Ring* (PHOTOGRAPHY BY DAMIANO ROSSI) › *Cloud 9 Collection 2013, Zeynap Necklace* (PHOTOGRAPHY BY ABRAHAM ALI, IMAGE WORKS AFRICA)

What are your company principles? At the heart of the company is the desire to produce beautiful fashion accessories showcasing the excellent materials and high quality hand-made goods of Africa. The company ethos, driven by a desire to serve in the region, is to create job opportunities and provide training in Kenya.

In which countries do you source your materials and production? The majority of our products are made in Kenya with some horn pieces being produced by artisans in Uganda. Materials are sourced from across Africa but mostly from Kenya, Uganda, Rwanda and DRC.

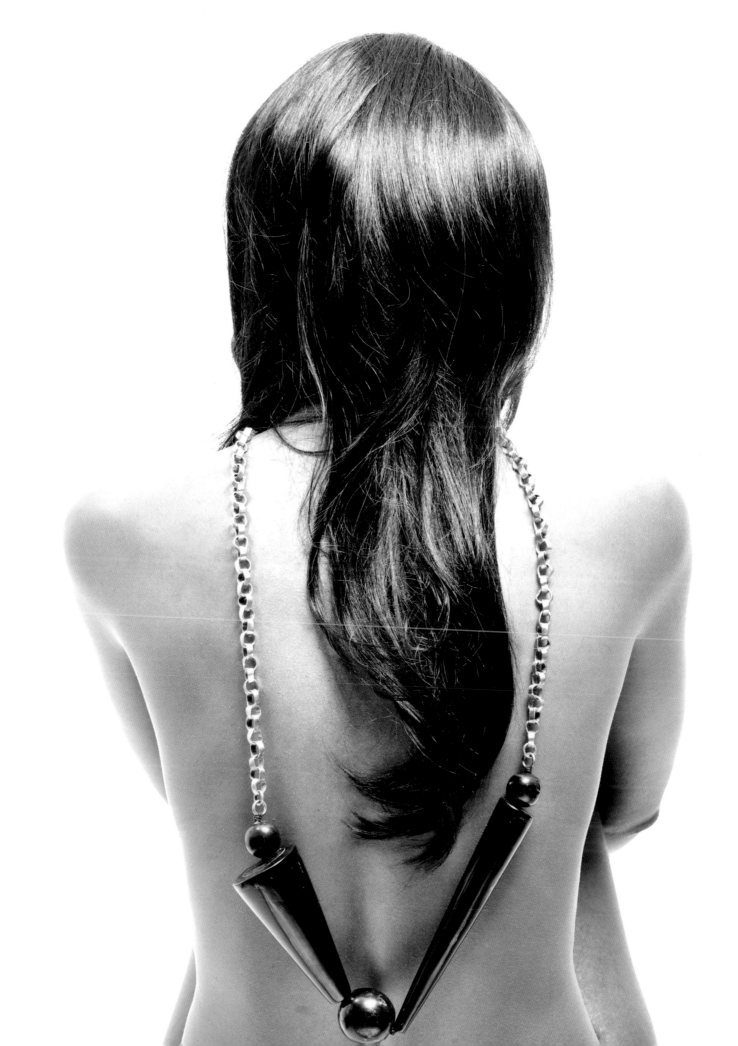

'Africa is at the heart of our company and our brand. I am passionately committed to changing perceptions about Africa through design and creativity'

What are the pros and cons of producing/sourcing in Africa? A major positive is the ability to work with recycled or reclaimed materials such as brass and ankole cow horn. Africa also offers an opportunity to work with diverse people both in the workshops and through our suppliers. The great variety in fabrics, beads and materials makes Africa a treasure chest of vibrant and inspiring options. We have found that in-house training affords us the opportunity to nurture creativity and technical skills among our employees and this helps to develop our products to the next level. The disadvantages are related to the advantages. Although you can source incredible raw materials for designs it is very hard to find the right fittings for bags and we often have to source these outside Kenya. Also a lack of technical training institutions in Kenya for artisans and tailors specifically for the fashion industry means there is no large skilled workforce available.

How do you think fashion made in Africa is regarded internationally? People are often surprised that our products are made by hand in Kenya. This comes from a bigger misperception that all fashion made in Africa is cheap to purchase and of a lower quality than products made in other places. We are working hard to change these perceptions by creating high quality beautiful goods which tell the story of where they came from.

What inspires you? I am inspired by everything around me. I grew up between Nigeria and Cambridge, UK and have always been interested in the connections between places and the inspiration one can draw from this. I try to take inspiration from as many things as I can from high-end fashion designers, to art, to nature and from the people I work with.

How does Africa relate to your company/brand and why Africa? Africa is at the heart of our company and our brand. I am passionately committed to changing perceptions about Africa through design and creativity.

Does your company work with any workshops/organisations in Africa? We run our own workshop in Kenya and we work with some independent artisans in Kampala for production of some of our cow horn pieces. We have also worked with Kakuma refugee camp (part of Dadaab) in Northern Kenya to help people trained in bag production to earn a living.

What is your ethical standpoint? Our company ethos is to provide fair and favourable working conditions to our employees and to create job opportunities. Working with recycled materials we keep waste to an absolute minimum by creating one-off products from waste materials. Most products are handmade and we avoid using chemicals. We want to create sustainable products from an environmentally friendly location.

Which African designers do you admire? Duro Alowu because of his world view, his African roots in his design and his international appeal.

Is Africa the future? In many different industries and in many different ways Africa is the future. There is a wealth of natural resources here, a young population and a growing and underemployed work force. With a growth in international interest and recognition from key players in the fashion industry as well as support and infrastructure for training and production the fashion industry can develop but it could take a long time!

> **TOP LEFT** *Grace Collection 2010, Patricia Necklace, Star Anise Choker, Maasai White Bracelets* > **TOP RIGHT** *Afri-Love Collection 2011, Michelle Bakuba Clutch, Dama Chain Bracelets, Adele Earrings* > **BOTTOM LEFT** *Grace Collection 2010, Stefania Hide Bag* > **BOTTOM RIGHT** *Rogo Collection 2012, Ro Sexes Necklace, Ro Ashanti Arm Bands, Bella Snake Arm Band, Lisha Earrings* (ALL PHOTOGRAPHY BY ABRAHAM ALI, IMAGE WORKS AFRICA)

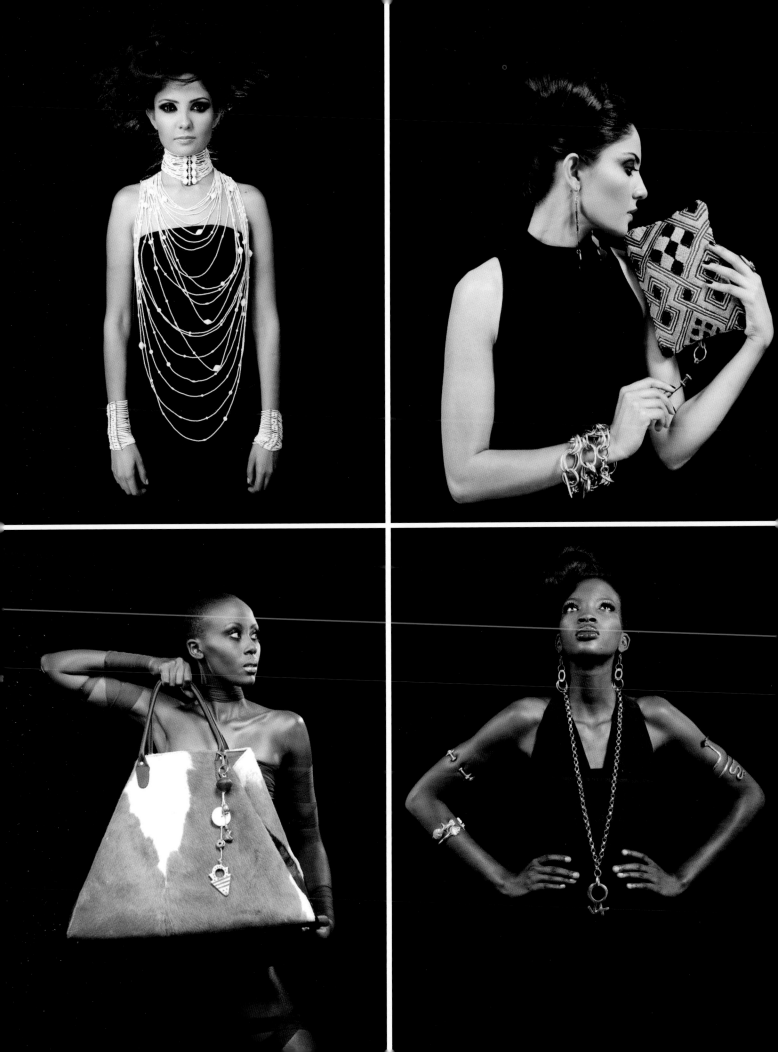

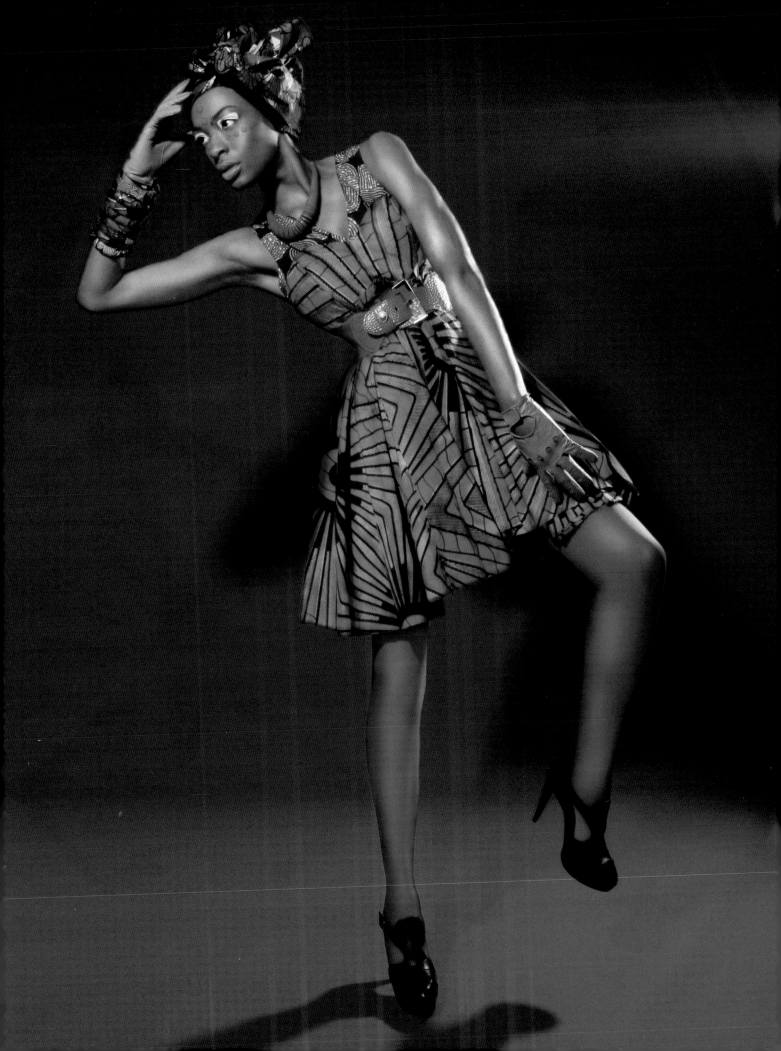

AFRO-CHIQUE

FACT FILE

LOCATED LONDON, UK

WEBSITE WWW.AFRO-CHIQUE.COM

FOUNDED 2008

AFRO-CHIQUE produces eclectic clothing and accessories harnessing the brilliant vibrancy of Caribbean culture and attitude, expressed through the colours and fabrics associated with the African continent.

AFRO-CHIQUE is a clothing and accessories brand known for combining the cultural identities of African prints and Caribbean colour with the stylish influence of contemporary London. Creative Director Janice Morrison, develops each clothing line with these specific elements at the forefront of her design process, resulting in unique, bold, collections filled with modern style, exhibiting strength, identity and attitude, and distinctively capturing the essence of African, Caribbean and European culture. Every AFRO-CHIQUE piece is made with quality fabric, cut and colours to ensure only the finest garments. Since its launch the brand has celebrated continued global growth and exposure featuring in many fashion publications and at noted industry events.

The company's mission is to firmly establish itself as a leading afro-centric brand within the fashion industry.

In which countries do you source and produce? Currently materials are sourced from different parts of Africa, and Europe. Clothing is produced in the UK but we are in talks with various companies in West Africa with regards to production and manufacturing.

'I think that Africa could very well be the future of the fashion and textiles industry. The continent has all the resources needed to establish such a position'

Do you use any traditional African craft techniques in your design process? I do research a range of various traditional techniques and try to incorporate them into either my designs or the actual making up of the garments.

Where do you go to for inspiration? Art and culture are the main sources of my inspiration. I love photography and to travel to different countries gaining experience of different arts and cultures. Whilst living in London I love the art of people watching, I'm inspired by what I see every day.

What do you see as the pros & cons of producing / sourcing in Africa? The main pro, amongst many for Afro-Chique would be the variety, colours, quality and individuality of the materials available and also the expertise at hand for the production of garments. The only cons that have been experienced to date are the high costs and taxes involved with international trade. Considering that Afro-Chique is a London based business these costs can sometimes make appealing opportunities not so attractive.

How do you think fashion made in Africa is regarded internationally? With the rise of awareness in Fair trade and companies like ASOS partnering with Africa when it comes to manufacturing, this has helped to put Africa on the map and makes working there the norm now. I believe that fashion from Africa is, or should be, regarded in the same light as fashion from anywhere else.

Which African designers do you admire? I am inspired by any designers who use colour and print and are not afraid to take risks when designing their collections. I like innovative designers whether it has to do with colour combinations, designs or the choice of fabrics, it's always nice to see something new.

How does Africa relate to your brand and why Africa? I made the decision to use African prints. I am very aware of my history and have made a conscious decision to reflect this through my choice of African textiles.

Is Africa the future? I think that Africa could very well be the future of the fashion and textiles industry. The continent has all the resources needed to establish such a position.

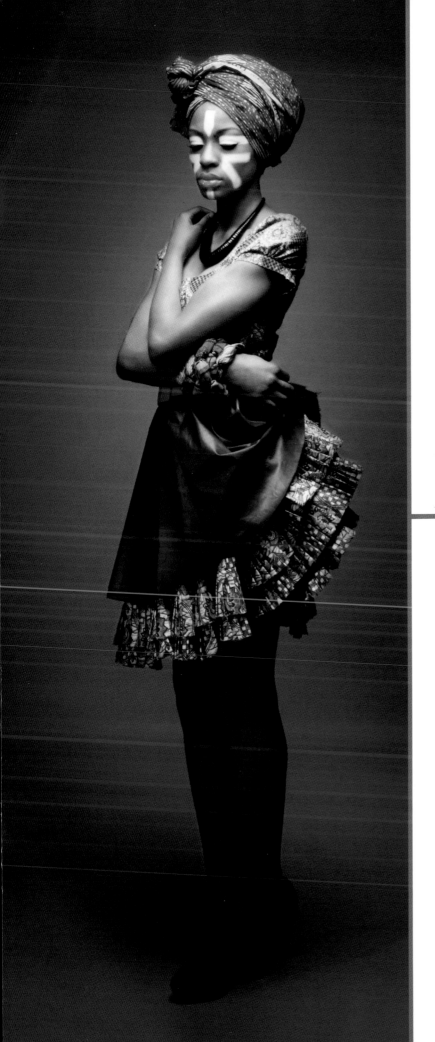
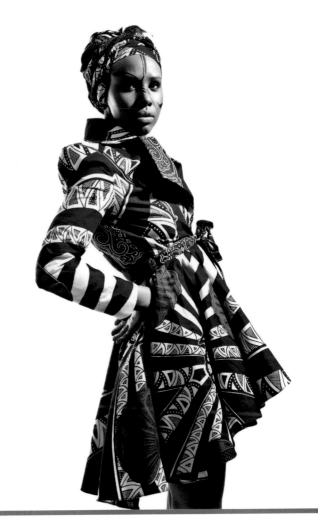
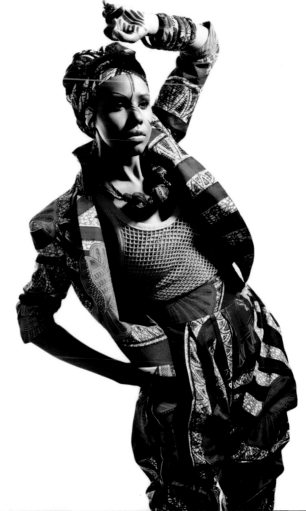

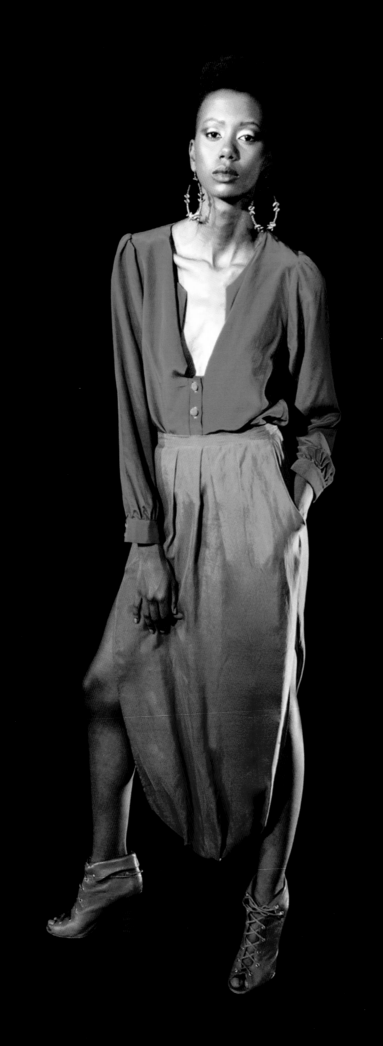

BESTOW ELAN

FACT FILE

LOCATED LONDON, UK

WEBSITE WWW.BESTOWELAN.COM

FOUNDED 2000

BESTOW ELAN, the womenswear label, was created in 2000 by former London College of Fashion student, and designer Ezrumah Ackerson. Based on the principles of a timeless, feminine chic, over the years the concept has organically evolved into the acclaimed label of today.

BESTOW ELAN began in 2000 as a small company test marketing designs in the Portobello Road Market, Notting Hill London. By 2003 it was supplying boutiques across London. Drawing inspiration from both classic and vintage stimuli, as well as influences from the heritage of founder Ezrumah Ackerson the label focuses on creating garments fit for every occasion, and appealing to women from all walks of life.

❮ *Blue print dress from the Silence is Deafening Collection* (MODEL, YASMINA DIALLO; PHOTOGRAPHER, COLIN JOHNSON; MAKE-UP ARTIST, VIANNEY LEIGH) ❯ *Illustration of Bestow Elan from Liberty Collection* (BY CAROL RYDER)

Ezrumah with her label BESTOW ELAN has many accolades and experiences behind her. Her first collection was exhibited in central London at the Profile 4 event and she assisted print designer Jonathon Saunders at his London Fashion Week debut. She also worked on Russian label KISA LONDON's Fashion Week collection. BESTOW ELAN was selected and participated in the KULTURE2COUTURE catwalk show at the V&A, showcased at the UNTOLD anniversary show and presented a capsule collection as part of Untold's February 2010 London Fashion Week . The label also received notable reviews and appreciation as part of an exclusive showcase held by the legendary LA GENEVE NORTH at the Grand Movida.

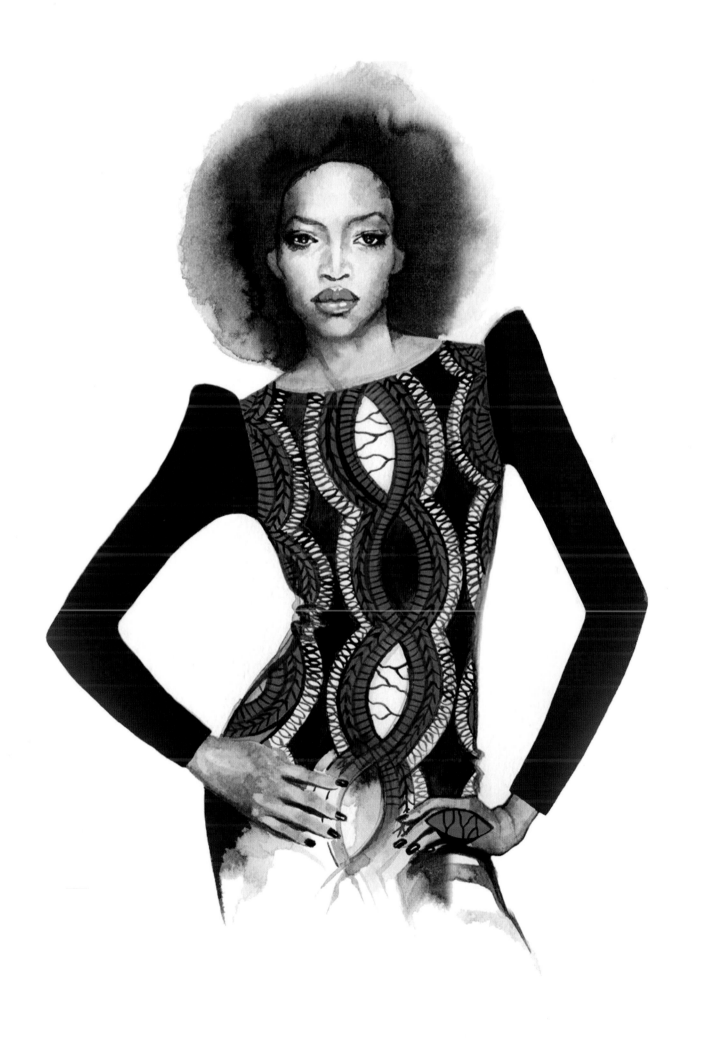

⟨ *From the Silence is Deafening Collection* (MODEL, YASMINA DIALLO; PHOTOGRAPHER, COLIN JOHNSON; MAKE-UP ARTIST, VIANNEY LEIGH) ❯ *From the Antithesis <1> Collection* (MODEL, JENNY EARLAND; PHOTOGRAPHER, VERONIKA PAPADOPOULOU; MAKE UP ARTIST, TERESA REYNOLDS)

In which countries do you source and produce? I have always had a long-term ambition to conduct my manufacturing in Africa – preferably in Ghana., however I currently source and produce my garments within the UK.

What do you see as the pros & cons of producing / sourcing in Africa? I think sourcing/producing in Africa has obvious advantages, such as helping the African economy to grow, encouraging a higher level of expertise within the African work force, providing cheap labour etc. But sometimes the cons outweigh the pros, especially in this industry, where you are working to tight deadlines with buyers. Africa isn't known for working to strict timelines - also quality can be a problem with the garments produced.

What inspires you? I find inspiration in everything and everyone, from day-to-day interactions with my 5-year

'Our intention is to be a sustainable, desirable and ethical, made in Africa fashion lifestyle brand'

old daughter, to people watching in urban Brixton in south London, UK.

What is your ethical standpoint? The intention is to introduce an organic range from Africa in the near future, but currently the garments are hand-made ethically, within the UK.

How do you think fashion made in Africa is regarded internationally? I think sometimes the mainstream buyer views garments produced in Africa as unstylish, badly made and cheap. But that definitely isn't the case. After travelling to Lagos for Arise Fashion Week and seeing with my own eyes the calibre of African design, I think there are a few things that can be learnt from our African counterparts.

How does Africa relate to your brand and why Africa? I think the identity of the label isn't overtly African, however my roots and experiences are always in play, therefore always keeping me engaged with what African represents In the modern age.

Do you use any traditional African craft techniques in your design process? We have used batik techniques previously.

Which African designers do you admire? I think there are more talented African designers than I can mention, but there are a few I admire, such as Mimi Plange, Maki Oh and Chichia.

Is Africa the future? Without any doubt – this emergence of talent is marking the future for not just us, but for future generations to come.

❯ *From the Antithesis <1> Collection* (MODEL, JENNY EARLAND; PHOTOGRAPHER, VERONIKA PAPADOPOULOU; MAKE UP ARTIST, TERESA REYNOLDS)

BROTHER
VELLIES

FACT FILE

LOCATED NEW YORK, SOUTH AFRICA & NAMIBIA
WEBSITE WWW.BROTHERVELLIES.COM
FOUNDED 2011 (EST. 1938)

Aurora James co-founded Brother Vellies, in 2011, continuing the legacy of handmade, leather shoemaking started in 1938 in coastal Swakopmund, Namibia. Made from sustainable vegetable-dyed Kudu leather by eight Damara gentlemen turning out just 20 pairs in an afternoon, the company today paints a positive contemporary picture of a very ancient traditional African method.

While relatively unknown outside of South Africa and Namibia, Velskoen, pronounced "fell-skoon" and known colloquially as "vellies," are the ancestor of the modern-day desert boot. Vellies were first made in the 1600s, inspired by the footwear of the Khoikhoi tribe and crafted using raw materials. Later, vellies were adapted by British travellers, packaged and renamed to be what are now known as desert boots.

Brother Vellies are made of Kudu skin which yields amazingly durable leather and suede that ages exceptionally well. These hides are taken from wild animals and they often show scars or other "imperfections" that domesticated hides do not. The Namibian government mandates the culling of these large native antelope to control their population.

❮ Esther & her basket full of Vellies, Mondessa, Namibia 2012 ❯ The Himba in Brother Vellies, Swakopmund, Namibia, 2012

Which countries do you source and produce in? Namibia, South Africa and Kenya and we source leather from within Africa as well as Italy and South America.

What do you see as the pros and cons of producing/sourcing in Africa? We are putting money into the economy, creating demand and providing jobs. Also, we use some incredible raw materials found only in Africa. Unfortunately consistency

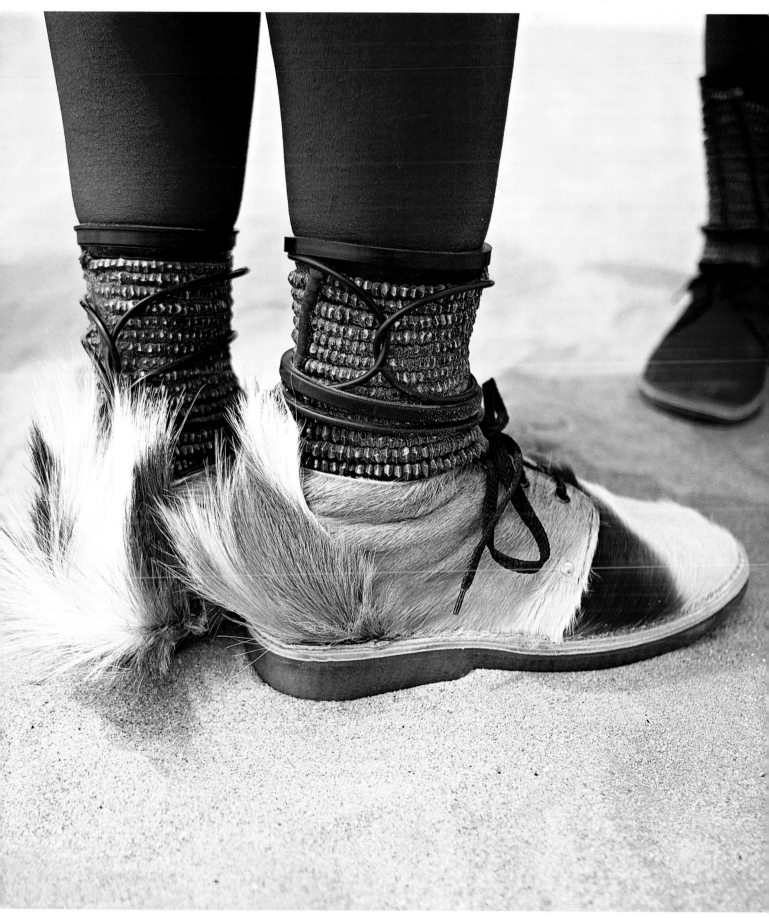

'I'm inspired by the people we employ, they in turn are inspired by the love our customers shower us with and our customers are inspired by our artisans and final products'

is difficult and Logistics are very expensive. Some of the African currencies tend to be very volatile. This makes costing when working with African suppliers a little all over the place.

How do you think fashion made in Africa is regarded as internationally? People are hopeful about Africa and are willing to invest in a product if they think it will help a situation that needs it. There are a lot of misconceptions about cheap labor and poor working conditions that can have a negative impact on items produced in Africa. People ignorantly assume 'Made in Africa' means made for 10 cents an hour by a minor – which in our case couldn't be further from the truth. People are yet to think of Africa as somewhere that produces luxury goods as well, but with my brand a lot of people hold our craftsmen and the quality of our leather and finished product in a very high regard. You really have to research and continue learning about and developing your product everyday. 'Made in Africa' can never be an excuse it should always just be an added bonus.

What inspires you? Markets and farms mainly. There is still so much of Africa I have yet to see. For my Mens SS14 collection I spent a lot of time in Kenya and sourced each and every inch of the shearling

used personally from small farmers there. From Nairobi to Nakuru, I'm not sure there's a farm I haven't seen. I did a little bit of bar hopping checking out what a lot of the young guys were wearing. The sandal for that season was based on a sandal a Masai man made for me using recycled car tires. The guys I work with are also really inspiring. Sometimes I will go over a design with them and they'll give me the 'look'. That means I've potentially gone off the deep end, this could be bad... or good. Depending on how you look at it!

How does Africa relate to your company? The Company would not be possible without Africa! We use kudu leather, springbok, South African crocodile, etc. Importing this to China to make a pair of traditional South African shoes would make zero sense. I'm inspired by the people we employ, they in turn are inspired by the love our customers shower us with and our customers are inspired by our artisans and final products. It takes a village and for me that village needs to be in Africa.

Do you use any traditional African craft techniques in your design process? Absolutely. We last our shoes using a last that is over a century old in its design. I don't speak often on tradition because I feel like tradition is born everyday but I do like intuition. I think a lot of our designs are intuitively African whether traditional or current.

What is your ethical standpoint? It's important to be accountable and transparent with every single thing you do. My goal with this company is to create something people want to wear and in turn create jobs doing so.

Which African designers do you admire? I'm actually super excited to see what Danielle Sherman does with Edun. I also love what Yodit has done with Bantu.

*❮ Brother Wamboland Boot ❯ **TOP LEFT** Vintage Zebra Belly Vellies ❯ **TOP RIGHT** Springbok Sandal ❯ **BOTTOM LEFT** Gold Vellies ❯ **BOTTOM RIGHT** Mickalene Thomas for Brother Vellies, Birds Shoe, 2013*

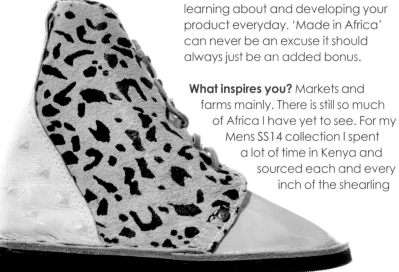

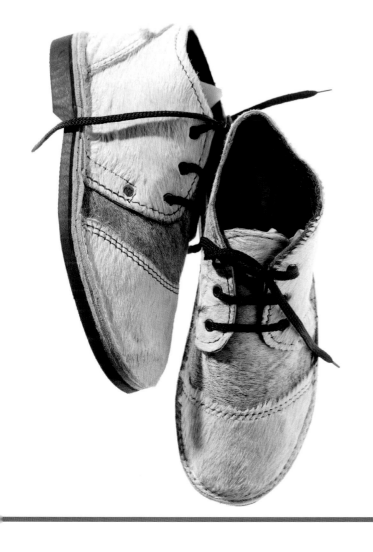
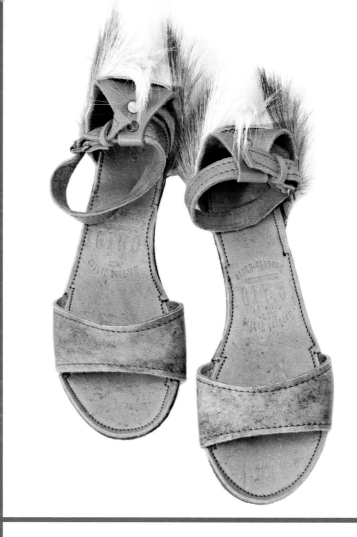
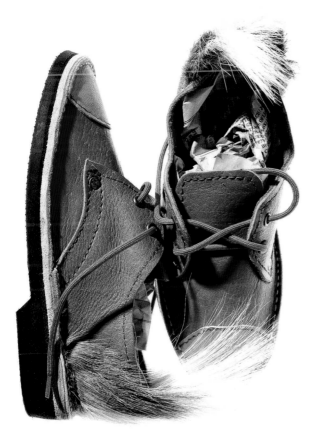
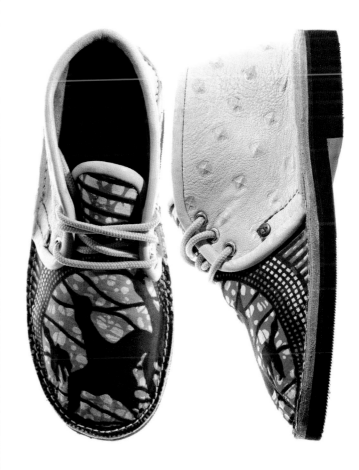

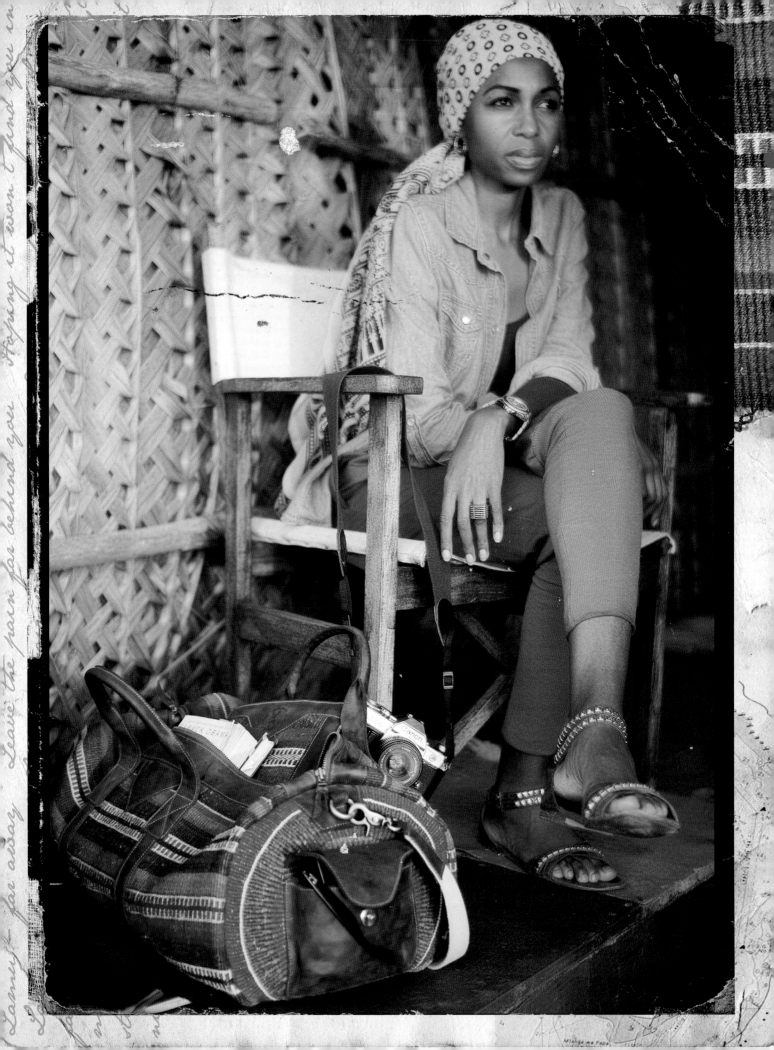

BUYU
COLLECTION

FACT FILE
LOCATED NAIROBI, KENYA
WEBSITE WWW.BUYUCOLLECTION.COM
FOUNDED 2012

BUYU COLLECTION was launched in October 2012 inspired during a family visit to Kenya by meeting and observing the local artisan weavers, their communal work practices and their ingenious use of sustainably harvested Baobab tree bark.

Buyu Collection is an African designer brand making timeless travel accessories from the bark of the ancient Baobab tree and distinctive leather. It was founded by Creative Director, Kimathi in 2012, who was later joined by Diana Owusu-Kyereko a British Born Ghanaian. Inspired by local craft traditions Kimathi saw that he could rework and design his range of luggage, while helping the local communities. The result was not only a beautifully designed, durable art and craft piece but was also something that celebrated his culture, his training as a designer and his roots.

Which countries do you source and produce in? Buyu operates in Kenya (sourcing and production) and the USA (distribution and sales and marketing).

What do you see as the pros and cons of producing/sourcing in Africa? The patchy infrastructure, affecting the availability and reliability of electricity and equipment can be highly problemmatic. Equally, government red tape and bureaucracy and political instability can often inhibit production and therefore growth. On the positive side Africa's cultural capital is it's richly skilled artisans, the highly unique organic materials to be found and it's ancient history in textiles, textures and patterns. There are opportunities to develop new markets and

❮ *Buyu Carry all Duffel*
❮ (FACT FILE PHOTO, MYRON CHRISTIAN PHOTOGRAPHY)
❯ *Buyo Soko Tote*

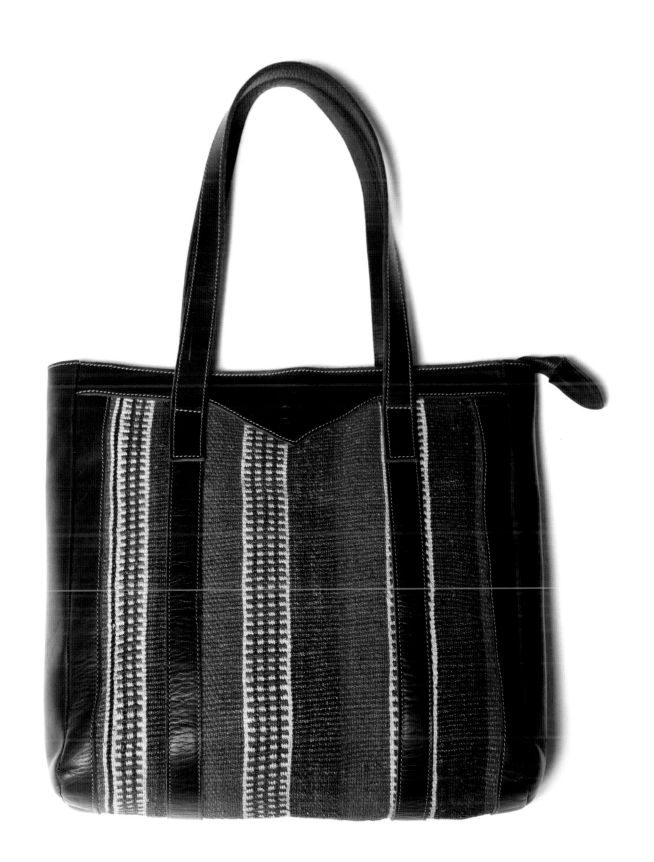

'Africa is our muse and inspiration. Our mission is to showcase and share the best of Africa to the rest of the world'

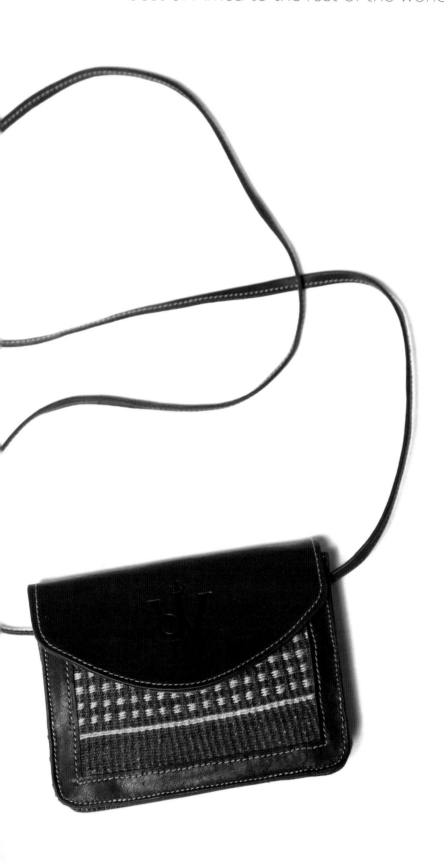

categories while providing new access to markets that can create a lasting social impact in tandem with creating a profitable business.

How do you think fashion made in Africa is regarded internationally? As culturally rich, organic and ethical.

What inspires you? Open air markets are powerful sources of inspiration and watching how people interact with products, incorporating them into their daily lifestyles.

How does Africa relate to your company and why Africa? Africa is our muse and inspiration. Our mission is to showcase and share the best of Africa to the rest of the world.

Do you use any traditional African craft techniques in your design process? At the core of our luggage production is a ancient endangered hand weaving process involving the women harvesting and organically dyeing the bark of the Baobab tree using sustainable methods.

Does your company work with any cotton programs or any production organisations in Africa? All material supplies used to manufacture our bags including the leather, Baobab fabric and hardware is 100% sourced in Africa and also our current collection is 100% percent manufactured in a factory in Nairobi.

What is your ethical standpoint? Buyu is a social business enterprise design company with a passion to create a sustainable impact with the communities and crafts with whom we partner.

Which African designers do you admire? Yinka Shinobare and Ozwald Boateng

Is Africa the future? It's the past, present and the future.

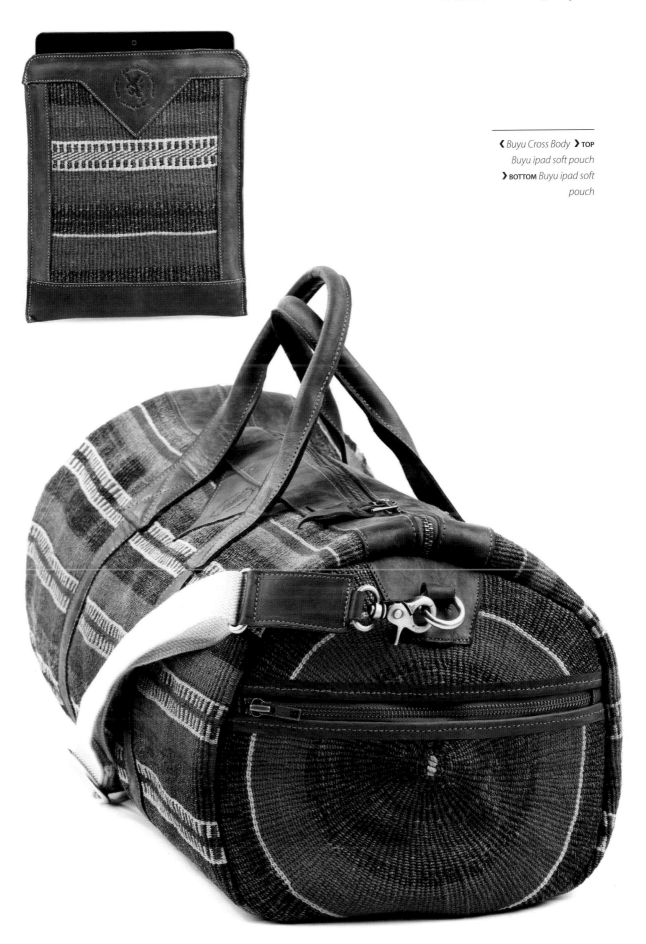

❮ *Buyu Cross Body* ❯ **TOP**
Buyu ipad soft pouch
❯ **BOTTOM** *Buyu ipad soft
pouch*

CHICHIA
LONDON

FACT FILE

LOCATED TANZANIA AND LONDON, UK

WEBSITE WWW.CHICHIALONDON.COM

FOUNDED 2007

Tanzanian-born Christine Mhando launched the label that bears her childhood nickname, CHICHIA in 2007. The ready-to-wear range is an amalgamation of the continents and cultures in which the designer was raised.

CHICHIA's intelligent use of eye-catching colourful prints in natural fabrics intermixed with beautiful embellishments and intricate detailing makes every piece uniquely innovative and a timeless addition to anyone's wardrobe. Each collection consists of an eclectic range of dresses and separates in modern wearable silhouettes and styles in a variety of succulent colours. Currently stocked in boutiques throughout the UK and online, Chichia's extensive press attention in distinguished magazines and independent newspapers have given the label a place on the London Fashion Week circuit and it has been showcasing in fashion events from Untold, Fashion Diversity to Arise Fashion Week.

Chichia has become recognised as an international African designer who modernises and transforms traditional illustrative East African textiles into stylish attire. The label was recently awarded the accolade of winner of the Ethical Fashion Forum Innovation Award 2011 for the Pure London category.

In which countries do you source and produce? We mainly source in Tanzania and also, from time to time we also source within the UK.

‹ SS10 Made in Dar 2010 Collection › Illustration of model at Arise Magazine Fashion Week Lagos 2011 by Katie Hemingway

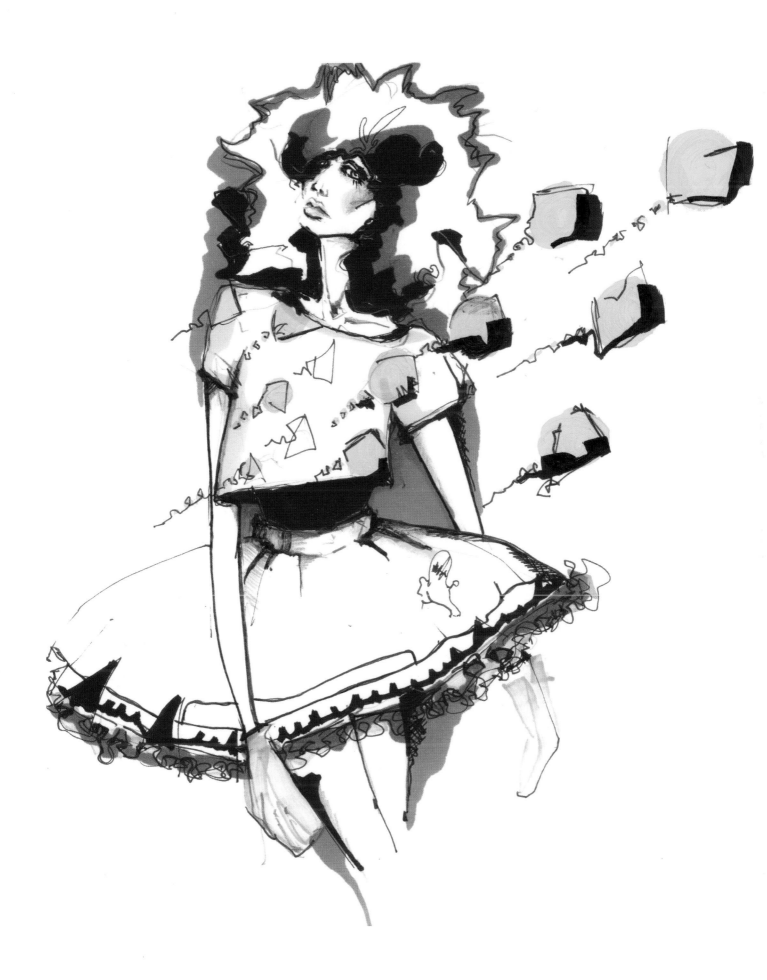

'As an African I'm inspired by my heritage, as it is part of who I am'

What do you see as the pros & cons of producing / sourcing in Africa? They are pretty much the same for any company whose base is away from where they source and produce. We face a lot of delivery problems and of course the fact that I have to travel back and forth between the UK - where the business is based- and Tanzania a few times within a year can be stressful. But it works for us.

How do you think fashion made in Africa is regarded internationally? Fashion made in Africa is rapidly becoming highly sought after. The fact that big designer brand names such as Suno NY and Vivienne Westwood to name a few, are now sourcing and or manufacturing their collections in African countries proves this point.

Where do you go to and what do you look at for inspiration? Inspiration is drawn from everything and anything that's around me. The fabric and prints I use play a big part and I love to experiment with colour. Living in London helps a great deal as it's a city filled with lots of culture and also a lot of fashion too, so by just walking around the city can trigger ideas.

How does Africa relate to your brand and why Africa? As an African I'm inspired by my heritage, as it is part of who I am, so incorporating Africa within my designs is a natural reflection of me as a person and designer.

Do you use any traditional African craft techniques in your design process? So far I haven't used any African techniques within my design though I use a lot of African-inspired embellishments.

Does your company work with any cotton programs in Africa and or any production workshops / organisations in Africa? In the beginning of 2011 we started an ongoing collaboration with a Tanzanian-based concept jersey brand named Made By Africa (*Chichia for Made By Africa*) and the garments were manufactured by Kibotrade Textiles Ltd which was the first Fairtrade registered textile factory in East Africa.

Which African designers do you admire? I'm a print fan of course so I usually notice designers that use prints well within their collections. I love Jewel by Lisa, Duro Ulowu and SUNO (who aren't African but as they source and produce in East Africa I think they have a right to be in the list).

Is Africa the future? I'd say Africa definitely is earning its rightful place within the fashion and textile industry.

❯ *SS13 On Second Thoughts Collection*

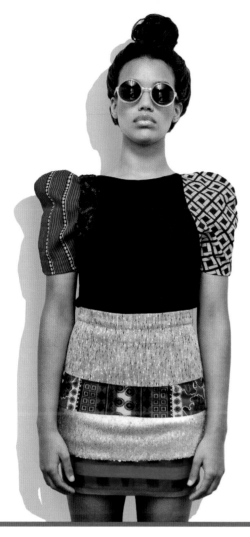
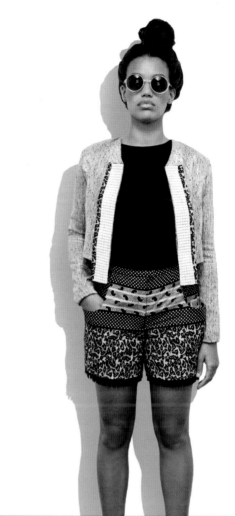

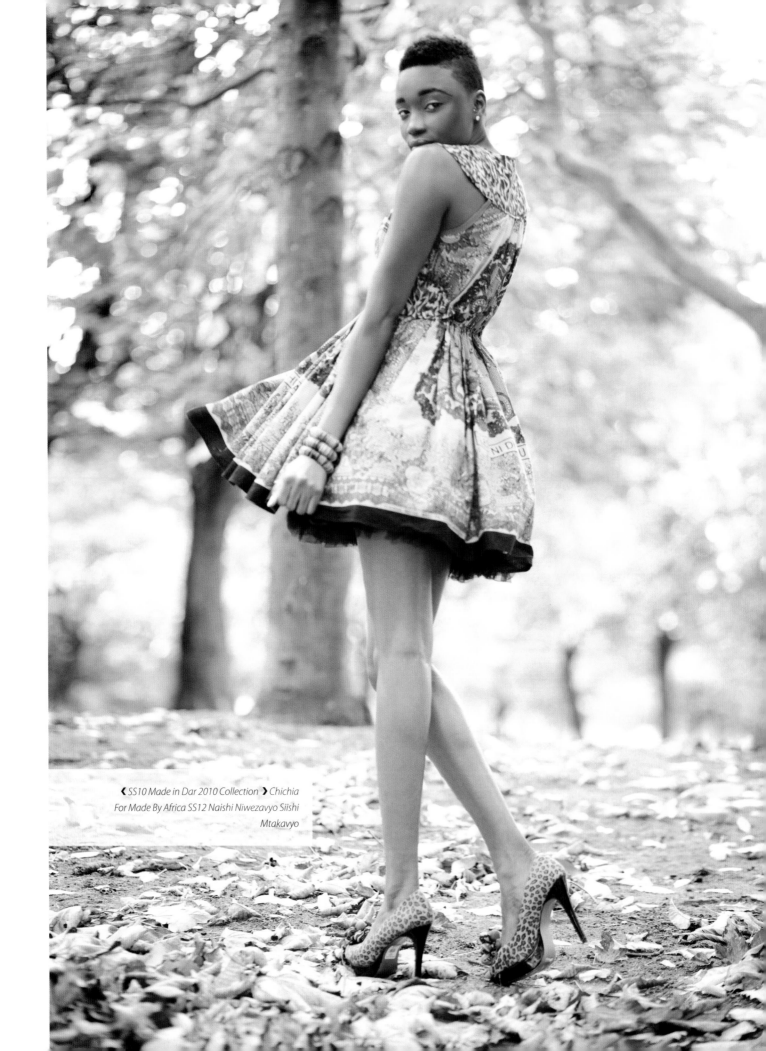

‹ SS10 Made in Dar 2010 Collection › Chichia For Made By Africa SS12 Naishi Niwezavyo Siishi Mtakavyo

'Fashion made in Africa is rapidly becoming highly sought after'

CHOOLIPS

FACT FILE
LOCATED LONDON, UK
WEBSITE WWW.CHOOLIPS.COM
FOUNDED 2006

CHOOLIPS collections focus on the luxury and craft of textile traditions. Their 'Golden Coast' collection is inspired by the soul of Ghana's streets, with material printed by batikers in Ghana and garments made by Kenyan seamstresses and tailors.

Choolips designer and founder Annegret Affolderbach moved to London from East Germany in 1994 to study fashion at Middlesex University. She set up CHOOLIPS in 2006 and combines her passion for traditional textiles with a mission to revive and sustain the small-scale artisans and entrepreneurs in developing countries who produce these materials. CHOOLIPS' innovative and colourful collections enable producers in developing communities to flourish as grassroots businesses.

The company won 'Barclays Innovative Business of the Year 2008' and was a finalist in the British Council's 'UK Young Fashion Entrepreneur of the Year 2009'. Her collections have seen successes at Topshop and Asos.com's 'The Green Room' and are sold across Japan, Europe and the US.

‹ *Marta, Diamonds & Animal Print, SS13*
› *Illustration Choolips 'Birgitte' dress, Chainmail Print, Spring 2011 collection* (BY ELENA SOFIA FINIS BOBEL)

How do you think fashion made in Africa is regarded as internationally?
Consumers generally are not aware of the potential Africa holds. As far as designers and retailers are concerned we are seeing some changes, such as the creation of the ASOS Africa range, which is entirely sourced and produced in Africa. Nonetheless, people are always surprised to learn that CHOOLIPS is entirely made in Ghana, not expecting such high quality and commercial output from the African continent. However designers, stylists, photographers, bloggers

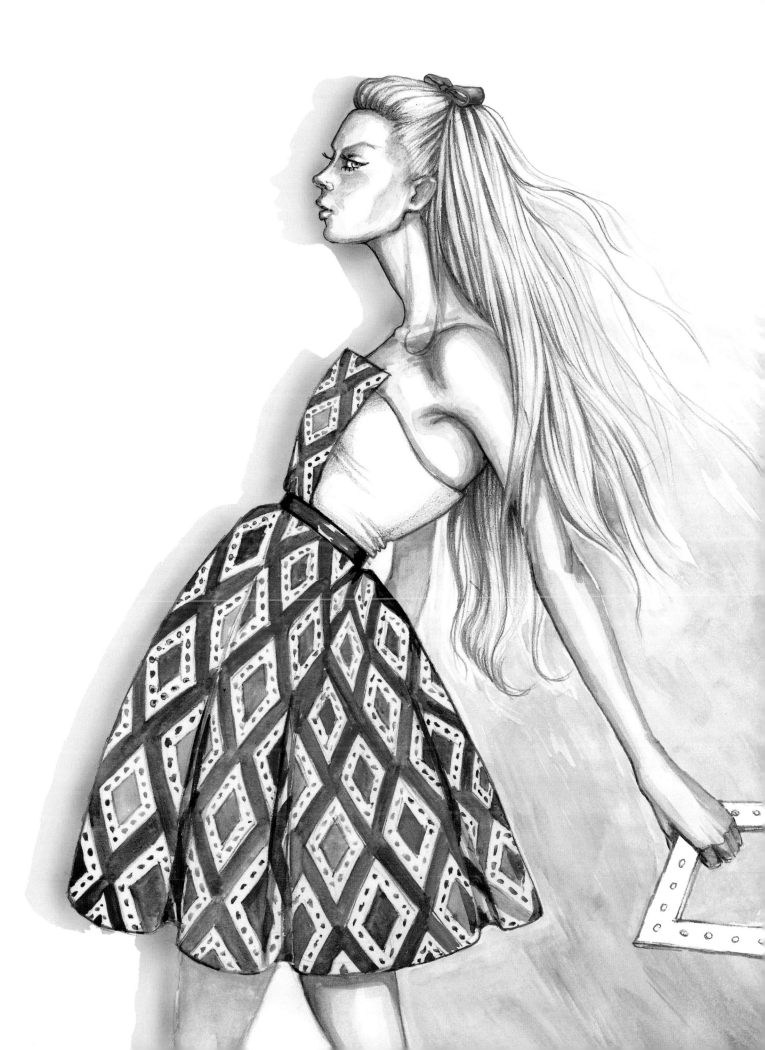

'We think of our brand as sustainable rather than ethical. Sustainability focuses on having a future'

and the fashion business could provide more leadership, for instance by setting up high quality, press-friendly fashion events and editorial.

Which countries do you source and produce in? Our 'Golden Coast' collection is designed in the UK and entirely sourced and made in Ghana.

What do you see as the pros & cons of producing / sourcing in Africa? The advantages of producing on the African continent mean we get to work with exciting textile traditions and combine our own ideas with the experiences and energy of our producers. We have been able to develop a truly innovative business model, which takes into consideration local infrastructures and the individual ambitions of our producers. Ghana was a first choice for us in terms of its infrastructure, the entrepreneurial approach of its people and its history of textiles and fashion.
Setting up any fashion business is a tall order. Personally, I have experienced the same issues in the UK as I have in Ghana. It's always difficult to communicate ideas across teams that have varied experience and insight. However, we believe that to manage a business sustainably takes careful strategic planning. It's always a challenge, but undoubtedly, it's a priceless investment in our futures.

Which African designers do you admire? I've seen a lot of collections with elements I love and sometimes inspiring stories. I go with the flow; my fashion taste really varies and evolves all the time. I wouldn't say I have a favourite designer, but rather individual elements and pieces that stay in my memory.

How does Africa relate to your company and why Africa? CHOOLIPS uses ancient textile traditions. Africa, especially West Africa, seemed like the most obvious starting point

Do you use any traditional African craft techniques in your design process? Our 'Golden Coast' collections use Ghanaian Batik traditions.

Does your company work with any cotton programs in Africa? Unfortunately, Ghana seems to be one of the countries that hasn't been targeted for cotton programmes. We hope in future, there will be more links between West African Cotton farmers, ginners and spinners and us.

What inspires you? Music, people, art, architecture, nature… it entirely depends on what I am working on. Music is another huge influence.

What is your ethical standpoint? We think of our brand as sustainable rather than ethical. Sustainability focuses on having a future. We trade fairly and keep our carbon footprint as small as possible by keeping things local without compromising the pursuit of good style.

Is Africa the future? Parts of the African continent will most certainly provide solutions to some of the fashion industry's social and environmental dilemmas. There is the potential for pockets of Africa to shine, offering tremendous heritage and resources and we ought to listen to the ideas. Whichever areas emerge as major players, I wholeheartedly hope that they will be bold and confident in what they have to offer and that they will receive the right level of support as they grow.

❯ **TOP LEFT** *Freya, Window Print, AW13* ❯ **TOP RIGHT** *Ronja, Apocalypse Print, AW13* ❯ **BOTTOM LEFT** *Melody, Apocalypse Print, AW13* ❯ **BOTTOM RIGHT** *Brynja, Quilted Meadow, AW13*

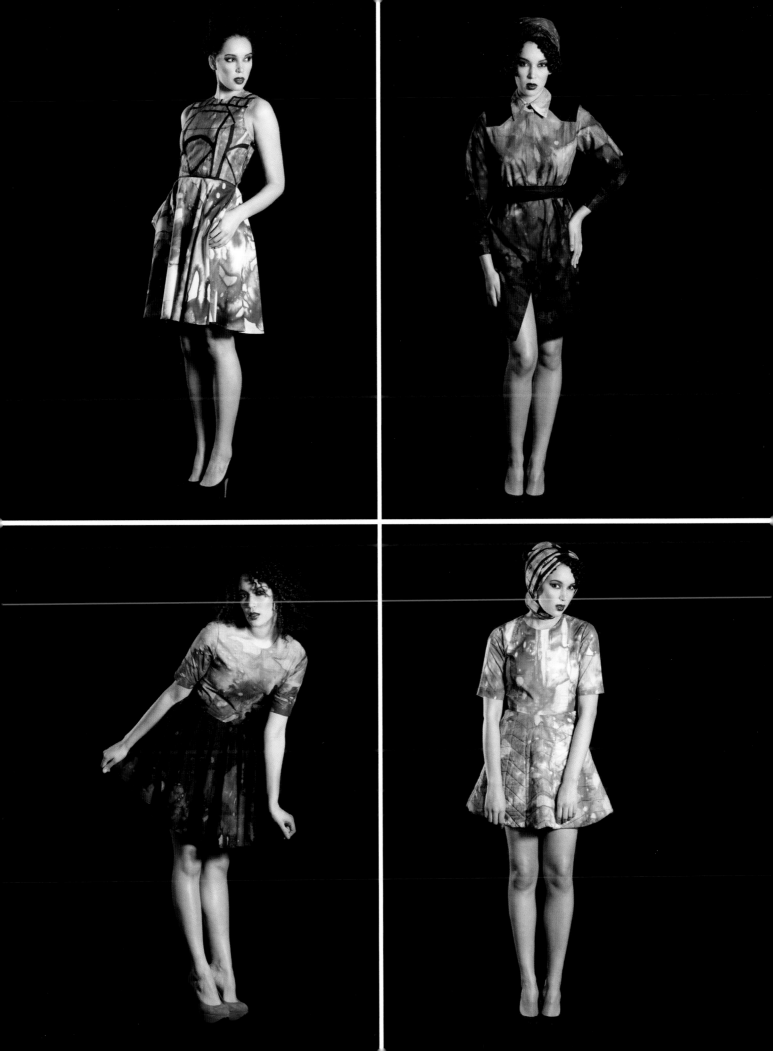

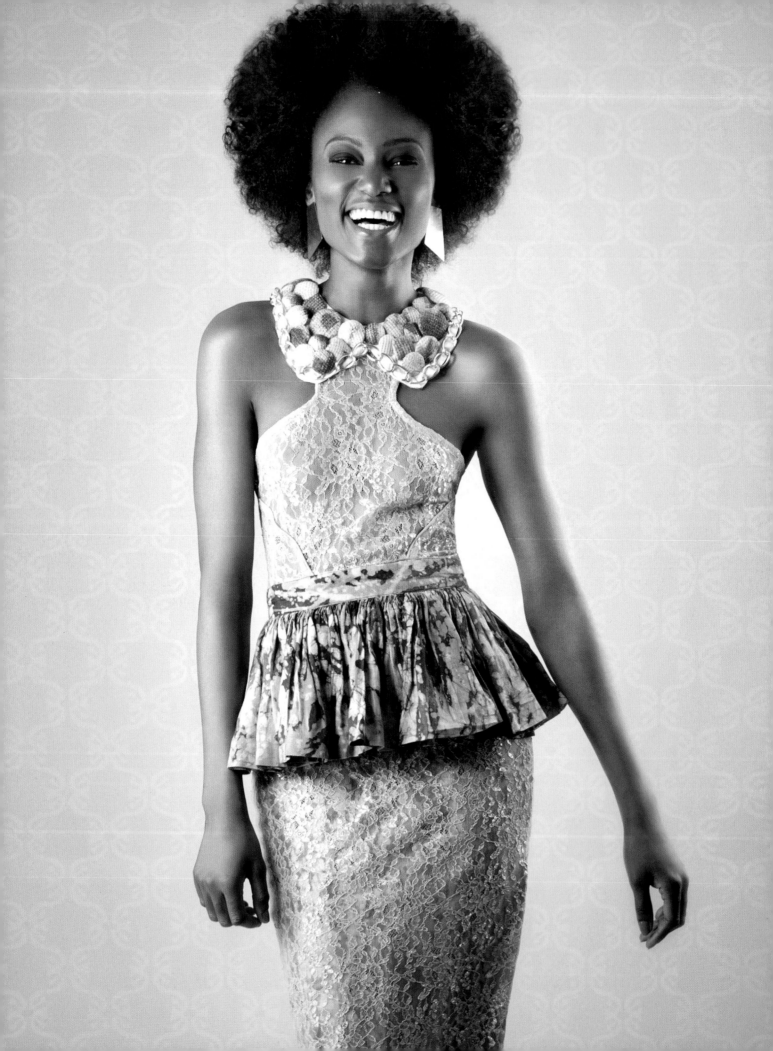

CHRISTIE BROWN

FACT FILE

LOCATED ACCRA, GHANA
WEBSITE WWW.CHRISTIEBROWNONLINE.COM
FOUNDED 2008

The mission of Ghanaian label Christie Brown is to promote African beauty. The luxury collections make bold statements, featuring clothes rich with colour, steeped in culture, and fit for the contemporary African woman.

CHRISTIE BROWN was founded by Aisha Obuobi in 2008. Aisha began her love affair with fashion at an early age, watching her grandmother, the eponymous Ms. Christie Brown, stooped over a sewing machine. The clothes, made from rich and vibrant materials, were like works of art and as a young girl Aisha loved to play with the scraps of African print, designing miniature collections for her favourite dolls.

Today, Christie Brown is one of Ghana's celebrated fashion labels, with pieces ranging from beautiful bespoke gowns, to practical statement pieces, to innovative accessories. All are inspired by and give African women the opportunity to express their culture in a way that's modern, sophisticated and can transcend international borders.

As well as winning 'Emerging Designer of the Year Award' at the 2009 Arise Africa Fashion Week in Johannesburg, Christie Brown was showcased at the Arise L'Afrique- a- Porter, as part of the 2010 Paris Fashion Week. The collections have captured the attention of global magazines, including Harpers Bazaar, Vogue Italia, Arise (UK), Canoe 53 Sails, Black Hair (UK), Destiny (SA), and Glamour.

How do you think fashion made in Africa is regarded internationally? African fashion has definitely inspired the world. In recent collections seen on

‹ From Resort '13, To Dye For Collection
› Illustration, Christie Brown design (BY KATIE HEMINGWAY)

'I think Africa is the present AND the future. Our culture is so rich and diverse. The talent within is untapped and the potential for continuous creativity continues to grow. Africa is definitely the continent to watch'

international runways, high-end designers have drawn on Africa for inspiration to build amazing collections. Also, African designers and their designs are progressively making their way onto mainstream runways, into internationally recognized retail stores and onto major high streets. Our fashion sense is definitely appreciated and sought after. It is really up to Africa to make this more accessible.

Which African designers do you admire? Tiffany Amber and Korto Momolu. Both designers have a unique take on fashion and are not afraid to add personality to their clothing.

‹ › *From Resort '13, To Dye For Collection*

In which countries do you source and produce? All the products and

materials used to manufacture Christie Brown clothing and accessories are sourced in Ghana. The brand's production team is locally based as well.

What do you see as the pros & cons of producing in Africa? Producing in Africa brings amazing benefits both to the brands and the economy as a whole. It is a great opportunity to be able to give back to the local community by creating more jobs and at the same time encourage and develop vocational skills. Because we are using African materials and labour, our products are well tailored to the African consumer. Nevertheless, there are always challenges in production and sourcing. It is not always easy to find large quantities of the same fabric to meet our production demands and we work hard to make sure all our clothing and accessories represent the quality standards we advocate. At Christie Brown, we are continually developing new and innovative mechanisms for sourcing material and managing quality control: we see these as opportunities for improvement rather than challenges.

What inspires you? The brand is inspired by women who like to look effortless, modern and chic while embracing that which is unique. I am inspired by photography, various forms of art, music, furniture and the list goes on. I allow any and everything I see and feel to inspire me, my creations and my brand as a whole.

How does Africa relate to your company and why Africa? This is an African brand, made by African people, for African women. This brand truly aims to "show off" African beauty through clothing, bearing the ultimate customer (or African ladies) in mind, it aims to satisfy their needs for a unique identity while exuding sophistication.

CRAIG NATIVE

FACT FILE

LOCATED CAPE TOWN, SOUTH AFRICA
WEBSITE WWW.CRAIGNATIVE.COM
FOUNDED 2000

Speaking to a generation of South Africans who until recent years did not have a voice, NATIVE has become a brand that's making noise. NATIVE designs are practical, aesthetically appealing, and make direct references to African social and environmental issues.

Growing up in the Cape Flats district of Cape Town during the apartheid regime, Craig Native found the only way to express himself was by sketching and designing objects. When he launched his own label Native in 2000, his passion for sports characterized his collections. 'AFRIQUE SPORTIF', one such collection, pays tribute to South African sports heroes who were unable to take part in global sports during the years of Apartheid sanctions.

Craig Native won the 'Trendsetter' category in the Men's Health MAN OF THE YEAR awards in 2010. His label has also won awards for South Africa's "Best Menswear" and "Most Promising Designer", and Craig was recently invited to be a Greenpeace international ambassador for design.

What is your ethical standpoint? Well, you are what you eat, you are what you wear. We all have choices, and we all have to face the consequences of those choices. We have used Made in Africa cotton since 2009 – a social trade initiative that helps African cotton farmers secure their own incomes.

‹ Mercedes Benz Fashion Week Africa 2012 Collection › Craig Native collection

In which countries do you source and produce? We primarily produce in South Africa and also in Morocco.

'Native is 100% inspired by Africa. I was born here and I don't know anything else. We are an ever evolving continent. We owe it to Mother Africa to sew into its evolution'

❮ ❯ *Craig Native collection*

What do you see as the pros & cons of producing / sourcing in Africa? Sourcing products from the East is very competitive, but I don't think it would be sustainable for us to apply the same working conditions in Africa. I am a supporter of African production but many retailers are not.

Where do you go to and what do you look at for your inspiration? The streets of South Africa, which are vibrant and inspirational and most music events, watching musicians play from the soul.

How does Africa relate to your company brand and why Africa? Native is 100% inspired by Africa. I was born here and I don't know anything else. We are an ever evolving continent. We owe it to Mother Africa to sew into its evolution.

Do you use any traditional African craft techniques in your design process? South Africa is the home of many different tribes, like the Ndebele, Xhosa and Zulu tribes. I am inspired by iconography of African symbols.

Does your company work with any cotton programs in Africa? Yes, as the designer of the 'Native for Cotton' Made in Africa brand for the OTTO group.

Which African designers do you admire? I'm a big fan of Esther Mhlongu, a traditional artist.

Is Africa the future? Africa has value to bring to the current market if the infrastructure is developed. There's so much raw inspiration out there: ideas are often hard to get to market because of basic issues like the lack of food, transport or water. It's hard to think of a cool idea when you haven't eaten for 24 hours.

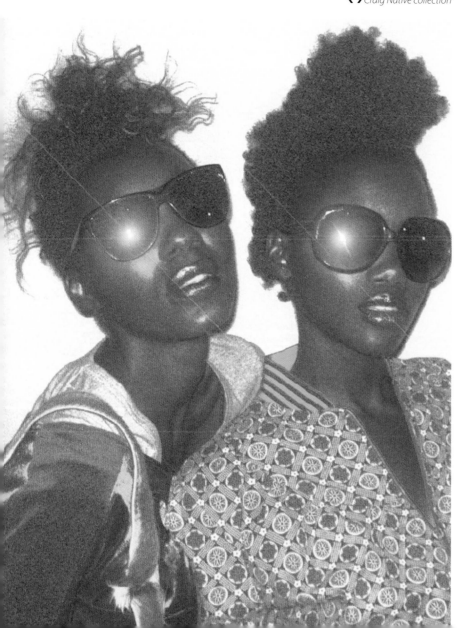

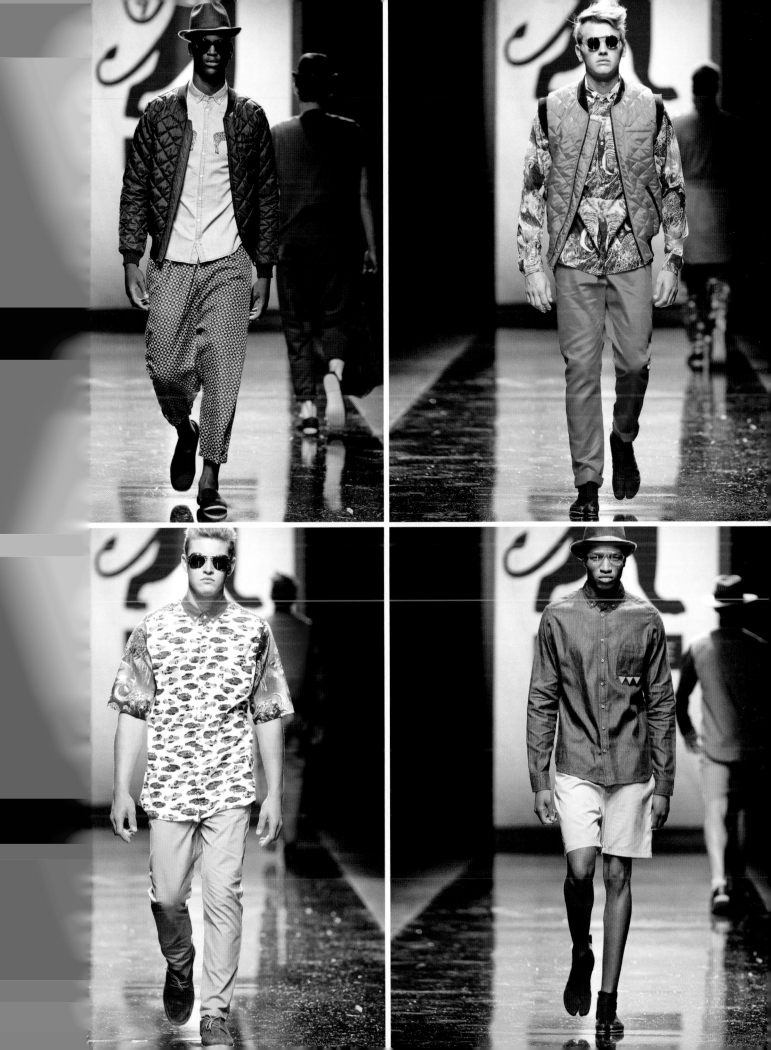

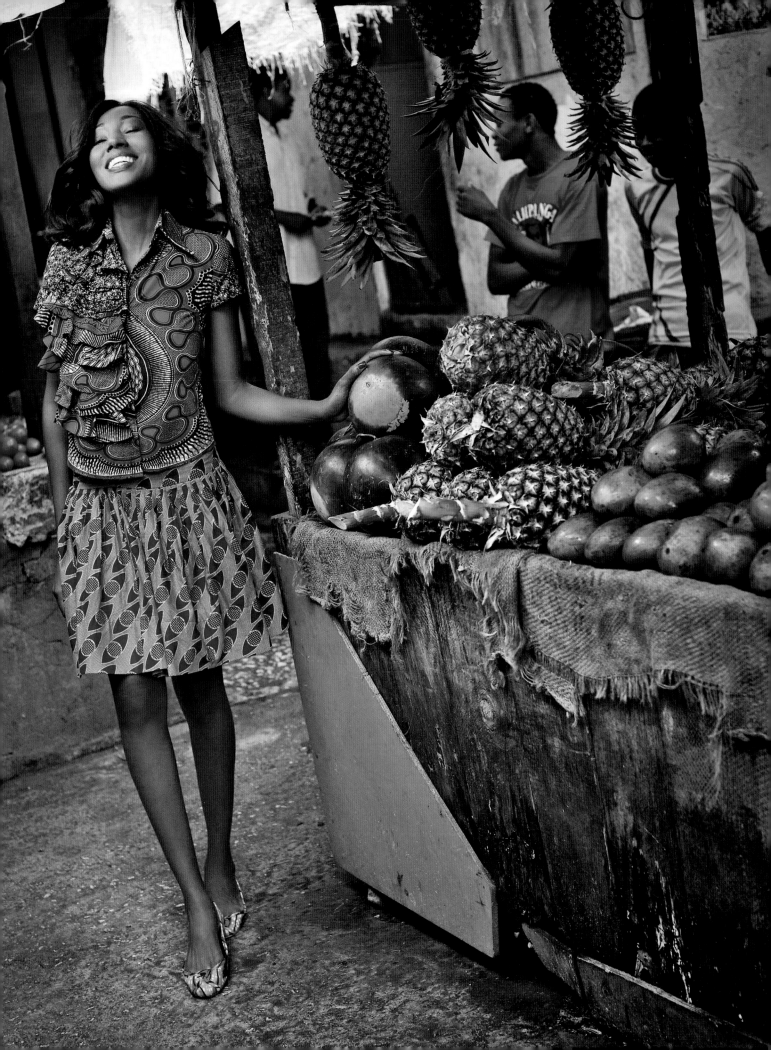

DOREEN
MASHIKA

FACT FILE
LOCATED ZANZIBAR, TANZANIA
WEBSITE DOREENMASHIKA.COM
FOUNDED 2008

Doreen Mashika Zanzibar's luxury fashion brand was launched in 2008 as a successful retail store. It's a unique mix of contemporary western styling and quality with traditional African materials and techniques offering desirable pieces to admire and treasure.

‹ › 2012 collection
(PHOTOGRAPHY BY WWW.
DAVINAPLUSDANIEL.COM)

Doreen Mashika's brand has a captivation for its native land combined with Swiss-instilled perfectionism acquired by the eponymous designer's career while in Switzerland. This has helped the brand become a growing force in the fashion industry. Doreen Mashika was named Accessories Designer of the Year 2012 by African Fashion Awards (Mercedes-Benz) and has been an award winner for two consecutive years at the Ethical Fashion Show Paris 2011 and 2012. Doreen Mashika's design strategy focuses primarily on bridging the high-end market divide of high quality fashion and it is clearly allied to a visible Corporate Social Responsibility ethos.

What is your ethical standpoint? While the company cares passionately about the unique look and finish of the goods we care equally about the means justifying the ends and not achieving success based purely on tangible fiscal corporate outcomes. Therefore, while we run a for-profit business, our goal is to endeavour to achieve our results based on a unique platform of local and international social collaboration. It is our view that to achieve corporate excellence in this way has clear, otherwise unattainable long-term entrepreneurial dividends.

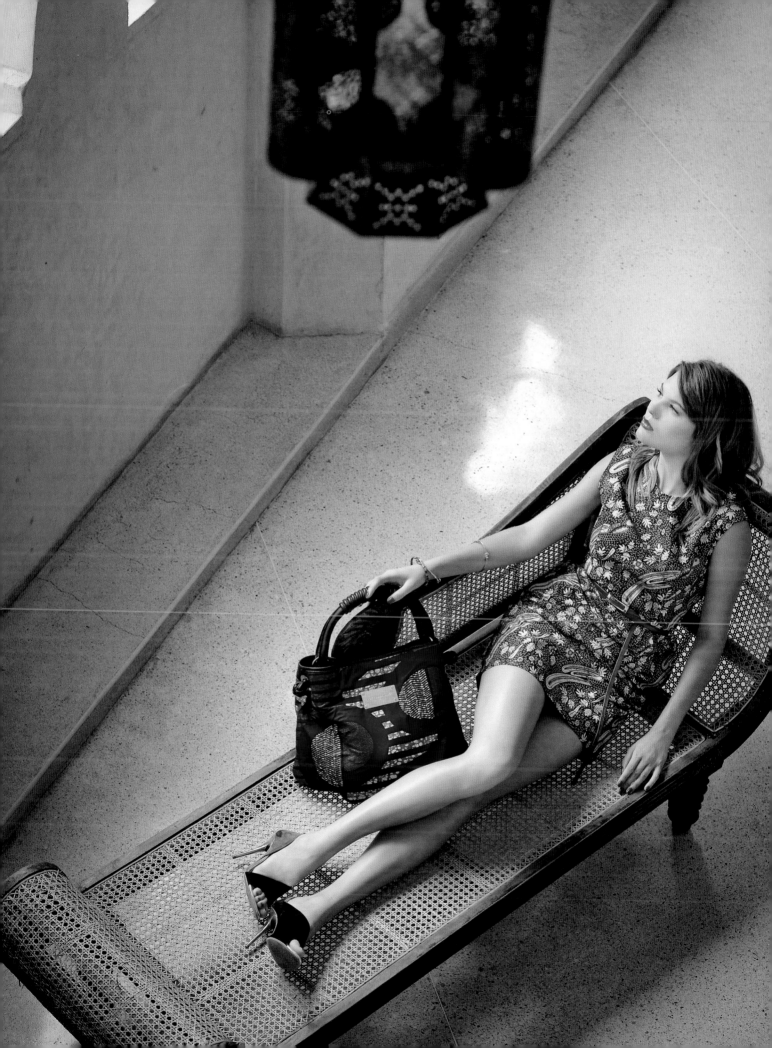

'We have thus far
successfully carved a
growing niche for quality
ready-to-wear clothes'

**In which countries do you source
and produce?** From Africa we source
and produce in Tanzania, Kenya,
Ghana and Mauritius. We also look to
European countries such as Portugal,
Italy, Holand and Switzerland

**How does Africa relate to your
company brand and why Africa?**
Apart from ensuring a socially stable
business environment born of mutual
respect, the rewards of which are
direct and clear-cut, the approach we
engender ensures that the potential
for consistent annual growth is richly
and fairly enhanced.

**Do you use any traditional African craft
techniques in your design process?**
We have thus far successfully carved
a growing niche for quality ready-to-
wear clothes lines and accessories
that bare a distinctive blend of the
traditional Afro-continental with a
universal appeal and now seek to
aggregate focused global growth.

❮ *2012 collection* ❯ *2012 collection* (PHOTOGRAPHY BY WWW.
DAVINAPLUSDANIEL.COM)

EDUN

FACT FILE
LOCATED DUBLIN, IRELAND; NEW YORK, USA
WEBSITE WWW.EDUN.COM
FOUNDED 2005

Founded by Ali Hewson & Bono, EDUN is a global fashion brand bringing about positive change through its trading relationship within Africa, and its positioning as a creative force in contemporary fashion.

The EDUN business model is based on five pillars of investment and development. These pillars incorporate the following: a Contemporary Collection for both men and women; EDUN Live, a grown-to-sew blank t-shirt programme made from 100% Ugandan cotton; the Conservation Cotton Initiative, Uganda (CCIU); African Artist Partnerships and Branded Collaborations. This last pillar is being realised through a 25-piece denim collection inspired by African creativity and co-designed by Diesel+EDUN.

Using raw, untreated denim, the Diesel+EDUN collection was built around a reinterpretation of the four-pocket jean of the 1970s popular on the streets of South Africa. Malian textile prints are echoed in the denim lining and across the jersey pieces in the collection. Embroidery details reference traditional Zulu weaving patterns, while the dresses feature Kenyan metalwork. Running through the whole collection are four unique symbols inspired by Dogon culture and designed to reflect the heart of the Diesel+EDUN collection: namely, UNITY, CREATIVITY, FERTILITY and ETERNITY

❮ ❯ Edun Collection

In which countries do you source and produce? We source our cotton entirely under the auspices of CCI's Uganda project. The DIESEL+EDUN project is also

'Desirability IS sustainability'

sourced and manufactured in Africa with the finest CCIU. The collection brings to life the two brands' commitment to promoting trade in Africa.

What do you see as the pros and cons of producing/sourcing in Africa? Africa had a booming apparel business in the 80's. The genesis of EDUN was specifically to do business with people in Africa and to be a part of increasing trade and building skills in the apparel sector. We wanted to show that beautiful clothes could once more be made on a global scale in places like Uganda and Kenya. We wanted to also be involved in the revival of the textile business threatened by global competition. In 2013 we will produce 40% of our fashion line in Africa and 100% of the EDUN Live blank t-shirt line.

How does Africa relate to your company and why Africa? EDUN was set up because we were aware the customer wanted to know the story behind their clothes; where they were being made, who was making them and who was benefitting along the value chain. The customer was starting to see meaning as the new luxury, wanting to look AND feel good about the clothes they were wearing. EDUN fully understands that to satisfy our customer, our clothes must be beautiful AND tell a story.

What is your ethical standpoint? In the 80's Africa had a 6% share of the world's trade. In 2011, 1% of global trade was worth $224 billion. This is nearly five times more than the region receives in international assistance. It is clear that trade with Africa is the way forward. Whether it is the factory worker in Madagascar, the Artisan in Nairobi or the farmer in the cotton field in Gulu, Northern Uganda, the fashion industry has a role to play with responsible trade. EDUN is committed to raising its expertise, scale and profile as a leading fashion brand doing business in Africa.

❯ *Edun Collection*

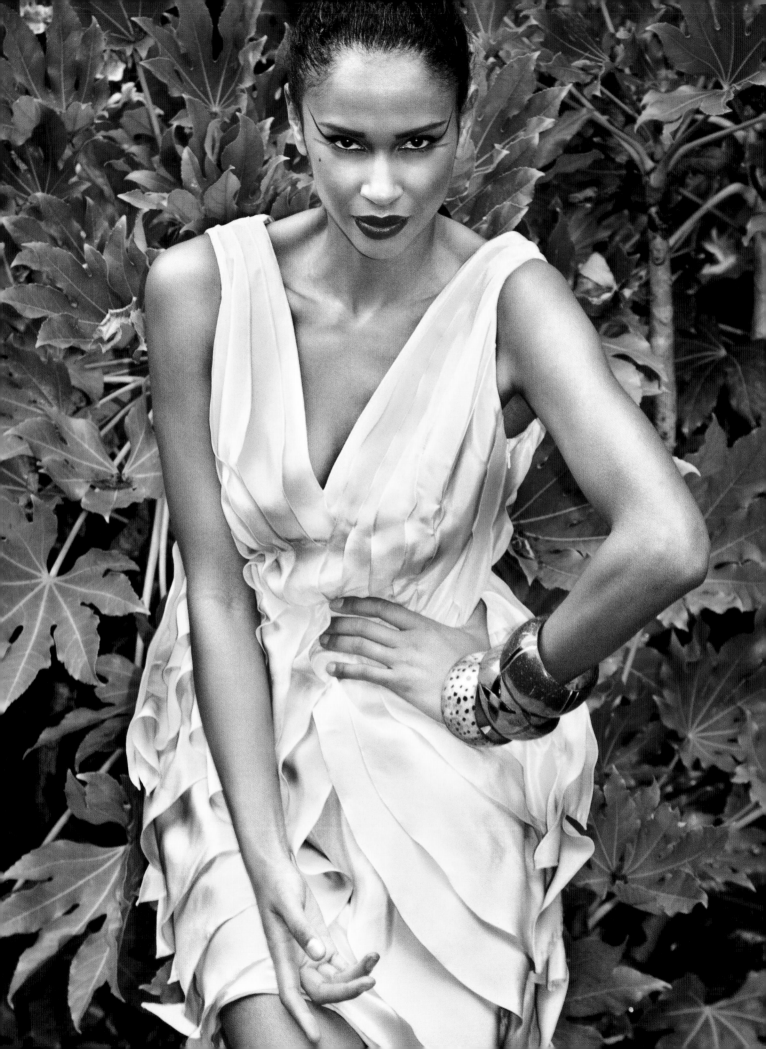

EKI ORLEANS

FACT FILE
LOCATED LONDON, UK
WEBSITE WWW.EKIORLEANS.COM
FOUNDED 2007

Hazel Aggrey-Orleans, the creative force behind Eki Orleans, was born in Germany, raised in Nigeria and educated in London. 'Eki' means "the centre of attraction", and that's how women feel who wear the bold and elegant silks and traditional African and Indian fabrics in her collections.

Despite originally pursuing a career in finance, Hazel nurtured her passion for fashion design and launched Eki Orleans in 2007, with a debut collection consisting of hand-made silk scarves using African and Indian fabrics. In 2009, Hazel expanded the collection to women's ready to wear, creating a signature style that fuses vibrant prints with the delicate texture of silk.

For inspiration, Hazel draws upon all of her cultural experiences, most notably growing up in the buzzing, chaotic and culturally diverse city of Lagos, where she developed a love for bold and vibrant colours and traditional West African prints. Where other fashion designers will tend to design the dress first and then find the fabric, Hazel creates the dress to suit her vision of the fabric design, creating floating and flattering day wear, evening wear and bridal collections.

In which countries do you source and produce? We produce and source between the UK and Asia.

How do you think fashion made in Africa is regarded as internationally? African fashion is still very matter of fact. It's not as extravagant as western fashion because the main focus is on saleability rather than creating extravagant collections for the runway. There is also still a very strong tailoring tradition in

‹ *Eki Orleans SS11, The mustard 'Wave' dress*
› *Illustration, Eki Orleans*
(BY DANIELE RACCICHINI)

'Starting my own fashion line and seeing it grow is what puts a smile on my face every morning'

‹ The 'Oceana' dress inspired by the waves at the beaches in Lagos **› TOP LEFT** *AW13 Inspired by the royal blues picked up by the Tuaregs in the Saharan desert* **› BOTTOM LEFT** *AW13 The migration of Butterflies through the Saharan desert* **› RIGHT** *SS13 The flowy Butterfly dress inspired by African butterflies on one of my trips to Mauritius*

African fashion and even the best designers tend to drift between wanting to be a recognised fashion designer and focusing on offering bespoke tailoring.

How does Africa relate to your company and why Africa? Why Africa? That's simple. I was brought up in Nigeria and have very fond memories growing up as a child there. I also remember being taken to numerous functions and being surrounded by women in the most beautiful and vibrant outfits. Africa plays a big part in my designs because I draw inspiration from African prints and symbols.

Which African designers do you admire? I usually buy into the person behind the brand and so when I met Nkwo, I was instantly drawn to her as well as her label. She is so passionate about what she does and has done an incredible job in creating her market. I also admire Jewel by Lisa. You have to hand it to her: she has created a brand that has evolved so beautifully over the years and her latest collection was amazing. She is another print lady to watch out for. Duro Owolu is an elegant designer with a great presence in Italy, fashion's temple.

What inspires you? I love travelling and exploring new cultures, a lot of my inspiration comes from my foreign travels. I can draw inspiration from exotic leaves for a colour palette, for example. I also draw inspiration from Ankara prints.

What is your ethical standpoint? Being sustainable and ethical is key to our business. I have a passion for nature and so it is very important to me to conduct an enviornmentally friendly business. We only work with natural fibres (silk). We print digitally, rather than litho, which creates less water wastage. We also produce all our garments in a London studio which already practises sustainability. In addition, we associate ourselves with African charities - we have worked continuously with th Georges Malaika Foundation in Congo, which focuses on providing education to underprivileged girls.

Is Africa the future? I do not believe any one market is the future, as fashion is all about drawing inspiration from different cultures.

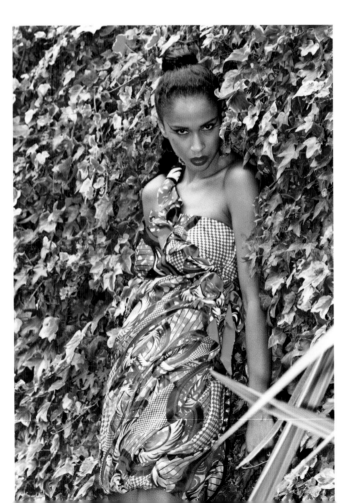

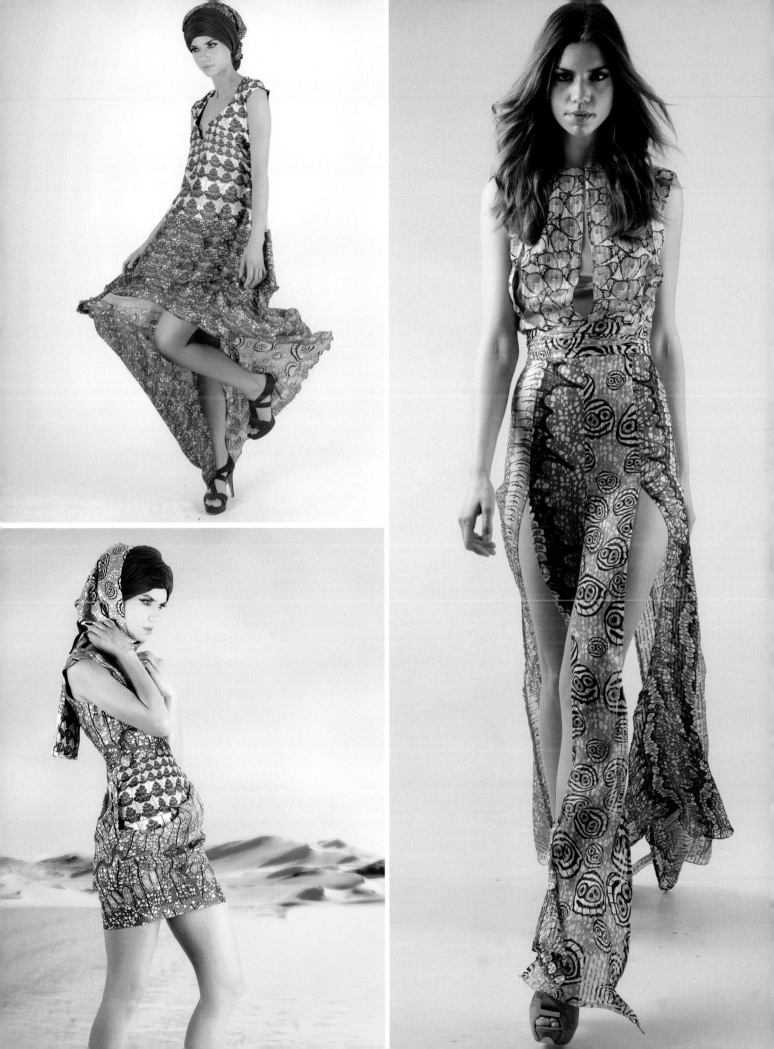

ENZI FOOTWEAR

FACT FILE

LOCATED ETHIOPIA AND KENYA

WEBSITE WWW.ENZIFOOTWEAR.COM

FOUNDED 2011

Four longtime friends bring their ingenuity and humour to the launch of a new line in African shoemaking. Founders Jawad, Azi and Sam grew up in Kenya, and studied in the UK and US. Fourth member Christian completed the team and in 2011 they established the ENZI label.

ENZI uses high-grade Ethiopian leathers to create premium footwear and uses high quality, eco-friendly materials for its complimentary apparel line. Jawad brings a decade of fashion designing across Europe to the team, with specialization in footwear. Azi manages partnerships with the factory and vendors in Ethiopia, while Sam and Christian spearhead business and marketing efforts.

Which countries do you source and produce in? We produce our footwear in Ethiopia and source the leather in Ethiopia, and the material for the soles in China and Kenya. Our fabric is sourced in Ethiopia, while the laces and other accessories come from China and Italy. We look to Kenya for our apparel production and source the organic cotton we use from Tanzania.

What do you see as the pros and cons of producing/sourcing in Africa? Africa is a major source of some of the best raw materials. We have discovered high grade leathers, organic cotton and fabrics that differentiate our products in the market. The region also has relatively cheap labor which brings down production costs and improvements in manufacturing capacity and equipment enable us to push the standards to target higher end consumers.

‹ *Enzi Footwear* › **TOP**
Enzi factory image
› **BOTTOM** *Enzi studio image*

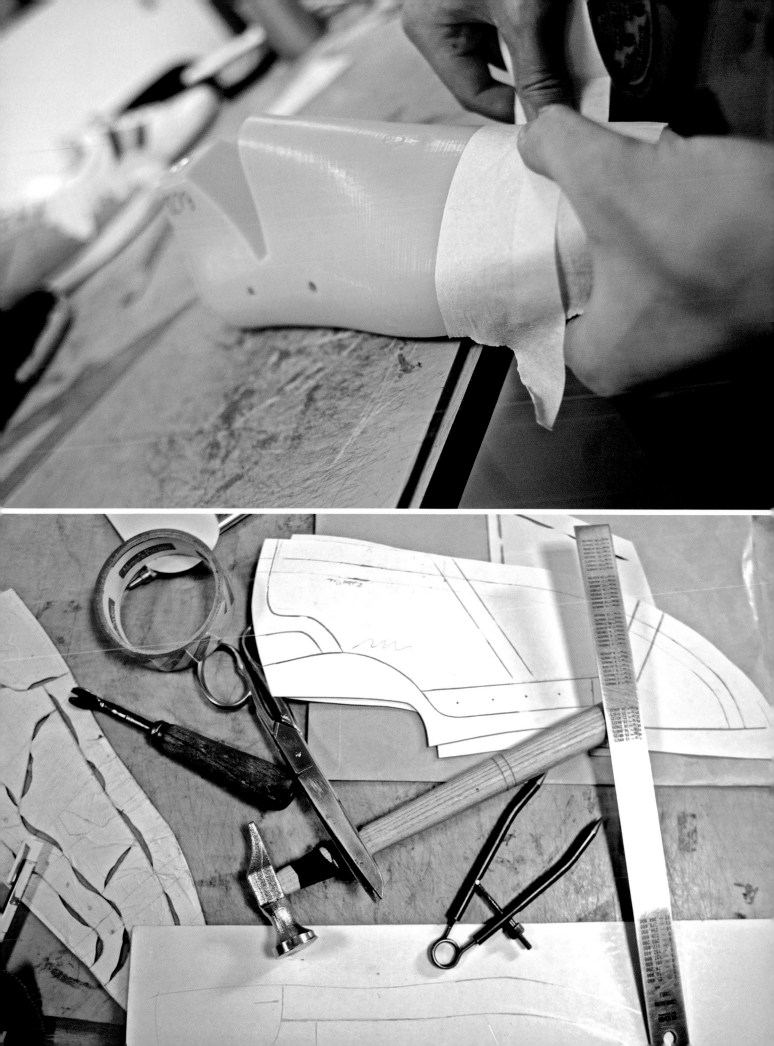

'The good thing is that African designers are becoming more commonly featured in international fashion shows'

Most manufacturers are set up for mass market, low cost goods. There are a limited number of manufacturers with the adequate equipment and production expertise to make premium goods. To avoid an excessive number of defects, we have had to ensure a close monitoring of quality control and tried to create monetary incentives for staff to pay closer attention to detail.

How do you think fashion made in Africa is regarded internationally?
Perceptions of fashion made in Africa are still widely traditional. People think of bold patterns and bright colors on layers of rich fabrics, often worn for ceremonial occasions. There is limited exposure of contemporary designers that have a more subtle approach in featuring cultural motif's and patterns in their designs. There is a growing online network of African brands,

‹ *Illustration* (COPYRIGHT ENZI FOOTWEAR DESIGNS)

magazines, blogs, Facebook groups and online stores that are changing and enriching the perception of fashion made in Africa.

What inspires you? I draw inspiration from the fashion culture and sights around me and the places I visit. I always have my iphone on me to capture images that stir creatively. I also find a lot of inspiration online and social media have made it easy to follow and share graphic information.

How does Africa relate to your brand and why Africa? We market ENZI as a premium African brand. Three of our partners grew up together in Kenya, which is important to the cultural heritage of our brand. It is important for us to label the specific countries where the products are made in order to emphasize the diverse potential of the region. For instance, our footwear is made in Ethiopia primarily because of the quality of leather we are able to source from Ethiopia tanneries. We want to showcase the quality of what is possible in Africa, while distinguishing how each country can contribute towards building our brand.

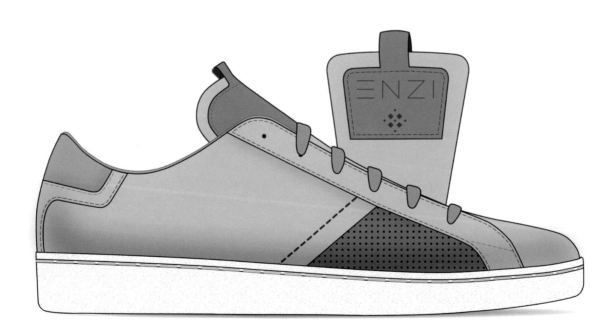

Do you use any traditional African craft techniques in your design process? In one of our new footwear designs we constructed the upper with Ethiopian traditional woven fabric. The concept of the shoe is a hybrid that combines the comfort of a slip-on with the sole of a light sneaker. The fabric provides the comfort and breathability of the shoe with a traditional pattern on the back panel that really sets it apart. This is ideal for us as it serves both a functional and aesthetic purpose. Another craft we are exploring is incorporating Kenyan Maasai beadwork in the branding of our shoes.

Does your company work with any cotton programs in Africa and or any production workshops/organisations in Africa? For our inaugural t-shirt line, we partnered with an export-oriented factory in Kenya. The factory is part of a unique conservation sanctuary that protects wildlife and improves biodiversity in the surrounding area. The factory complies with standard for carbon neutral and fair trade production towards what they've termed Consumer Powered Conservation. For our t-shirts we sourced 100% organic cotton from a supplier in Tanzania.
We also source organic cotton dust bags from a small NGO in Ethiopia that was set up to provide alternative income for women who traditionally carry heavy bundles of firewood to make ends meet. These bags give a nice traditional touch to the packaging of our footwear while financially supporting these women.

What is your ethical standpoint?
We have a strong commitment to do things the right way. We strive to produce footwear and apparel in a way that is beneficial to the people and environment we work in. From the start we tried to identify tanneries with eco-friendly processing such as chrome free or vegetable leather tanning to protect the environment. We were also adamant about working in factories that took care of their workers by providing a healthy work environment and reasonable work shifts. We managed to partner with a factory that met our standards. Our desire for eco-friendly inputs was not practical for the tanneries at the volumes we needed, but they were willing to consider altering the process when we could generated enough demand to meet the relevant costs. We have had more success with our ethical approach on the apparel side. Our t-shirts are produced from 100% organic cotton that is sourced locally and made in a factory that is fair trade and carbon neutral certified.

Which African designers do you admire? One of African designers we admire is Adrien Sauvage. He is a young and upcoming designer with unique approach in constructing formal wear for the casual consumer. His custom fit suits feature classic cuts with simple, yet sophisticated shapes. Sauvage takes risks with incorporating traditional African patterns in a playful way without overpowering his collections. The quality of his work and his approach is an inspiration to us.

› *Enzi T-shirt, Kenya*

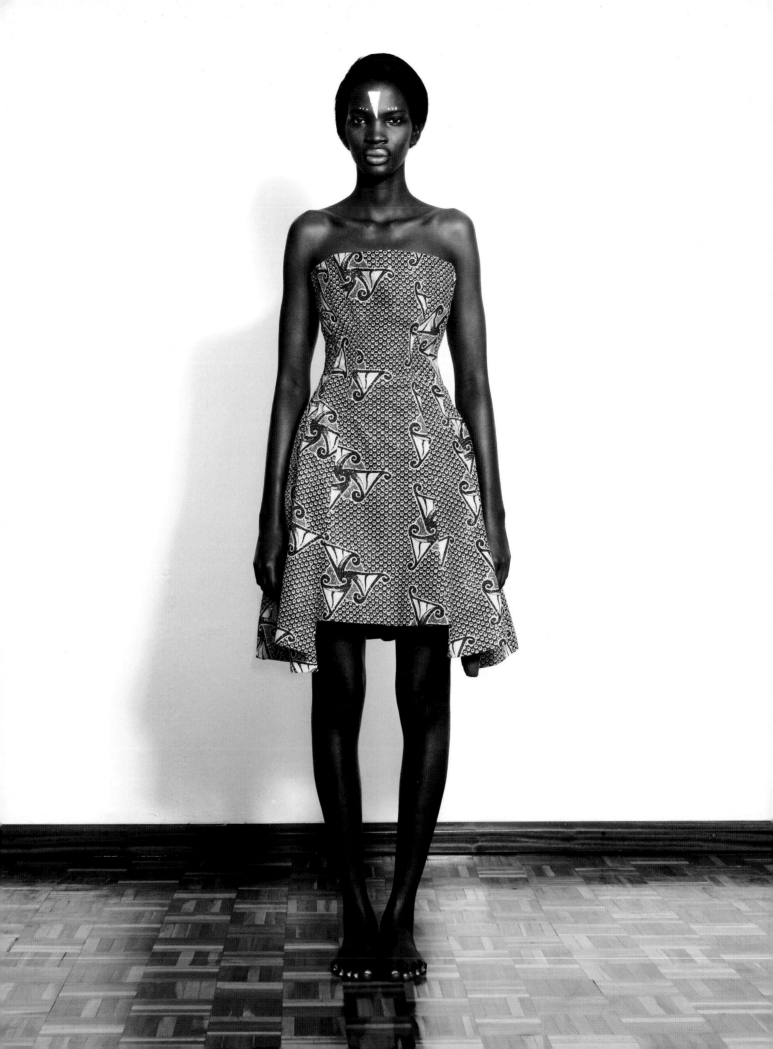

GLORIA WAVAMUNNO

FACT FILE

LOCATED KAMPALA, UGANDA

WEBSITE WWW.GLORIAWAVAMUNNO.COM

FOUNDED 2009

From feather trimmed dresses, to Kitenge-printed blazers and bow ties, Gloria Wavamunno pushes the boundaries of African fashion with a quirky combination of sharp tailoring, senusal designs and bold policical statements.

Gloria Wavamunno spent her childhood moving between the fast-paced capitals of London and Kampala, Uganda. After graduating from the American Intercontinental University, London in 2008, she spent time as an intern for Ozwald Boateng, where she acquired impeccable tailoring skills. She chose to take on the fear and excitement of becoming an entrepreneur and in 2009 founded her own label with her first collection, Love. The very same year, one of her dresses graced the cover of ARISE magazine and she showcased her third collection, 'A-Freak-A', at the AFI Africa Fashion Week. Her reputation as an upcoming fashion-designer was made.

Gloria's collections have become known for their striking contrast of sharp cuts with raw African fabric, the luxurious with the functional, the whimsical and the real. Her work is shown on runways in London, America and Africa.

‹ *Runaway Nymph* (PHOTOGRAPHER MARTIN KHARUMWA) › *Runaway Nymph* (PHOTOGRAPHER MARTIN KHARUMWA)

Which countries do you source and produce in? We produce our garments in Kampala, Uganda. Our materials are sourced from around the world, including various African countries, the UK and China.

What do you see as the pros and cons of producing / sourcing in Africa? One advantage of producing and sourcing in Africa is that prices are reasonable

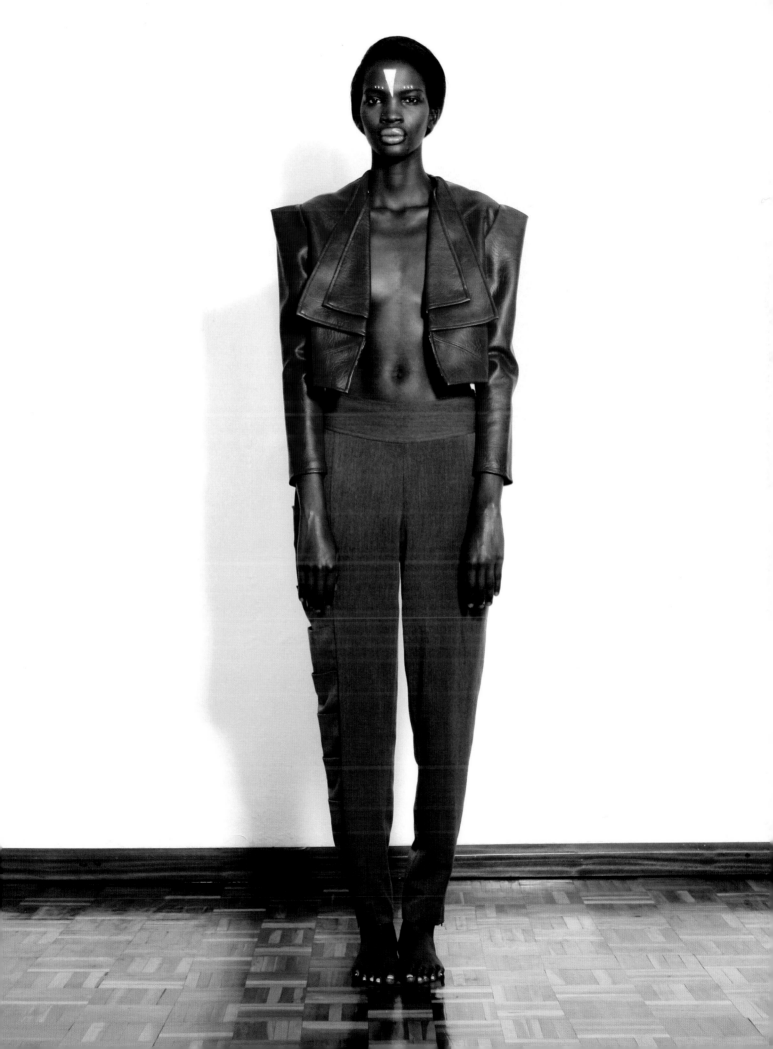

'The Gloria Wavamunno mission is to create and display the highest quality garments our clients will come to expect from this brand. Accomplishing this through the unique individual style and design this brand has to offer'

in comparison with other markets. The challenges are that we do not have the educated workforce with the capability to create factories that can produce garments to the quality and quantity required. This means we need to work with smaller teams, even when there are big orders to fulfill, which can cause delays. As for the economy, depending on the country or the government you are talking about, there is some unrest in some countries and when things are unsettled, this can affect day-to-day operations.

How do you think fashion made in Africa is regarded internationally? I believe that fashion made in Africa is on the rise and that as designers we have so much to achieve. The international market is slowly seeing what we have to offer, which is more than just providing production and manufacturing resources. We too have something to create and share with the world, and should command the same respect.

How does Africa relate to your company brand? Why Africa? Well Africa is who I am and my brand is who I am. It's as simple as that.

Which African designers do you admire? I have incredible respect for menswear designer Ozwald Boateng. I admire his brilliant craftsmanship and his unique take on tailored men's suits, which reflect his African influences. He is a wonderful example of what an African designer can achieve, especially on the international stage. Believing in yourself and your work is key.

What inspires you? I am inspired by everything around me, from music to people to emotions, from life in general. That's how I create. My work is me; it's personal. So wherever I am at any given time inspires my work process. It's all about watching, listening and learning, and then creating something from that moment.

❯ TOP LEFT *Runaway Nymph* (PHOTOGRAPHER MARTIN KHARUMWA) ❯ TOP RIGHT *Runaway Nymph* (PHOTOGRAPHER MARTIN KHARUMWA) ❯ BOTTOM LEFT *Mensch/UnMensch* ❯ BOTTOM RIGHT *Num* (ALL IMAGES PHOTOGRAPHER MARTIN KHARUMWA)

What is your ethical standpoint? I completely believe in fair trade first of all for the development of the economy within African countries. We need to stand by the worth of our work, as others do in foreign countries, and demand equality just as they have, since the quality we are producing is just as good. And we must promote top quality in our products, which will in turn provide jobs and skills that will help the economy. This is what African countries need: skills training and education in the value of skills so that people can see and be motivated by what they are creating.

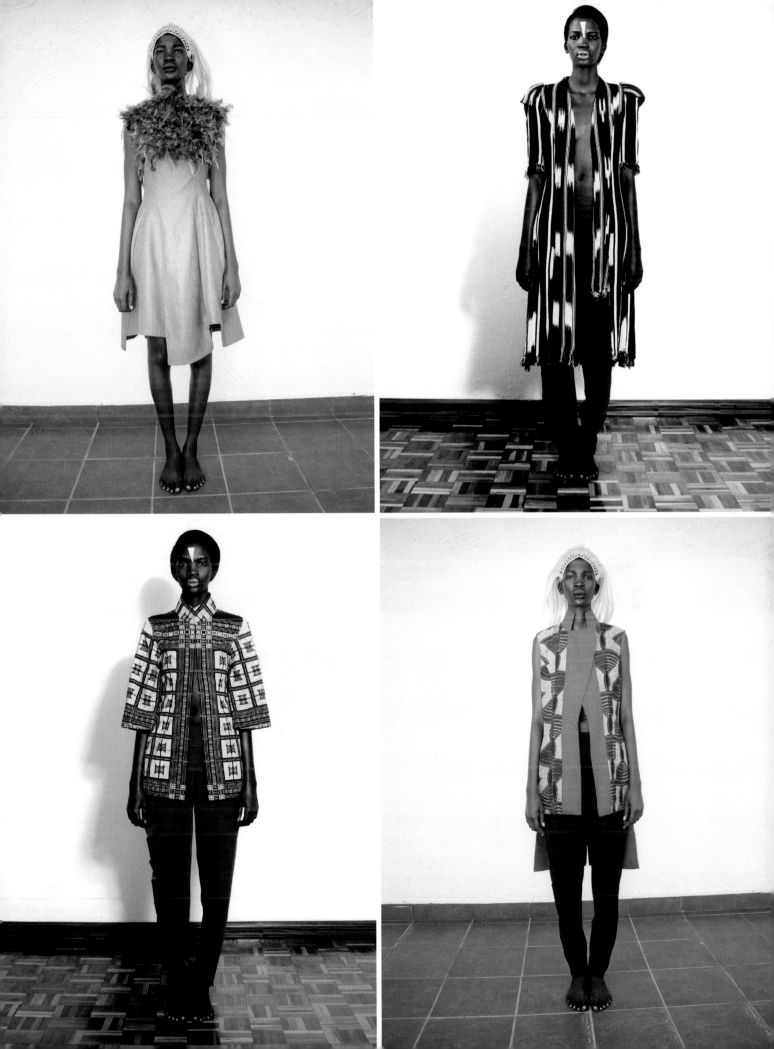

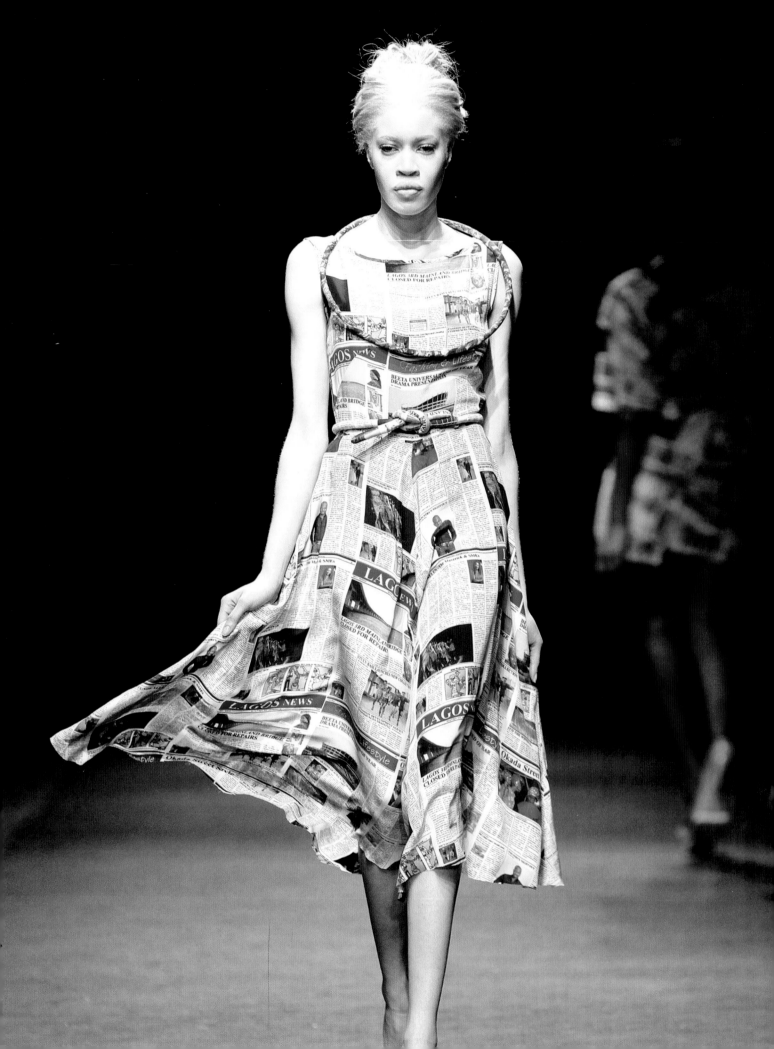

ITUEN BASI

FACT FILE

LOCATED LAGOS, NIGERIA

WEBSITE WWW.ITUENBASI.COM

FOUNDED 2008

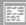

In the detail of the designs lies the real beauty of an original ITUEN BASI outfit. The company is quickly developing as the brand that sets the standard in more ways than one for the Nigerian fashion industry.

Creative Director Ituen Bassey completed a BA Theatre Arts degree at Nigeria's University of Ife. While she was there, she designed and tailored costumes for stage productions and beauty pageants, inspiring her to go on to study at the London College of Fashion. Ituen's training means that she brings a blend of expertise in design development, pattern engineering and bespoke tailoring. As a result, her collections are wearable works of art, celebrating the feminine silhouette and incorporating intricate craftsmanship.

As well as designing and producing garments under her own label, Ituen runs a garment manufacturing unit that produces small runs for independent designers and micro fashion businesses based in Nigeria and the UK. Since it was founded in 2008, the Fashion Development Agency (FDA), has grown from being a training ground for emerging fashion designers, to establishing a reputation as a leading authority in Nigeria on all aspects of fashion design and production. The FDA helps designers mass produce their designs and establish brands by training people in all areas of fashion business management, production management, pattern cutting and machining.

Which countries do you source and produce in? We source and produce locally. We go to local markets and choose what the traders offer. This can

‹ › *Ituen Basi Collection*
(PHOTOGRAPHY BY SIMON DEINER / SDR PHOTO FOR AFRICAN FASHION INTERNATIONAL)

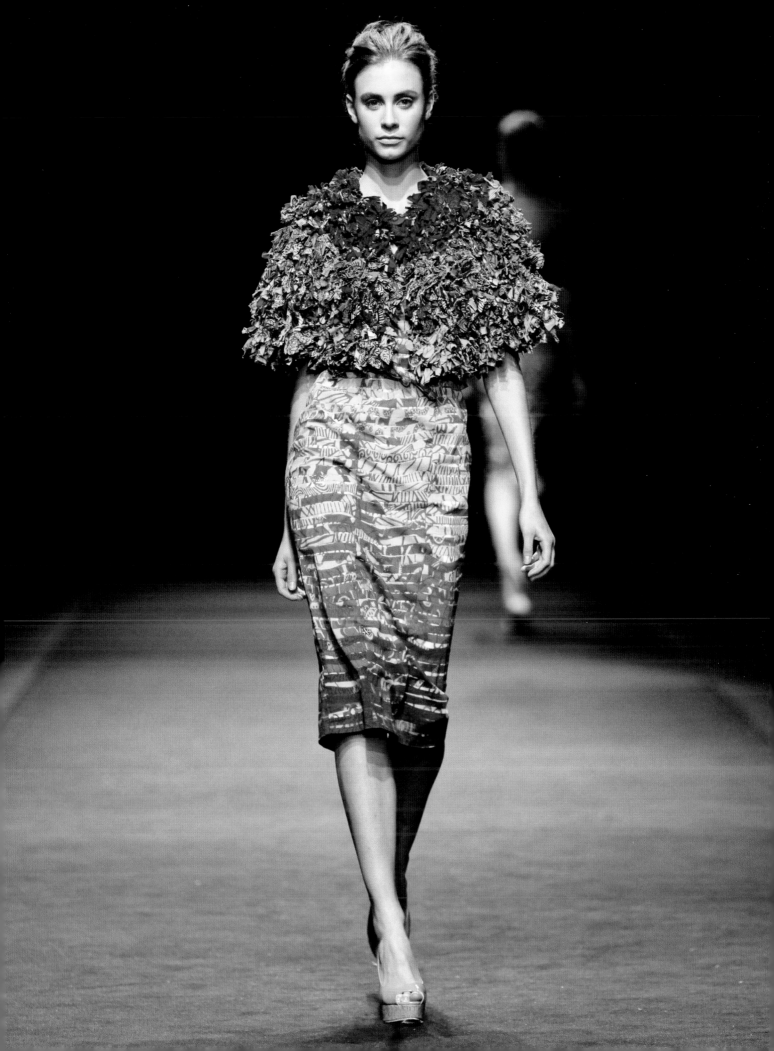

'Unfortunately, I think (African fashion) it is still largely regarded as exotic pieces or artifacts made mostly by women in communities that still rely on charity from the international community'

How do you think fashion made in Africa is regarded internationally? Unfortunately, I think it is still largely regarded as exotic pieces of artifacts made mostly by women in communities that still rely on charity from the international community.

What role does Africa play in your brand? Our brand has been warmly received across Africa and I'm totally humbled by our success on the continent. We regularly receive stock enquiries and invitations to show our collections across the West, East, Central and Southern African states. For instance, I was pleasantly surprised by how the brand was received at the Festival Mondial in Dakar, Senegal.

be a bit tricky, because you might not get the same prints when you return. Our solution is to regularly update our ranges. We have set up a production company, which is also used by a couple of other designers in Lagos.

What do you see as the pros and cons of producing / sourcing in Africa? Nigerian retailers often buy end of bales from overseas mills, meaning that the quality, colour-ways and even fibre ranges are limited. So for me it was an easy choice to use locally sourced prints: they were readily available, in a wide variety of prints and in the quantities I needed. What I do is find ways to vary the textures to differentiate our clothes. We have also had challenges recruiting skilled labour, so it's necessary to train your team to produce garments to international standards. Unfortunately, we also have challenges others in the fashion industry wouldn't face because our business is based in Lagos. Government policies don't encourage growth either. However, even though the fashion industry is in its infancy here, Nigerian fashion designers have done tremendously well to achieve international recognition in a relatively short time.

How does Africa relate to your company brand? Why Africa? The brand recognition and collective sense of ownership is evident across the West, East, Central and Southern African states. We regularly receive invitations to show across these regions as well as stockists enquiries. We showed at the Festival Mondial in Dakar, Senegal over Christmas and I was pleasantly surprised at the way the brand was celebrated.

Do you use any traditional African craft techniques in your design process? Our use of African craft techniques is usually dependent on the collection specifications. We often borrow and celebrate Nigerian and African viewpoints and influences. The technical aspects are often dictated by the requirement of the collection.

❯ *Ituen Basi Collection*
(PHOTOGRAPHY BY SIMON
DEINER / SDR PHOTO
FOR AFRICAN FASHION
INTERNATIONAL)

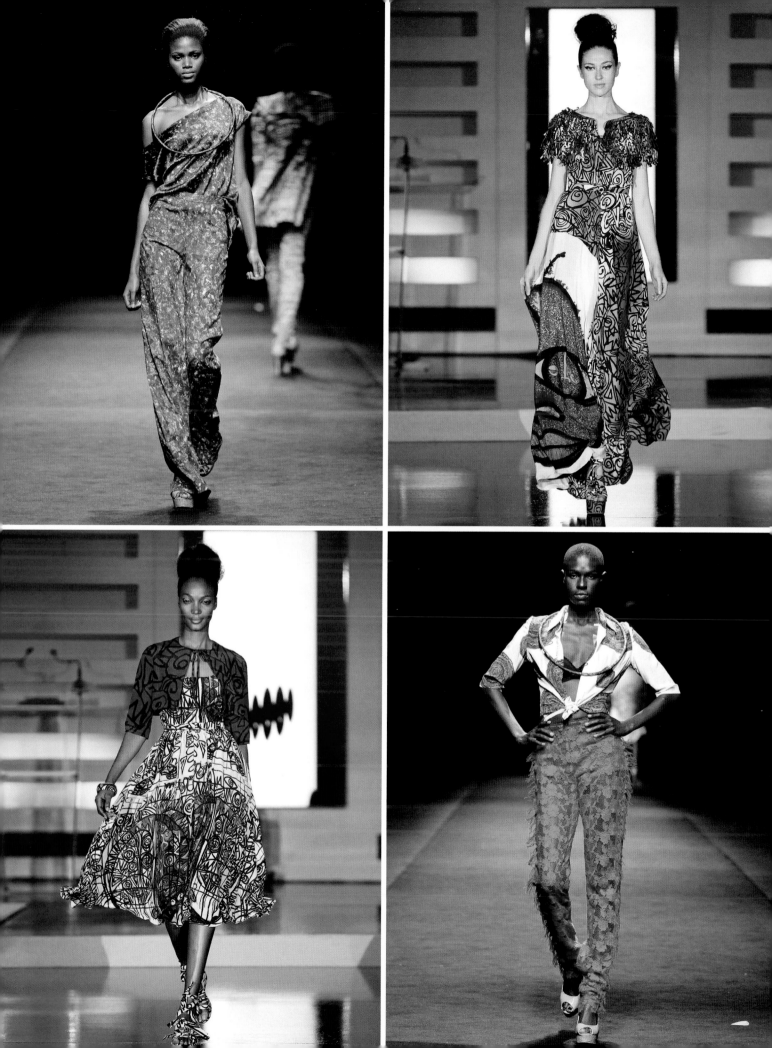

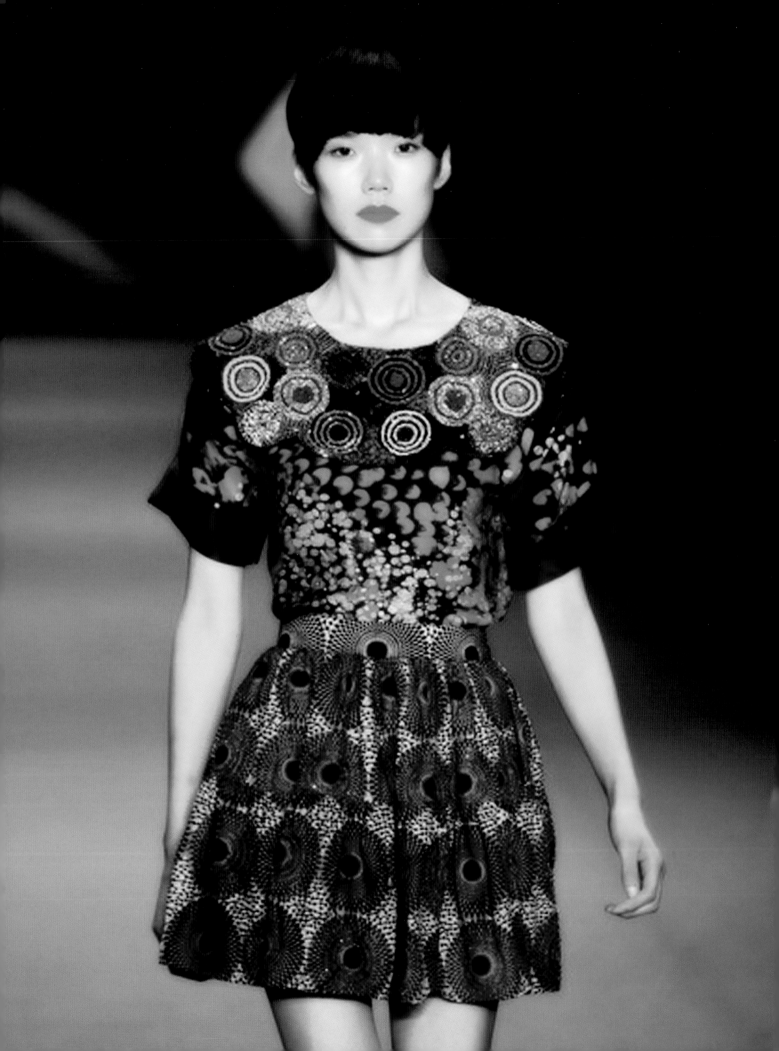

JEWEL BY LISA

FACT FILE

LOCATED LAGOS, NIGERIA
WEBSITE WWW.JBYLISA.COM
FOUNDED 2005

JEWEL BY LISA celebrates the Ankara fabric – traditionally loved by West Africans and presented now with new sophistication and sparkle. The collections of womenswear, accessories and home furnishings are all created using the highest quality Vlisco-Hollandais Ankara.

Lisa Folawiyo started out in 2005 making skirts from Ankara – a fabric originally known as Dutch Wax and adopted by West Africans who fell in love with its bright colours and patterns, which over time reflected tribal prints. Since making those first skirts, Jewel By Lisa has perfected the art of wearing Ankara. The textiles are now embellished with sequins, Swarovski crystals and beads and she frequently mixes the material with other fabrics, ranging from taffeta, linen, cotton, chiffon, chantilly lace and silk. Some of the most intricate designs can take 120 hours to make. This craftsmanship shines through her collections, which ooze quality at the same time as being easy to wear. Judging by the popularity of Ankara in contemporary fashion designs, Jewel By Lisa has sparked a new revolution in Ankara couture.

❮ SS2010 collection at Arise magazine fashion week Lagos ❮ Profile shot (BY LAKIN OGUNBAWO) ❯ SS12 collection "Vintage Love" (SHOT BY CASEY BROOKS)

What inspires you? Sometimes, when I'm using the Ankara print, it's the fabric that determines the shape of the garment. Other times, it's a design idea that will have us searching for the perfect fabric. I'm inspired by what I see as the most fashionable eras - the 40's, 50's, 60's and 70's. Flicking through a magazine, travelling and even by nature. I just love fashion and the way it can totally transform a woman and sometimes for that reason alone I am continually inspired to create and have fun with it.

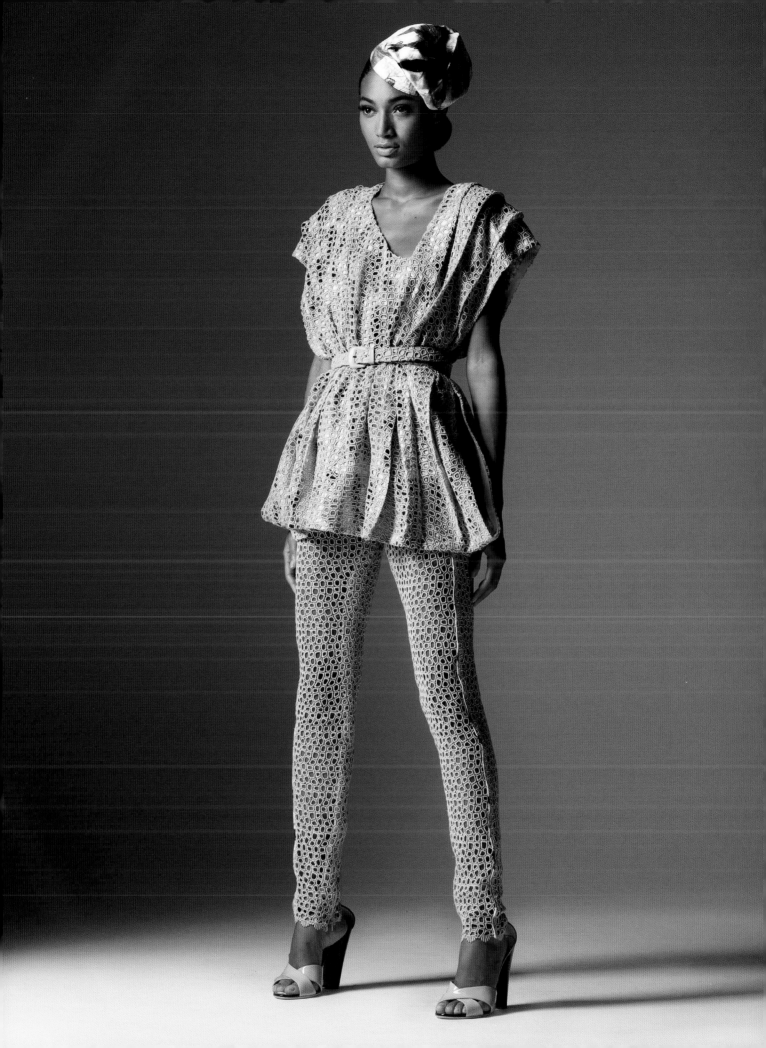

'I believe that...African fashion will have no choice but to be acknowledged internationally because of the depth of talent'

What is your ethical standpoint?
Sustainable fashion is about being able to create beautiful pieces in a way that stands the test of time, and has a long term impact socially, personally, and economically. It is about looking inwards at your own practices to make sure they are ethical. It's also about what materials you use and where they're from. The environment is a very important issue and we need to do our bit.

Is Africa the future? I wouldn't necessarily say Africa is the future of fashion but I do think there is huge talent waiting to be discovered here. I do believe that in the future as fashion becomes more global, African fashion will have no choice but to be acknowledged internationally because of the depth of talent.

Which countries do you source and produce in? We source the majority of our Ankara fabrics in Lagos. Other fabrics, like silks, chiffons and cottons are produced in the UK or provided by a Lagos-based international fabric supplier. We've just started producing our own custom-made silks – our own take on Ankara and tribal prints – which are produced in the UK. However, all the actual garments and products are manufactured in Lagos.

What do you see as the pros and cons of producing/sourcing in Africa? One major issue with producing in Africa has to do with the infrastructure; not having a continuous power supply and needing to rely on generators is a huge

> SS12 collection "Vintage Love" (SHOT BY CASEY BROOKS)

issue. We also don't have the right machines to produce certain kinds of pieces and for a luxury brand like ours it's a challenge to find the right kind of haberdashery.

How do you think fashion made in Africa is regarded internationally?
When a big company like Edun supports a local enterprise, for instance young traders or cotton production, this attracts major attention. In other cases, I believe people still regard African fashion as a 'third-world' industry, which is fair enough because we still have a lot to learn. But there are brands with excellent production values, creating pieces that can stand side by side with international brands.

How does Africa relate to your company brand and why Africa?
I've always been interested in fashion without borders. I don't want to be seen only as a Nigerian or an African brand – I want that to be incidental. I want my clothes to speak for themselves, to represent good design, cut, fabric and a global perspective. I want people from Bali to Milan to New York to love my brand for what it offers them, as well as knowing it has been created and produced in Nigeria. I will definitely champion Nigeria, so in a sense I am an ambassador.

Do you use any traditional African craft techniques in your design process?
Not specifically. All our pieces are produced by machines. But the majority of the pieces that require embellishment are individually hand sewn.

Which African designers do you admire? I admire Black Coffee and also Loin Cloth & Ashes.

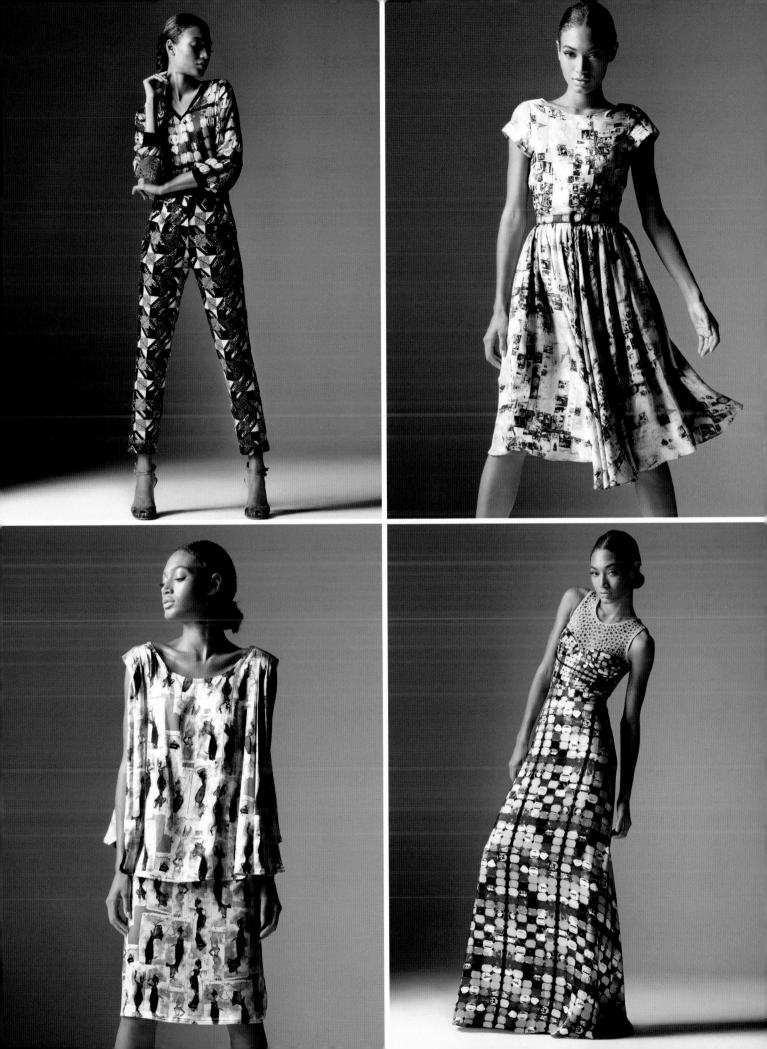

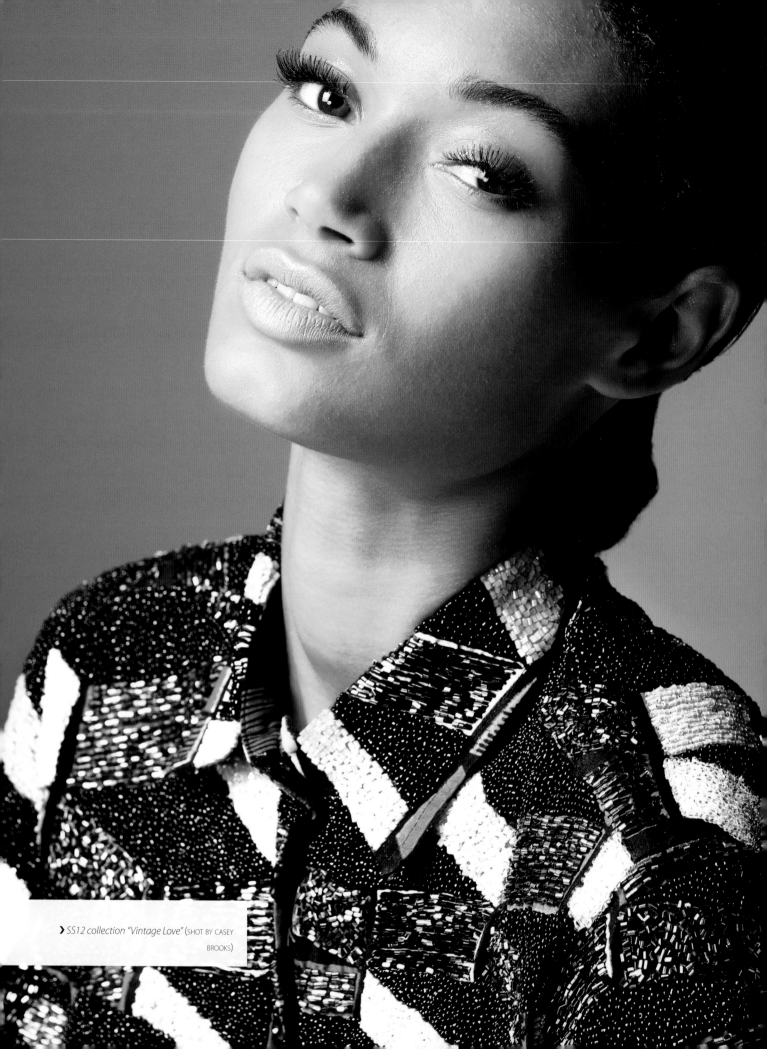

❯ *SS12 collection "Vintage Love"* (SHOT BY CASEY BROOKS)

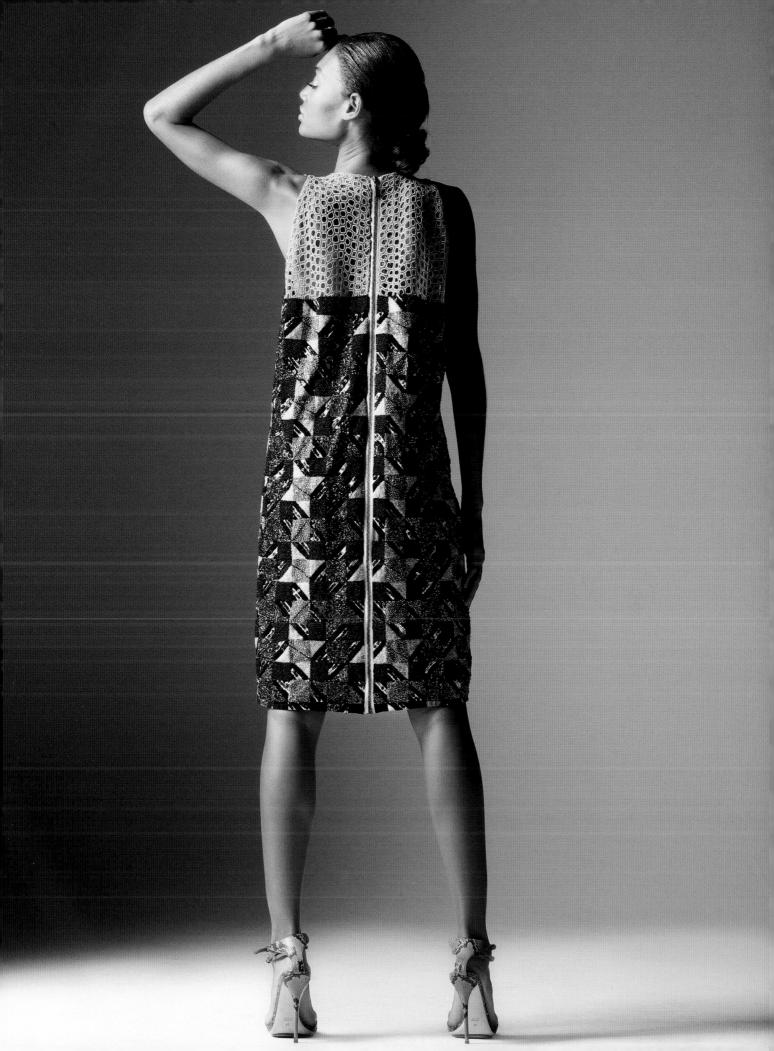

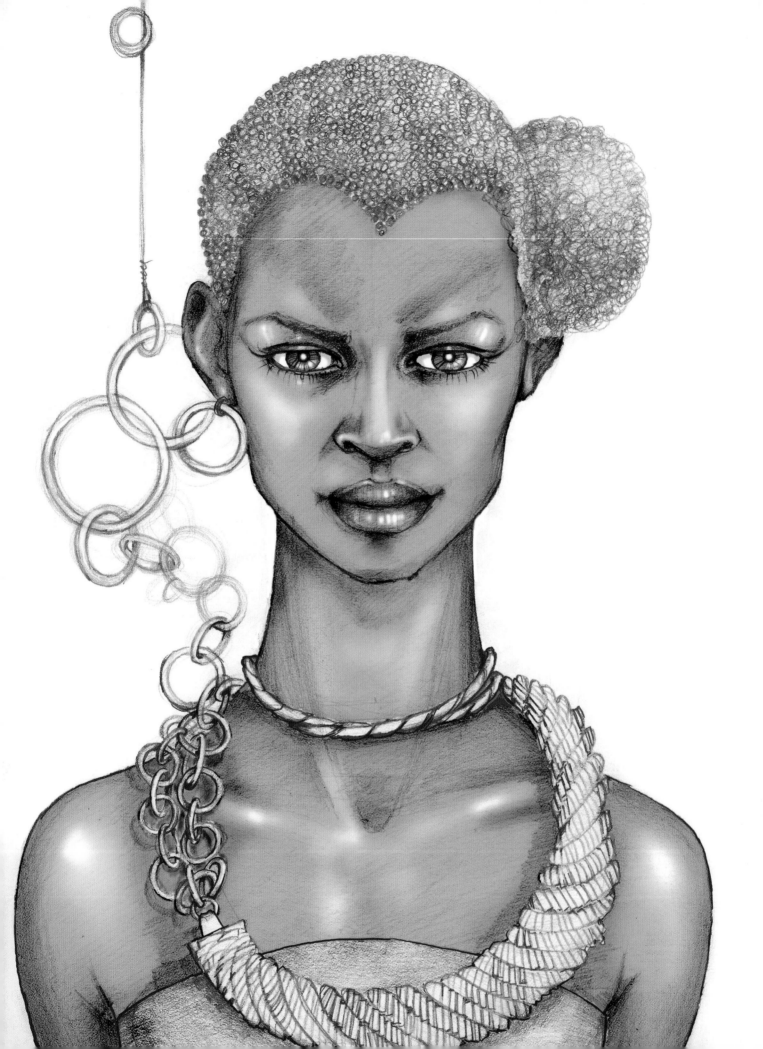

JEWELS OF THE KALAHARI

FACT FILE

LOCATED LONDON, UK

WEBSITE WWW.ONEFINETHREAD.BLOGSPOT.COM

FOUNDED 2010

The JEWELS OF THE KALAHARI collection is a San of the Kalahari collaboration with Anna Haber, a jewellery and gemstone industry professional. Introduced to the work of the Bushmen she began collaborating with the tribe advising on quality and design and introduced the jewellery to new markets in the West.

❮ *Illustration, Jewels of the Kalahari Collection* (BY ELENA SOFIA TINIS BOBEL)

❯ *Product shots, Jewels of the Kalahari Jewelery Collection*

Anna Haber formed ONE FINE THREAD in 2010, a business focused on buying products from and collaborating with tribal communities to bring their unique work (primarily jewellery) to market in a sustainable manner. One Fine Thread aims to create awareness of the plight of indigenous communities through the storytelling traditions that are connected to their arts and crafts, while also creating a sustainable business for the tribes to generate a consistent income and ongoing work. The aim of the business is to encourage upstream stakeholders to invest in products on a long-term basis, to ensure that these stories can continue to be told, and passed on to future generations, through sharing their unique skills and traditions with the world.

Most recently, Anna collaborated with UK based jeweller, Sabine Roemer and the Bushmen of the Kalahari Desert to create a unique collection of jewellery forming the Jewels of the Kalahari collection. The Bushmen apply their traditional skills to create a fashion-orientated collection, fusing natural resources available to them, such as the ostrich eggshells and incorporating unusual and rare materials to create pieces that capture a classical flair. The collection symbolises the Bushmen's journey linking their rich and cultural past to today's modern world combining ancient designs with the new inspiration drawn from the changing world around them.

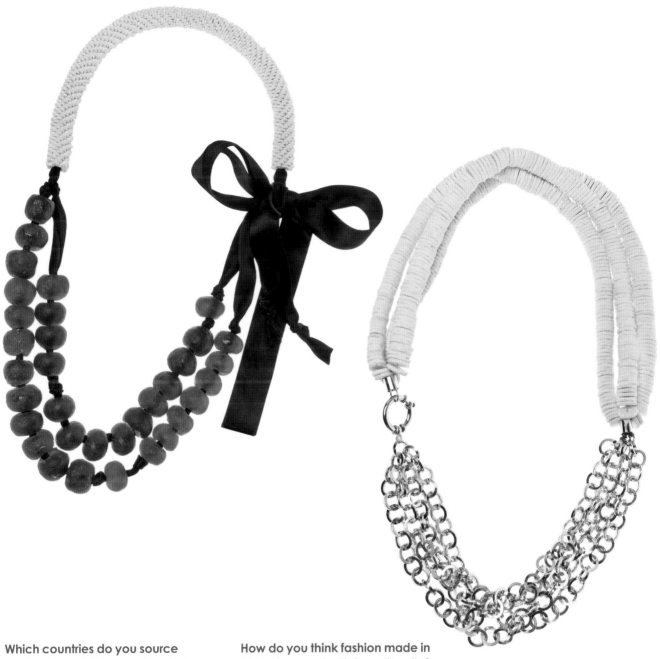

Which countries do you source and produce in? Currently only in Botswana but I am always looking for new opportunities to create new partnerships with indigenous artisans.

What do you see as the pros and cons of producing / sourcing in Africa? One of the difficulties of working in Africa is our different understandings of the concept of time. I have overcome this by making sure that we give retailers a realistic 3-month delivery timeline. Communication is also difficult at times due to bad Internet connection and the fact that few in the team have access to a computer. I have found that calling is often the best way to follow up.

How do you think fashion made in Africa is regarded internationally? Fashion made in Africa is gaining more momentum and respect as more designers from Africa and international designers are making their collections in Africa.

How does Africa relate to your company brand and why Africa? The Jewels of the Kalahari collection is 100% African. It is said that the ostrich egg-shell jewellery created by the San is the first recorded jewellery in history. Ostrich eggshells are a natural resource to the San, no part of the egg or shell goes to waste. One egg feeds a whole family, then the shell is used as a water container, and eventually the

'The Jewels of the Kalahari collaboration aims to create awareness of the Bushmen's plight through the storytelling traditions that are connected to their arts and crafts, while also creating a sustainable business for the tribe that will generate a consistent income and ongoing work'

broken shards are incorporated into unique pieces of jewellery.

Do you use any traditional African craft techniques in your design process? The techniques used by the San today are ancient craft techniques. For countless generations the San have been making beautiful jewellery to adorn themselves and their loved ones. Largely isolated from the outside world until the last century they created intricate pieces using wild seeds, sticks; bone, leather, tortoiseshell and most importantly of all, beads painstakingly created from ostrich eggshell. Each bead is hand-made from individual shards of broken eggshell.

What inspires you? I look for inspiration everywhere, from nature, colours, architecture and street fashion from London and Mumbai, Ladakh and Timbuktu to the Serengeti to Ouagadougou. I am so inspired by the photography of Seydou Keita and Malick Sidibé from 1960's Mali – I love the styling, the clothing, the framing, the light and the subjects.

Which African designers do you admire? I admire so many of the tribes in Africa, as they make their own clothes and jewellery adorned in vibrant colours and intricate designs.

The Surma and Mursi tribes of the Omo Valley have a truly creative, elaborately decorative style inspired by their own environment. The bronze metal jewellery created by artisans in Ghana, the beadwork of the Maasai and ofcourse the San. I love the African inspired patterns that fashion designer, Duro Olowu uses for his signature dresses.

What is your ethical standpoint? The Jewels of the Kalahari collaboration aims to create awareness of the Bushmen's plight through their storytelling traditions and arts and crafts, while also creating a sustainable business for the tribe to generate consistent income and ongoing work. The ecological and economic impact of mass production is inescapable and our obsession with fashion and mass produced products is now quite literally costing us the earth. We are living in a time where we have to learn to express ourselves with integrity. I believe it is important and our responsibility to buy clothes and products that bring fair trade and sustainability to the forefront, creating the possibility of fairness for all, good design and lasting quality.

Is Africa the future? I think it is an exciting time for Africa and Africans. Designers and brands from the West have forever taken inspiration from Africa and now a new generation of young designers from Africa are launching fashion and jewellery collections that are being nurtured within Africa and reaching the global stage through the influx of fantastic new magazines, websites, blogs and stores dedicated to promoting African fashion and design, whilst also re-educating the world on African ideas of style. It is a long road but Africans have taken the first steps.

❯ *Product shots, Jewels of the Kalahari Jewelery Collection*

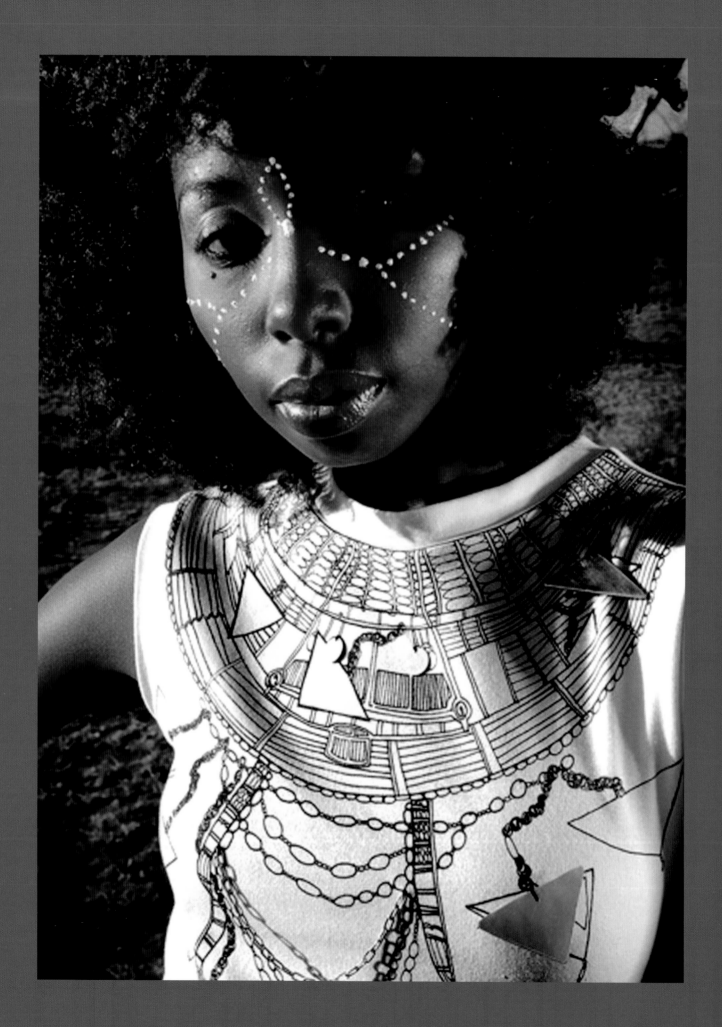

JOHARI

FACT FILE
LOCATED NAIROBI, KENYA
WEBSITE WWW.JOHARI.CO.UK

The enterprise Johari Designs helps to develop skills and provide long term employment for the local Nairobi community; one hundred per cent of the profit goes into funding the Johari Foundation's Miale Programmes.

Meaning 'something precious' in Swahili, JOHARI is a social enterprise operating in Kenya to produce ethical, stylish and beautiful clothing. Not just a philosophy, this ethos infuses everything they do. From their Design Council combining talents from diverse backgrounds and skills, to the material sourcing, tailoring and production, Johari make every effort to ensure their fashion is beautiful inside and out. Philanthropist David Sibbald set up the Johari Foundation as a registered charity in Scotland and in Kenya to support child education and self-sustainability. Johari Foundation, Kenya, established Johari Designs to develop technical skills, which would help to provide long-term employment and would in time help to fund the Miale Programmes.

Which countries do you source and produce in? All of Johari products are individually handmade in Nairobi, Kenya. We source most of our materials in Kenya also, and we source beads for our jewellery pieces in Uganda.

What do you see as the pros & cons of producing/sourcing in Africa? The clear advantage of sourcing and producing in Kenya is in creating opportunities for young adults, which in turn makes them self sufficient. The biggest disadvantage we have found is in sourcing certain materials – for example we have had

❮ Fuhura Dress ❯ Nyota Necklace, Illustration, Johari (BY MICHELLE KLEYR)

'At the Apprenticeship Centre, I have learnt different ways of making jewellery and even come up with my own designs. The skills that I have acquired are a great investment that I can use in the future'

difficulty finding Fair-Trade organic cotton to use for some of our designs.

How do you think fashion made in Africa is regarded internationally?
People are changing the way they view African fashion. Previously it was seen as mainly targeted at tourists but more and more people now like the idea of buying locally-made, ethical fashion with a story to tell.

❮ Nzuri T Shirt ❯ Red Kilele Dress

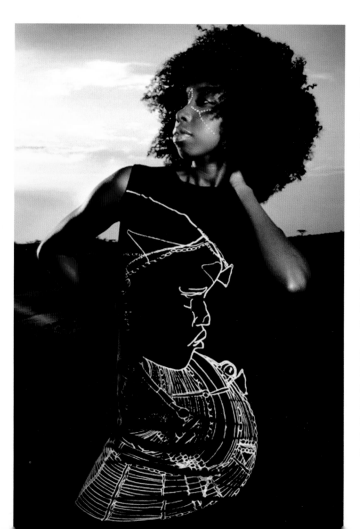

What inspires you? We get our inspiration from local Maasai people and their Kenyan surroundings. We take the traditions and culture of the country and try to incorporate them within our designs.

Do you use any traditional crafts techniques in your design process?
The coloured paper beads sourced from Uganda that we use in many of our jewellery pieces are based on a traditional African craft. The beads are made from tightly wound magazine/newspaper then varnished.

What is your ethical standpoint? The Miale Apprenticeship Programme aims to provide all of our students with a good skill level in fashion and jewellery making and the ability to utilize these skills either running their own small business or working for an organization such as Johari Designs Ltd. The young people entering the Apprenticeship Programme are generally from a vulnerable background with insufficient education to be self-reliant. Rather than face a bleak future with no prospects they can come to the Apprenticeship Centre where we help them learn life-enhancing skills, which can lead to ongoing employment.

We deliver an 18-month curriculum in fashion and jewellery making skills. In addition to this we also provide basic business and life skills training, meals, along with social care and a monthly stipend. Our aim is for at least 90% of the programme participants to be self-reliant by the time they have completed the course and found employment.

Is Africa the future? We are dedicated to working in Africa and believe, as a company we are making an investment in Johari Designs to make a difference to children and young adults in giving them a better life and making them become self sufficient.

JOSÉ HENDO

FACT FILE

LOCATED LONDON, ENGLAND

WEBSITE WWW.JOSEWORLD.COM

FOUNDED 2010

 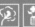

Josephine Kyomuhendo, founded "José Hendo", a sustainable eco-fashion brand taking a fresh approach to contemporary fashion design, as a challenge to the throw-away culture prevalent in today's society and particularly in the world of fashion.

Jose Hendo graduated from the London College of Fashion (University of the Arts) where her research into sustainable fashion, borne from the desire to get away from the culture of "fast fashion", garnered data which clearly indicated that the future trend within the fashion industry was towards sustainability. She studied the life-cycle of a garment, from growing the crop, making the cloth, garment production, distribution to the customer, then to landfill through the concept of the "throw-away culture". From the knowledge she gained she made the conscious decision to combine good design and a sustainable fashion ethos. Designing clothes required an awareness of the environmental impact of the fashion industry, thus the 3Rs - Reduce, Reuse, Recycle – became the cornerstone of José Hendo label. Passionately conscious of the times and inspired by the surrounding world, José Hendo utilizes eco-friendly fabrics creating from organic barkcloth, cotton and used garments including suits, denim and wedding dresses, unique, one-off pieces designed to flatter all body shapes. The designs are contemporary, edgy, tailored, timeless pieces.

A subsidiary company, Jose Original, offers bespoke services, supporting other designers with their collections and production runs, as well as a re-vamping service which re-works and updates a customer's existing garments for a new and fresh take on the original.

‹ *Resonance Collection*
(PHOTOGRAPHER OLIVER MORRIS)
› *Resonance Collection,*
as seen on Vogue It
(PHOTOGRAPHER OLIVER MORRIS)

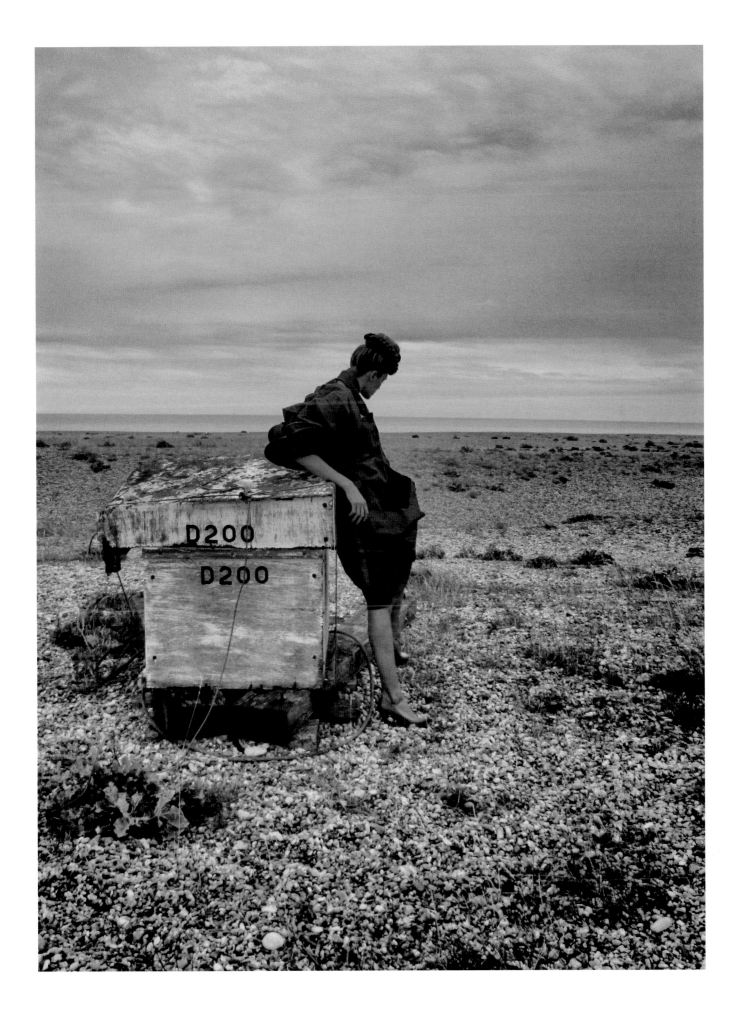

'Organic fashion has moved from the fringe into mainstream fashion, as a result it's important for eco-clothing companies to produce fashionable garments'

From materials to clever cutting and simplified production processes, the company prides itself on its quality and environmentally friendly designs.

In which countries do you source and produce? At present we are sourcing samples of organic cotton t-shirts from Uganda. Despite starting to source from abroad however, it is still important to be aware of our environmental footprint so it is only in the countries where the raw material is made that our production will happen.

Do you use any traditional African craft techniques in your design process? We are in collaboration with a weaving company in Uganda to develop a unique combination of fibres. Also my choice of textile is Barkcloth from Uganda. Barkcloth has a 600 year old tradition and is considered the oldest manmade fabric. It was declared a UNESCO World Heritage Material in 2005. My dream is to make bark cloth work alongside mainstream fabrics.

❯ *Resonance Collection*
❮ *José Hendo bark cloth dresses* (PHOTOGRAPHY ADRENUS CRATON)

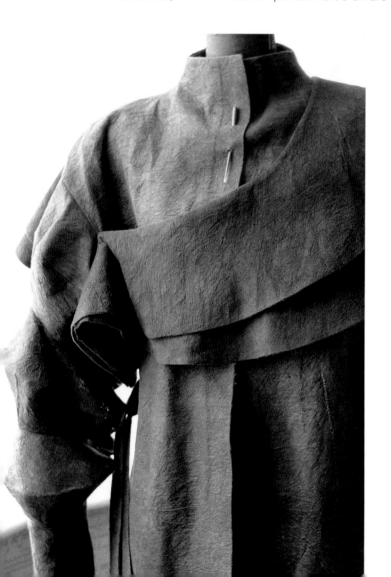

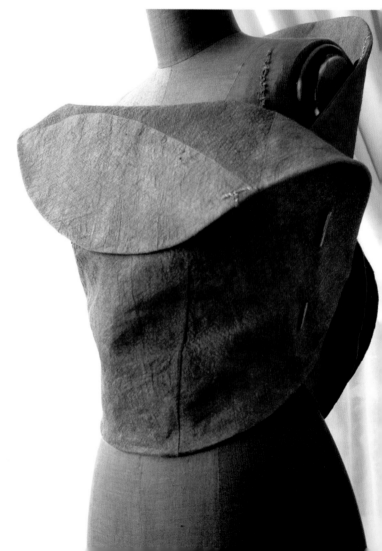

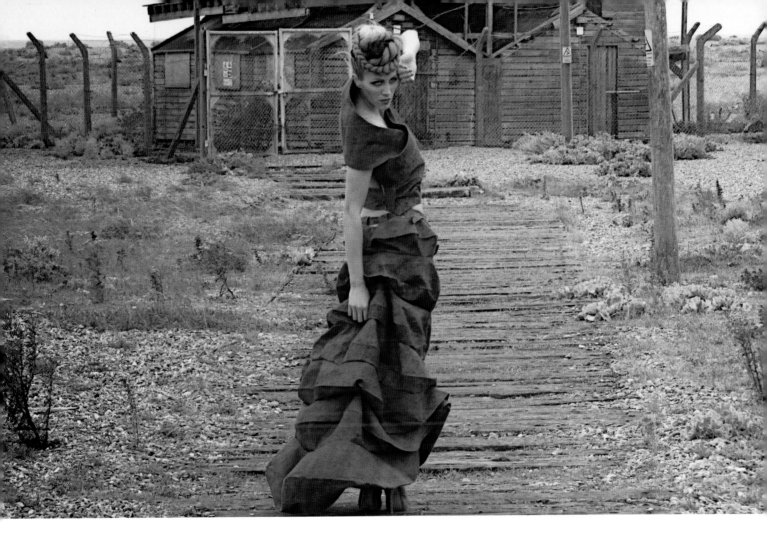

Does your company work with any programs in Africa and or any production workshops/organisations in Africa? One project we are interested in pursuing in Africa is to provide workshops to help women who have talent to develop small cottage manufacturing using the most basic methods. The success of this depends on getting local support, but as the company already provides workshops here in the UK this would be a natural progression.

Through sustainable fashion Jose Hendo wants to make a positive contribution to society. We seek to offer apprenticeships, work experience and free workshops as a way of giving back to the community, and also creating awareness of sustainable fashion.

How do you think fashion made in Africa is regarded internationally? There has been a positive mood on fashion made in Africa for the last few years but there is still a mindset that sees African fashion as lesser that needs to be challenged and changed.

What inspires you? I am inspired by the world around me: nature, art sculpture, architecture, different cultures and most importantly people.

How does Africa relate to your brand and why Africa? Africa is a part of me, it is where my ancestors originate so it filters through in my designs.

What is your ethical standpoint? I am a member of the Fellowship 500 Ethical Fashion Forum and The Centre of Sustainable Fashion so an Ethical policy is very important to me.

Is Africa the future? Africa is the future, it has the potential of being the next 'big thing' in terms of production and consumption.

KAYOBI

FACT FILE
LOCATED ACCRA, GHANA
WEBSITE WWW.KAYOBICLOTHING.COM
FOUNDED AUG 2008

 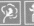

KAYOBI clothes and accessories have a clear desire to tell, through positive and thought-provoking fashions, the story of Africa and the diverse array of cultures and tastes revealed on the continent and wherever Africans are globally.

It is traditional for the Akan tribes of Ghana to call every child born on a Tuesday 'Kwabena', which is why Kwabena Oppong Boeteng picked the Japanese word for Tuesday as the name for his fashion label. While he also just liked 'kayobi' because it sounded like his initials K-O-B, the word also reflects Kwabena's love for the Japanese design and art aesthetic. Founded in Accra, Ghana in 1988, the Kayobi collection has evolved from producing t-shirts to now include collections of accessories and art. Kayobi products are sold in Japan, Ghana and Belgium.

‹ 'Oh chale' tee from the new world africans collection (PHOTOGRAPHER, CAROLINE ANJELICA DAVIDRAJUH) ❯ *Designer, Kwabena Oppong Boateng* (PHOTOGRAPHER, CAROLINE ANJELICA DAVIDRAJUH)

In which countries do you source and produce? Most of our shirts are 100% Turkish cotton and are hand-printed in London. Our shirts that retail in Ghana and West Africa are sourced from a range of countries due to the informal nature of the fashion industry. All Kayobi (Ghana) shirts are printed in Accra, Ghana.

What do you see as the pros & cons of producing/sourcing in Africa? In Ghana where we printed our first shirt it was not easy sourcing stock t-shirts, tote bags and the appropriate ink for screen printing. Blank tee shirts are essentially of low quality to cater for mass marketing for churches, businesses and political parties. There is also a lack of good quality, colours and styles. Sourcing ladies shirts in

'The positive aspect of producing in Africa is mainly the abundance of inspiration for designs'

Accra is extremely difficult unless they are purchased from the mall which is not economical. We have had to improvise to create our own women's shirts by using local tailors who deconstruct men's shirts and create fitted women's tops from them. Using local printers can also be a challenge, as one has to stay with the printer whilst he prints to ensure the shirts are printed on time and to the best quality. Essentially working in Ghana is time consuming as you have to oversee every aspect of production whilst in comparison in the UK we can produce a whole collection without ever leaving our office. An inefficient postal service and a lack of online retail infrastructure (Paypal, Visa) also makes it difficult to sell products online globally.

The positive aspect of producing in Africa is mainly the abundance of inspiration for designs. As an African-inspired brand creating our first collection in Ghana was much easier than creating the 'New World Africans' collection in London. The cost of setting up and printing shirts is cheaper in Ghana as a screen made in Ghana will be four times cheaper than a screen made in the UK. Working in Africa is also flexible when it comes to minimums for prints and colour variations as printers are not as rigid with minimums as UK printers are. This enables Kayobi to provide a bespoke service for our Ghanaian customers who want their own special colourways of our shirts. There is an abundance of skillful and affordable labour which with the right direction, can create excellent products.

❯ All images from the new world africans collection (PHOTOGRAPHER, CAROLINE ANJELICA DAVIDRAJUH)

What inspires you? We get our inspiration from local Maasai people and the Kenyan surroundings. We take the traditions and culture of the country and try to incorporate them into our designs. The abundance of life and colour in Ghana is extremely inspiring and prompts creativity in me.

How do you think fashion made in Africa is regarded as internationally?
People are changing the way they view African fashion. Previously seen as mainly targeted to tourists now, increasingly, people are liking the idea of buying locally made, ethical fashion with a story behind it.

In my opinion however, there are three views on fashion made in Africa. There is the completely ignorant mindset; the save Africa camp, and the ethnic crusade. Despite Africa having a rich history of textiles and our own fashion culture, African fashion has been segmented by people who are totally oblivious of African fashion and appear to think that anything coming out of Africa is inferior. Some people purchase African fashion because they believe it is ethical and that it might save Africa. The big global brands are "inspired" by Africa to create "ethnic" or "tribal collections". One only has to look at the western fashion media to see that the African orientated brands usually featured are either ethically inclined or big brands inspired by Africa. Why can't African fashion simply be looked at on the standard scales for creativity and quality? This is no judgment against brands that genuinely use local African labour or have an truly ethical interest in Africa but it can sometimes seem like it is trendy to be doing something to "help".

Fashion is a business and Africa is ready for business. African fashion should be seen as a force to be reckoned with and not an aid project or a source of occasional inspiration. Its great that platforms such as Arise magazine, FAB magazine and the

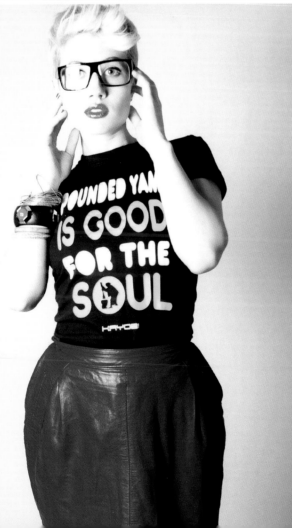
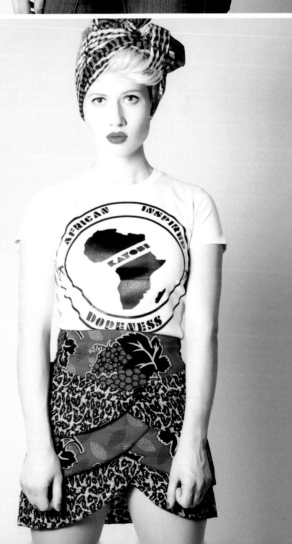

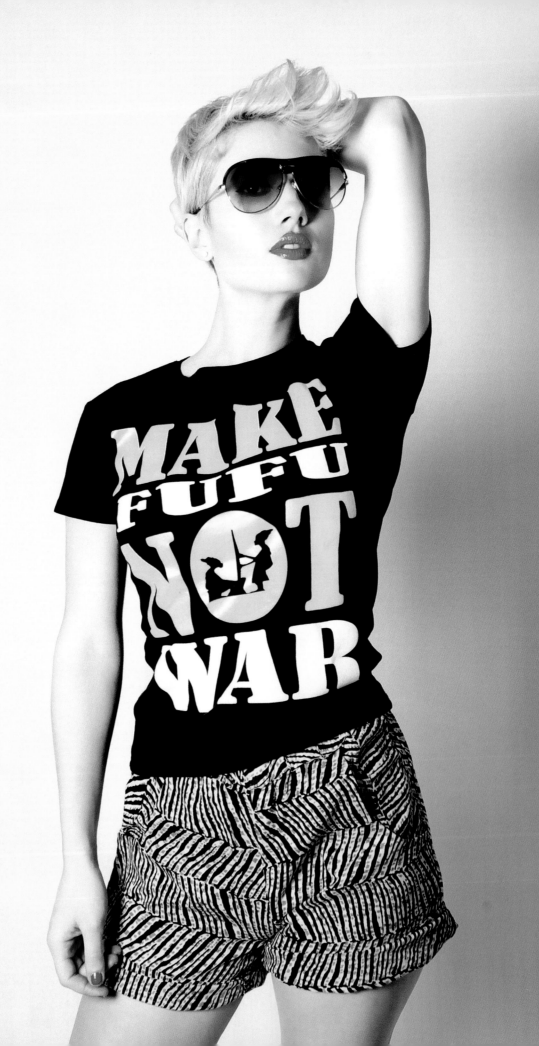

Africa Fashion Guide are exposing the amazing fashion talent coming from the continent.

What inspires you? Talent and inspiration are God-given so when amazing ideas occasionally drop into my head, they can only be ascribed to God. Inspiration to create is all around especially in Africa and I infuse the culture, food and daily imagery into my designs. I love to travel and I always a carry pen, my moleskin notebook and iPhone to capture inspiration on the go. KAYOBI is essentially classic African with a twist as the brand has African roots but a global reach. I love to walk and people watch as you learn a lot about how people dress and what works. Galleries, museums and shops are always good places for inspiration. The Internet is also an amazing resource to learn about trends and find images, which can be rendered into designs.

Do you use any traditional African craft techniques in your design process? This is definitely our aim in the near future, as we want to build a truly African lifestyle brand. African craftsmanship is one of the best in the world and as we plan our menswear collection we will be utilising this craftsmanship.

What is your ethical standpoint? Most of our shirts are Fair Wear and the printers we use are African or Caribbean owned and run companies. We also work with and support quite a few charities that invest in Africa's youth such as Watoto, Inspire Action Foundation, Sabre Trust and Tomorrow's Kaleidoscope of Artists Foundation (TKA). As we grow as a company we hope to use processes that are friendlier to the environment and production models that equip young Africans to achieve their dreams. Overall the aim is to have our new collection made and sourced in Africa and we are currently planning that project.

'Fashion is a business and Africa is ready for business'

Which African designers do you admire? My favorite African designer is Christie Brown. Its lead designer Aisha is innovative and brings a different perspective to the now ubiquitous African/Ankara print designs. I also love Chichia London as its designer Christine Mhando creates edgy unique designs that set her brand apart. And I also admire African streetwear brands such as AITF (Africa is the Future), Jamhuri Wear, Gold Coast Trading Company and Zulu Rose.

Is Africa the future? KAYOBI is inspired by the beauty of the African people and continent, and it is a visual celebration of all things positive about Africa, its past, present and future. At the centre of our philosophy is the aim to promote the Africa seldom seen on the television screens of the west and the Africa that most African's or visitors to Africa constantly dream about when they long to go back to the place of eternal sunshine. Our aim is to create visual stories that extol the history of Africa and that educates the world about our culture, food and traditions through the modern medium of clothing. We want it to be African yet chic, African yet modern, African yet accessible to all. Without Africa there will be no KAYOBI.

❮ *Make Fufu Not War tee from the from the New World Africans Collection* (PHOTOGRAPHER, CAROLINE ANJELICA DAVIDRAJUH)

KEMKEM STUDIO

FACT FILE

LOCATED LAGOS, NIGERIA

WEBSITE WWW.KEMKEMSTUDIO.COM

FOUNDED 2001

The exclusive Kemkem Studio weaves a modern version of the Yoruban Aso Oke fabric through its couture and ready-to-wear collections, deftly marrying ancient traditions to a thoroughly contemporary representation of African culture and high fashion.

Kemmy Solomon, the creative director and founder of Kemkem Studio, has lived in London, New York, Florence and Lagos, where she is now based. She draws on all of these influences to create fabulous one-of-a-kind youthful pieces imbued with a hint of classical, rock, and glamour.

Kemmy creates a mix of couture and ready to wear garments using traditional African fabrics, such as Aso Oke with silks, cottons and lace. Her team has created their own more durable version of Aso Oke – a hand woven cloth worn traditionally in the Yoruba culture, combining it with other African prints such as Ankara for their high street line KKS.

In which countries do you source and produce? We source our fabrics from all over the world and produce all products right here in Nigeria.

What do you see are the pros and cons of producing / sourcing in Africa? Some of the benefits are having access to a lot of local fabrics. The downsides include the lack of consistent lighting supply and skilled workers. We also have a definite need to train our workers to meet international standard productions.

❮ *Multicolor aso oke jacket with skater aso oke skirt, Heritage Autumn/ Winter 2011/2012*
❯ *Yellow and black stripe aso oke reversible jacket with skinny aso oke pant , Heritage Autumn/Winter 2011/2012 collection*
(PHOTOGRAPHER MIKE NWOKOLO)

'Africa is my first foundation when sourcing for inspiration'

How do you think fashion made in Africa is regarded internationally? Our reputation is developing rapidly and people are now realizing there are high quality products coming out of Africa.

How does Africa relate to your company and why Africa? I can't help but communicate that Africa is part of me through my designs in one way or another: Africa is my source of inspiration. I'm of Nigerian heritage and love the multicultural communities around me. I'm forever learning the different cultures and traditions of each community. Each is very unique and special in various ways.

Do you use any traditional African craft techniques in your design process? Moving back to Nigeria, one of the things I wanted to do was to preserve the traditional ways of looming and weaving the Aso-Oke textiles. I first learned how to do this from my grandmother, who also taught me different ways of producing tie-dye fabrics and it's come in handy because we use all of these techniques in our ranges. We also use traditional hand embroidery techniques on some of our products.

Does your company work with any cotton programs in Africa and or any production workshops/organizations in Africa? We have developed our own production workshops here in Nigeria. Our facilities give our workers high quality working environments. We train them in our own specialist techniques and we have an established quality control department. We also support 'Sewing Hope', a fount of mercy program that trains locals to sew in order to feed their families.

What inspires you? I love taking trips to rural areas and markets to people-watch.

Which African designers do you admire? Young labels like Bunmi KoKo, Duru Oluwo and Pierre Anthoine Vettorello to name a few.

What is your ethical standpoint? We live on this planet, so we are responsible for the way we chose to live our lives. We have a personal responsibility to keep our environment clean and preserve its natural resources, and this includes what we wear. We use a lot of recycled fabrics, in for instance or our vintage Aso-Oke collections. Kemkem Studio workers are paid a fair salary and work in great environments.

Is Africa the future? It's definitely a new market; a lot of international companies are starting to tap into our fashion and textiles. This is a great time for us.

❯ *Heritage Autumn/ Winter 2011/2012 collection*

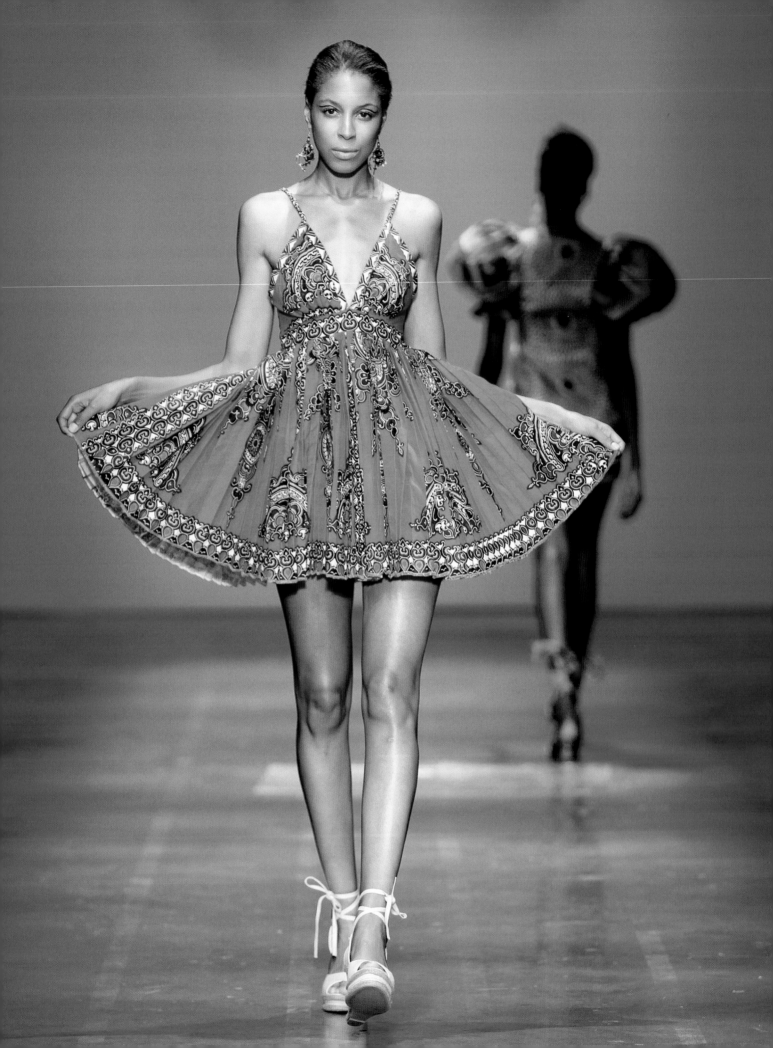

KIKI CLOTHING

FACT FILE

LOCATED ACCRA, GHANA

WEBSITE WWW.KIKICLOTHING.COM

FOUNDED 2002

Consciously Afro-centric, KIKI Clothing has thrived over the past decade in the stable economy of Ghana. The company specializes in unique ethnic designs for children and adults, merging vibrant colours, Afro-centric prints and easy wearable styles that are smart, organic and playful.

Founded in 2002 by Titi Ademola, KIKI CLOTHING creates footwear, ladieswear, children's wear and funky t-shirts with a design aesthetic consciously Afro-centric, consisting of bright colours and traditional textiles, coupled with modern silhouettes and styles.

KIKI Clothing's mission is to become known for the creation, manufacturing and retail of the highest quality clothes and footwear made in Africa.

In which countries do you source and produce? At the moment, all Kiki products are sourced and manufactured to a high standard in Ghana.

What inspires you? Many things including the Internet, movies and music videos. Researching traditional history and culture from around the globe inspire and inform. Current trends in colours and silhouettes and the clothes the everyday person wears at the shopping malls and on the streets of Accra are priceless sources of inspiration.

⟨ *Paisley Fan Dress*
⟩ *Zebra Dress, Illustration,*
Kiki Clothing 2009/2010
collection (BY ERICA SHARP)

Is Africa the future? It's a catchy notion, but I would like to believe Africa IS the future. It's such a diverse continent – fifty-three beautiful countries, with great potential and cultures. There are so many opportunities here, waiting to be

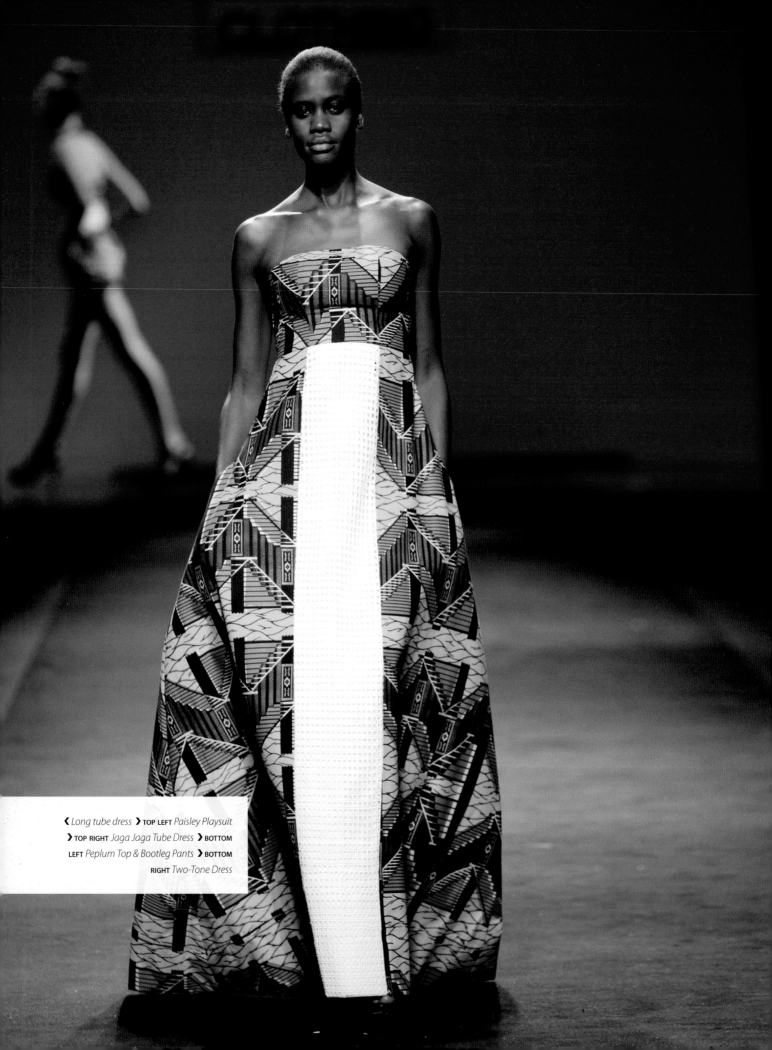

❮ *Long tube dress* ❯ **TOP LEFT** *Paisley Playsuit*
❯ **TOP RIGHT** *Jaga Jaga Tube Dress* ❯ **BOTTOM**
LEFT *Peplum Top & Bootleg Pants* ❯ **BOTTOM**
RIGHT *Two-Tone Dress*

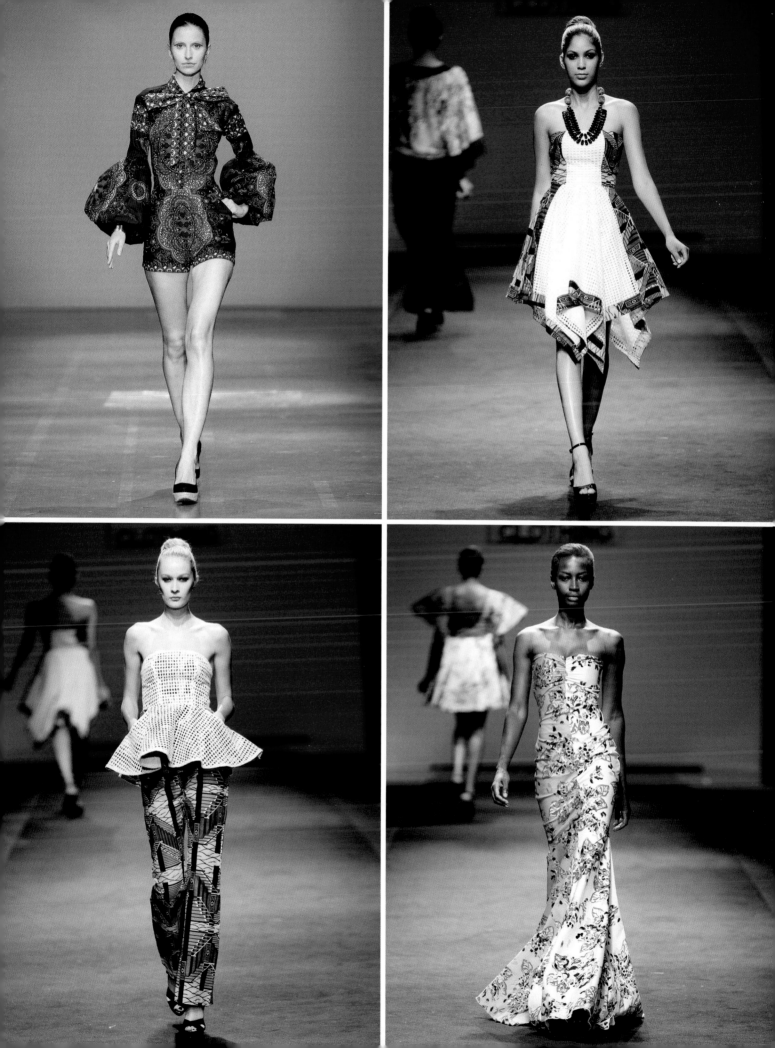

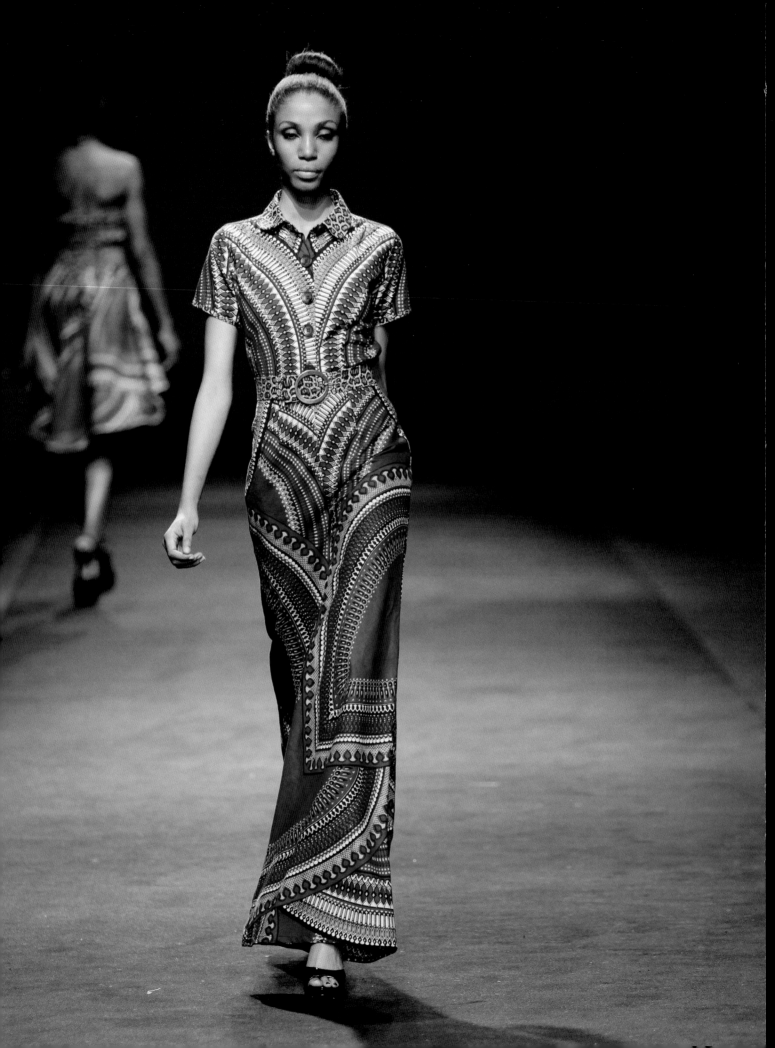

'I think Africa, generally, is becoming more relevant and it's exciting to be an African and to live and work in Africa as an entrepenuer'

explored, especially in Ghana, where a healthy middle-class income group is developing. It's also a continent blessed with incredible resources, rich cultures and a vibrant environment. For so long the international community has painted a very one-sided view of Africa in terms of 'the third world'. But thankfully, times are gradually changing. Fashion weeks in South Africa, Kenya and Nigeria are happening every year now. The Internet enables African designers to showcase their work around the world. There are challenges yes, and we do need better education, training and experience. But this is only the beginning.

How do you think fashion made in Africa is regarded internationally?
Africa is generally becoming more relevant and it's exciting to be African and to live and work in Africa as an entrepreneur. For so long, artists in other parts of the world have been inspired by African culture, arts, music and clothes. It is encouraging to see Africans being recognized for their contribution to the creative world, such as African designers participating in the major international fashion weeks.

What do you see as the pros and cons of producing/sourcing in Africa? In recent years Ghana has enjoyed consistent political and economic stability and this has been key to the success of Kiki Clothing. Not only have

we been allowed to grow steadily as a business, but there has been a large influx of foreign workers, students and tourists, which has widened our potential target market. Producing in Ghana gives us better control over what we are manufacturing and how. We can control the working conditions of our tailors and seamstresses. We can keep a closer eye on quality control. And we and our customers have the satisfaction of knowing that we are promoting quality, made in Africa products.

Although there are positives to manufacturing in Ghana, a major challenge is finding enough qualified employees to help expand our business. It is a lot of hard work to supervise the day-to-day running of a design, manufacturing and retailing enterprise producing goods made in Africa and to do this we need better trained staff. Other issues are maintaining the consistency of products and catering for large orders. Bangledesh, India, China and Dubai are countries that are well-known for having the machines, experience, qualified and inexpensive labour and it's hard to compete with that.

How does Africa relate to your company brand and why Africa?
KIKI Clothing's mission and dream is to promote quality, products made in Africa. There was a time when you could only wear African-inspired attire in Africa. One would feel silly wearing it down Oxford Street in central London. It is rewarding to hear our clients all over the world saying that they wore their KIKI Clothing garment to a wedding in Lebanon or the theatre in New York and not only did they feel good in what they were wearing but they stood out from the crowd for all the right reasons.

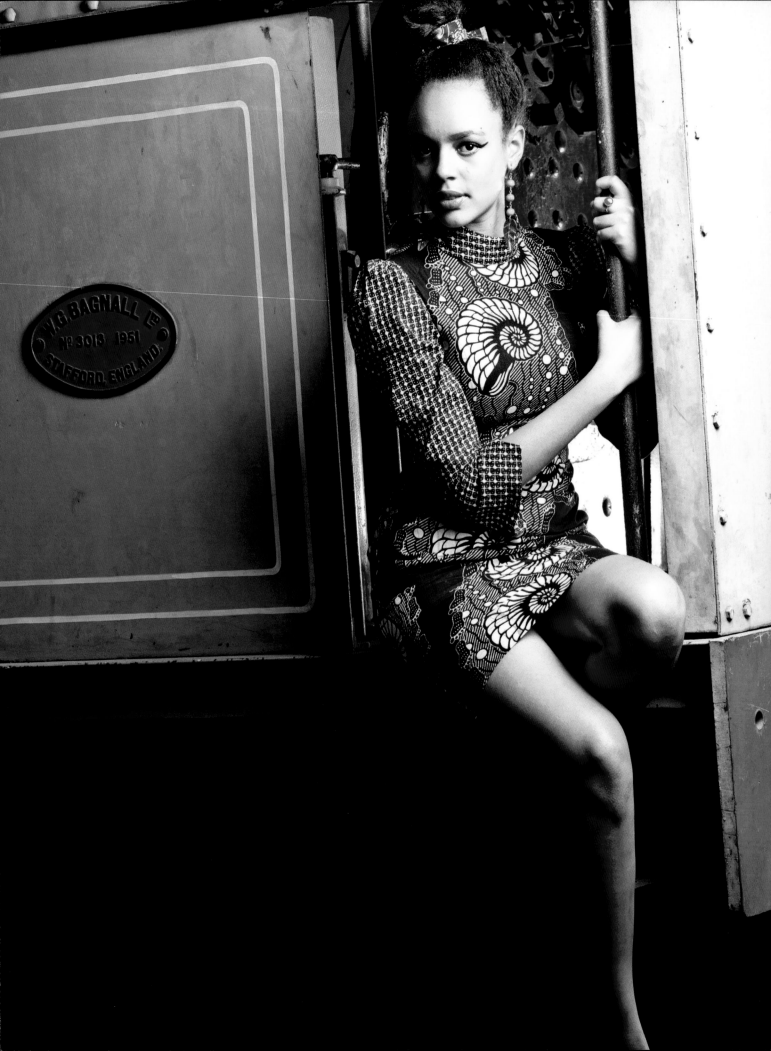

KIKOROMEO

FACT FILE
LOCATED NAIROBI, KENYA
WEBSITE WWW.KIKOROMEO.COM
FOUNDED MAY 1996

Ann McCreath launched her fashion house KikoRomeo, which means 'Adam's apple" in Kiswahili, to help create jobs as well as unique, high quality products for retail. KikoRomeo produces ready-to-wear and custom-made fashion, accessories, and sandals for adults and childrens.

Scottish born Ann McCreath completed an Arts degree in Edinburgh and Fashion Design studies in Rome, and followed this with a stint in Barcelona working as a designer. She took a three-month break doing aid work in Kenya and ended up staying on for three years, before deciding to go back to her fashion design profession with a new focus on doing trade instead of aid.

Hoping Kenyans would take pride in African-inspired contemporary fashion, and promote their economy through buying locally-made fashion, she set about creating ethically sound products with input from community artisans and women's groups, and retailed them through her own shop. Since then KikoRomeo has continued to offer ready-made garments, cut to international fashion trends, using African made fabrics, often with handcrafted details. KikoRomeo currently involves a number of young Kenyan designers including Ann's assistant Norbert Ochieng, who studied at Maseno University. They form the design team and work closely with artisans and fine artists such as El tayeb Dawelbait, who handpaints on textiles.

Ann founded the Festival of African Fashion & Arts (FAFA), in 2008 with other arts and media professionals. Kenyan and Pan-African designers came together for the "Fashion for Peace" event in the Nairobi National Park, which is now an annual event and a recognized platform for designers from Africa and the African diaspora to showcase their work.

‹ › *40's Street Chic Collection AW2013*
(PHOTOS BY EMMANUEL JAMBO)

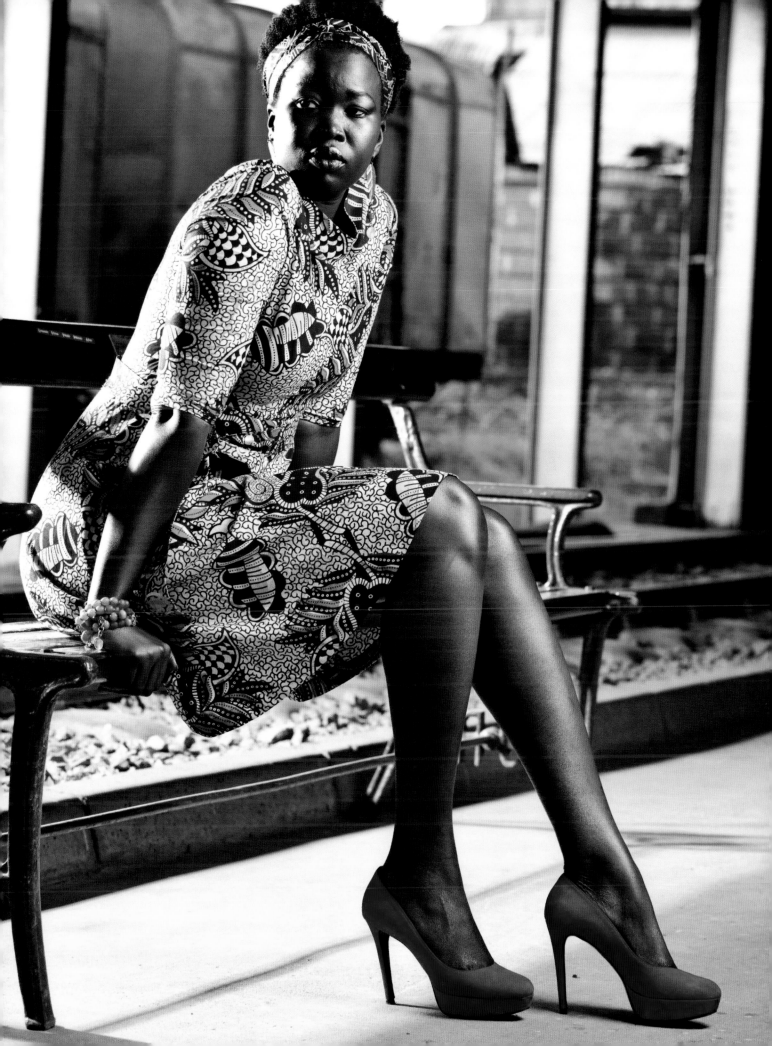

'We are constantly looking at new ways to integrate handcrafted elements'

How do you think fashion made in Africa is regarded internationally? It is difficult to assess when you are living in Africa. I imagine we are a source of curiosity and inspiration but seen as poor country's cousins in terms of quality and sophistication (even if not true).

What do you see as the pros & cons of producing/sourcing in Africa? Our brand was set up to create jobs in Kenya, so it's not about pros and cons. Our brand is committed to that so although we may buy some fabrics from outside the continent, those are not the majority.
We are constantly looking at new ways to integrate handcrafted elements in a standardised quality fashion item. it is up to us to find solutions to the problems which arise, just as one adapts to working environments in any other part of the world.

How does Africa relate to your company brand and why Africa? I chose to live here as I was inspired by the colours, the crafts and the culture. KikoRomeo was created in 1996 to do trade not aid through fair trade practices.

In which countries do you source and produce? KikoRomeo is sourced and produced in Kenya mainly but some print fabrics are sourced from Ghana, Nigeria, Mali, Cote d'Ivoire and some from India.

Do you use any traditional African craft techniques in your design process?

❯ *I Pray to the One of Many Colours Couture Collection inspired by Maasai culture SS2012*
(PHOTOS BY BARBARA MINISHI)

Yes, we use tie dye, embroidery, hand painting, handcrafted buttons and hand weaving techniques. Our fabrics include hand-woven and factory-made cottons, conservation Kenyan silk and organic cotton jersey. Our craft techniques include hand-painting, tie dyeing, knitting, crochet, beading, metal work and embroidery.

What is your ethical standpoint? We are a Kenyan company, everything is done in Kenya. We work with many small scale artisans, fine artists and women's groups as well as employing people directly in production, admininstration and retail. We've always traded fairly and find it very important. We like to use organic cotton and conservation silk, but don't do so exclusively. Creation of jobs is critical to build the economy.
Our business is based on respect for those who craft the different elements of the product, and so we have always practiced fair trade. I want to help improve craft skills and assist our community partners to improve their own products. I also enjoy mentoring design students and assist them in acquiring better skills, before setting up their own businesses.

Which African designers do you admire? There are so many I admire and for different reasons. I was originally inspired by Alphadi, who continues to encourage and inspire other African designers. I am particularly fascinated by those who use traditional techniques and materials in a modern way e.g. Kofi Ansah & Modela Couture.

Is Africa the future? I don't know from the world's point of view, but with regards to ourselves within Africa, of course. We are a growing market in terms of population and buying power and Africa to Africa trade is on the increase, so we are our own future.

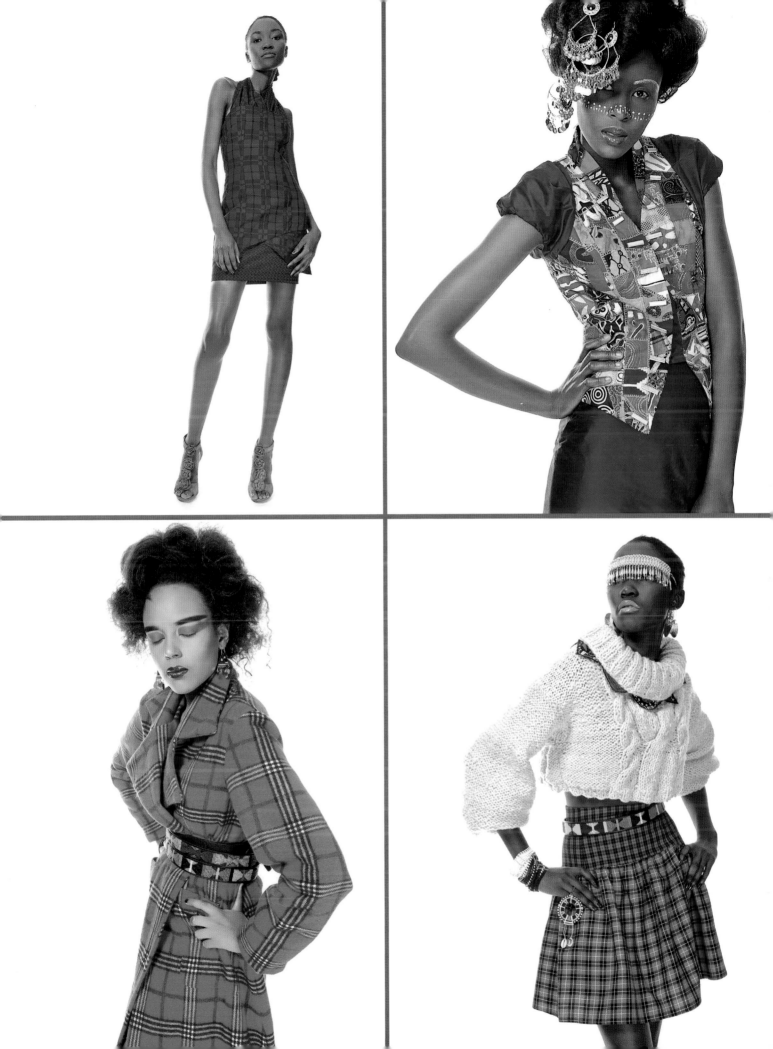

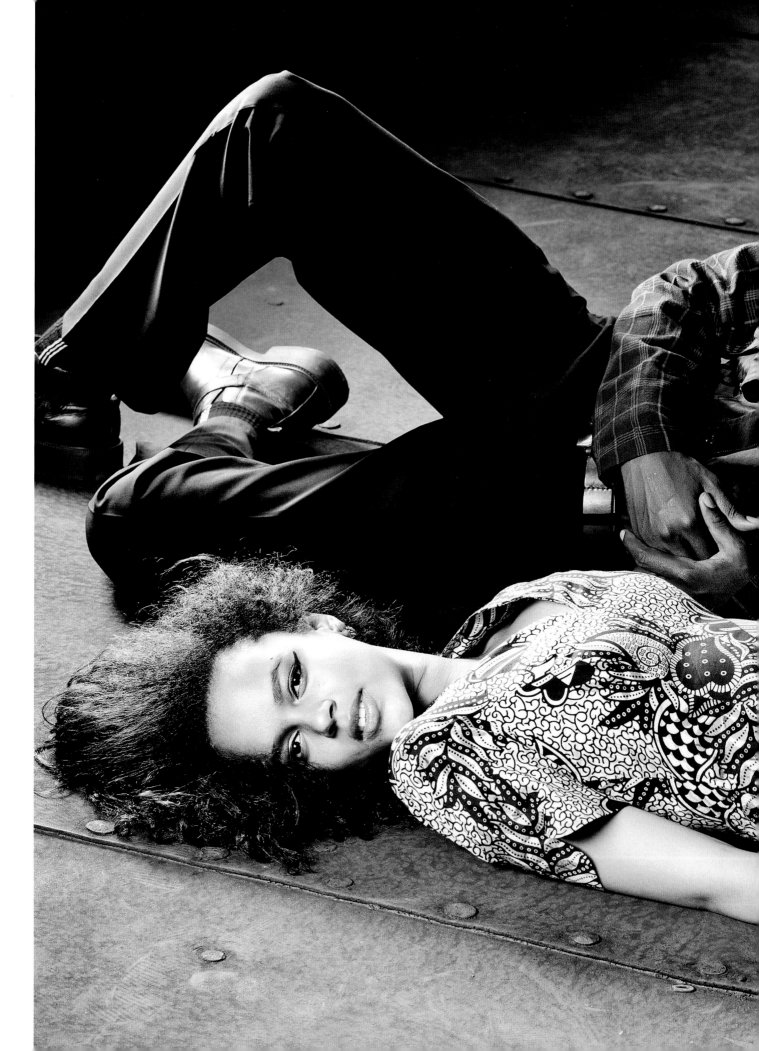

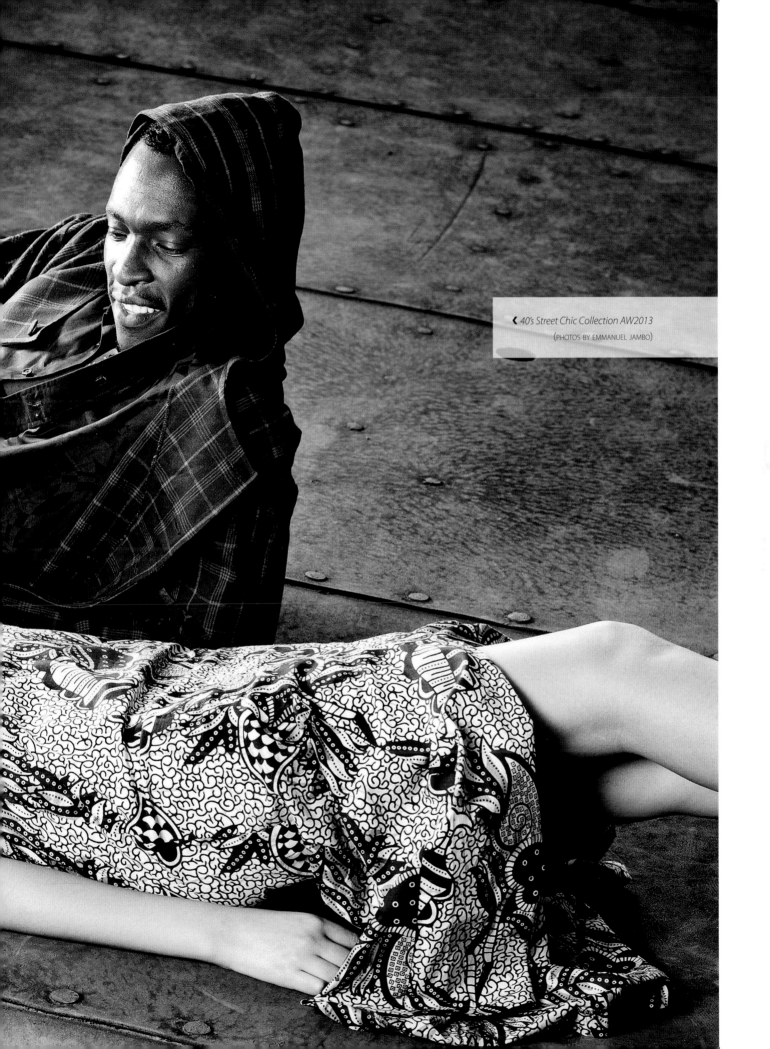

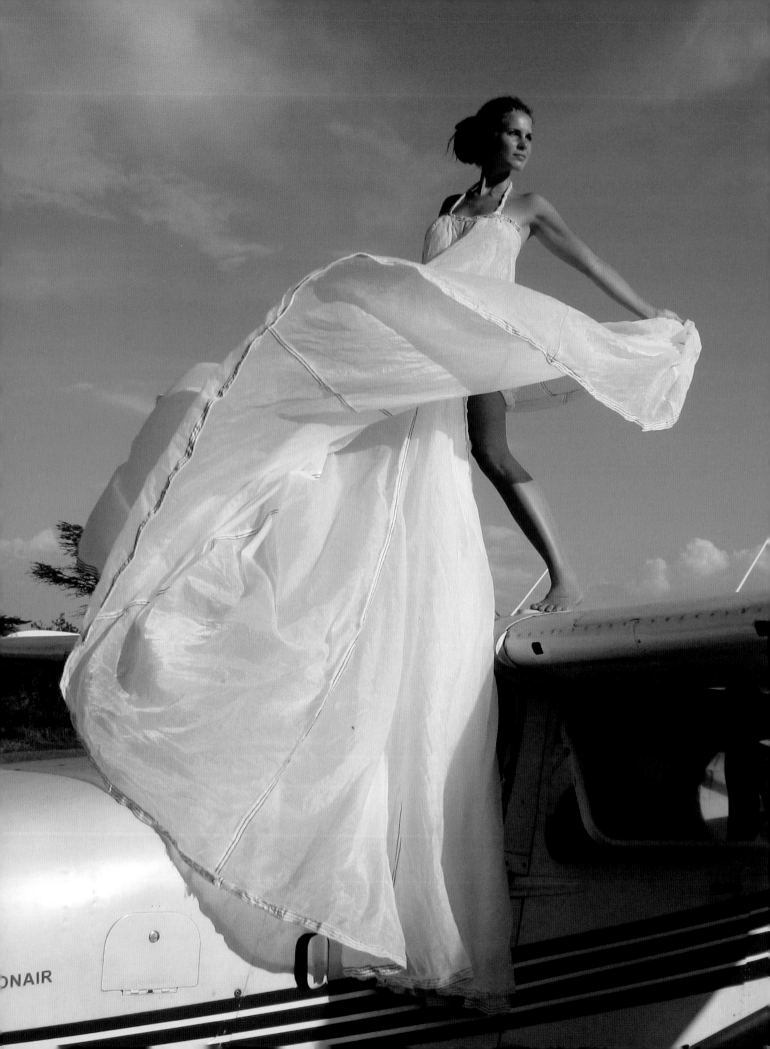

KONDAKIS

FACT FILE
LOCATED NAIROBI, KENYA
WEBSITE WWW.KONDAKIS.BIZ
FOUNDED 2008

KONDAKIS, a socially and environmentally responsible company in Kenya, creates collections utilizing unique materials from parachutes, deadwood and peace silk. Produced locally under Fair Trade values they contribute a portion of their profits to educating Maasai girls.

‹ *Flower pocket dress (parachute), elastic leggings (parachute), Dead wood piece bangle, Ethiopian horizontal choker* (PHOTOGRAPHER, JONATHAN HYAMS)

Of Greek and Danish descent, Nike Kondakis grew up in Europe where she learned her art and design school craft. In 2002 Nike joined the KaosPilots, a 3-year Danish programme in responsible entrepreneurship (www.kaospilot. dk), after which she moved to Kenya where in 2008 she founded KONDAKIS. Combining her background in art, design and responsible entrepreneurship she seeks to provide an ethical alternative to the traditional fashion industry.

The KONDAKIS Parachute Collection marries the principles of environmental awareness and practice, with a beautiful design sensibility. Each piece, made from original, expired, (no longer fit for jumping) un-dyed parachutes, bears the manufacturer's stamps showing when and where the parachute was orginally produced and can each be worn in several uniquely different ways. In the same vein the accessories in the collection are created from deadwood (the term applied to wood naturally falling from the tree), garnered due to wild game breaking off branches as they play or forage for food. The designs integrate the roughness of the bark into the bangles, necklaces and earrings and each piece is cut to reveal the shape of the original branch from which it was crafted. .

The KONDAKIS Peace Silk Collection is the newer collection. Unlike conventional silk, produced by letting silkworms spin their cocoons and then destroying them prior to hatching to avoid breaking the silk threads, "peace"

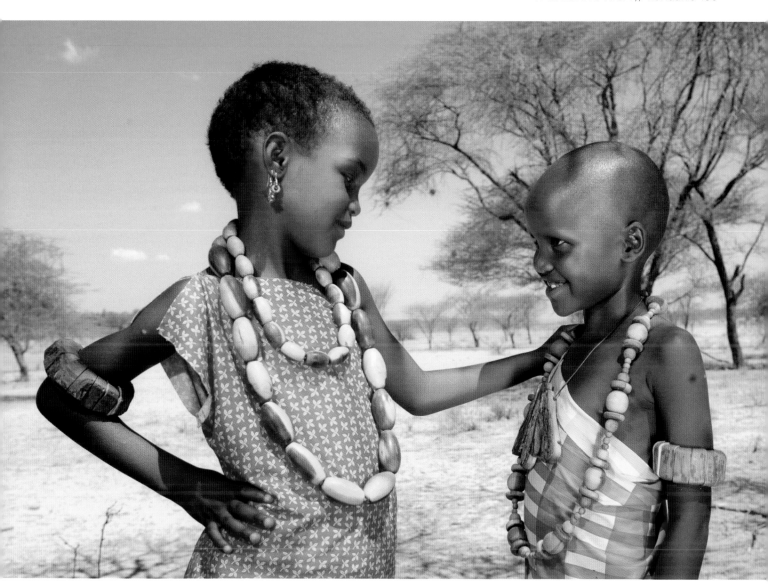

silkworms live their full lifecycle in peace producing a slightly more roughly textured silk, formed after the silkworm hatches by re-joining the broken threads of the cocoon. The hand-spun silk yarns are used for hand-knitted garments and are organically dyed using tea, coffee, spices and vegetables.

Which countries do you source and produce in? The parachutes are sourced in the US, UK and Australia and our deadwood from the Kenyan bush. Our peace silk fabrics are currently from India. We produce our peace silk yarn designs in Kenya and are working closely with a local silk producer to develop the peace silk

fabric here too. All our garments and jewelry are produced locally by Kenyans.

What inspires you? I travel a lot. I love the buzz of the cities: New York, Paris, London, Athens, Copenhagen, Berlin. Coming home from these trips, I feel inspired. I also get a lot of inspiration from being in the bush and doing my yoga and meditation. True inspiration and creativity happens in the balance between a busy and a quiet life.

What is your ethical standpoint? We include fair trade and have a focus on both the people we work with and our environment. We use organic, sustainable and recycled materials

❯ *Maasai children with (left) Deadwood acacia, small; Deadwood acacia, large; Deadwood piece bangle with bark and (right) Deadwood, long mix necklace, wild olive. Big dead wood drop choker, wild olive. Deadwood piece bangle without bark*

'Your mind is like a parachute, it only works when it is open'

and furthermore support Maasai girls to go to school through a percentage of our sales.

Is Africa the future? Africa could be one of the future hubs for the fashion and textile industry, but the key lies in producing locally for a local market, not sourcing from one place, producing in the next place and selling to the third. Our beautiful planet will only survive if we start thinking ethically, environmentally and locally in everything we do.

How do you think fashion made in Africa is regarded internationally? It seems that African-made fashion was once seen as not good enough when it came to quality and dependability. Now things are changing and big international brands are sending the signal that African produced fashion can be great. Furthermore Africa still has an exotic touch and a mystery that comes with the story.

What do you see as the pros & cons of producing/sourcing in Africa? Kenya and Africa has so many beautiful natural resources and that makes it easier to source and get inspired. On the other hand being a European running a fashion company in Africa also has it's challenges and cultural clashes that one has to navigate in in order to become successful.

Why Africa? I found my first piece of parachute in Kibera (one of Nairobi's biggest slums) so it all started here. Choosing to be in Africa was not the question, but rather it was what to do in Africa.

❮ *Illustration, Kondakis parachute dress with bow by Katie Hemingway* ❯ **TOP LEFT** *Yellow maasai neck dress (parachute); Olive green scarf (parachute); Dead wood, oval bead bangle* ❯ **TOP RIGHT** *Long white wedding dress (parachute); Dead wood acacia, large; Dead wood, odd shape necklace; Dead wood, square and organic shape bangles, wild olive* ❯ **BOTTOM LEFT** *Longs grey knitted dress (parachute); Maasai beaded jewelry* ❯ **BOTTOM RIGHT** *Green summer dress knitted from recycled parachutes, green parachute scarf, dead wood bangles* (PHOTOGRAPHER, JONATHAN HYAMS)

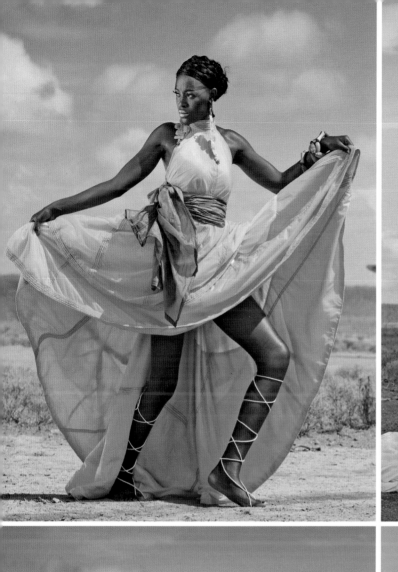
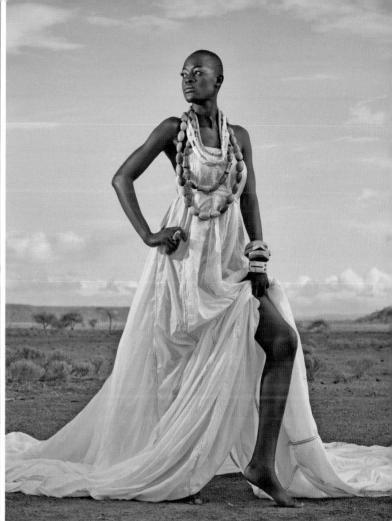
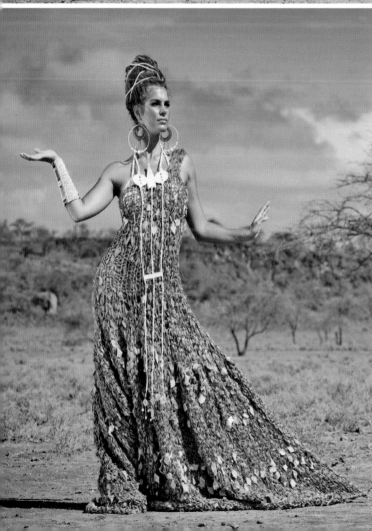
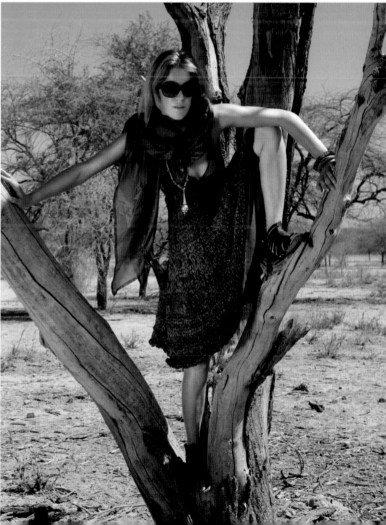

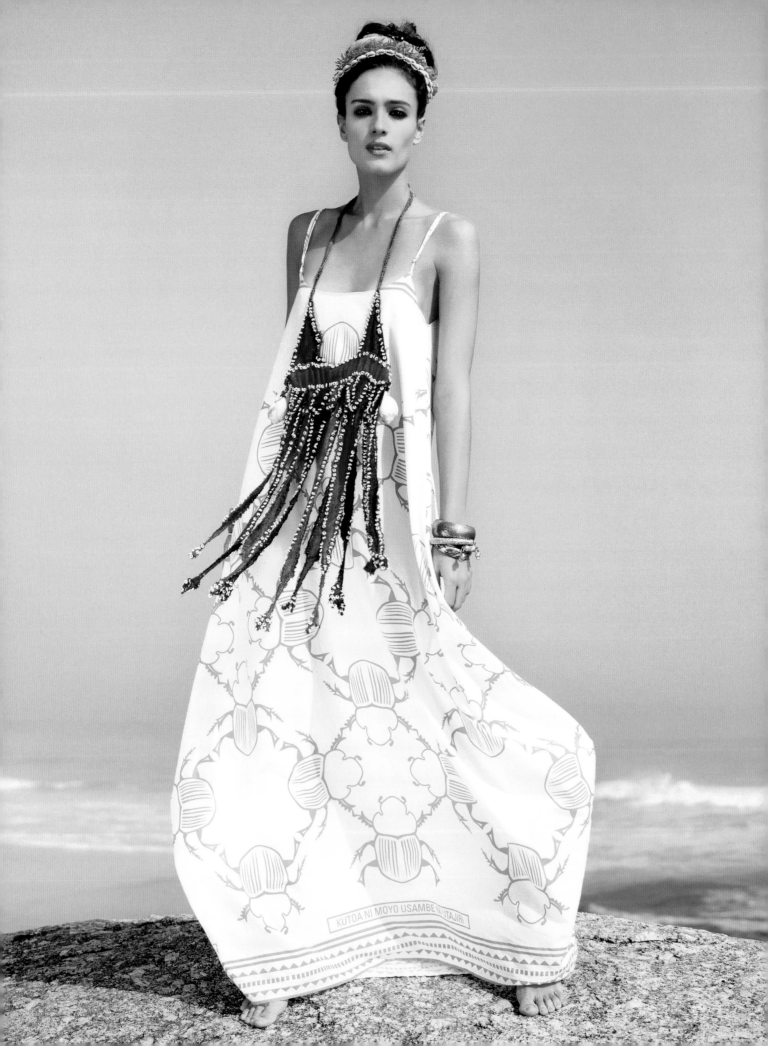

LALESSO

FACT FILE
LOCATED NAIROBI, KENYA
WEBSITE WWW.LALESSO.COM
FOUNDED 2005

LALESSO, founded in 2005 by fashion students Alice and Olivia, was inspired by the island of Lamu on the North Coast of Kenya with it's Arabic and Swahilli influences. The holiday fashion brand is noted for its trademark khanga fabric skirt designs.

❮ Bakuli Dress, Spring Summer 2013
❯ Illustration - Binti Kaftan, Spring Summer 2012

Alice Heusser and Olivia Kennaway studied fashion together in Cape Town. It was a holiday they took together off the northern coast of Kenya on the culturally rich Island of Lamu that inspired them to create their vibrant and carefree summer fashion label LaLesso.

'Lesso' is another name for 'khanga', the popular East African cotton print used to make wraps and other traditional clothes. The brand was originally launched with a range of distinctive skirts made with a variety of khanga colours and prints, and cut with a hankerchief hem and flattering contrasting wasteband. The skirts were a sellout hit. Once they finished their fashion studies, they went on to expand their line using the trademark khanga prints.

Their first full collection was launched in London at the end of 2007 when the actress Sienna Miller was spotted wearing a Lalesso dress and soon afterward their designs were snapped up by Top Shop's Oxford Street store. Since then, the pair have gone on to win the Ethical Fashion Forum's Innovation award and the South African Glamour Magazine's Woman of the Year award for ethical entrepreneurs. Their collections have been featured at fashion weeks in London and Capetown and in the pages of Vogue, Grazia and Scene.

The brand concept for Lalesso is for simple yet flattering and stylish summer clothing using the East African khanga as a trademark to all designs. The

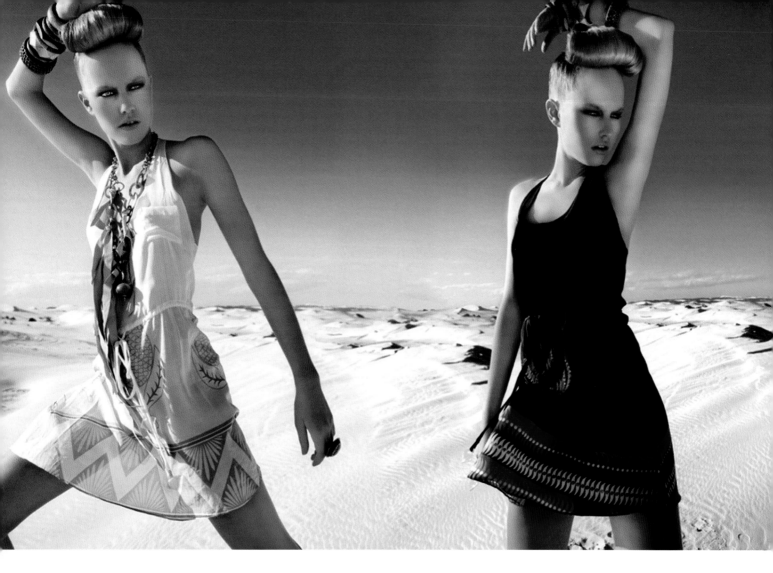

garments are ethically produced in Kenya, providing jobs with a higher than average wage, supporting the community in as many ways as possible.

Which countries do you source and produce in? All our garments are produced in Ukunda, Kenya by SOKO. We started printing our own fabrics five years ago and also source bespoke printed fabric from India because of the lack of available textile producers and printers in East Africa. We had spent a year researching whether it was possible to source fabric in East Africa, but it was apparent that the small factories could not deliver a high enough quality product or stick to deadlines.

Following our invitation to design a collection for Woolworths in South Africa, we were given the name of a fantastic ethical textile company in China. The quality is faultless and they deliver on time which as a small business is essential. We would prefer to support local businesses, so we're still keeping our options open to bring this element of production back to East Africa.

We also use various other trims and embellishments sourced locally: our buttons are made using old coconuts washed up on the beaches and are hand carved by unemployed 'beach boys'; our beaded bracelets on the swing tags are made by Maasai tradesmen and use brass charms make by a project in Nairobi's largest slum. We also use the brass works of Bombolulu, an APDK (Association of the Physically Disabled in Kenya) project as trim detail on certain designs. And our ballet pumps are made in Kenya's third largest slum Korrogocho, by the Bidii Shoemakers – another self-help initiative. In the past we sourced crochet made by Zimbabwean refugee nuns in Nairobi.

❮ *Maliki Cape, Spring Summer 2013*
❯ *Lalesso Skirt, Spring Summer 2013*

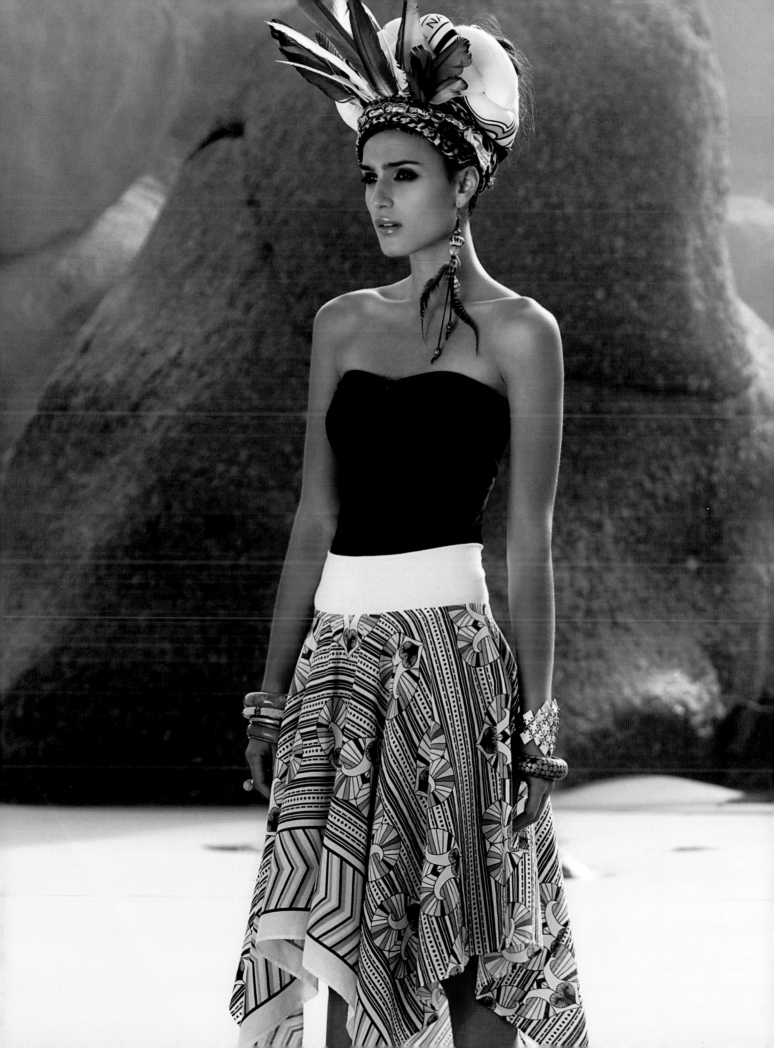

'I think there has been quite a considerable shift in the international opinion of fashion made in Africa in the recent years'

How do you think fashion made in Africa is regarded internationally?
There has been a considerable shift in international opinion of fashion made in Africa in recent years. When we first launched Lalesso in the UK over four years ago buyers were definitely sceptical. At the time I thought it was a bit unfair but now I can see why. I think the scepticism was based on a lower standard of quality and not delivering on schedule. As a brand, we have had issues with both of these factors. Fortunately you can only learn from these kind of setbacks and they are things that we won't allow to happen any more. About two years ago there seemed to be an 'African craze' and for buyers it suddenly became very trendy and unique to have clothing from Africa. Today, buyers are slowly starting to accept that Africa does have the ability to produce a high quality garment and deliver on schedule. Companies like SOKO are forerunners in allowing this. They provide a high quality and reliable service, setting a good precedent for clothing made in Africa. With big names like ASOS, Edun and Suno producing in Africa it also lends support to the fact that Africa does have the capabilities.

How does Africa relate to your company brand and why Africa?
I was born and grew up in Kenya and Alice moved to South Africa when she was 9 years old so we both have African blood running through our veins. I think once you have that in you, your heart will always be in Africa. The concept of Lalesso was also born in Africa and was a result of the inspiration of the beautiful khanga. It wasn't really an option to build the brand anywhere else.

What do you see as the pros and cons of producing/sourcing in Africa?
The way we work in Africa is very hands on, we very rarely go through a middle man. This benefits and directly impacts the talented person making the product to get the full value of the product they have made. But a middle man is essential because deadlines and quality control are very often overlooked by these artisans. Unless there is someone constantly checking up on the quality and assisting with time management these factors will almost certainly not be adhered to. We are fortunate enough to be based for the most part of the year in Kenya so we can act as the middle man ourselves and be even more certain that the job is being done properly. Many designers from Europe come to Kenya and build a collection with various suppliers and as soon as they leave everything falls to pieces which obviously has serious financial set backs. In terms of sourcing and product development we have found that the skills base is abundant, often self trained, but the actual design aesthetic needs direction and translation to suit the Western world trends.

What inspires you?
Bridging the gap between African design and contemporary fashion is an inspiration in itself. To translate the vibrant and richly patterned khanga into something not just wearable but stylish and contemporary is always an exciting challenge. Lalesso is an exclusively summer brand and we want to build upon that aspect so that when people think of going on holiday they immediately think of Lalesso. As a result we look to all ultimate holiday destinations as a source of inspiration, from Copacabana to Gauguin's Tahitian paintings to the

❯ *Buibui Dress, Spring Summer 2013*

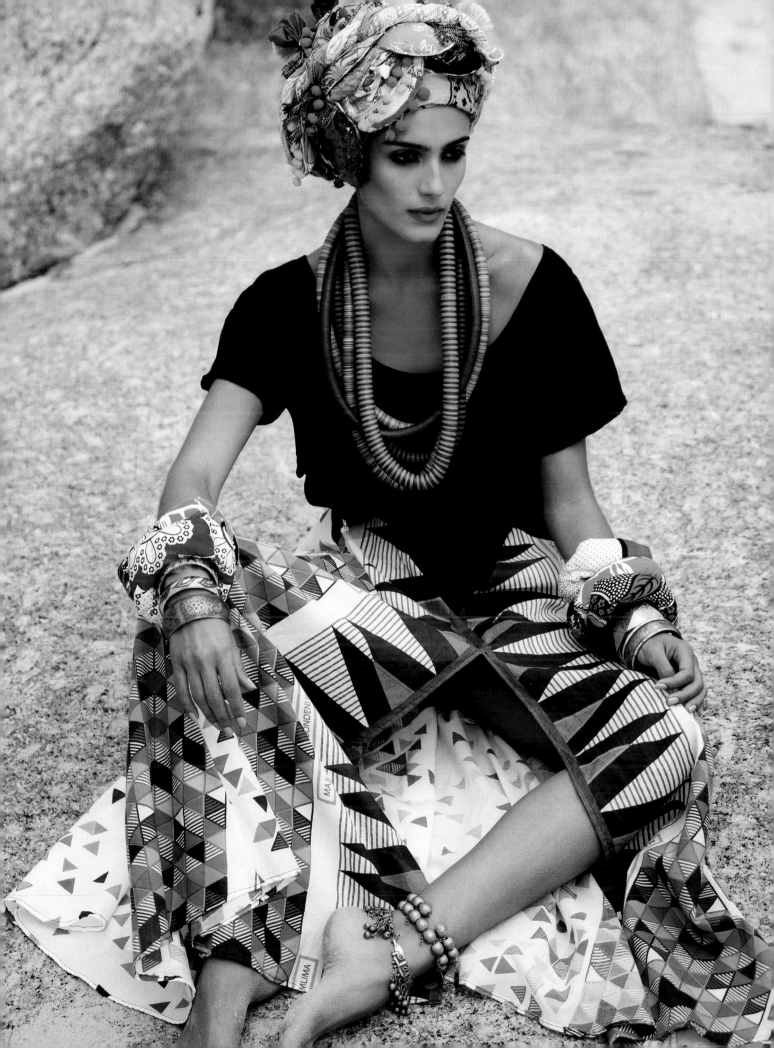

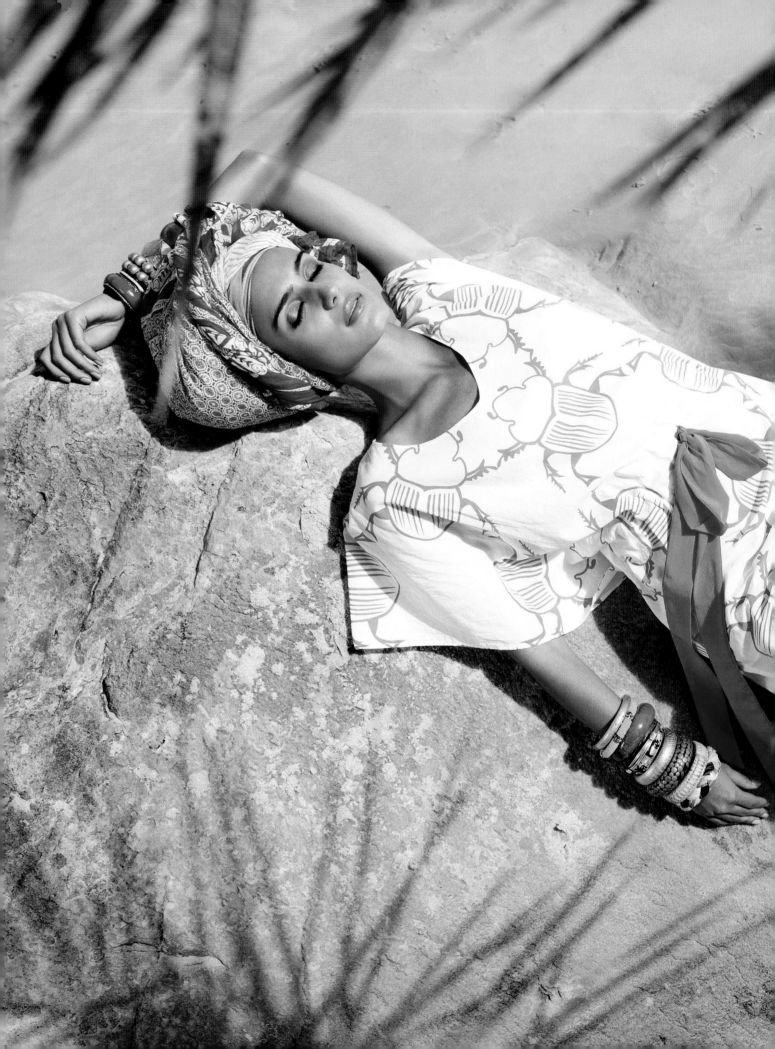

edgy summer street wear in cities like Sydney and Cape Town and so on. Each season we draw on a specific source of inspiration and build on that. In effect, we could say that we source inspiration from African design but find it most effective to use the local skills to produce our own designs.

What is your ethical standpoint?
Lalesso was originally centred around the social aspect, more one of benefiting communities and providing a fair wage in a sustainable manner. However we are always expanding on this and have in fact recently become a Carbon Zero company. Essentially this means that we calculate the carbon emissions Lalesso generates and offset these through www.co2balance.com a carbon off-setting company

Which African designers do you admire? Suno is a great inspiration. They came on the scene very recently and have almost instantly made a big name for themselves. The manner in which they source and incorporate African inspiration into their designs is very clever and works well.

Is Africa the future? As long as the demand for cheap fast fashion is there, the East will continue to be the key player in the garment and textile manufacturing sectors. But we can safely say that the Western world has an increasing amount of confidence in Africa, and this support means that local industries that were suffering are slowly finding their feet again. Essentially, demand comes from the end consumer. We need to feed this demand so that Africa can trade its way out of the poverty hole we are stuck in. It really could have an impact on the world of fashion.

❮ *Wimbi Kaftan, Spring Summer 2013*

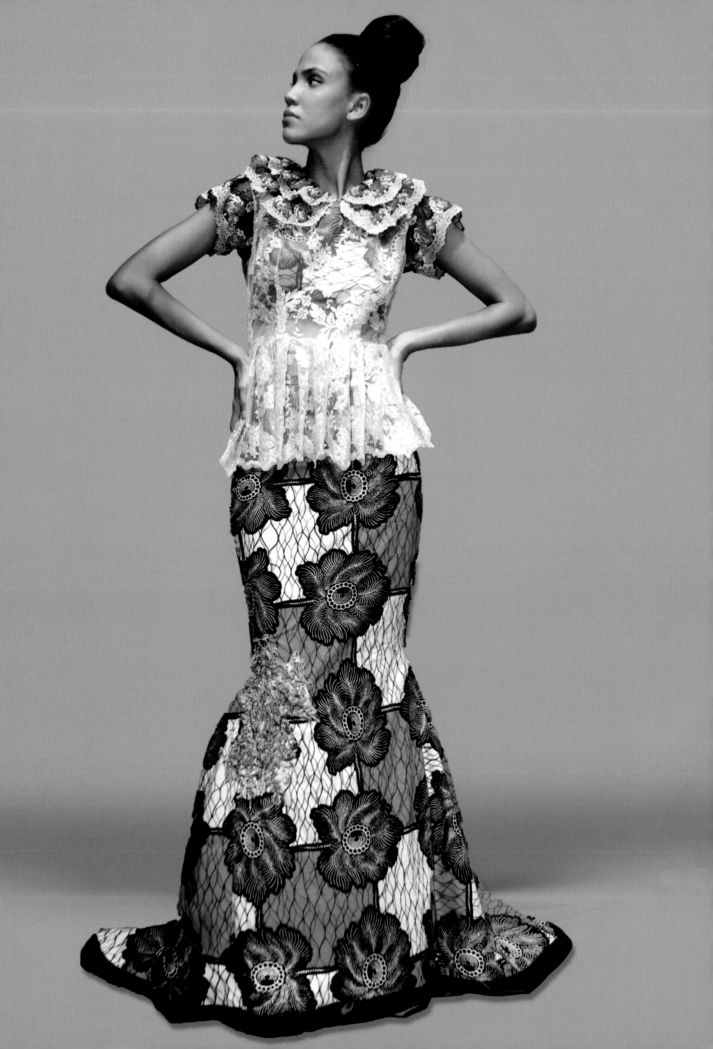

LANRE
DA SILVA AJAYI

FACT FILE

LOCATED LAGOS, NIGERIA

WEBSITE WWW.LANREDASILVAAJAYI.COM

FOUNDED 2005

Lanre Da Silva Ajayi's eponymous design label LDA, founded in Nigeria in 2005 showcases signature, iconic 1940's-style couture. LDA has evolved into a modern, cutting-edge brand, a full-blown fashion house, media darling and favourite of fashion-loving celebrities.

< *From the SS2013 collection Gallery of Poems*
> *Illustration, Lanre Da Silva Ajayi* (BY LISA STANNARD)

The LDA brand has created couture collections as well as prêt-a-porter and elegant accessories collections featuring hairpieces and statement jewellery. The label creatively combines pattern, print and exquisite traditional fabrics to produce timeless daywear, eveningwear, gowns and cocktail dresses. For Lanre the LDA woman is the personification of sophistication, femininity, brilliance and boldness. As she states "Couture, colour and boldness with an edgy twist are the signature of my designs".

In January 2012, Roberto Cavalli renowned designer and Franca Sozzani Editor-In-Chief of Vogue Italia and Goodwill Ambassador of Fashion 4 Development went to Lagos, Nigeria as part of an humanitarian visit and Sozanni and the Vogue Italia team took the time to go to LDA's flagship boutique to view her collections. They were so pleased the visit resulted in LDA showcasing a capsule collection during the Mercedes Benz New York Fashion Week Fall 2012/13 with "Fashion 4 Development" an initiative supporting the United Nations Millennium Development Goals and the unprecedented global effort "Every Woman Every Child ".

Since then the label has achieved an extraordianry level of global success and exposure particularly in the United KIngdom and in Italy. The brand was featured in the L'Uomo Vogue, May-June 2012- "Rebranding Africa" issue dedicated to showing how the continent is developing a modern identity, one not confined to

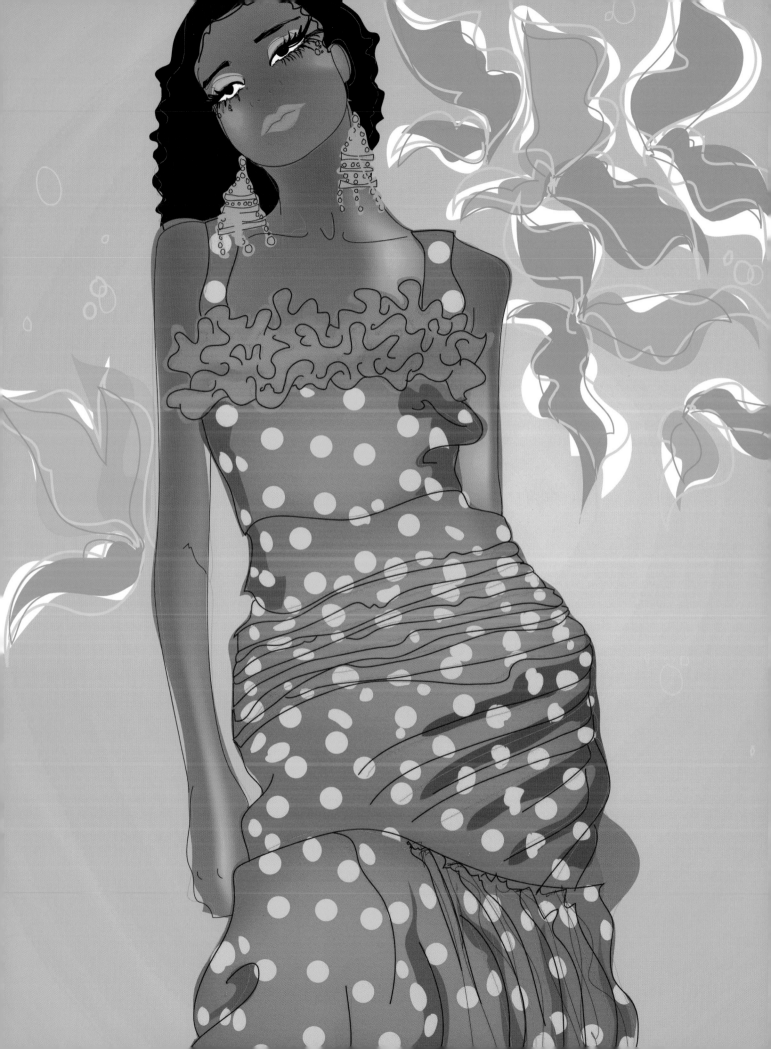

poverty and illness. LDA, according to L'Uomo Vogue are "the evidence that Africa is developing and progressing

How do you think fashion made in Africa is regarded internationally? In the last year other parts of the world are just beginning to catch up with what we have in Africa; it's like we just became the new buzz and fashion has realised that we have been relegated to the background far too long. We are not getting the attention we deserve at the moment but I know we will catch up very soon. We will give our counterparts a run for talent and creativity but as you have mentioned we do have a lot of homework to do. We have to overcome our financial,

economic and infrastructure issues to be able to compete on the world stage.

What do you see as the pros & cons of producing/sourcing in Africa? One of the pros of producing/sourcing in Africa is that the continent has a lot of untapped and hidden resources other parts of the world are unaware of. However, as an African designer I am beginning to enjoy the attention the rest of the world is giving to African fashion. The world is beginning to take notice that Africans are blessed with a lot of talented hard working young minds, hungry for fashion. There are however a few cons:
a) Fashion needs to be taken seriously as a viable sector in the economy as it is in the UK, US, Europe and Asia. We need investors and more government initiatives.
b) Production relies heavy on the stability of power to function properly and that is one of the challenges I am facing producing from Nigeria. If power can be stabilised then our overhead costs will be reduced.
c) There was an importation ban on fabrics in Nigeria. Though the government has lifted the ban, we still face the same issues bringing in materials for production.
d) The lack of established high machinery factories in Nigeria is a major issue we designers face. More factories with all the machinery needed to produce pieces with exceptionally high quality and finishing would cut down on our current labour costs.
e) Proper training of local tailors. It is very expensive for us to train our tailors since we basically fund the business ourselves.
f) Retail is slow and returns are low as we are producing clothes for a very small market.

Do you use any traditional African craft techniques in your design process? Definitely! Most part of the finishing of each piece is done by hand.

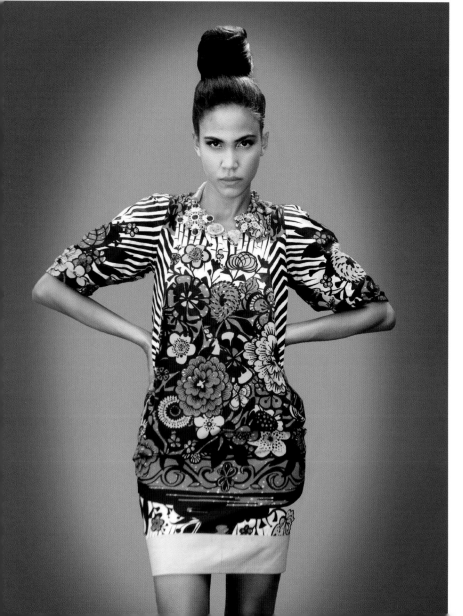

❮ From the Cruise collection ❯ From the Cruise collection made with Vlisco wax specially tagged 'Gallery of Poems' in 2011

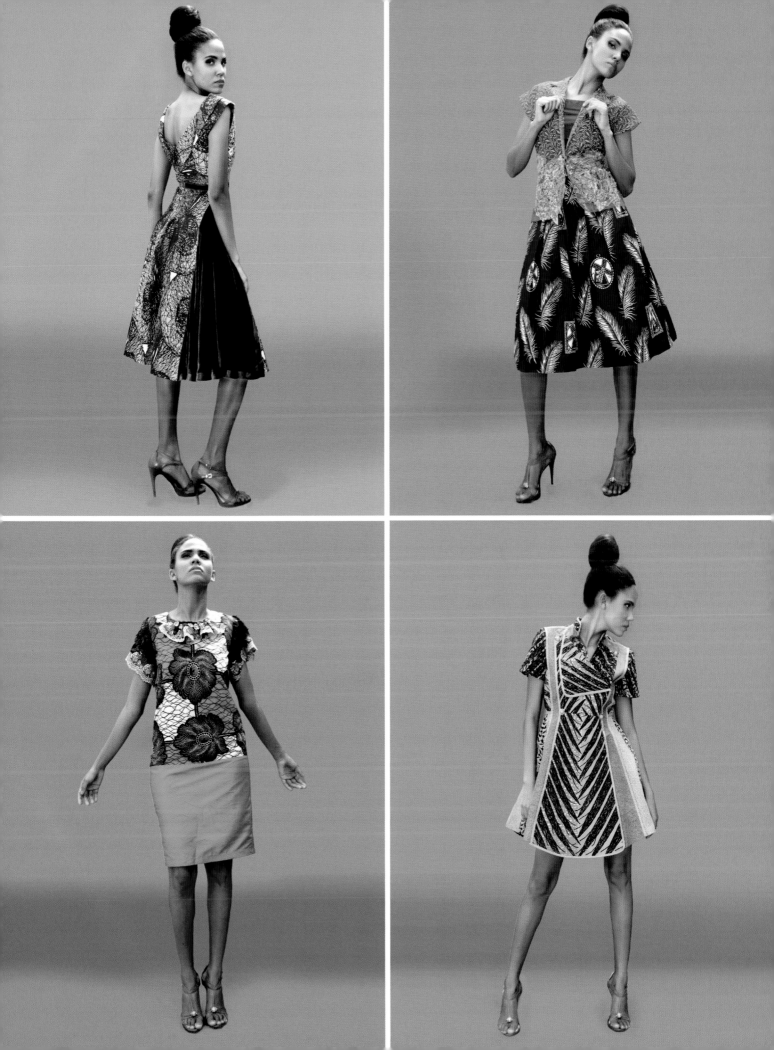

'Couture, colour and
boldness with an edgy
twist are the signature
of my designs'

In which countries do you source and produce? I source my fabrics and other accessories from different parts of the world - Africa, Europe, Asia and produce in Nigeria.

How does Africa relate to your company brand and why Africa? There is a very strong influence of the signature English 1940s couture in my designs however I always try to merge this with my African roots in any piece I create. Like any established fashion designer in the world, I forecast trends based on history and seasons in fashion. My designs evolve continuously as it is important to keep things fresh and interesting all the time.
My brand aesthetic is focused around my clientele who are mainly African women so I always keep in mind their body type, how a confident African woman wants to dress and be seen in today's ever-changing world. But my designs are not limited just to Nigerian woman as I make clothes for any sophisticated, feminine bold and brilliant woman across the world.
My fascination with the Victorian era/silhouette is simple; women back then were particular about their look and took care and time to achieve it, showing their curves in a lady-like manner without coming across as vulgar. Women dressed like they were queens and confidently showed great taste in style

What inspires you? There is a certain amount of 1940's that comes with my style. I have been particularly inspired by the fantasies of images and emotions of fashion that are sculpted from the things in our daily lives. I have been creatively inspired by history, art, cities I have visited and wished to visit and my daily experiences.

Is Africa the future? Africa is fast becoming the new hub for fashion and other parts of the world are now beginning to catch up with what we have in Africa; it's like we just became the new buzz.

❯ *From the collection Gallery of Poems*

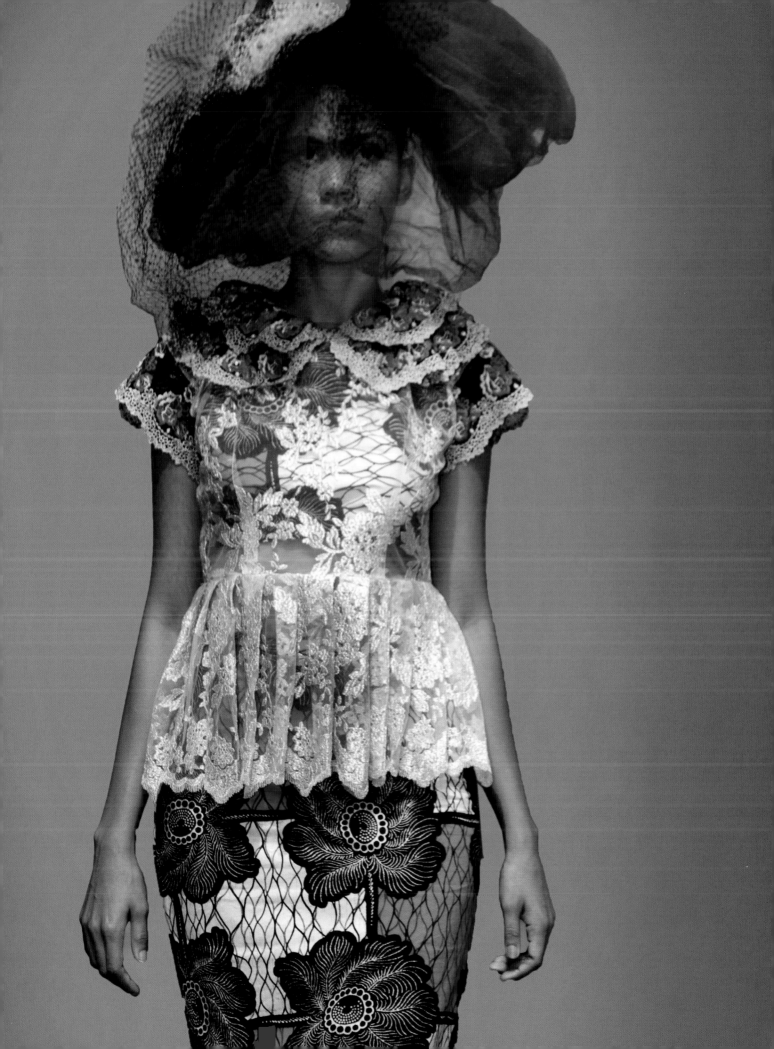

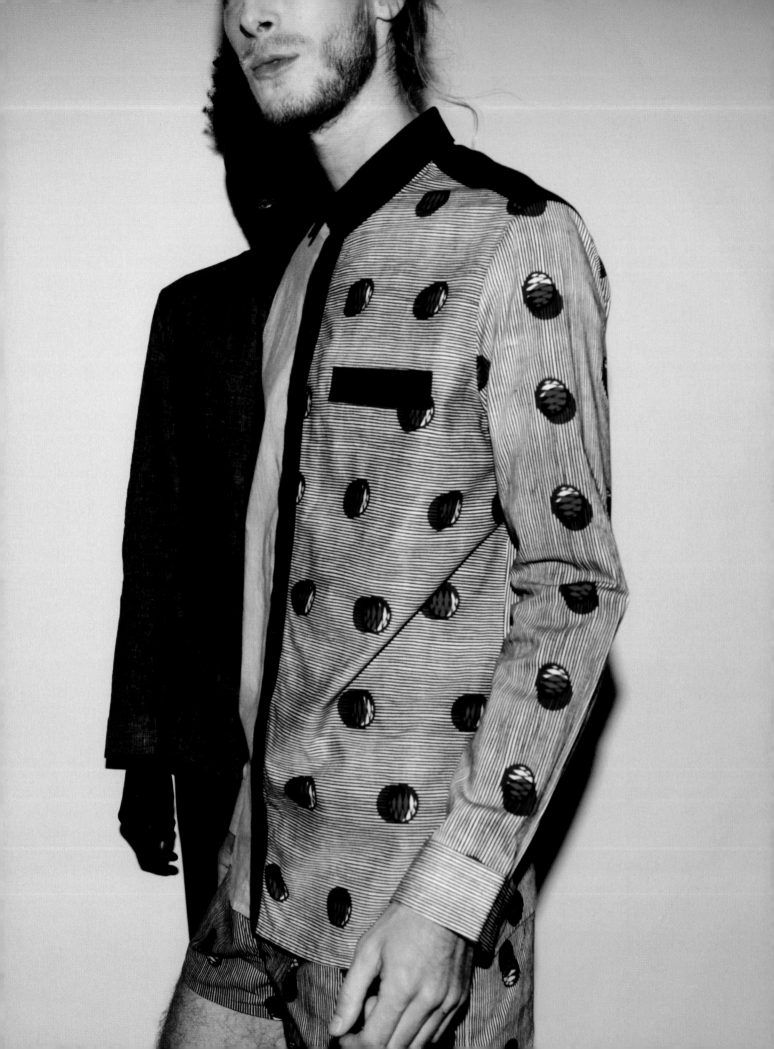

LAURENCE
AIRLINE

FACT FILE
LOCATED ABIDJAN, IVORY COAST (WORKSHOP), PARIS, FRANCE
WEBSITE WWW.LAURENCEAIRLINE.COM
FOUNDED 2010 BY LAURENCE CHAUVIN-BUTHAUD

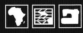

LaurenceAirline was founded in 2010 by Ivorian, Laurence Chauvin-Buthaud. The luxury brand celebrates the richness of African culture via its contemporary minimalist aesthetic of silhouettes and bold patterns, and it stands at the forefront of sustainable and ethical fashion.

LaurenceAirline is somewhat of an unconventional name for a label. However having spent much of her time on planes, travelling avidly in the name of fashion, perhaps designer Laurence Chauvin-Buthaud was inspired to give a sense of destination to her brand. Paris-based but originally from the Ivory Coast, where the collections are manufactured in strict accordance with ethical practices engaging local African communities, Laurence started off as a Womenswear designer, only to find that Menswear would be her calling and lead her to her success. Influenced by the soul of Africa and its visual footprint, Laurence Airline is a modern interpretation of the continent's rich cultural and aesthetic ingredients.

❮ Collection AW12/13 (PHOTOGRAPHER, ILLARIA ORSINI; MODELS, EMMANUEL MARTIN, BABACAR YOUM) ❯ Collection AW12/13 (PHOTOGRAPHER, ILLARIA ORSINI; MODEL, BABACAR YOUM)

What are your principles? Boldly creative, yet wearable, menswear that re-imagines the African continent's cultural inheritance in a way that is distinctly modern and international. With LaurenceAirline as an international label, I want to tell a story of West Africa meeting other continents through the fashion medium. We're building Africa's modern reality for the international fashion scene in terms of high quality production and bold contemporary design made in Africa.

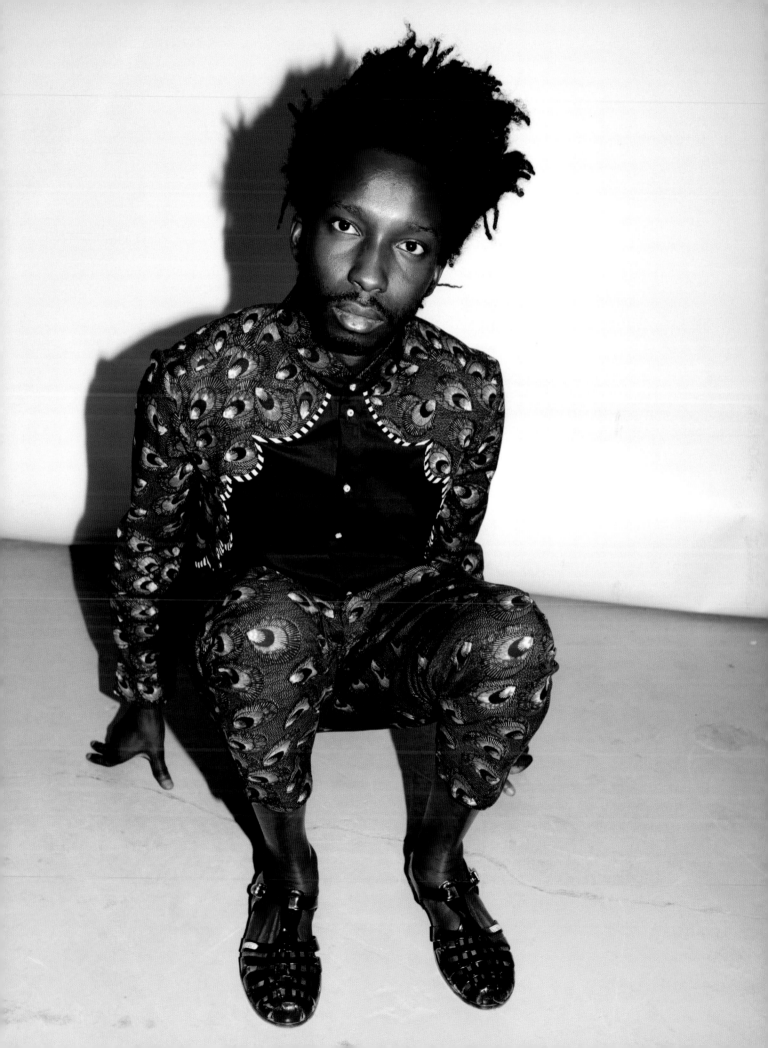

'Valuing bold aesthetics and sustainable development, the label merges creativity coming from Africa with the sophisticated standards of modern society'

It's important for Ivorians to be proud of their achievements in the fashion industry and in turn this will help to elevate their personal self-esteem.

Which countries do you source and produce in? The fabrics used in my collections are sourced both in Europe and directly in Africa. Fabrics bought in Abidjan are produced in Togo, Ivory Coast. I produce in Africa.

What do you see as the pros and cons of producing/sourcing in Africa? Producing the collections in my own workshop in Abidjan was a natural choice. To me, the main goal of LaurenceAirline is to build Africa's modern position in the international fashion scene in terms of high quality production and creative design. Producing high quality garments in Ivory Coast means that local people can be trained and learn from work exchanges in a positive and conscious process.

How do you think fashion made in Africa is regarded internationally? Lately there are many talented African designers who are emerging. I think that what is interesting is to avoid the traditional 'tribal' clichés often associated with African inspired fashion, in order to instead, re-imagine the continent's cultural inheritance in a way that is distinctly modern and international.

Where do you go to and what do you look at for inspiration? My ideas are nourished by the world that surrounds me. Art, music, encounters with amazing people. I consider myself an information catalyser connecting and transcribing these experiences into my creative work. My aesthetic reflects my everyday and inner lives. My African heritage and itinerant lifestyle are infinite sources of inspiration.

How does Africa relate to your company brand and why Africa? Although raised in Europe, I was born in Africa and my father still lives there. It was a natural choice to settle the workshop in my hometown. Communication, PR and sales happen in Paris. The workshop where the collections are designed and produced is in Abidjan, where the main inspirations come from African patterns and fabrics directly sourced in Africa. The collections obviously reflect new African identity. LaurenceAirline is deeply rooted in Africa but also references and reflects other cultures each season in the collections.

What is your ethical standpoint? The entire line is made in accordance with conscious and sustainable manufacturing practices in LaurenceAirline's workshop in Ivory Coast, where local people are trained to produce high quality garments following international standard. Valuing bold aesthetics and sustainable development, the label merges creativity coming from Africa with the sophisticated standards of the modern society and way of life. In that frame, and sold worldwide LaurenceAirline's collections help build Africa's modern reality into the international fashion scene.

❯ TOP LEFT *Collection SS13* (PHOTOGRAPHER, BRETT RUBIN; MODEL, DAVID AVWUNUVWERHI) ❯ TOP RIGHT *Collection AW12/13* (PHOTOGRAPHER, BERTRAND LEPLUARD, MODEL, JEAN-SEBASTIEN POUGNANT) ❯ BOTTOM LEFT *Collection SS13* (PHOTOGRAPHER, BRETT RUBIN; MODEL, CHIPO MAPONDERA) ❯ BOTTOM RIGHT *Collection SS13* (PHOTOGRAPHER, PHILIPPE GALOWICH; MODEL, JEAN SEBASTIEN POUGNANT)

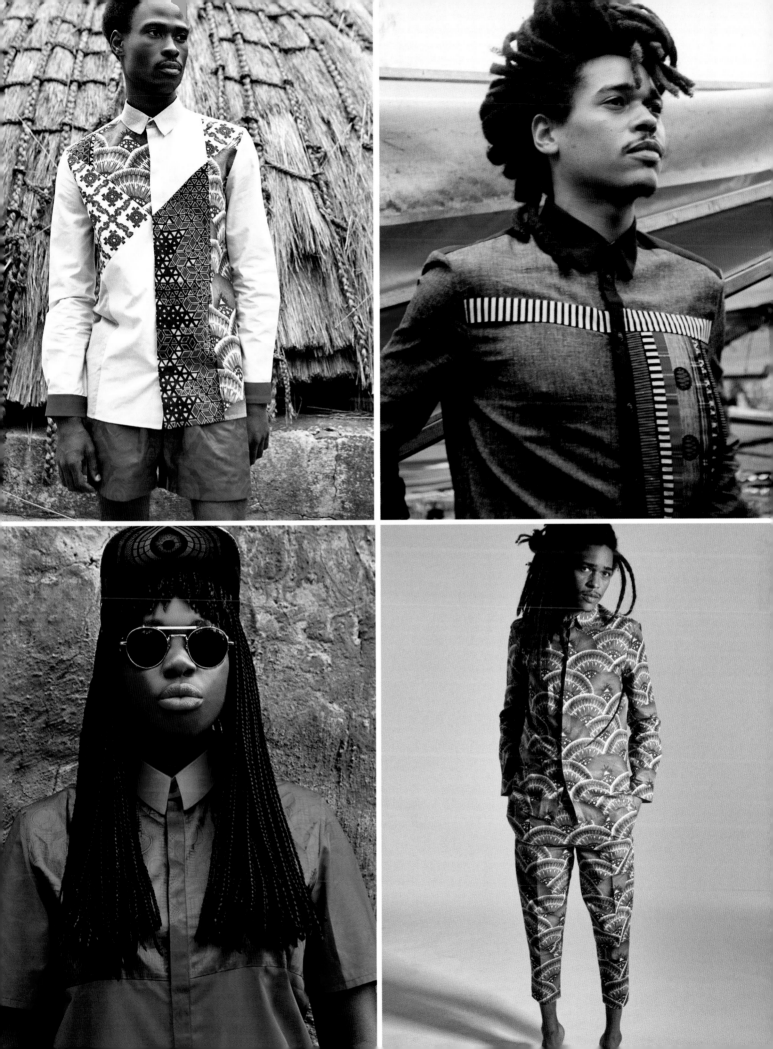

> *Collection AW12/13 (photographer, Illaria Orsini;*
> *Models, Emmanuel Martin, Babacar Youm*

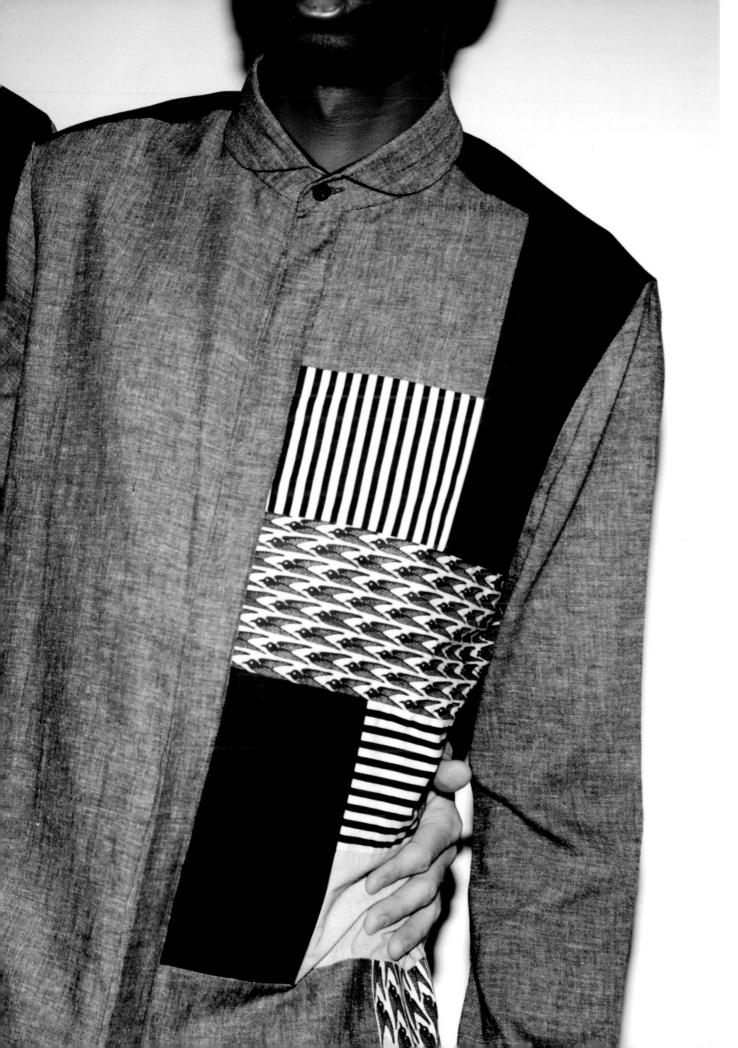

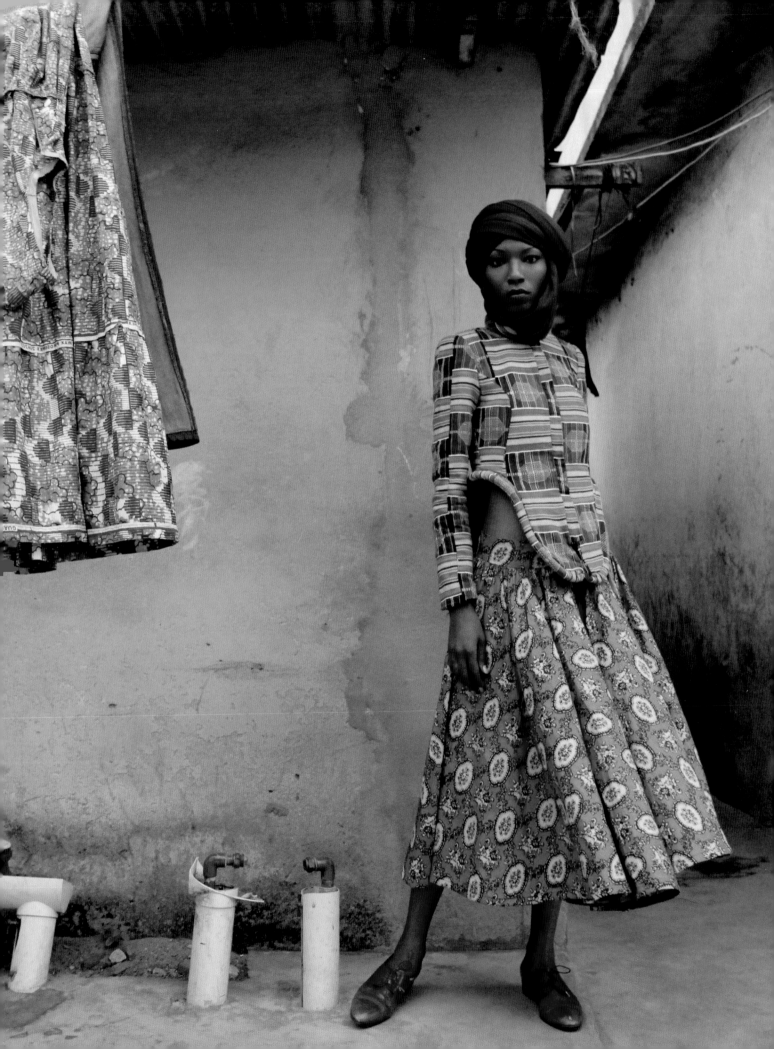

LOZA
MALÉOMBHO

FACT FILE
LOCATED ABIDJAN, COTE D'IVOIRE
WEBSITE WWW.LOZAMALEOMBHO.COM
FOUNDED 2009

ATELIER Loza Maléombho is an African womenswear brand founded in New York in 2009 with a vision to redefine African made clothing in the eyes of the world and ameliorate the social and economic conditions of women in Côte d'Ivoire.

Loza Maléombho was born in Brazil, and raised in Côte d'Ivoire, but she is now based in New York. With a truly global perspective she currently produces her collections in Abidjan, the current economic and former official capital of the Ivory Coast. Inspired by the Akan tribes of Ghana and the local Baoule tribe in Côte d'Ivoire she creates collections which utilize the hand-woven regional cloths which allows for unique sculptural volume and a rich palette of authentic hues and bold pattern combinations.

What do you see as the pros and cons of sourcing/producing in Africa? One main positive is that the raw material we need is available on site. Also we have a direct connection with the artisans (weavers, dye, craft etc) we use which allows for full creativity. We also have control over process, quality and product rotation. Unfortunately, many Artisans aren't industrialized which makes it a challenge to produce in large quantity. Given the size and ancient history of the continent there are often cultural challenges increasing the need to understand the local people. There is a constant need for supervision of employees in order to to be able to maintain quality. The high costs of transportation and custom costs to imports are a challenge and finally, there can be some high political risks.

‹ ›*AW12 collection*

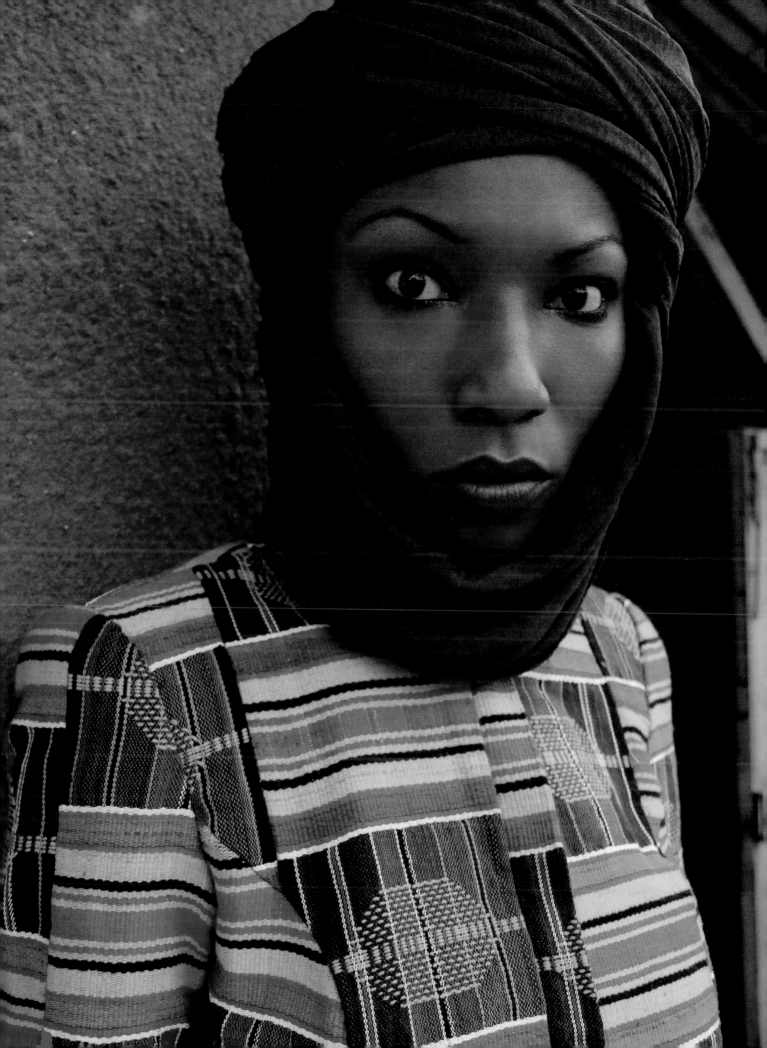

'There are new fashion labels almost daily and social networks finally provide a chance for exposure on the international level'

What inspires you? I don't wait around for inspiration. I absorb everything. I am obsessed with common towns, markets, villages, because that's where you find life. Humble places always deliver life, shapes, color, moments. There, you can't help but to witness that magic of possessing little to create your means. And that magic is the inspiration behind the brand.

❮ ❯ *AW12 collection*

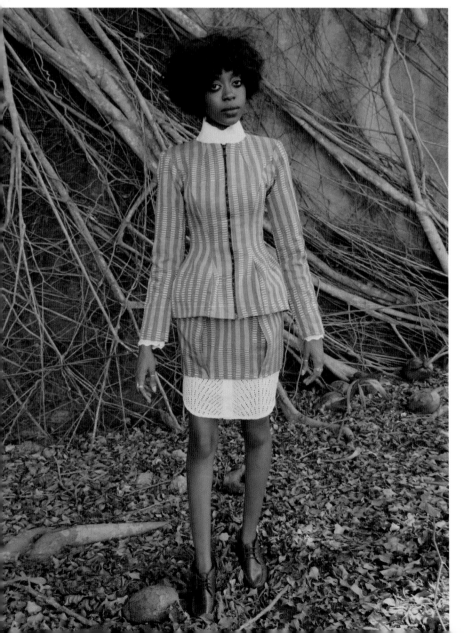

How does Africa relate to your company/brand and why Africa? Africa relates to the brand through what I mentioned earlier: this idea of "having little to create your means." In Africa necessity is still very much the mother of invention and it is in this that the truly, highly, naturally creative essence of the continent is revealed.

Do you use any traditional African craft techniques in your design process? I use Kente cloth from Ghana and Bazin from Mali. I also use tie-dye techniques. I often look for traditions that are now mastered because the practice has existed for years and brainstorm ways to redefine how they can be commonly used. I also use traditions in new innovative garment concepts; the Kente jacket for instance is the brand's signature, or the AKAN ring (Mask gold ring).

Do you work with any programmes or production workshops in Africa? I work with a Nun's center focused on training young girls in tailoring. They offer a three year program to girls who have unfavorable backgrounds. In the past, these girls would have trouble finding a job after graduating from the program and ended up back in the streets. Our plan is to recruit these girls once they graduate and provide them with a steady income.

Which African designers do you admire? I admire what Laurence Buthaud Chauvin is doing with LAURENCEAIRLINE in menswear. I am also fond of the work of Maki OH

Is Africa the future? It definitely looks like it is. A lot is happening in the textile industries: There are new fashion labels almost everyday and social networks finally provide a chance for exposure on the international level. What we need as African designers are official seasonal trade shows that will provide the opportunity to sell our product to international buyers.

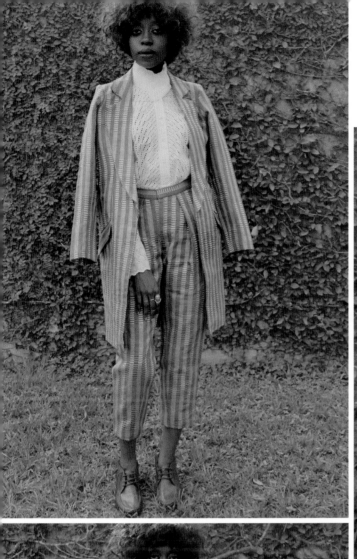

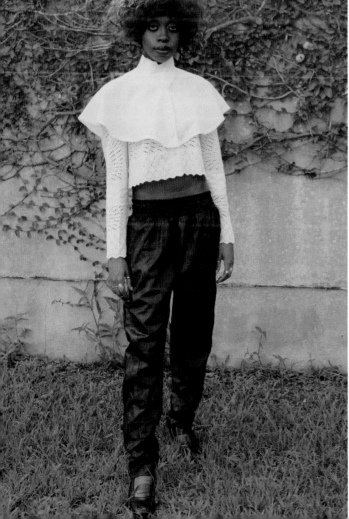

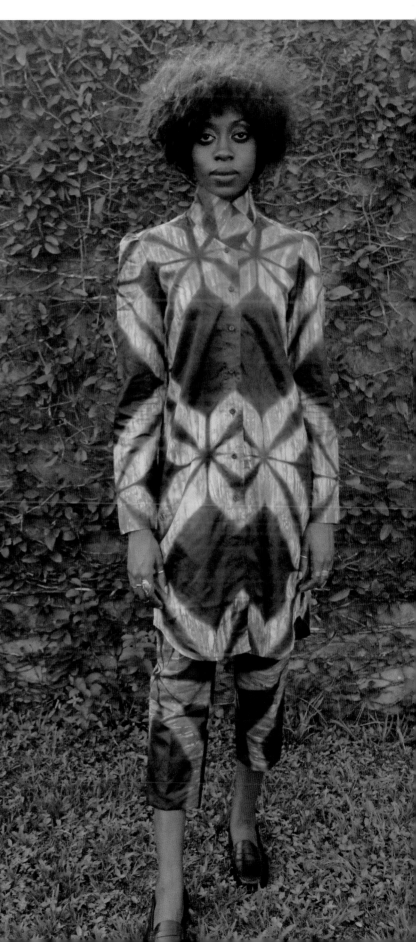

MADE

FACT FILE
LOCATED LONDON, UK
WEBSITE WWW.MADE.UK.COM
FOUNDED 2004

MADE was founded in 2004 by Italian designer Cristina Cisilino, borne out of her overall disillusionment with the excess consumerism driving the fashion industry and from a growing love and fascination with Africa, it's people and it's ancient craft traditions.

Italian by birth, Cristina Cisilino moved to the UK to study Buying & Merchandising at the London School of Fashion. After a long and very successful career sourcing clothing in Italy for Harrods and Harvey Nichols she moved over to sourcing leather shoes and accessories for major leading department stores in the UK. Around 2004 Cristina started to become very disillusioned with the fashion industry, the rise of disposable fashion and the mass move of the clothing market to China.

During various trips to Africa Cristina fell in love with the people and saw the potential in the craftsmanship of jewellery being made in the slums of Kibera in Nairobi. It was clear to her that the workmanship of the products made for tourists could easily be transferred into ideas for jewellery and could be marketed on the UK high street. This would give the artisans a whole new retail outlet with a regular income. MADE started as a small collection of jewellery and the company now boasts it's own beautiful workshop with eighty full time workers producing stunning collections and collaborations for Whistles, Topshop, John Lewis, ASOS and high profile collaborations include Louis Vuitton, Alexa Chung, Laura Bailey, Livia Firth, Pippa Small and Natalie Dissel.

❬ *Illustration, Made Jewellery* (BY ABBY WRIGHT) ❬ *Production manager Nicholas Origi* ❭ *Illustration, Made Jewellery* (BY DANIELE RACHICHINI)

'Africa is where Made was started and where our workshop is. Africa is and always will be at the heart of our business'

Made jewellery, model Laura Bailey ❯*Made jewellery (PHOTOGRAPHER, ADRIEN CRASNAULT)*

Which countries do you source and produce in? East Africa – Kenya

What do you see as the pros & cons of producing/sourcing in Africa? The main benefit for MADE derives from the fact that Africa and Kenya in particular is a developing market which means there are less constraints. As Africa is still an emerging market in the fashion industry, we find that suppliers are very keen to do business and show a high level of enthusiasm and willingness to do so. Made is setting a precedent in terms of showing that, not only can a fashion business be set up in Africa and be extremely successful but it can also be run entirely to ethical and fair-trade standards.

In addition there are many unusual and distinctive materials such as recycled brass, bone (which is a by-product of the food industry) and recycled glass from discarded soda bottles etc., that are uniquely African. The biggest positive in Africa is seeing the difference Made is making. People in Nairobi have a chance to work themselves out of poverty, learn new skills and be a part of an inspirational and sustainable company.

The negatives are the standard gripes that surface when dealing within emerging markets. In order for our business to grow and strengthen we have had to establish structures in many different areas which takes time, money and patience.

Logistically there are still some issues with sourcing materials in accordance with our tight production schedules – a significant majority of the material we use is locally sourced and the suppliers themselves are reliant on external sources beyond their control which will affect availability. We have already seen a significant increase in the level of professionalism and adherence to initial production dates by external suppliers and we find that the more business we provide to them the more money they in turn have to invest into increasing and growing their own supply lines.

How do you think fashion made in Africa is regarded internationally? In theory it shouldn't matter where a product is made – it is the quality and design of the product which is most important to the consumer. If a product is poorly made and has poor design then regardless of its origin the fashion company will struggle to compete at the top level as its product is not appealing to the consumer. However in practice, Africa is most

certainly not considered a major player in the fashion market. There is a stigma concerning African made jewellery and accessories, people seeing it as being of "ethnic design" and not appealing to the high street western markets. With the rise of successful campaigns by ourselves and the ASOS Africa collection along with major fashion brands such as LVMH investing in ethically aware brands such as EDUN, the fashion industry is starting to appreciate fashion made in Africa. Equally brands that manufacture in Africa are beginning to be considered as serious competitors both financially and product wise in terms of their versatility and level of expertise.

What inspires you? For MADE's core collection inspiration is drawn from a mixture of current trends combined with traditional African techniques which are married together and developed by our fantastic in-house development team in our Nairobi workshop. We look at catwalk and high street trends to inspire our seasonal collections and we are always looking to incorporate new materials and designs where possible. MADE have also worked on a variety of collaborations each bringing with them new styles, techniques and certainly new inspiration from around the world. We have worked with well known designers such as Laura Bailey and Hattie Rickards to produce truly successful high street collaborations and an upcoming collection by award winning designer Imogen Bellfield is sure to follow in this mould.

How does Africa relate to your company brand and why Africa? Nairobi, Kenya in Africa is where Made was started and where our workshop is. Africa is and always will be at the heart of our business.

Do you use any traditional African craft techniques in your design process? We use many many traditional techniques such as traditional East African bone craft, Skilled metal work and Maasai bead work. All our jewellery and leather production is heavily influenced by traditional craft techniques.

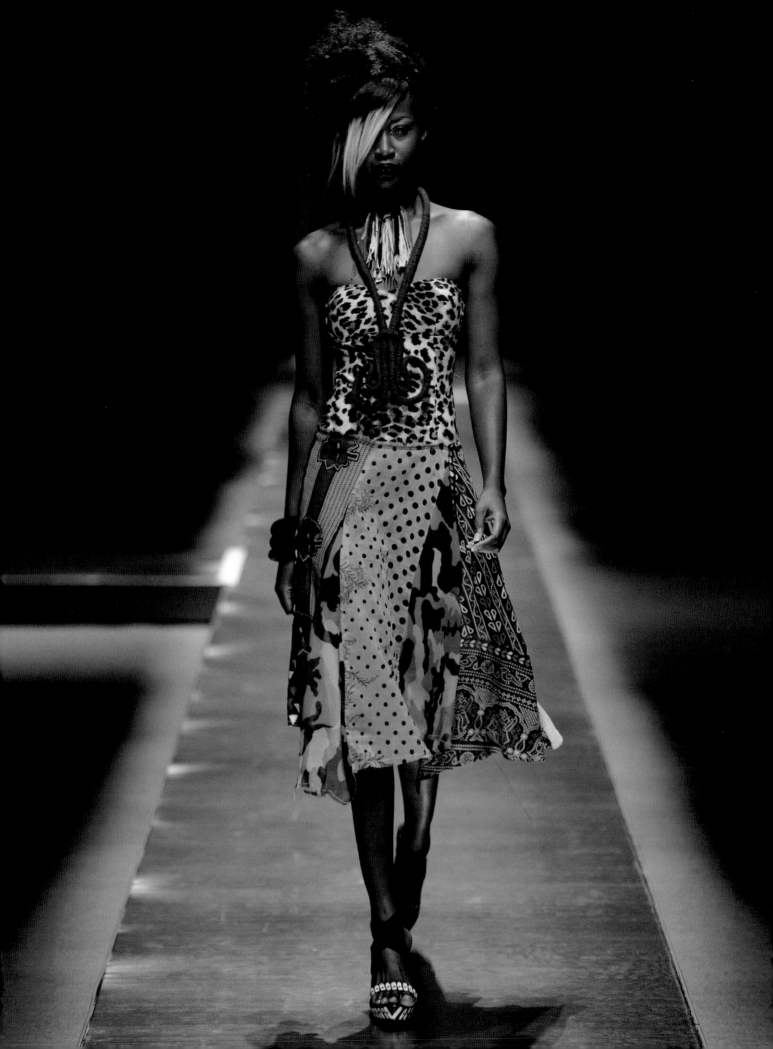

MARIANNE FASSLER

FACT FILE

LOCATED SAXONWOLD, JOHANNESBURG

WEBSITE WWW.MARIANNEFASSLER.CO.ZA

FOUNDED 1992

Marianne Fassler has spent two decades in the fashion business operating from Leopard Frock, her creative workshop in Saxonwold, Johannesburg. Her superbly crafted work appeals to women who cherish individuality, craftsmanship and diversity in their wardrobe.

Marianne Fassler could not imagine herself working anywhere else in the world but South Africa. Surrounded by loyal, highly skilled crafts people and technicians the collections are designed and manufactured in an atmosphere of complete creative freedom. She is of course affected by the local and global economic climate but not materially as we sadly know that the rich are getting richer while the poor are getting poorer. All one needs to look at is the rise in sales and orders experienced by the luxury designer labels.

Where do you go to and what do you look at for inspiration? I try to plug into contemporary African art and music and follow the urban subcultures as well as the ancient tribal remnants that still exist even in a sophisticated city like Jo'burg. I can take you on a tour of downtown Jo'burg that will make you understand what it means to live and work in this city. It is amazing! I also travel regularly and widely to experience other cultures. I travel to other African countries but also to Europe, India, Asia, Mexico, the US. I am always in search of truth and authenticity as well as art and craft.

❮ ❯ *AFI Fashion WEEK*
Spring/Summer 2010

How does Africa relate to your company brand and why Africa? Africa is me, Africa supports me, Africa inspires me. I am an African.

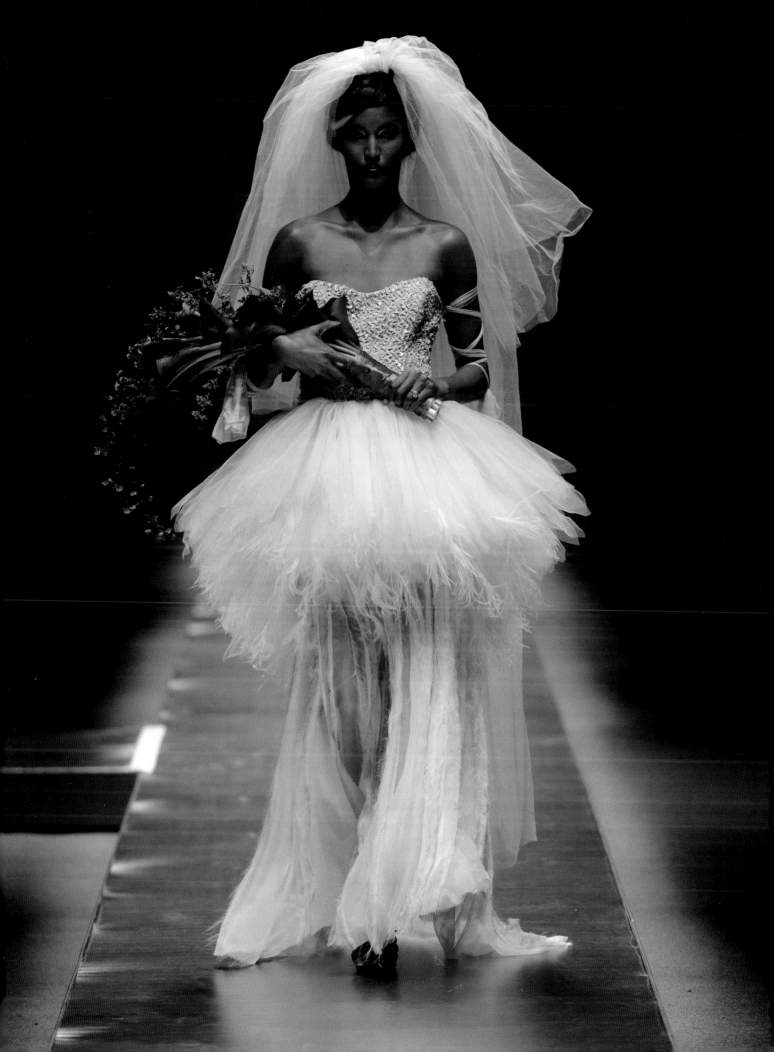

'I don't need to supply to the world. I have made the conscious decision to do what I do best...to work in a creative environment and supply a very loyal and ever migrating clientele'

What is your ethical standpoint? I live in Africa and to do so one has to live with grace. I treasure my team, my environment and my infrastructure. I have worked hard at making traditional African prints, especially the Southern African *Shweshwe* fabric, fashionable and desirable. I did not want that tradition to disappear and know that I have been responsible for more colour being introduced into the prints and want the fashion world to sit up and take note. Many South African designers now use the fabric in many fabulous ways and even young fashionistas think it is cool. There are some articles and academic papers being written about the fabric. The opening up of South African society to the rest of Africa has also brought the fabulous colourful fabrics from Ghana and Nigeria and Kenya. Many people forget how cut off trade and society was before 1994.

Which African designers do you admire? There are so many but sadly many of them lead their creative lives outside of Africa. But when I think of African designers I think of Xuly Bet and Deola Sagoe,

Is Africa the future? I would love to think it is but I don't know exactly where fashion fits into the bigger picture. Africa is a very large continent and in many countries people don't wear modern European clothes.

Africa will continue to inspire the jaded western world with its amazing creativity and integrity of design. It also leads the way with recycling because there is so little that gets discarded on a continent where many people literally live from hand to mouth, living off the soil.

Which countries do you source and produce in? We are absolutely committed to manufacture only in South Africa and we source many of our fabrics locally. We are known for our use of African prints and fabrics but we also use Indian fabrics and we source fabrics on my travels abroad. Many of our fabrics are 'created' by using dye techniques and recycling.

What do you see as the pros & cons of producing/sourcing in Africa? Africa is my muse. I live and work in Africa and want to produce quality contemporary fashion that reflects my environment and day to day experiences in this country. I am well aware that fashion, in its purest and most original form, is created on the street and shaped by politics and current affairs.
South Africa is a melting pot of cultures and diversity and as such provides for a never-ending creative dialogue.

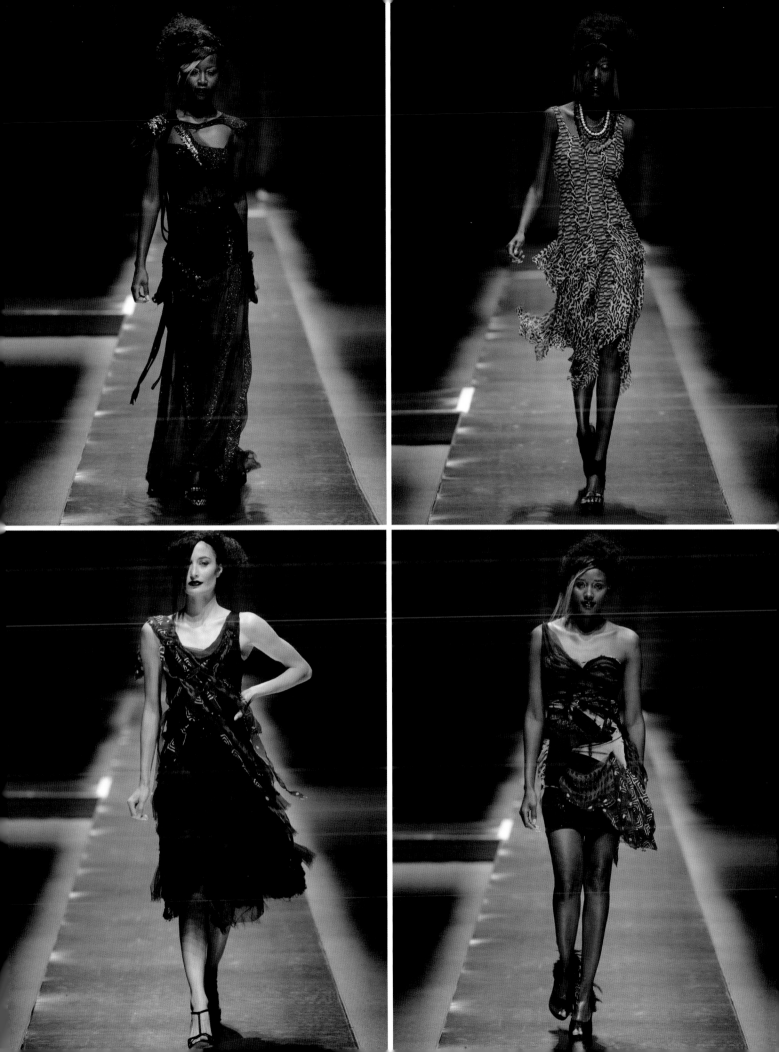

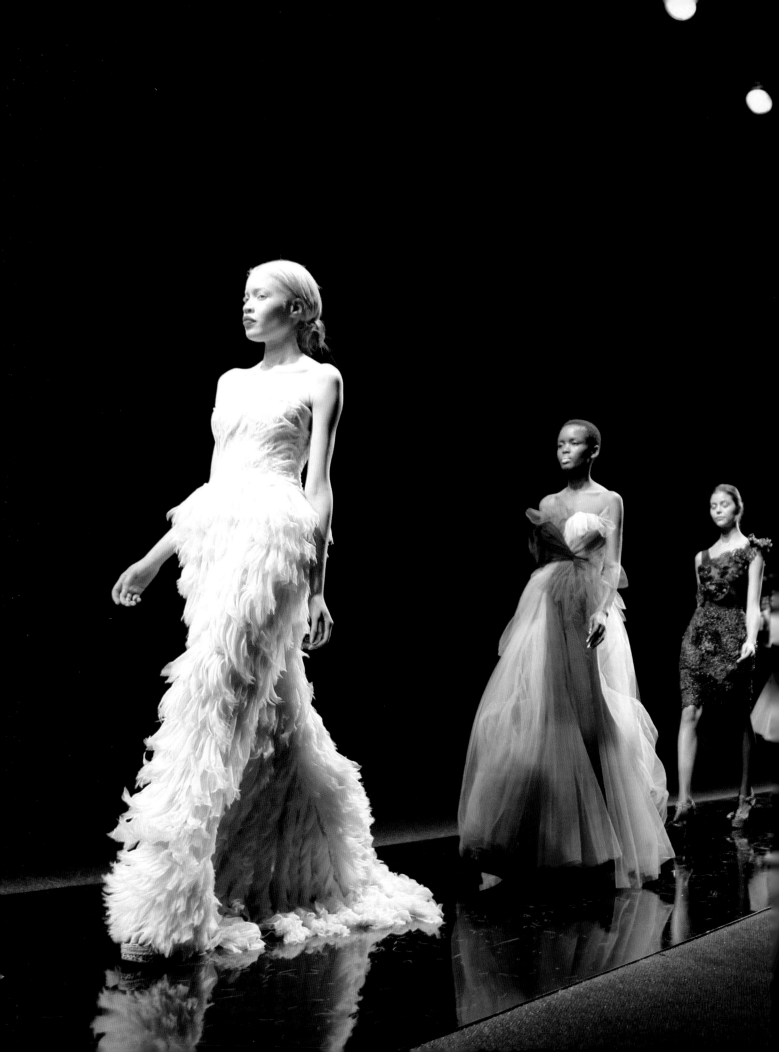

How do you think fashion made in Africa is regarded as internationally?
I don't know how fashion made in Africa is regarded internationally but I can imagine that it suffers from the stereotypically negative perception out there. I do know that South Africa used to have a very sophisticated clothing manufacturing sector which exported and produced goods of very high quality. Then came sanctions in the 80's and by the time liberation came and the world started wanting to do business, the world had changed. The American, Italian and French manufacturing sector was severely impacted by the rise of the Asian Tigers and all the game plans had changed. These days we have a smaller but very productive manufacturing sector but I don't know how much is actually exported to the rest of the world because we cannot be competitive and ethical at the same time.

❬ *Mercedes BENZ FASHION WEEK 2012*
'Fassler The Remix' Spring/Summer 2012

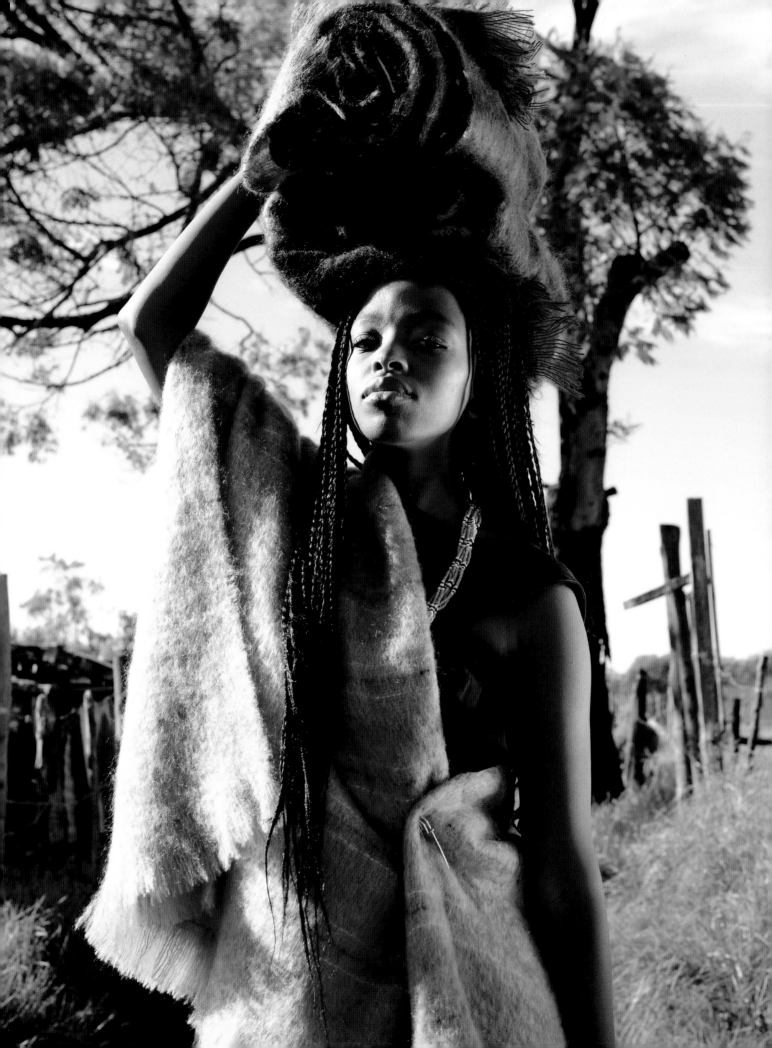

MAXHOSA

FACT FILE
LOCATED PORT ELIZABETH, SOUTH AFRICA
WEBSITE WWW.MAXHOSA.CO.ZA
FOUNDED MARCH 2011

MaxHosa by Laduma was founded in 2010 to help preserve and celebrate traditional Xhosa aesthetics within a vibrant and dynamic ready-to-wear knitwear collection, created in premier South African mohair and merino wool from Port Elizabeth and Cape Town.

❮ From a collaboration with Hinterveld (www.hinterveld.com), the co-brand name of the collection is MaXhosa by HinterveldaxHosa ❯ 2013 Men's Autumn Winter collection (PHOTOGRAPHER, SIMON DEINER, SDR PHOTO)

MaxHosa a distinctive knitwear brand is rooted in Laduma Ngxokolo's journey creating modern Xhosa-inspired knitwear. Using traditional Xhosa beadwork motifs and patterns as inspiration, Laduma states his mission "was to create a modern Xhosa-inspired knitwear collection suitable for amakrwala (Xhosa initiates), who are prescribed by tradition to dress up in new dignified formal clothing for six months after initiation". As a person who has undergone that process, Laduma felt that he had to develop knitwear that genuinely and authentically depicted his cultural aesthetics. Along his journey Laduma delved into exploring the astonishing traditional Xhosa beadwork crafts, cultural patterns, symbolism and colours. "They were the best inspiration for my knitwear, which I then incorporated into the modern knitwear."

What do you see as the pros and cons of producing/sourcing in Africa? The positives are that we are creating jobs locally while preserving our heritage and I get to control the product Intellectual Property. Unfortunately, the lack of support from our local government for emerging designers is disheartening at times.

'Through our design aesthetic, we always try to tell the story of our brand in a way that embraces Africa'

What inspires you? I read anthropology books, and visit art museums that have relevant information about the inspiration that I'm hunting. I also reference traditional finds and fuse them with the modern.

How does Africa relate to your company brand and why Africa? Through our design aesthetic, we always try to tell the story of our brand in a way that embraces Africa. We focus on Africa because our roots and origins are from the continent and the culture we celebrate relates to all the other cultures scattered throughout the continent.

Do you use any traditional African craft techniques in your design process? We have just started using traditional Xhosa button decoration techniques on our 2013 A/W knitwear collection, using the small shell buttons.

Does your company work with any cotton programs in Africa and or any production workshops/organisations in Africa? We work with Mohair South Africa and the Mohair Empowerment Trust, an organisation specifically supporting black mohair farmers.

What is your ethical standpoint? Ethically we stand for fair trade principles, for supporting the local people. We stand for the protection of the environment, use organic and sustainable materials and we want to see a healthy "for-profit" economy.

Which African designers do you admire? Nkensani Nkosi, Zano Sithetho and Marianne Fassler.

Is Africa the future? I think African fashion and textile is picking up slowly but it will be highly influential in the end.

❮ MaXhosa by HinterveldaxHosa (ASTRID ARNDT PHOTOGRAPHY) ❯ TOP *AW2012* (ROSS ADAMI PHOTOGRAPHY) ❯ **BOTTOM LEFT** *AW2013* (PHOTOGRAPHER SIMON DEINER, SDR PHOTO) ❯ **BOTTOM RIGHT** *AW2012* (PHOTOGRAPHER SIMON DEINER, SDR PHOTO)

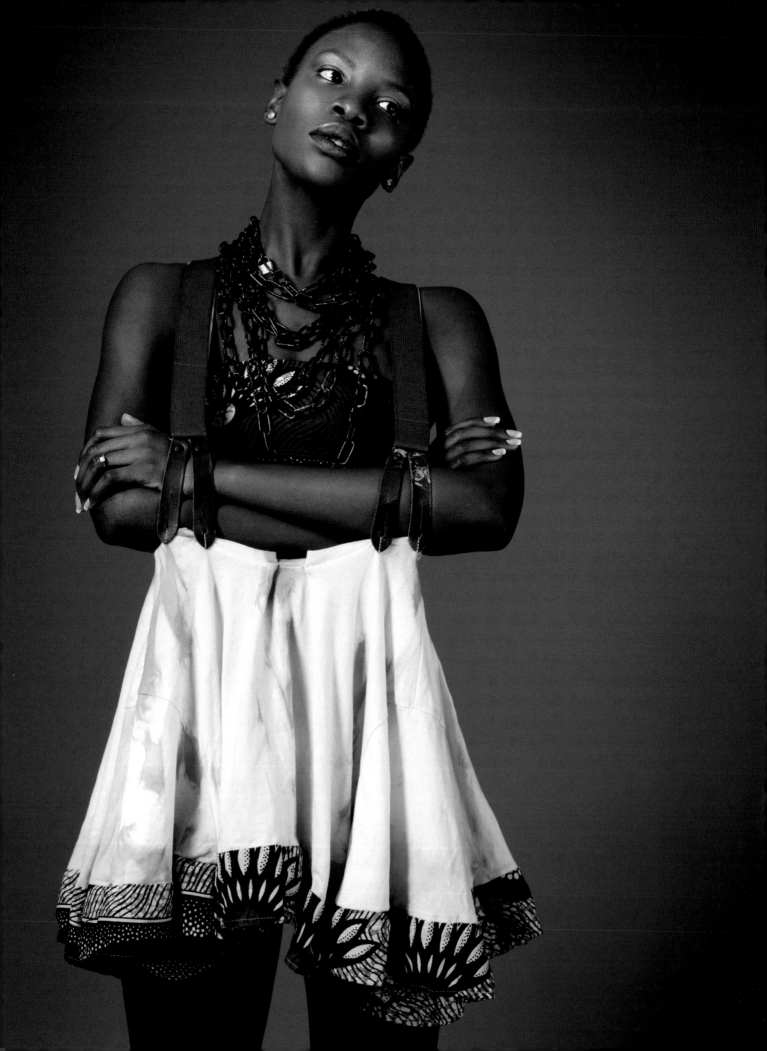

MIA
BY MIA NISBET

FACT FILE

LOCATED GLASGOW, SCOTLAND AND MALAWI

WEBSITE WWW.FASHIONBYMIA.COM

FOUNDED 2008

MIA by Mia Nisbet fuses recycled fabrics and traditional Malawian textiles to produce a collection that combines the richness of African textiles with Western styling. The line is inspired by the difficulties created by street markets where large volumes of imported second-hand clothing is sold.

After graduating with Honours from Glasgow School of Art in 2003 Mia developed her skills as in-house designer for Michiko Koshino. By 2005 she was designer in charge of the Soviet label at USC and launched her own ethical label MIA by Mia Nisbet in 2008. Almost immediately the label attracted major awards. In particular: winner of the prestigious Make Your Mark in Fashion Award 2008 for ethical fashion design during London Fashion Week and also winner of the Ethical Fashion Forum Innovation Award 2009.

The street markets in Malawi sell large volumes of second-hand clothing imported from the US, Europe and elsewhere. This cheap second hand clothing has made it very difficult for locally produced clothing to compete in the local market. MIA by Mia Nisbet works with producers in Malawi to create ranges which turn this challenge into an opportunity. Collections are designed and marketed to an international fashion market. Profits are reinvested in communities in Malawi as well as in the training, equipment and infrastructure needed to increase market access and create sustainable livelihoods.

❮ *Lookbook AW 2012*
(PHOTOGRAPHY BY JAKOB
IWANIKI) ❯ *SS10 collection*
(PHOTOGRAPHY BY MISS SMITH
PHOTOGRAPHY)

In which countries do you source and produce? We primarily source and produce in Malawi.

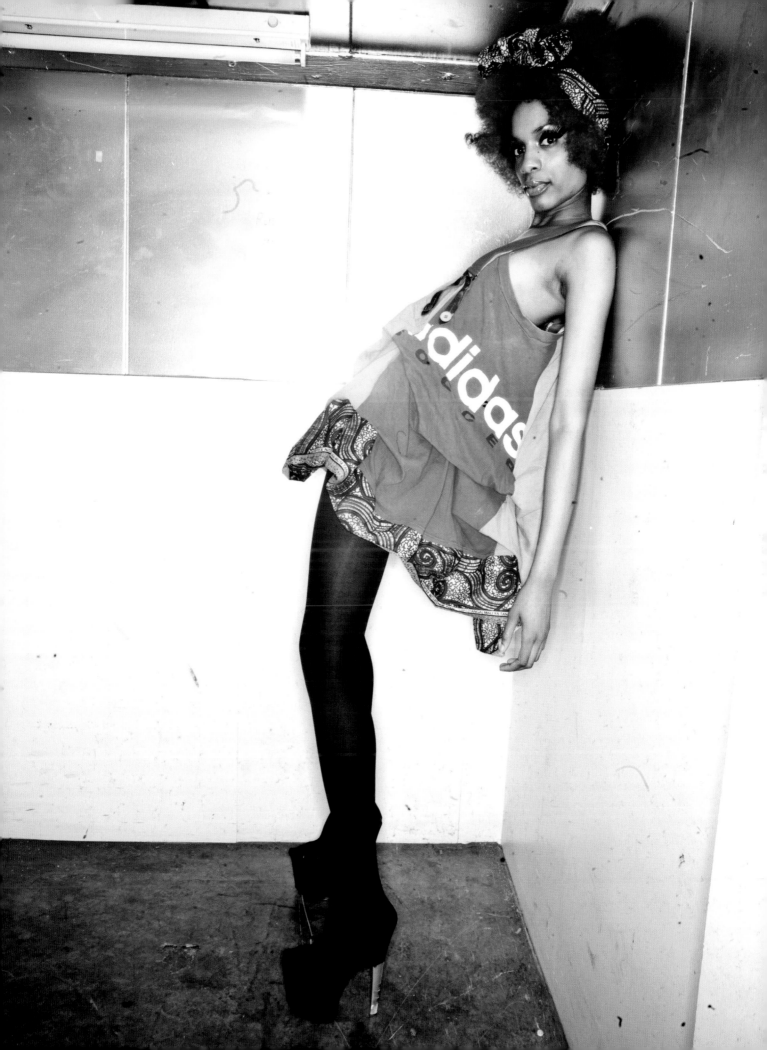

What do you see as the pros and cons of producing/sourcing in Africa? Quality control is a big issue. As I pay per garment made, I found the tailors were rushing the job trying to get more done, faster, because they were getting paid per unit. I then trialed a tailor on an hourly wage and that worked to the opposite effect; he did an immaculate job but was incredibly slow.

How does Africa relate to your company/brand and why Africa? Africa is a place very close to my heart, where I have spent a lot of time. I first travelled there in 2002 to help at an orphange with my sister. I love working with Malawians. Malawi is known as 'the warm heart of Africa' because the people are so friendly and inviting. I had travelled back to Malawi on several occasions to visit the orphange and it was during these visits where the concept of my collections was born. In the street markets locals are selling copious amounts of second-hand clothing, which are donated and imported from the western world. The sheer volume of clothes was astounding. It became apparent these markets would be a great place to source clothes for my recycled collection.

MIA fuses recycled fabrics with traditional Malawian textiles to produce a collection that combines the richness of African textiles with western Styling. The design concept is ethical fashion that not only unites two cultures, but one which is sustainable and designed to be wearable.

What inspires you? My inspiration comes from my observations of everyday life, especially from time spent in Malawi. I love how Malawian people mix their traditional Chichenji fabrics with the donated clothes (kaunjika in Chichewa) sold in the street markets. My observation of how Malawian citizens mixed these imported clothes with their traditional dress and printed textiles was the visual inspiration for my range. The cross between tradition and modernity, between the North and the South and the combination of different cultures makes for an eye-catching fusion.

What is your ethical standpoint? To help bring financial independence to the tailors we recruit to work for the MIA label, and to bring economic empowerment to second-hand clothes sellers and textile partners. MIA is an upcycled label with a social and environmental conscience based upon ethical, sustainable and wearable fashion uniting two cultures

MIA fuses recycled fabrics with traditional Malawian textiles to produce a collection that combines the richness of African textiles with western Styling. The design concept is ethical fashion that not only unites two cultures, but one which is sustainable and designed to be wearable.

Does your company work with any cotton programs in Africa and or any production workshops/organisations in Africa? I am in talks with mayamiko (UK registered charity) about a possible collaboration.

What is your ethical standpoint? To bring financial independence to tailors recruited to work with the MIA label, to bring economic empowerment to second hand clothes seller and textile partners. MIA is an Upcycled clothing label with a social and environmental conscience. The design concept is ethical fashion that unites two cultures, and importantly, is sustainable and wearable.

Which African designers do you admire? Anisa Mpungwe of Tanzania

Is Africa the future? I believe it will play a huge role in the fashion industry both inspirationally and practically.

❯ **TOP LEFT** *Lookbook A/W 2010* ❯ **TOP RIGHT** *Studio Shoot S/S 2010* ❯ **BOTTOM LEFT** *Studio Shoot S/S 2010* ❯ **BOTTOM RIGHT** *Lookbook A/W 2010* (ALL PHOTOGRAPHY BY MISS SMITH PHOTOGRAPHY)

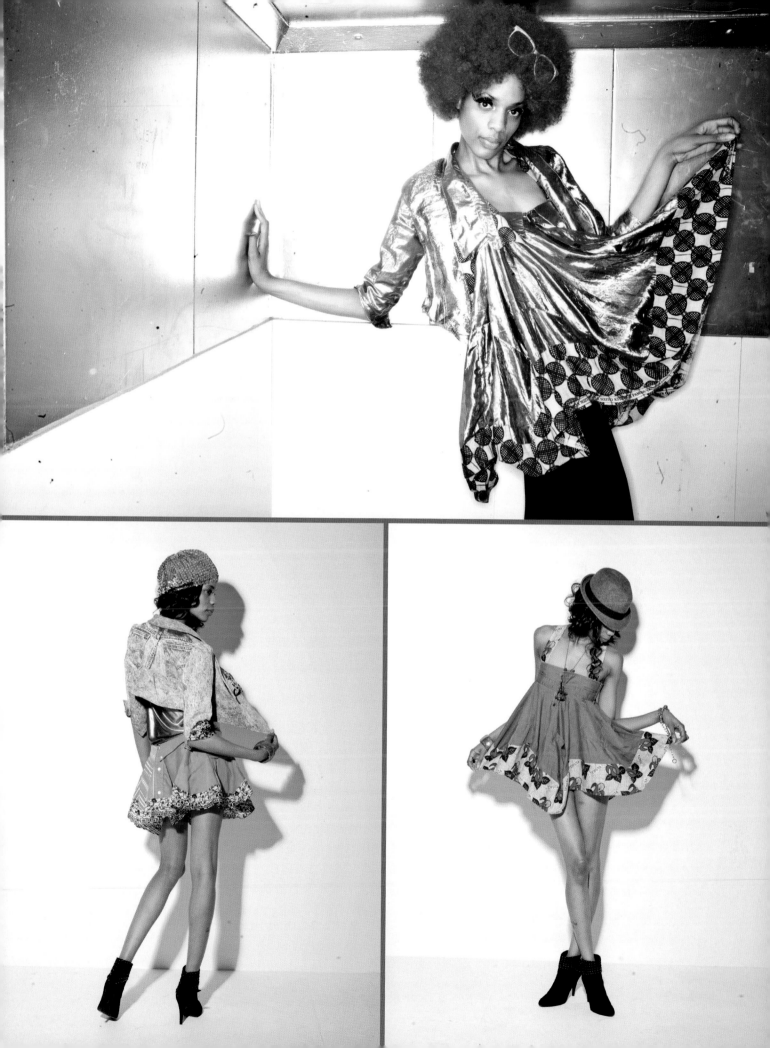

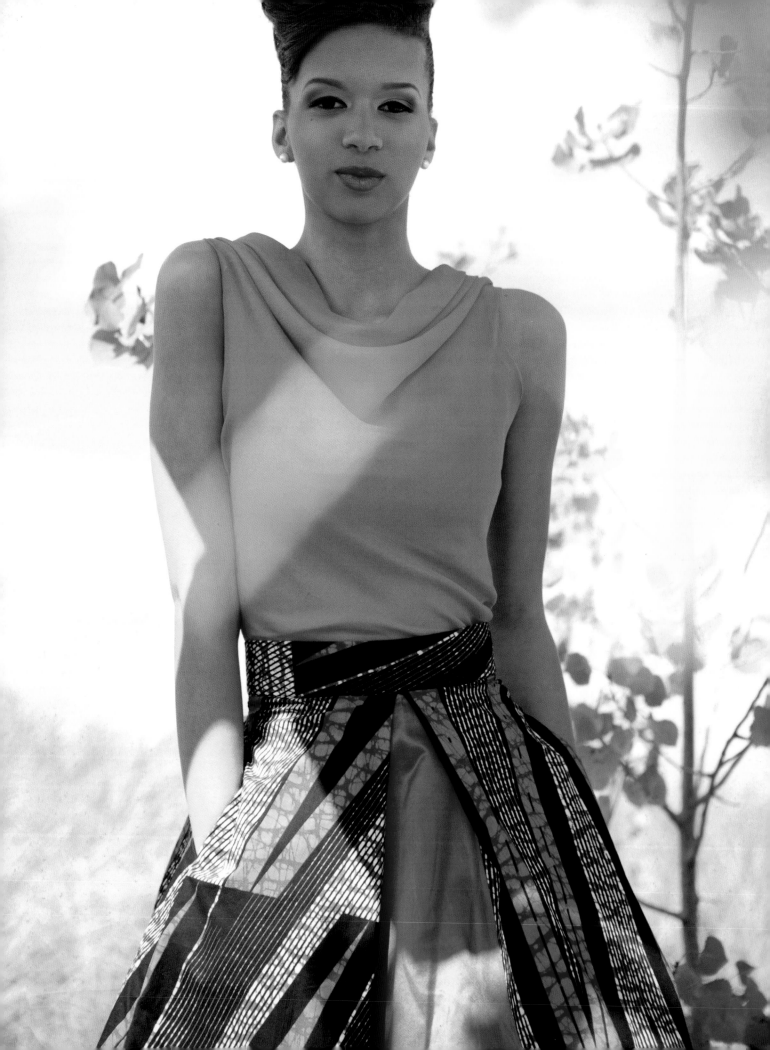

MODAHNIK

FACT FILE
LOCATED CHICAGO, IL, USA
WEBSITE WWW.MODAHNIK.COM
FOUNDED 2009

MODAHNIK is a socially conscious womenswear line consisting of feminine modern pieces fusing the designer's vibrant African heritage with western design sensibilities.

Kahindo Mateene is a Congolese (DRC) womenswear designer who founded her label Modahnik (an anagram of her first name and the first initial of her last). Kahindo has lived and traveled in several different countries on the continent of Africa, as well as in Europe and North America. These multiple cultural experiences influence her design aesthetic along with seeing her mother in beautiful colorful African print dresses during the 70s and 80s. Kahindo holds a BFA in Fashion Design from the Illinois Institute of Art-Chicago and a BA in International Business & Economics, from Blackburn College.

The creative vision of Kahindo epitomizes the chic and sophisticated lifestyle of the modern confident independent woman who is not afraid of color, embraces her femininity and is bold and daring when it comes to her fashion choices.

Modahnik is produced in Kenya, where Kahindo attended school, using fair trade practices, creating sustainable jobs for underprivileged communities and helping to reduce poverty overall.

❬ *Modahnik SS2013 look book* ❭ *Modahnik SS10 collection*

In which countries do you source and produce? I source Hollandais Wax from Holland currently but I am now looking to source more African produced prints.

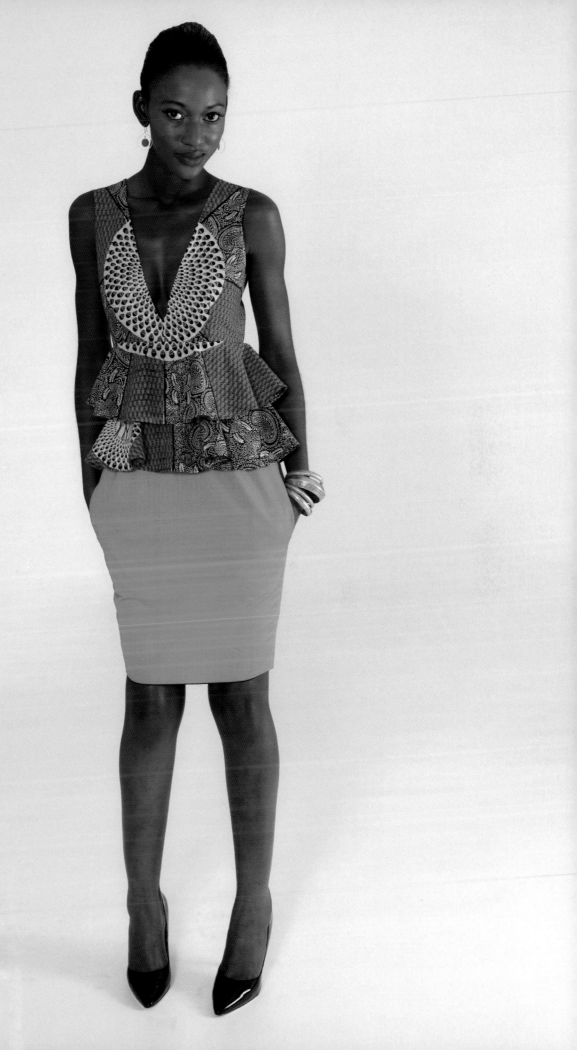

'Africa is home. I am from Goma, DRC. I was born in Uganda, went to school in Kenya and lived in Ethiopia, Niger, Nigeria'

What do you see as the pros & cons of producing/sourcing in Africa?

Being based in the U.S. my primary obstacle in producing in Africa is logistics. Shipping fabrics, patterns and trims to Kenya and then having the finished goods shipped back to the US, can become very expensive especially for a small label such as mine. But AGOA definitely provides some duty incentives when importing into the U.S. The other thing that can become a challenge is quality, since I am not in Kenya, it can be hard to do quality control, this also applies to sourcing fabric. I need to have the highest quality in terms of fabric and production in order for the branding of my line to fit in the contemporary market.

What inspires you?

I get inspiration from my African heritage as well as from everything that surrounds me; the sounds and smells of a metropolitan city, the architecture of Chicago, the white sandy beaches in Zanzibar and Cape Town and all types of music. Summer is my favorite season, so the *joie de vivre* in the air is another inspiration.

I also look to the Modahnik woman for inspiration, what she likes, what she needs and what she wants in terms of her fashion choices. I am designing for the woman who has a strong sense of individual style, an intelligent, worldly, spontaneous and effortlessly sexy woman who I need to cater to.

Do you use any traditional craft techniques in your design process?

My signature is the use of African print and mixing that with a modern edge. I am looking to incorporate more craft techniques in the future, such as hand beading.

How do you think fashion made in Africa is regarded internationally?

The International audience doesn't really have a good example of the capability and quality of Made in Africa products. But it is growing and with brands such as mine delivering high quality products that fit in the western world's culture, the sky is the limit. We need to prove that our growing apparel industry has the ability to compete with the likes of India and be a sustainable ethical alternative solution to Chinese production.

How does Africa relate to your company and why Africa?

Africa is home. I am from Goma, DRC. I was born in Uganda, went to school in Kenya and lived in Ethiopia, Niger, and Nigeria. My father was a Diplomat so we were blessed to travel to many different countries within Africa. The multiple cultures that I experienced during my childhood in Africa play a huge role in my design sensibility and my cultural identity.

Does your company work with any cotton programs in Africa and or any production workshops/organisations in Africa?

I have worked with Soko-Kenya to produce my SS2011 collection.

What is your ethical standpoint?

Modahnik has a socially conscious mission at its core, to ethically produce in Africa using fair trade practices which will create sustainable jobs for underprivileged communities and aid in poverty reduction.

Is Africa the future?

Yes I believe so. We have the talent, resources and the drive. We just need the support, opportunity and education to back the apparel industry in Africa.

❯ *All from Modahnik SS2013 look book*

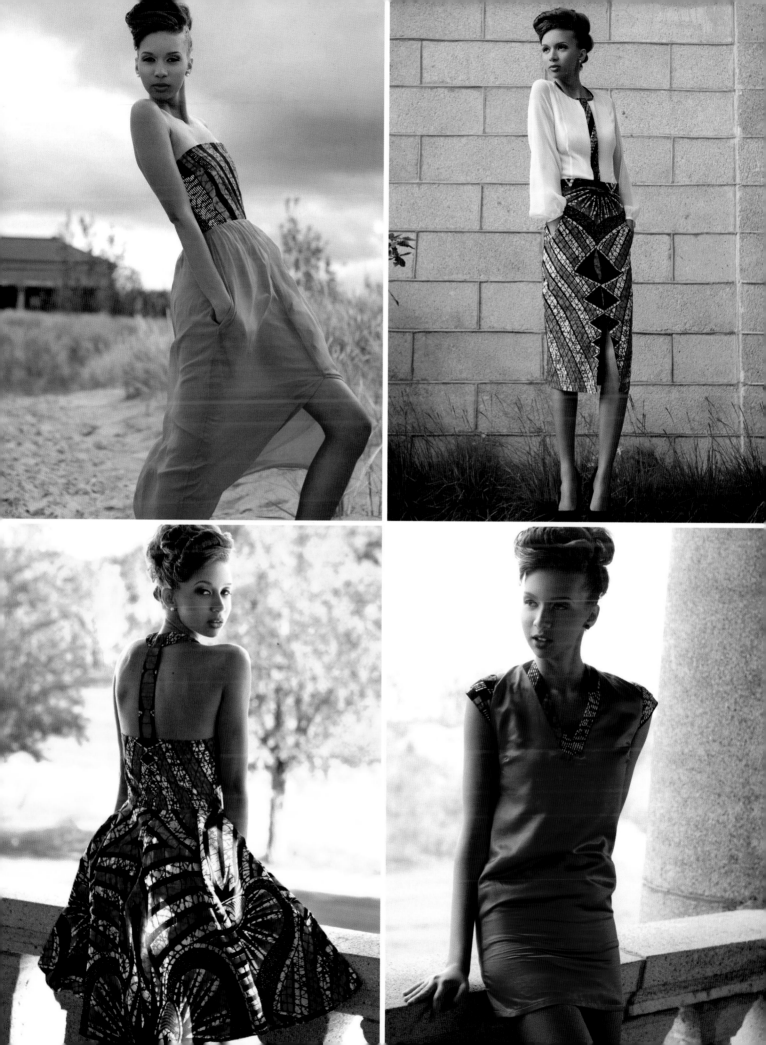

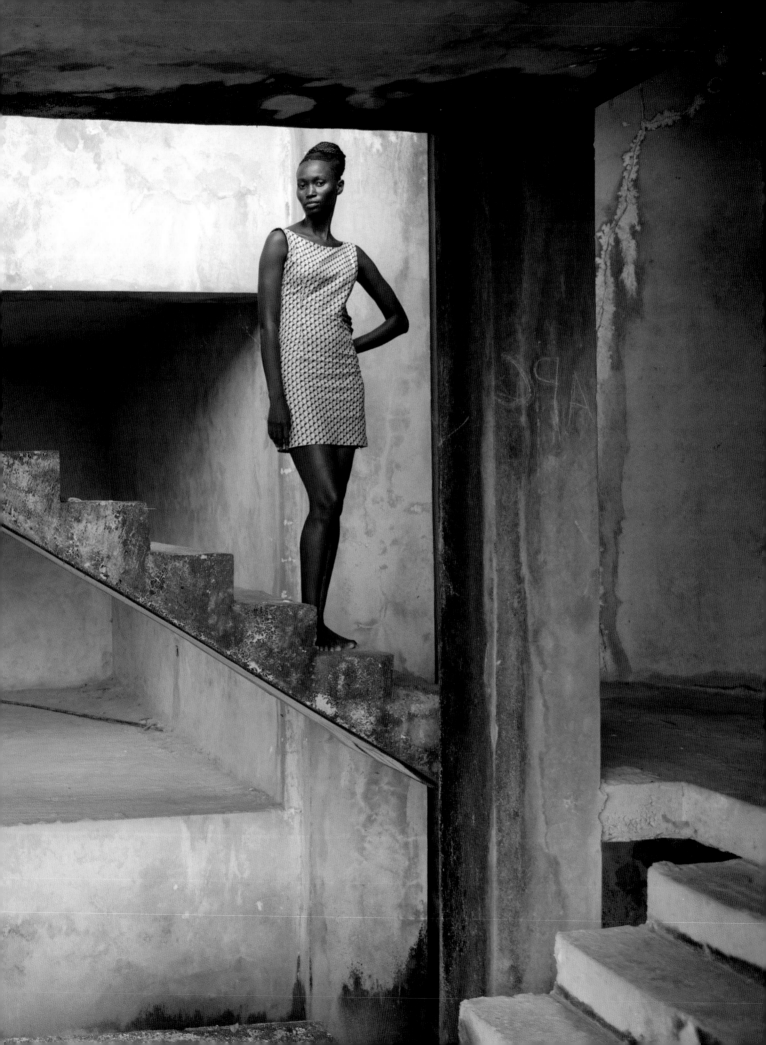

NEARFAR

FACT FILE
LOCATED SIERRA LEONE AND LONDON, UK
WEBSITE WWW.NEARFAR.CO.UK.
FOUNDED 2009

NEARFAR founder, Stephanie Hoggs aims to capture the imagination of the "thinking fashionista". NearFar combines cutting-edge design with traditional Sierra Leonean prints to create a stunning collection of wearable yet highly original pieces.

Stephanie Hogg moved with her parents to Sierra Leone in 2005 for three years. While there she became influenced by her mother and sisters who had begun to make dresses from local African prints. Loving the vibrancy and energy of the people and their incredible positivity despite such hardships, she saw these attitudes perfectly reflected in the beautiful fabrics that lined the streets and she immediately saw potential in the capital's talented tailors; potential that if harnessed, could play a large part in the country's development.

Stephanie returned to London, graduating from Goldsmith's University in 2009 upon which she returned to Sierra Leone and immediately began building her business, looking for tailors who exhibited exceptional craftsmanship and also those who were helping the community and therefore keen to work with her.

NEARFAR has developed into a company working closely with organisations involved in the training of young Sierra Leoneans in the art of tailoring. Ten years of Civil War has left the country with many uneducated and unemployed young people. Many of the tailors have lived as street children, been victims of the commercial sex trade or have been subjected to domestic abuse.

In association with their close partner GoalSTA, NEARFAR has been able to help tailors profit from their skills and rebuild a life of stability for themselves and their families. NEARFAR's commitment to this cause is demonstrated by the fact that

❬ *Freetown Dress*
❭ *Illustration, NearFar*
2010 collection by
Danielle Shepherd

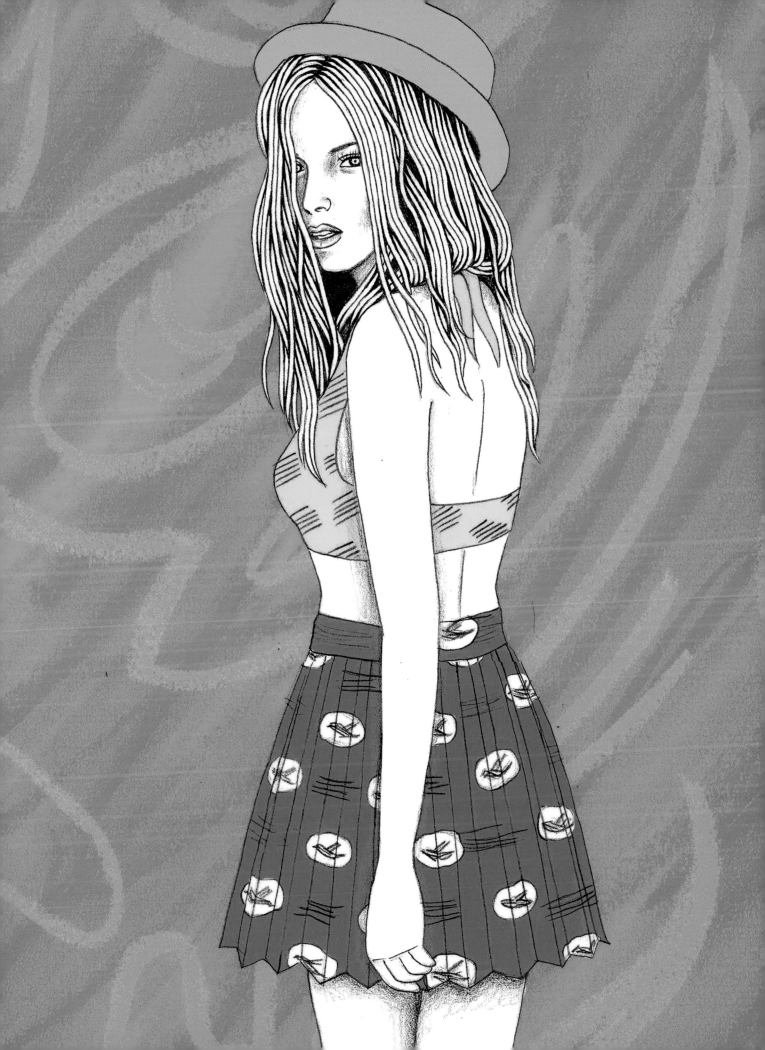

'I believe that NearFar has the potential to play a role in its development as well as raising the awareness of the country and creating sustainable employment for the people'

10% of all sales is reinvested into the training of young tailors.

NEARFAR has been launched in Anthropologie, a store reknowned for championing soulful brands with beautifully designed pieces; it is no surprise that they picked up on NEARFAR. At the heart of the brand and its designs is the passion to work with and be inspired by the Sierra Leonean people. The company aims to capture the imagination and conscience of the thinking fashionista and to provides an alternative to the mass-produced and an antidote to the mundane.

In which countries do you source and produce? Sierra Leone

How do you think fashion made in Africa is regarded internationally? Due to the current fashion frenzy on African prints, fashion in Africa has become highly desired but most unfortunately, is not created in Africa. I think to most people fashion made in Africa isn't leading the way in terms of frontline fashion. However African designers are emerging from all parts and creating a buzz through the fashion world. In time there will definitely be place for fashion made in Africa and it will be highly respected.

What is your ethical standpoint? NearFar is a reflection of my strong belief that ethical fashion and fair trade can play a major role in reducing poverty. Our beautifully tailored pieces give cutting edge design the vibrancy of West Africa. We work with carefully chosen tailors who like us believe that training young people in the art of tailoring can help in the nation's development.

How does Africa relate to your company brand and why Africa? I have always felt a strong connection with Africa. I lived much of my early life in Ethiopia before moving to Kenya and then spent three years in Sierra Leone. Understandably I have had a strong desire to work there. While in Sierra Leone I fell in love with the beautiful fabrics that lined the streets of Freetown and saw great potential. But it was my desire to be a part of the country's re-development. Everyone I spoke to had been touched somehow by the war. Thousands of young people denied an education leaving many on the streets with little or no support. If I can just help on a tiny scale by creating some sustainable employment and raising people's awareness of the country it will have been worthwhile.

❯ **TOP** *Beach Skirt*
❯ **BOTTOM** *Tombo Jacket*
(PHOTOGRAPHY BEX SINGLETON)

What inspires you? My initial inspiration was from the Sierra Leoneon people themselves, their amazing structured dresses and headwraps. Normally on a Sunday as they head to church in their best it's an amazing scene of colour and design. I am inspired by people on the street rather than the catwalk. I love fashion in London and you know that it's always ahead of the trends, it's a great place to people watch and gain inspiration.

Is Africa the future? Sierra Leone is bursting with potential with many talented tailors and a wealth of exciting fabrics giving ana impact in the fashion world. It is this important individuality that really gives it the edge which has been lost in many areas to the mass produced. However the infrastructure is a real stumbling block. With very little exports, shipping is expensive, adding to product costs making it difficult to compete financially with other markets. The growth of ethical fashion should help the development of the industry.

NKWO

NKWO started with an obsession with dolls and a mother who taught her how to sew. Nkwo Onwuka earned a degree in Pschology, but her love of making pretty things has turned into a thriving fashion business.

At the prestigious Kulture2Couture, 2007 the NKWO label won the coveted Phoenix Award presented by the Mayor of London's office in conjunction with the V&A Museum. The label now focuses on creating collections of womenswear, jewellery and accessories that capture the African story, told with a 21st century slant and with a sense of the nomadic, inspired by the lives of the people of the desert and great plains. Modern interpretations of early methods of weaving, beading, hand dyeing and embroidery, create texture and surface decoration on fabrics as each collection becomes a celebration of the artisan and the nomad. One of the key features is the 'retro-wrap' which re-engineers early methods of dress where a single piece of fabric is draped, tied or wrapped around the body to form a garment. The unique wrap has won various accolades and was presented to HM Queen Elizabeth when she opened the business centre at the University of East London.

Another key feature is the 'one collection'. Conscious of the impact running a fashion business has on the environment, waste is controlled by producing one major collection a year. NKWO is devoted to promoting a positive image of Africa, and her unique interpretation of the rich history, culture and traditions.

❮ *SS13 titled City of Hope*
(PHOTOGRAPHY, KOLA OSHALUSI, INSIGNA PHOTOGRAPHY)
❯ *SS13 titled City of Hope*
(PHOTOGRAPHY, KOLA OSHALUSI, INSIGNA PHOTOGRAPHY)

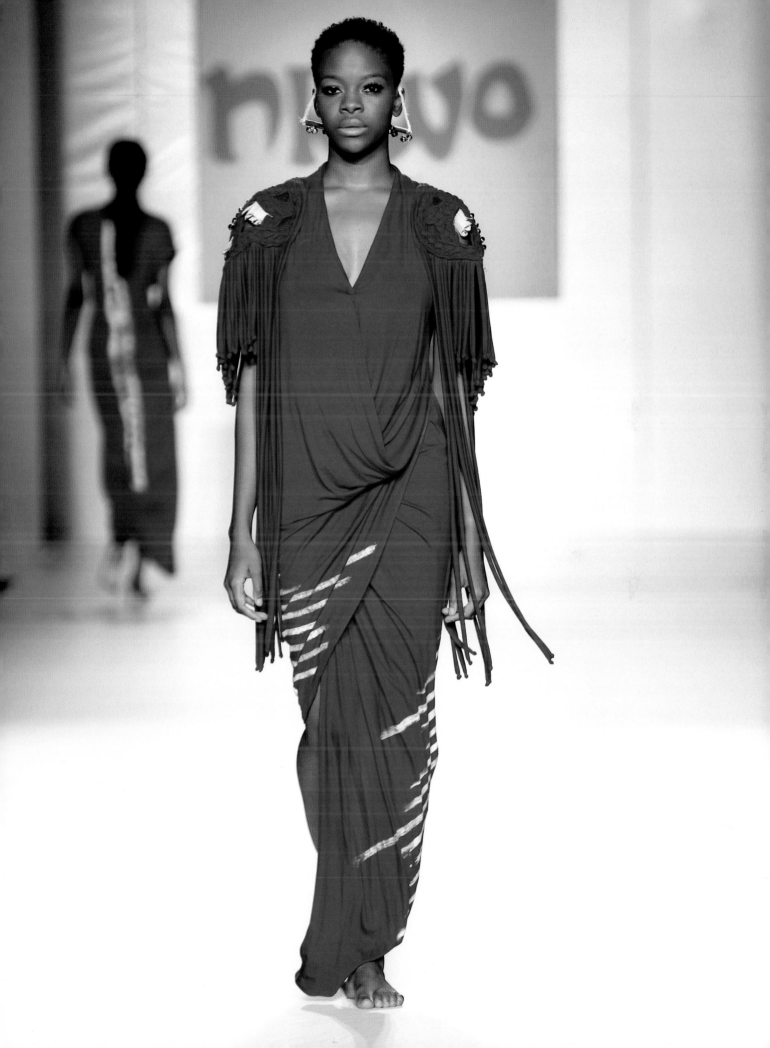

'Through my work I am promoting a positive image of Africa - we are not just about famine, wars and corrupt leaders'

Which countries do you source and produce in? Our collections are primarily made with silk and cotton. The silks we source from Europe and Asia,while majority of our cotton fabrics are sourced from West Africa where we are looking at collaborating and working with a production unit but at this time we do most of our manufacturing here in London.

What do you see as the pros & cons of producing/sourcing in Africa? A major positive is that we are providing work for local talent, thereby facilitating a means for the communities to achieve a level of self-sufficiency. Africa offers access to a wide variety of materials and offers us the ability to work closely with the local suppliers.
Things that are not as good are the inability to control intellectual property due to the fact that there are no copyright laws; issues with

technology that make it difficult to contact the suppliers on the phone or do business over the internet and small scale industries often find it difficult to produce on an industrial scale.

What inspires you? I find a lot of things around me inspiring. A sentence in a book, the words of a song, the colours, textures, sounds and smells of markets and craft centres. I am greatly inspired by the wild freedom and innovation of the '60s and '70s but also by the tribes of Africa, in particular the Masai with their free nomadic ways.

Do you use any traditional African craft techniques? It's important to keep our traditions alive and a great way to do that is to work with artisans who use the traditional methods of fabric treatment like tie and dye, the woven fabrics like aso-oke (from Nigeria) and kente fabrics (from Ghana).

How does Africa relate to your company and why Africa? Africa is fused with my brand. My collections are full of the colour and vibrancy of the cities, I use fabrics which are either made in Africa or have African inspired patterns and through my work I am promoting a positive image of Africa - we are not just about famine, wars and corrupt leaders.

How do you think fashion made in Africa is regarded internationally? For a long time Africa was only a source of inspiration but its fashion and style was regarded as too indigenous to have a place on the international scene. We as young Africans would not wear it - it was to be worn by our mothers or only for traditional occasions. However, that is no longer the case as there is a new breed of African fashion designers turning what is perceived as 'African style' on its head and breaking into the international market where we are respected and counted as making a valuable contribution to the fashion industry.

❮ *Nkwo braided capelet, 2011 Happy Lives Here collection* (PHOTOGRAPHY, 2SHOOTERS.COM) ❯ *SS13 titled City of Hope* (PHOTOGRAPHY, KOLA OSHALUSI, INSIGNA PHOTOGRAPHY)

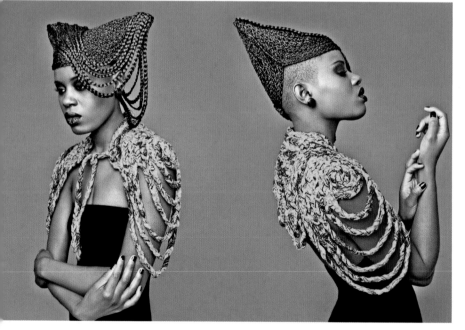

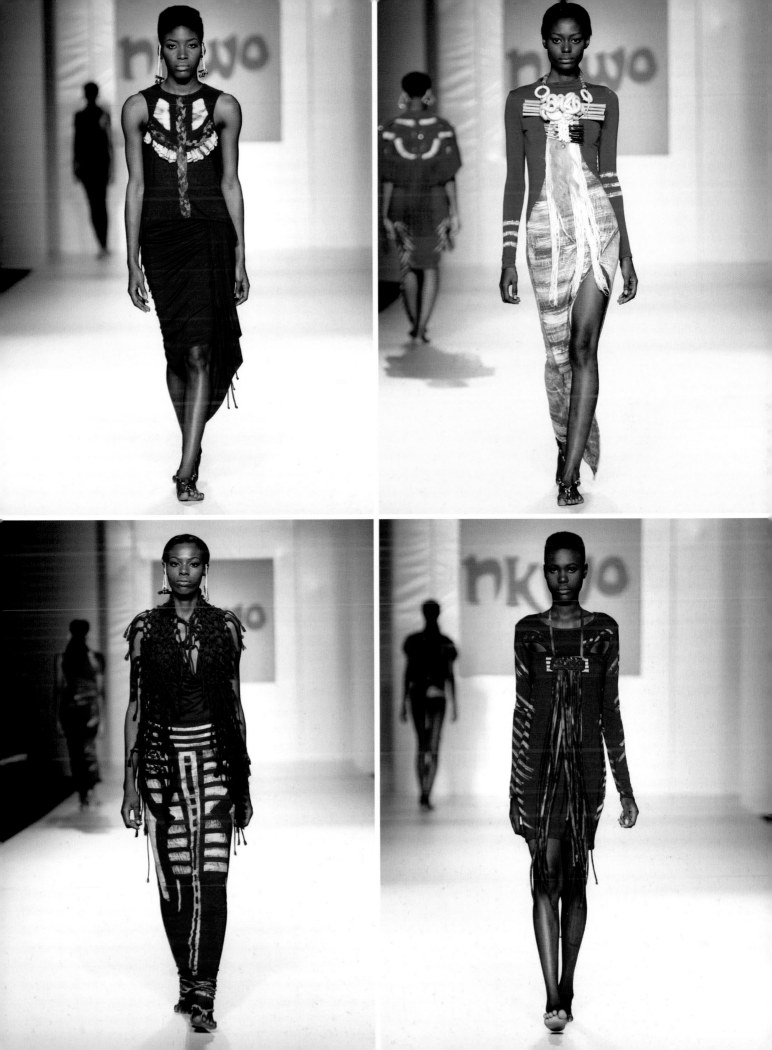

NOIR

FACT FILE
LOCATED COPENHAGEN, DENMARK
WEBSITE WWW.NOIR.DK
FOUNDED 2005

NOIR was established in 2005 with the vision of creating high-end fashionable apparel through socially and environmentally responsible production principles. The Noir brand embodies sensual, old-world elegance edged with menswear-inspired suiting and leather materials.

The mission of NOIR A/S is to create luxury fashion based on CSR-principles in all links of the supply chain. Centrally, the mode of production aims at having respect for and taking care of our social and environmental surroundings. The NOIR brands (NOIR, NOIR Illuminati II, and BLLACK NOIR) strive to adhere to this by complying with the principles of the UN Global Compact, the International Labor Organization and the International Chamber of Commerce as guidelines in all levels of the process. NOIR brand collections for both the fashion aesthetic and the social conscience of the consumer, combine luxurious clothing with a focus on fair-trade and organic woven cotton fabrics from Africa. Illuminati II is 100% cotton fabric grown organically and fair traded from Uganda. The fabrics are offered to NOIR and BLLACK NOIR and to other apparel and fashion brands that have an interest in including ethical fabrics into their collections. NOIR Illuminati II was launched in 2005 and BLLACK NOIR by NOIR was established in 2008 as a diffusion line and launched Spring/Summer 2009. The brand BLLACK NOIR embodies the sensuality and edge from NOIR with an edgy twist.

‹ Noir SS11 collection
› Illustration, Noir by
Elena Sofia Tinis Bobe

In which countries do you source and produce in? Illuminati II cotton is produced in Africa. Due to the high quality demand for the NOIR brand the production takes place in Europe primarily in Lithuania. BLLACK NOIR strives to source and

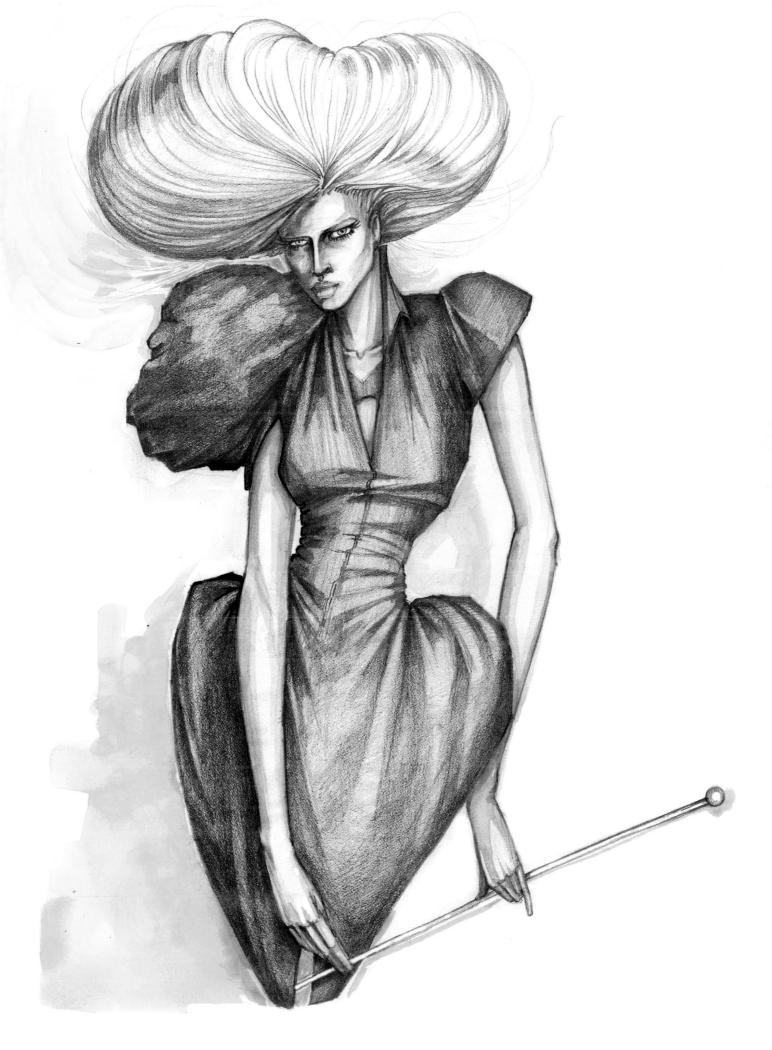

'It is an intrinsic part of our DNA to turn sustainability sexy'

produce outside of Europe in order to drive a sustainable business model while at the same time work as a catalyst for improvement of social ethics, environmental standards and sustainable business in countries such as China and India.

What do you see as the pros & cons of producing/sourcing in Africa? One reason for choosing Uganda in Africa for our Illuminati II cotton growing was the readiness of the government to attract investments. Furthermore there is a huge tradition of growing cotton and good climatic conditions. Thus there was already an established setup that we could step into. Finally, the challenges such as HIV, malaria, tuberculoses and deforestation enables us to make a strong impact via our presence in Uganda. The disadvantages are as cotton production and design are located on different continents we have to deal with the remote management. Moreover there is only little organization of the farmers which sometimes leads to difficulties.

Where do you go to and what do you look at for inspiration? The luxury collections from NOIR are inspired by classical deeds, Victoriana, art and rock. Each collection we look for an inspiring influence such as a beautiful yet haunting classic novel and movie

❯ TOP LEFT, TOP RIGHT,
BOTTOM LEFT *Black Noir
SS11 collection*
❯ BOTTOM RIGHT *Noir AW09
collection*

such as "Picnic at Hanging Rock" that we used for NOIR SS11. The BLLACK NOIR look is inspired by street savvy rock chicks allowing for individual styling.

Does your company work with any cotton programs in Africa and or any production workshops/organisations in Africa? We work with the cotton development organization which is the official body of the Ugandan government. Apart from that we work with our local partner Bruce Robertson, who develops our cotton production in Uganda on a daily level. He is responsible for organizing the 1100 farmers in the Gulu district in Northern Uganda, ensuring that Union certified organic cotton criteria are delivered to and in return reassuring that the fair trade principles are adhered to.

What is your ethical standpoint? Since our cotton brand Illuminati II is fair traded, adheres to ILO conventions, uses organic cotton and is a member of the UN Global Compact we pursue an ethical standpoint of fair trade and environmental sustainability. Bruce Robertson is from Gulu Agricultural Development Ltd in Uganda. The principles (based on ILO conventions) are carried out in the ginnery and with our partner - Phenix Industries, in Uganda, They are chosen based on their ability to prove that they too adhere to UN Global Compact principles.

How does Africa relate to your company and why Africa? Some of the world's best cotton grows in Africa. It is an intrinsic part of our DNA to turn sustainability sexy where

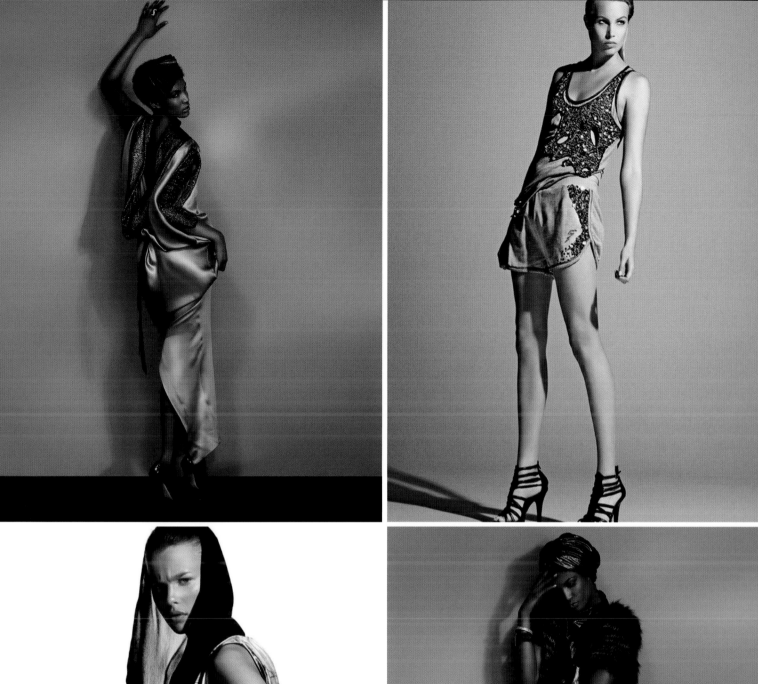

the production is made in Africa however designed in Europe for high fashion consumers.

How do you think fashion made in Africa is regarded internationally? Africa is not traditionally linked to fashion. However with the increasing consumer demand to work with a transparent supply chain and to act socially responsible, Africa arises as a unique alternative to the established fashion countries and thus the continent will become accepted by both brand owners and end consumers over time.

Is Africa the future? Africa could very well be the future for agriculture, delivering cotton and food to the world.

❮Noir AW09 collection

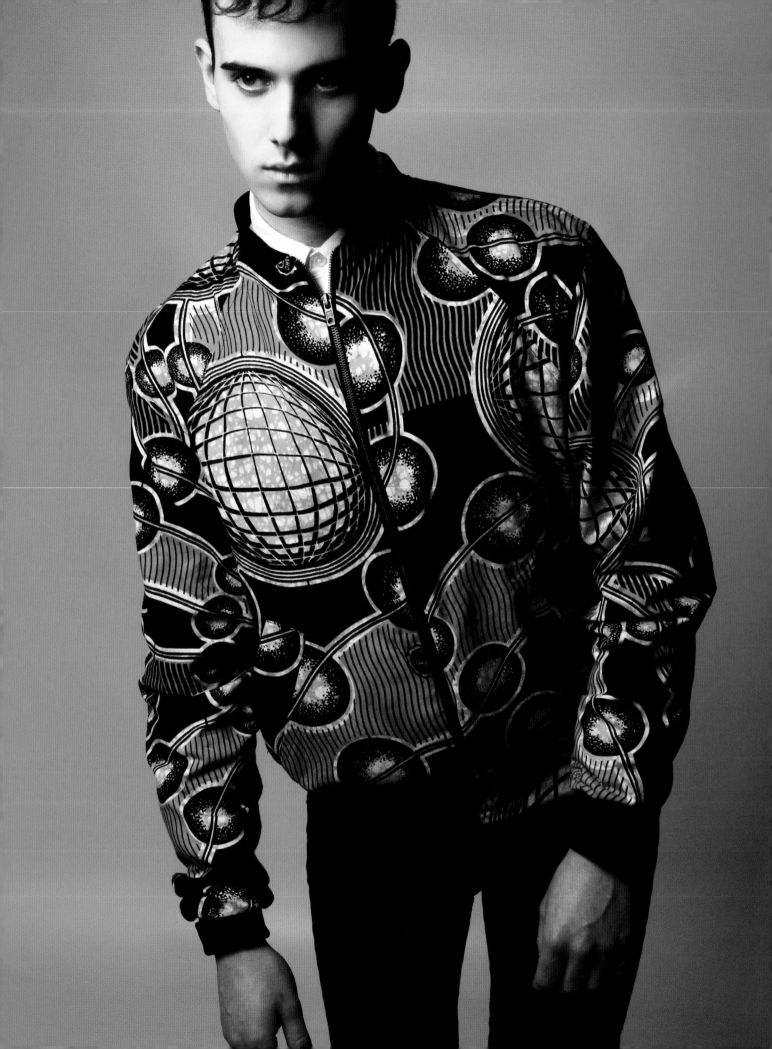

OHEMA OHENE

FACT FILE
LOCATED LONDON, UK
WEBSITE WWW.OHEMAOHENE.COM
FOUNDED 2008

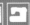

OHEMA OHENE, the brainchild of British born designer Abenaa Pokuaa, came to life in late 2008. The name (meaning Queen and King in the Ghanaian language of Twi) refers to Abenaa's Ghanaian heritage and her plans to create a brand for both men and women.

OHEMA OHENE produces exciting, high quality, stylish seasonal clothing that represents London's multicultural population and blends quintessentially British tailoring with West African textiles. The line produces womenswear and menswear as well as an exciting range of footwear under its OH! brand and has received many accolades for achievements including a Precious award for Best Business start up of the year 2009, O2x Young Entrepreneur of the Year 2009 and GUBA award for Best designer nominee 2010. OHEMA OHENE has also been shortlisted for an African Fashion International (AFI) award for Best International Menswear 2010, BEFFTA awards Best Fashion Designer nomination, as well as a GUBA nomination for Best Fusion Designer.

The brand has caught the attention of leading media, including Vogue, Pride Magazine and major London newspapers. The line is sold at selected boutiques in the UK, France, Belgium, Japan, and at its very own store in the heart of Brixton in London, UK.

What do you see as the pros and cons of producing/sourcing in Africa? Time frames are difficult to create or uphold and there can be a lack of clear concise information freely available with regards to shipping, import and export duties and charges. The transportation of goods to and from the continent can be

❮ ❯ *Menswear SS13*

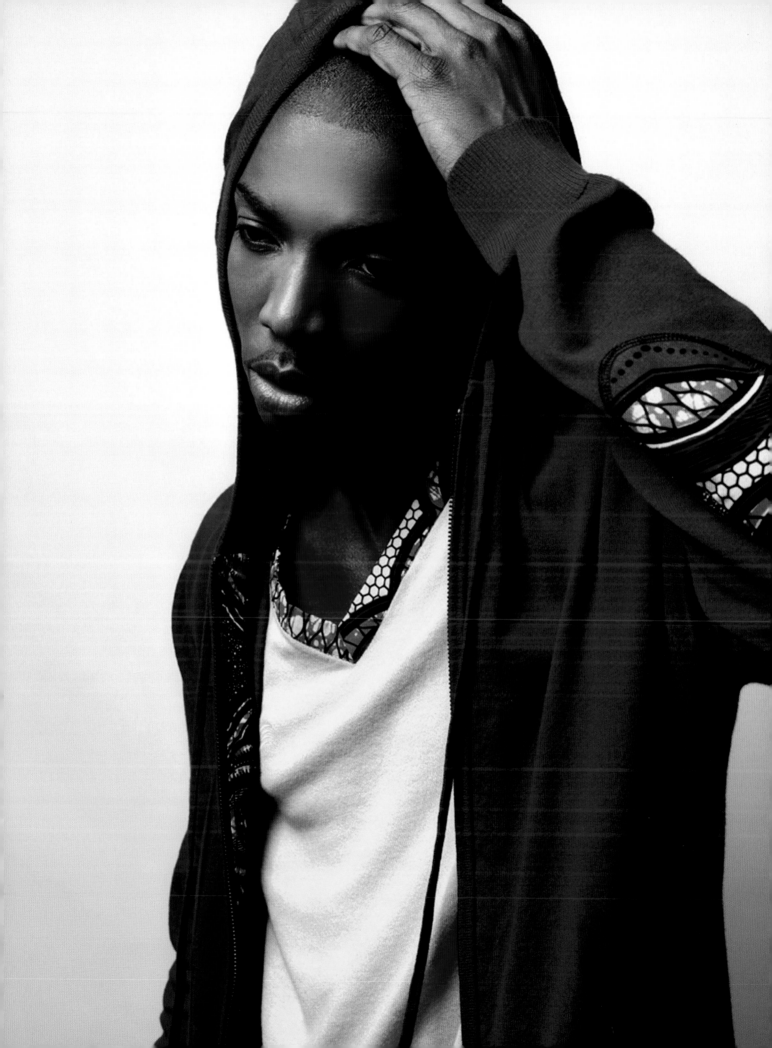

fraught with challenges. More positively new markets allow opportunities for those who wish to capitalise on the lack of competition. Also Africa has many skilled artists and craftsman who can utilize production techniques which are expensive to produce elsewhere or not so readily available.

Is Africa the future? Yes. Manufacturers are seeking new emerging markets as sources of opportunity in terms of profitability and sustainable growth. Especially as South America, China and India have all been over exhausted, causing production costs to increase.

Which countries do you source and produce in? We produce in the UK

How do you think fashion made in Africa is regarded internationally? Many regard African fashion as visually beautiful, but see it as often being poorly made.

Which African designers do you admire? Oswald Boateng. As a fellow Ghanaian I'm proud of Oswald's achievements. He has shown that race and ethnicity is not always a barrier.

❮ *Ladieswear SS13* ❯ *OH!*
Footwear

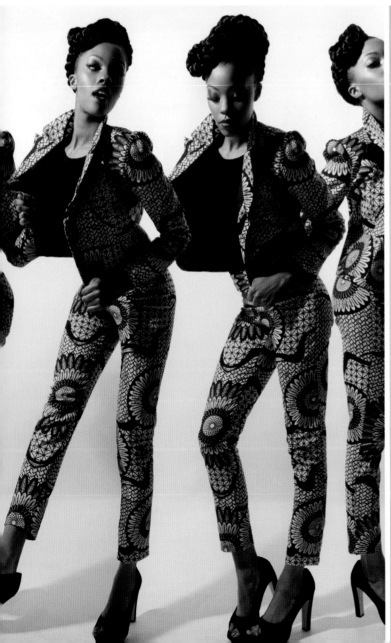
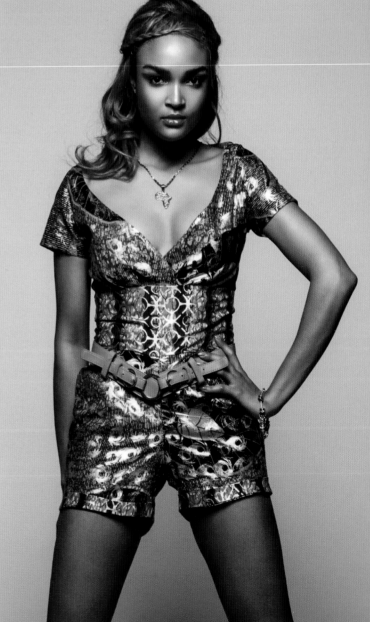

OLIBERTÉ

FACT FILE

LOCATED ADDIS ABABA, ETHIOPIA AND OAKVILLE, CANADA
WEBSITE WWW.OLIBERTE.COM
FOUNDED 2009

OLIBERTÉ was launched in 2009, by founder Tal Dehtiar. OLIBERTÉ has the tagline 'This is Africa' and produces premium leather footwear exclusively made in Africa.

In Africa the middle class is increasing in size and one of OLIBERTÉ's goals is to support that growing middle class by building a world class footwear brand that can create thousands of jobs and also encourage manufacturers from other industries to work in Africa. The team at OLIBERTÉ do not see an Africa categorised by negative generalizations. They believe that with the right partners each country within Africa has the means to grow and support its people. So with this belief, OLIBERTÉ partners with factories, suppliers, farmers and workers to produce premium footwear in Africa, and above all work to create fair jobs, with the goal of contributing to the development of a thriving middle class.

In which countries do you source and produce? We primarily in Ethiopia, Liberia and Kenya.

What do you see as the pros & cons of producing/sourcing in Africa? For talented crafts people, there is a large pool of untapped potential. With that being the case the people want to work and they work hard. Also, Africa has unique, quality, resources; beautiful leathers, hides and other natural materials. On the downside, the time delays we continue to face are really the only one disadvantage. Everything else is improving.

❮ *The Adibo brown/ yellow pullup with a jagged black sole, the signature style of Oliberté* (PHOTO BY AGATA PISKUNOWICZ)
❯ *Illustration, Oliberte* (BY NATSUKI OTANI)

How do you think fashion made in Africa is regarded internationally? It's a blend between Italian quality and Chinese mass production - so it has the potential to be the best in the word of all things to all people.

What inspires you? Casual trends that are classic - boots, boat shoes, combat boots, loafers, etc.

How does Africa relate to your company brand and why Africa? Africa is the very essence of why we started Oliberte - to show that Africa is full of pride, power and liberty and if treated properly - can make the most beautiful shoes in the world.

The Shasa style is one of Oliberté's first women's shoes (PHOTO BY JOHN HOOK)
The Kuko, Oliberté's made-in-Africa take on a duck boot (PHOTO BY AGATA PISKUNOWICZ)

Do you use any traditional African craft techniques in your design process? Not necessarily but we do use traditional footwear techniques like a special stitch called a stitch out.
Does your company work with any programs or workshops in Africa? We do partner with leather tanneries, a

local bag manufacturer and have our own ethical shoe factory in Ethiopia.

Which African designers do you admire? That would be every person working at our factories - those are our heroes because without them Oliberte would just be a name.

What is your ethical standpoint? Our number one priority is making quality footwear that creates millions of jobs - we are about building a better Africa by building a thriving middle class through our beautifully crated and designed shoes.

Is Africa the future? For those who believe it is, yes. For those who want quality, yes. For those who want to make products that matter, yes. For those who want cheap products and cheap labour - no and please don't come.

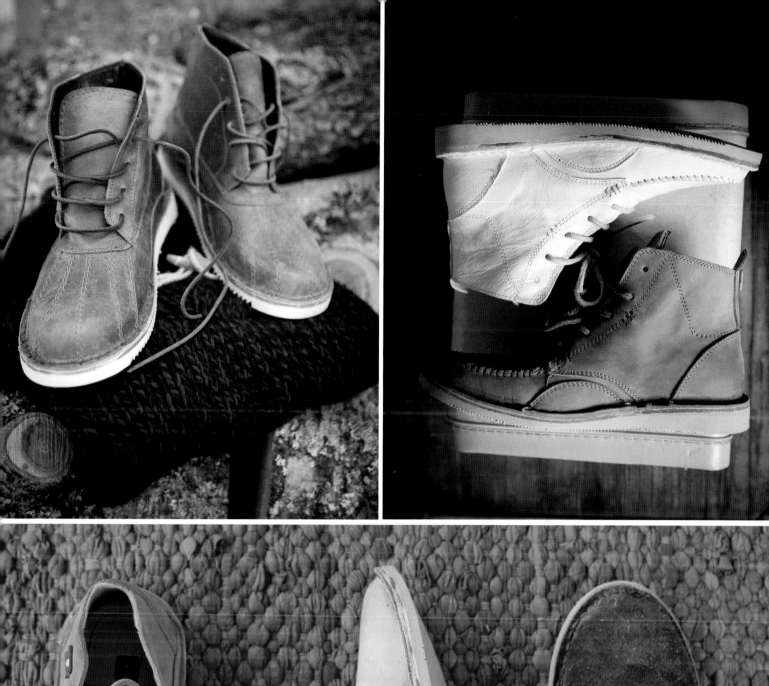
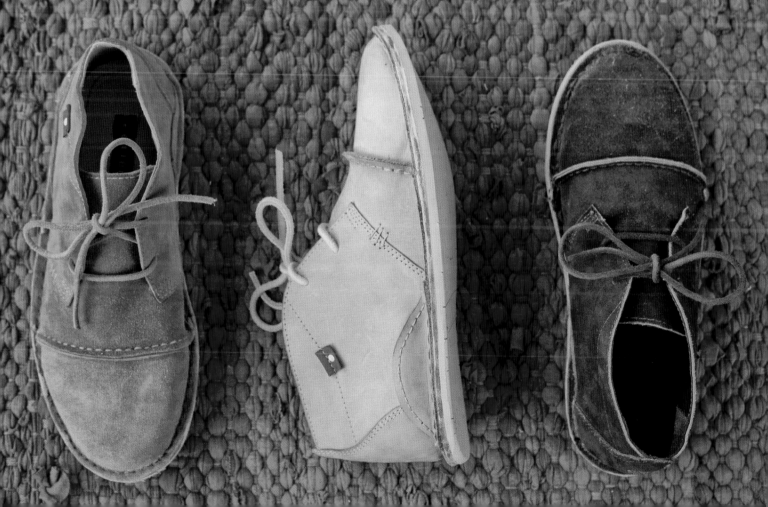

SANDSTORM
BAGS

FACT FILE
LOCATED NAIROBI, KENYA
WEBSITE WWW.SANDSTORMKENYA.COM
FOUNDED 2003

Sandstorm Kenya bags and accessories have been made in Nairobi since 2003 to the same exacting specifications as the luxury safari tents that first made our name; each one crafted, individually and ethically from hand-selected leather hides, 18oz all cotton canvas, and solid brass fittings.

Sandstorm Bags, Kenya was founded in 2003 and actively retains strong links with its safari roots while continuing to custom-make products like fitted vehicle seat covers, safari chairs and other outdoor accessories for leading camp and lodge operators. From careful cutting and preparation, to sewing, hand-finishing and finally quality control, it is the craftsmanship of the team that makes a Sandstorm bag so special and unique. Today the company operates seven Sandstorm Kenya retail outlets in East Africa: four in Nairobi, one at the Kenyan coast, one in Nanyuki and one in Dar es Salaam. In terms of material, five years ago their sales were split 80% canvas / 20% full leather, however today that split is now closer to 50 / 50 and a good barometer of the continuing shift in East Africa's economic fortunes. In 2014 we will turnover close to $1.5m – a tiny amount by international standards but meaningful for an East African bag company with 80% of its business within the region. The company are ambitious and optimistic about the future.

‹ *Sandstorm Kenya travel bag close up*
› *Sandstorm Kenya workshop, Nairobi, Kenya (Sandstorm Kenya)*

What are the pros and cons of sourcing/producing in Africa? Africa isn't a country so it isn't possible to give a balanced answer to the question, however it's fair to say that for us producing/sourcing in Kenya is far from straightforward. Challenges include punitive duties levied on imported raw materials; the time

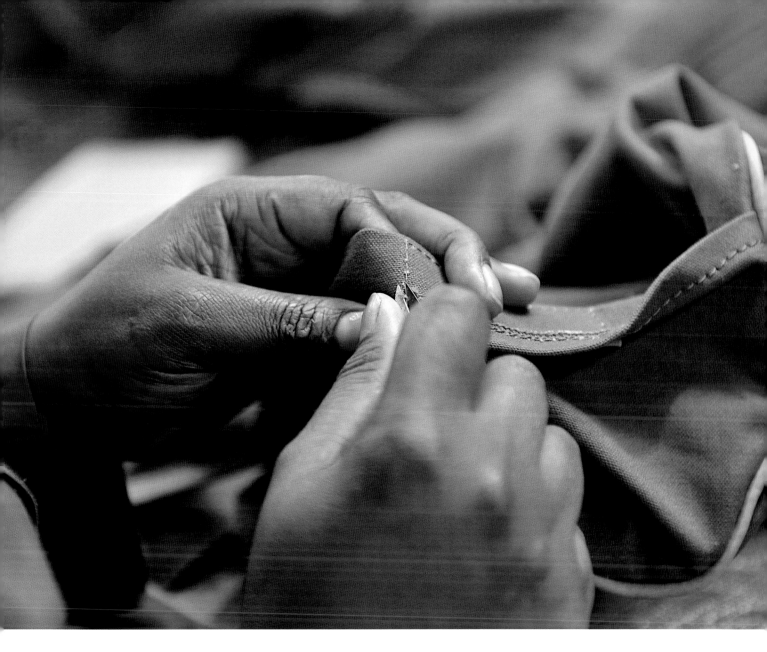

it can take to bring those materials into the country; the cost of shipping overseas (especially air freight); and a lack of genuine economic cooperation within the East African Community. By and large there isn't the capacity/infrastructure to deliver volume production for global brands competitively; the economic argument is still weighted overwhelmingly in favour of Asian manufacture: it's a 'head and heart' thing - many brands would love to have product that carries a 'Made in Africa' tag but while their hearts say 'yes', their heads still say 'no'. But overcoming these challenges is all part of the fun, and when we do we wind up with interesting, beautiful and long-lasting products supported by a powerful story that will be a great asset as we grow internationally: we're always encouraged when overseas customers visiting our shops ask why they haven't heard of us before.

What inspires you? As a brand with international ambitions naturally we look at what is happening in the wider world but increasingly we're inspired by things happening here in Kenya, especially in Nairobi, or that have a clear Kenyan connection. We're always looking for interesting opportunities to collaborate and more often than not the profit motive is secondary: the first thing we ask is whether the people / product /

'We've never trumpeted 'ethical best practice' because it's just good business sense'

Sandstorm Kenya leather travel explorer bag **TOP** *Sandstorm Kenya workshop, leather cutter, Nairobi, Kenya* **BOTTOM** *Sandstorm Kenya workbags, white batian bag and white fishing bag* (SANDSTORM KENYA)

brand inspire us, do we like them and will working with them be fun? If the answer to those questions is 'yes' we worry about the money later.

How does Africa relate to your brand and why? For Africa read Kenya. Our safari heritage informs the functionality of much of our product - well made, robust, versatile, fit for purpose - but increasingly we relate to contemporary Kenya and especially our Nairobi home: a dynamic, inspiring and creative city.

Do you use any traditional African craft techniques in your design process? I wouldn't say that any of the craft techniques we use are uniquely African; in fact we operate a strict 'no beads' policy.

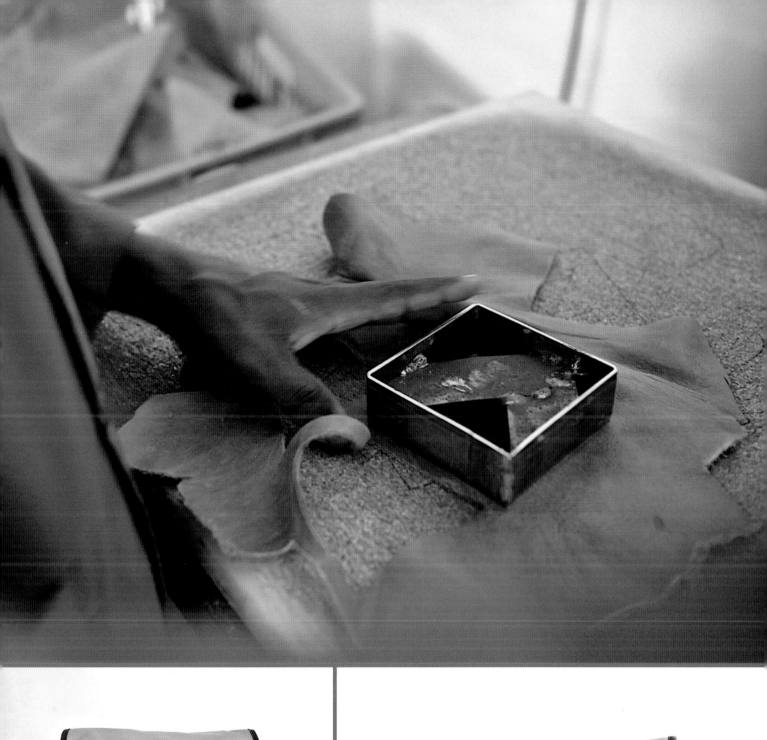

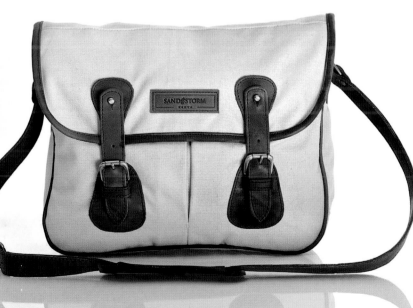

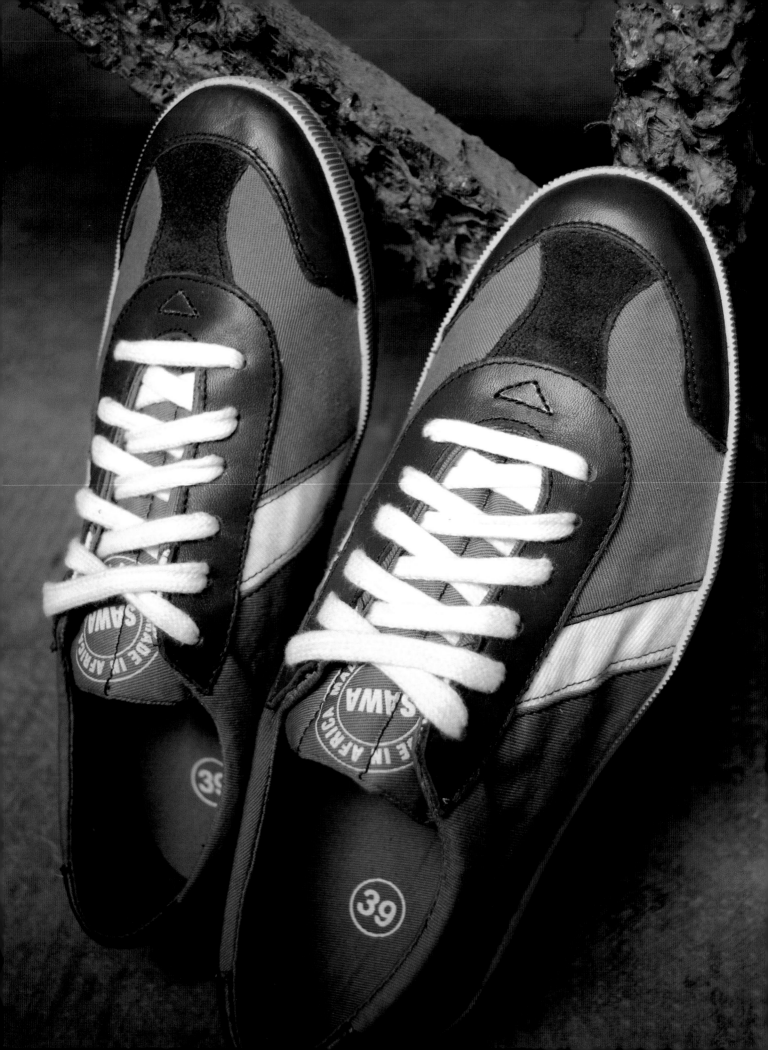

SAWA SHOES

FACT FILE

LOCATED CAMEROON AND PARIS, FRANCE
WEBSITE WWW.SAWASHOES.COM
FOUNDED 2009

SAWA sneakers started in Cameroon in 2009 from the energy of African cobblers who, together with SAWA, are challenging the traditional North/South industrial flow (raw materials from Africa transformed elsewhere into finished goods). SAWA sneakers finished goods are "100% Made in Africa".

❮ *Sawashoes, 'Dr Bess' shoe* ❯ *Sawashoes, factory*

Three friends, Fabio, Frederic Barthelemy and Medhi Slimani, founded SAWA Shoes in Cameroon in 2009. Fabio, acquired a solid background in product creation working at Adidas in Germany and later met Frederic Barthelemy (who still maintains a day job in banking) and Medhi, at Le Coq Sportif in France. Mehdi, worked for ten years in the finance departments of major corporations in Brazil, China and France before making a career move as a product manager for Le Coq Sportif. Frederic and Mehdi both originally come from the Ardennes in France and attended the same school.

While travelling in Cameroon the founders delved into and admired the energy and the spirit of everyday African life and used this as inspiration for the SAWA label of today; a company that accepts the challenge of producing entirely in Africa. SAWA as a brand is committed to giving a boost to local shoe manufacturing, while keeping the added value in Africa. African industrial partners followed their lead and thanks to the combined goodwill and serious efforts the first SAWA sneaker was born. The shoe was called Dr Bess as a tribute to Bess the technician who contributed the most to build it and like a doctor always wore a white coat.

SAWA is a fashion brand with a firm economical point of view and goal to give a new boost to local shoe manufacturing, while keeping the added value in

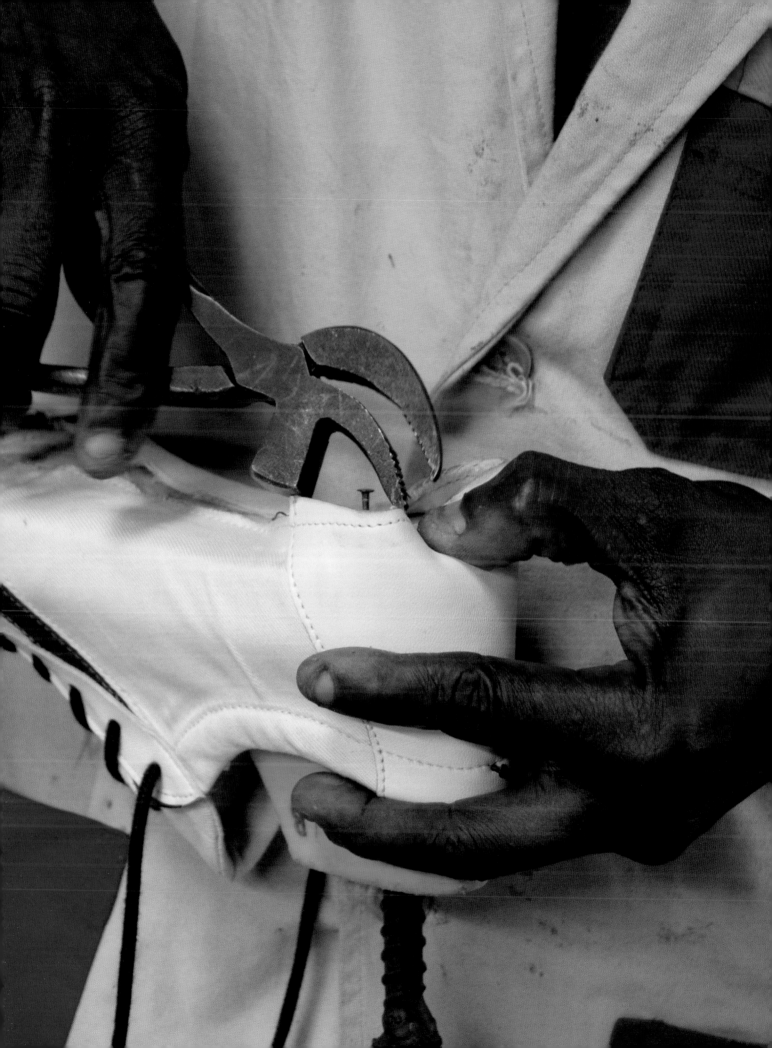

'Together we are growing and improving day by day'

Africa and being supported by the best boutiques and concept stores in Paris, London, New York and Tokyo.

How do you think fashion made in Africa is regarded internationally? Expected to happen but unexpected when it happens.

Which African designers do you admire? We admire any expression of art, music, creation and production which puts forward local African skills. We respect anybody who proudly puts in his/her creation a bit of his/her roots, from the world famous singer, to the unknown craftsman trying to make his way through.

Does your company work with any cotton programs in Africa? SAWA works with one of the Cameroon's major cotton industries which has years of history and represents a reference on local made cotton textiles.

What is your ethical standpoint? SAWA ambition is to set the foundations of a sustainable economy, thanks to a product enriched in value from local genuine know-how. We are not doing charity, but trying to create business opportunities for us and for our partners. Our work creates work where it is strongly needed and our partner suppliers find new business opportunities, allowing them to enlarge their scope and create new jobs.

❯ *All Sawa shoes*
❯ **BOTTOM LEFT** *Copyright Sawa shoes*

How does Africa relate to your company / brand and why Africa? Africa is the core of our company; The

foundation of our brand. The whole concept is based on the product added value generated in Africa. SAWA is part of Africa.

Which countries do you source and produce in? Our shoes are manufactured in Cameroon and all their components are sourced throughout Africa. This is what makes us proud to say "100% made in Africa". The materials come from different countries. Leather from Morocco, laces from Tunisia, canvas from Cameroon, rubber from Egypt.

What do you see as the pros & cons of producing / sourcing in Africa? Firstly logistics require a great effort. We source materials from across the continent which need to arrive to production simultaneously. We have high expectations for our production and quality control as do our partners. Additionally the business relationship with our manufacturers and suppliers is based on a mutual medium term profitability of the project as well as its perpetuation. In order to support them we purchase directly the components of the shoes and take care of all logistics in place of the manufacturers. This has a dramatic positive influence on our partners' treasury. All of this is not an easy task or many others would have done it already.

What inspires you? SAWA sneakers find their vintage inspiration from the omnipresence of second hand clothes from developed countries into the African economy. The second-hand business competes with local fashion, taking away market shares from locally made products. Our sneakers have started the inverse journey towards the "western" markets!

Is Africa the future? This continent has a great potential in any field, thanks to the energy of the people. SAWA is introducing the African know-how to the rest of the world.

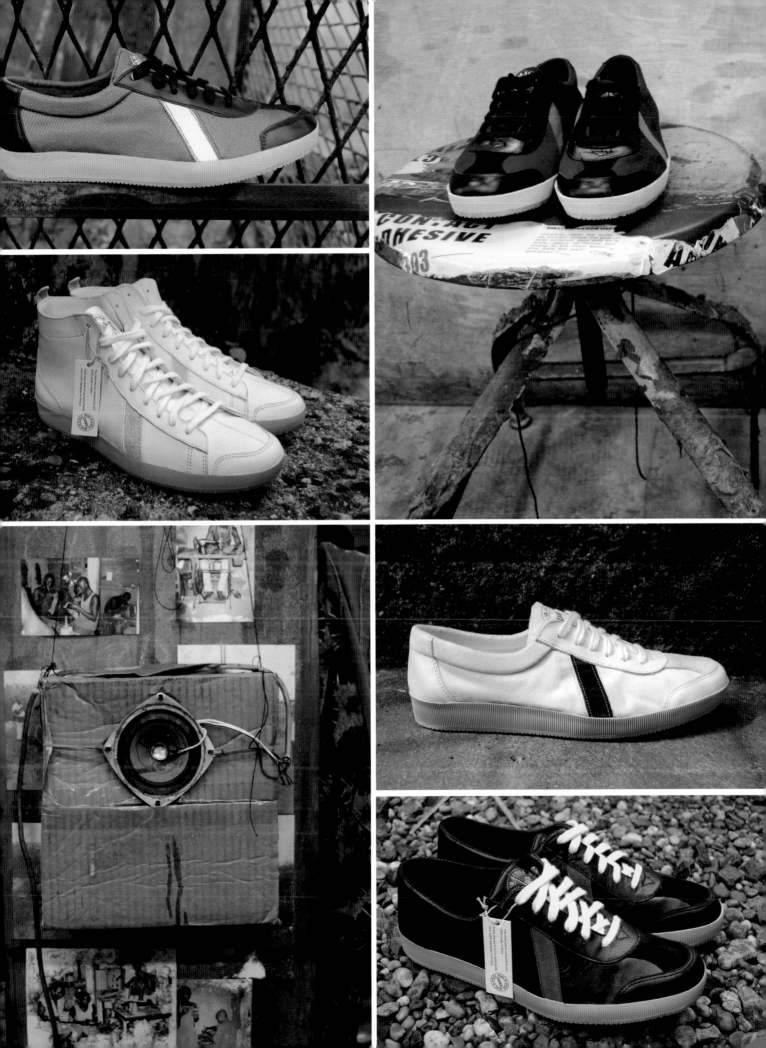

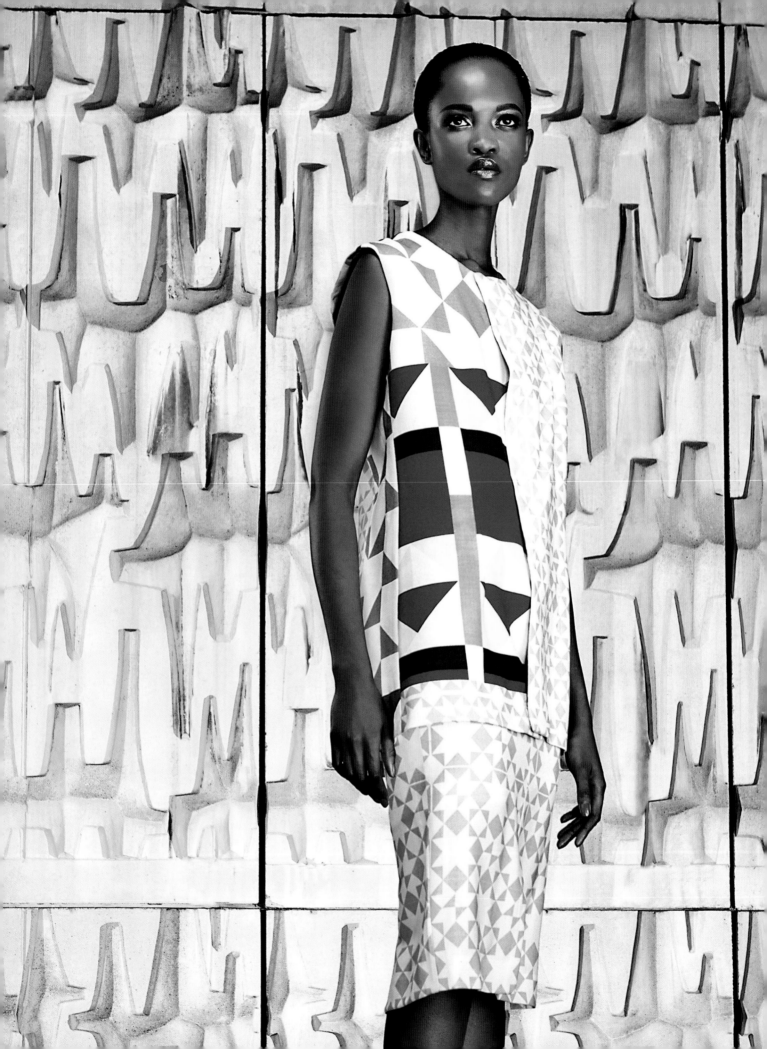

SINDISO KHUMALO

FACT FILE

LOCATED LONDON, CAPE TOWN AND JOHANNESBURG
WEBSITE WWW.SINDISOKHUMALO.COM
FOUNDED OCTOBER 2012

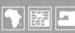

Sindiso Khumalo is a ready- to-wear womenswear label with a strong focus on textiles and innovative luxury materials. It aims to bring bespoke textile design to a global market, by creating garments with a strong craft heritage and a contemporary edge in the design.

Textile designer Sindiso Khumalo lives and works in Hackney, East London. She studied Architecture at University of Cape Town before moving to London to work for award winning architect David Adjaye. She then went on to study for an MA Design for Textile Futures at Central St Martins College of Art and Design. In October 2012 she was shortlisted for the Elle Magazine Rising Star Competition and showcased her debut SS13 collection at the Awards. In February 2013, her Aretha Dress was was nominated for "Most Beautiful Object in South Africa" by the Design Indaba Cape Town. Through her label Sindiso believes fashion can become an empowering agent by creating positive economic activities in otherwise marginalized parts of the world.

◀ ▶ *SS2013* (PHOTOGRAPHY, BRETT RUBIN; STYLING & ART DIRECTION, NICOLE VAN HEERDEN; MODEL, NEO MOFOKENG BOSS MODELS; HAIR & MAKE-UP, AMY ANSTEY)

What do you see as the pros and cons of producing/sourcing in Africa? The continent has unique products that can be sourced and the wealth lies in the craft heritage Africa holds. It is relatively easy to find beautifully handmade pieces. That, is true luxury. Unfortunately, reliability is our biggest Achilles heel in Africa. When a supplier promises a deadline they can't meet, it all has a domino effect on the production line. We need to be more reliable and have consistency in the products we deliver.

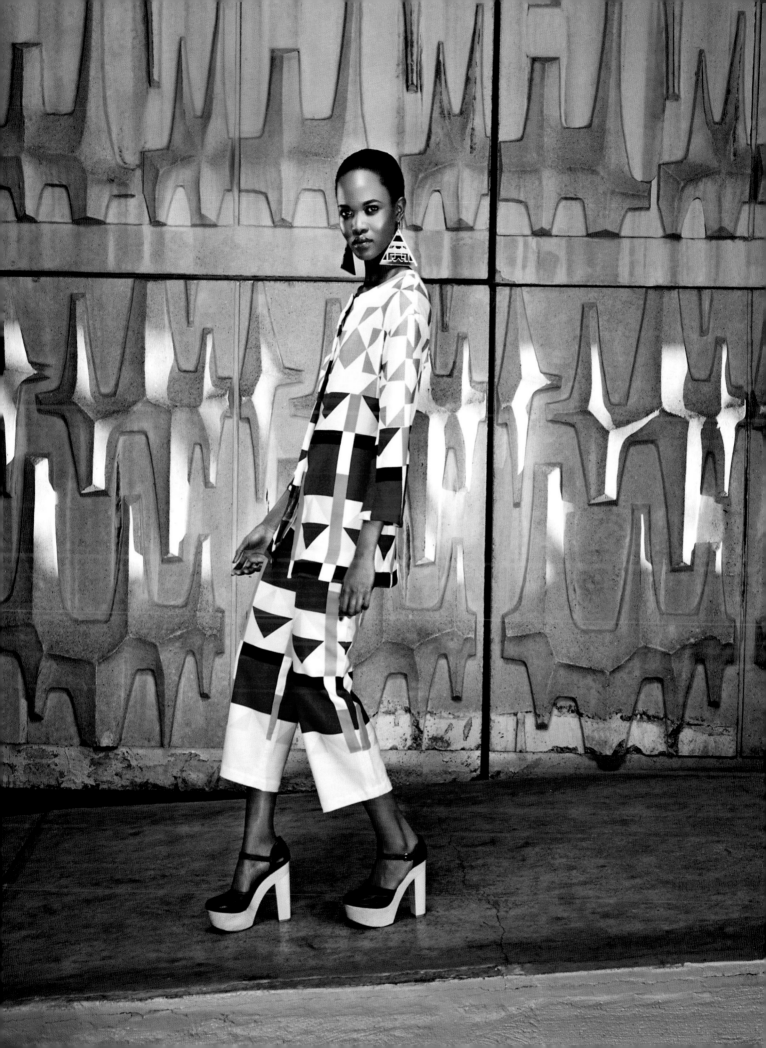

'We need to be more reliable
and have consistency in the
products we deliver'

How do you think fashion made in Africa is regarded internationally? There's definitely a paradigm shift slowly taking place. Africa has increasingly become politically less troubled, which has opened up various opportunities.

What inspires you? Inspiration is everywhere; on the streets, in my house, with my friends. Especially in the everyday. I could be braiding my hair at a salon, and get inspiration from a type of braiding technique being used. Its all around you, you just have to tap into it.

How does Africa relate to your company/brand and why Africa? I do all my manufacturing in South Africa and am also looking into developing new fabrics and materials in South Africa.

Do you use any traditional African craft techniques in your design process? Yes, for our Autumn Winter collection we collaborated with South African NGO Africa Ignite, to create beautiful handcrafted tops using a Zulu weaving technique. It has been passed down over generations and the specialist weavers are located in parts of rural KwaZulu Natal, South Africa. I'm very pleased with the results and look forward to really growing this relationship.

What is your ethical standpoint? At Sindiso Khumalo, we are passionate about craft and bringing forward strategies towards ethical forms of making. We believe the choices we make in our supply chain can really have an effect on peoples livelihoods. By collaborating with NGO's and other local artisans, we feel our company can become an empowering agent, developing products that are not only desirable but also have a meaningful story behind them.

Which African designers do you admire? Maki Oh, Thula Sindi, Laduma Maxhosa, Babatunde, Black Coffee, Dokter and Missus.

Is Africa the future? I think there is great potential to create something unique and exciting in Africa. I do however believe in a collaborative method of working, so I don't believe only Africa is the future, but rather the world is. Its about the collaborations that Africa makes with its global partners that will redefine its place in the world.

> SS2013 (PHOTOGRAPHY, BRETT RUBIN; STYLING & ART DIRECTION, NICOLE VAN HEERDEN; MODEL, NEO MOFOKENG BOSS MODELS; HAIR & MAKE-UP, AMY ANSTEY)

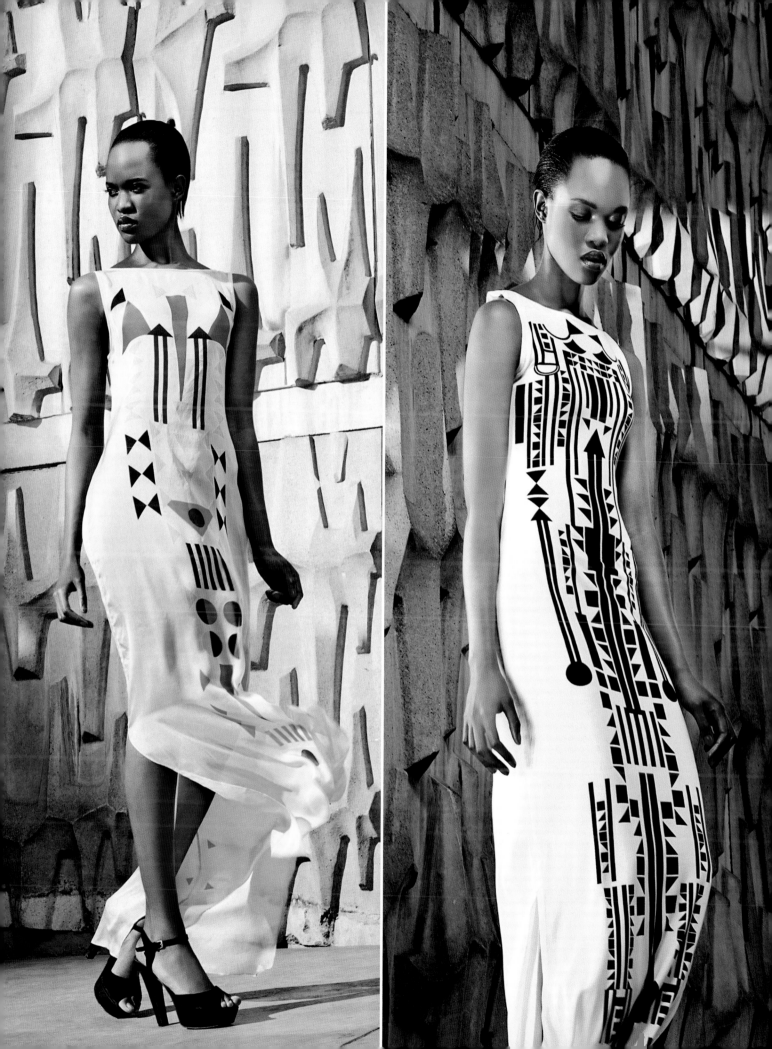

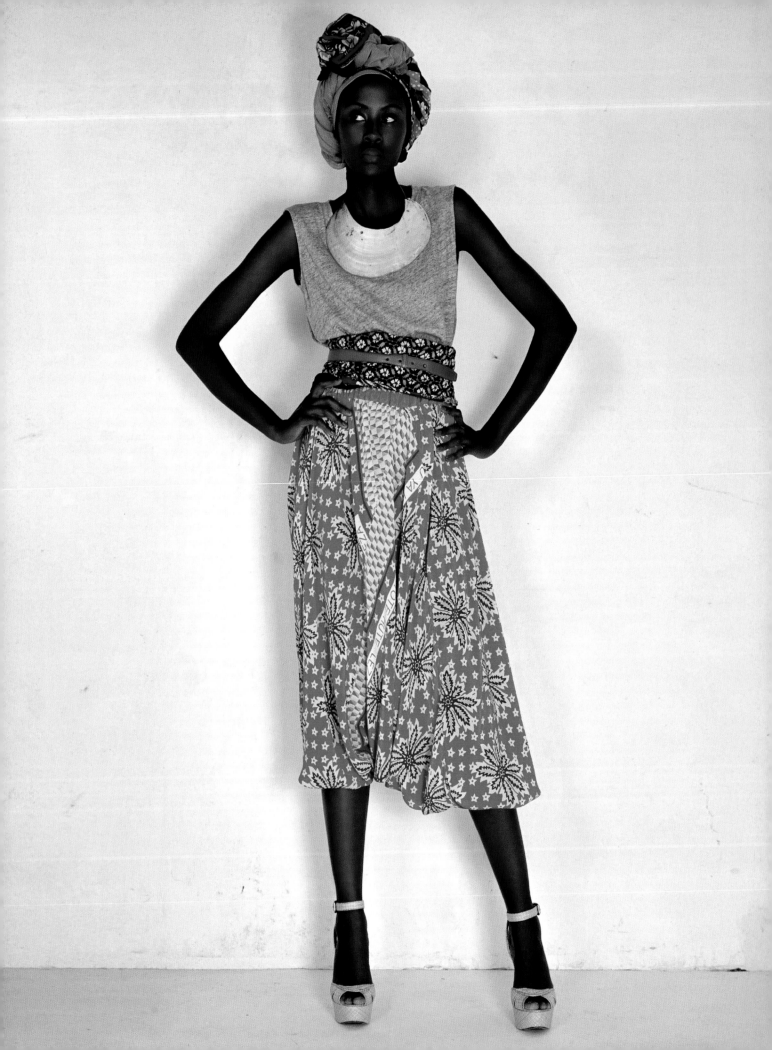

SUNO NY

FACT FILE
LOCATED KENYA AND NEW YORK, USA
WEBSITE WWW.SUNONY.COM
FOUNDED 2008

SUNO NY was founded in 2008 by Max Osterweis after more than a decade of collecting textiles in visits to Kenya and as a reaction to the post-election violence that took place in Kenya in 2007 and 2008 and to provide a positive impact to the country's suffering.

SUNO's first Spring/Summer collection in 2009 was designed by Max Osterweis and Erin Beatty. While they design and develop the women's ready-to-wear product in New York City they manufacture in Kenya, India, and NYC. By keeping part of the production for SUNO in Kenya, it firstly helps to develop the industry there by providing jobs and teaching (already skilled people) new skills; secondly, it assists in changing the world's perception of what is and can be possible in Kenya. The prospect that Kenya's recent past turmoil might keep foreigners from visiting or investing in a country overflowing with natural resources, talent, and goodwill became the catalyst for SUNO's founders to actually do something, starting with the utilizing the fabrics collected over the years and then by building a successful and visible company employing local Kenyan talent. The company ethos, one that treats workers fairly and showcases some of Kenya's artistry, could potentially be a driver for positive and lasting social and economic change in the country.

‹ *SUNO SS2010 collection*
› *SUNO SS2011*

Do you use any traditional African craft techniques in your design process?
In previous collections we have used textiles from East Africa as well as incorporated traditional dyeing techniques on our fabrics.

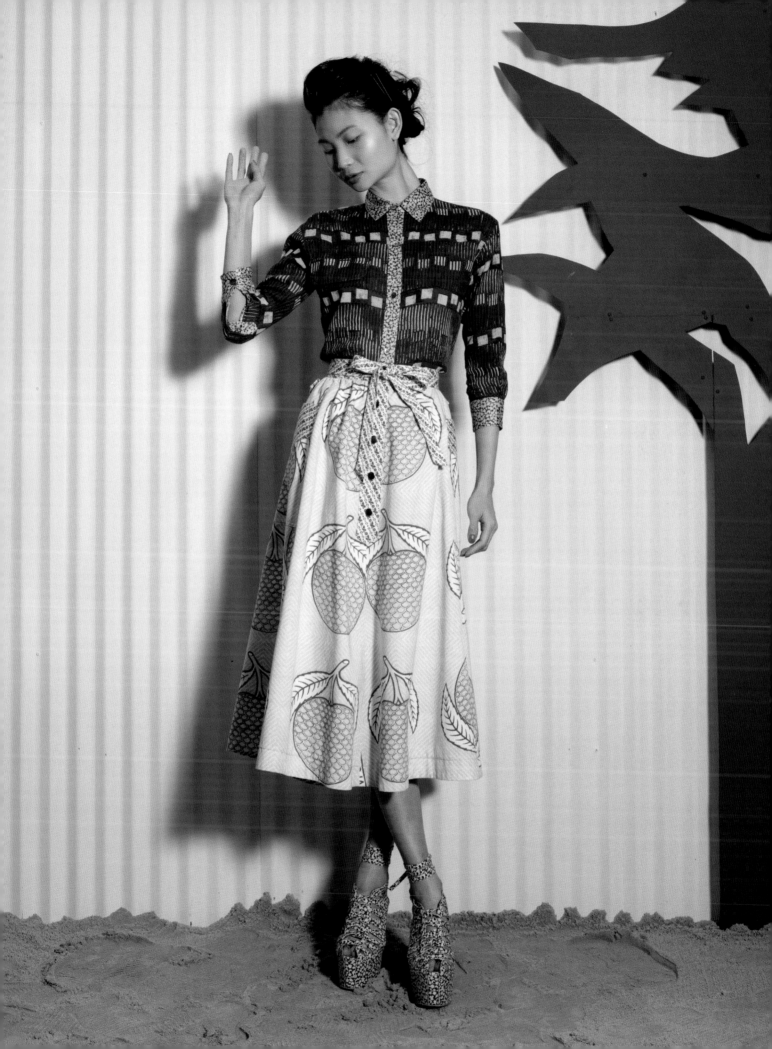

'If we are successful in creating a luxury brand that primarily produces its goods out of Kenya, the world can start to see Kenya with new eye'

What inspires you? Inspiration is everywhere we go. Wherever we can we take in art, music, film, architecture, and are equally inspired by nature, other fashion design, or by certain people. We start a collection thinking about a friend or a group of paintings and then we look at fabrics from all over the world, vintage clothing, people on the street, paintings and photographs.

What is your ethical standpoint? We believe in fair wages and good working conditions. We strive towards being more green every day, but ultimately if we can help contribute to economic stability and sustainability we can affect positive social change.

❮ *Illustration SUNO collection by Giulio Iurissevich* ❯ **TOP LEFT** *SUNO SS2010* ❯ **TOP RIGHT** *SS2011 collection* ❯ **BOTTOM LEFT** *SUNO SS2011* ❯ **BOTTOM RIGHT** *SUNO SS10 collection*

Is Africa the future? Africa's future in fashion and textile industry. It would require more manufacturing incentives from governments both for local producers and foreign investors; trade treaties that are practical and not burdensome, governments that are stable; an end to corruption, and it would need an investment in the infrastructure (power, water, roads) who's focus is the support of Africa's fashion and textile industry.

Which countries do you source and produce in? We source fabrics in Kenya, Tanzania, Japan, Italy, Korea, Australia, and India. At least 70% of our production is in Kenya, our beaded and embroidered pieces are from India, and there are always a few pieces in our NYC sample factory.

What do you see as the pros & cons of producing/sourcing in Africa? From our point of view, the many cons are the difficulty in navigating the bureaucracy, the customs community is so used to dealing with corruption that they expect it; the power outages, and no real pre-existing industry. The pros are that we get to be a part of what will hopefully be a great change. We get to work with customs officials and members of government to help explain how the incentives/ treaties/rules could be made better for those working within the system. We help train a generation of tailors to help build an industry.

How do you think fashion made in Africa is regarded internationally? I think within the western media there are occasional feel good stories about people doing things similar to the way we are working here, but overall it hasn't caught on. Hopefully one day that will change.

Which African designers do you admire? Yves Saint Laurent and Azzedine Alaia.

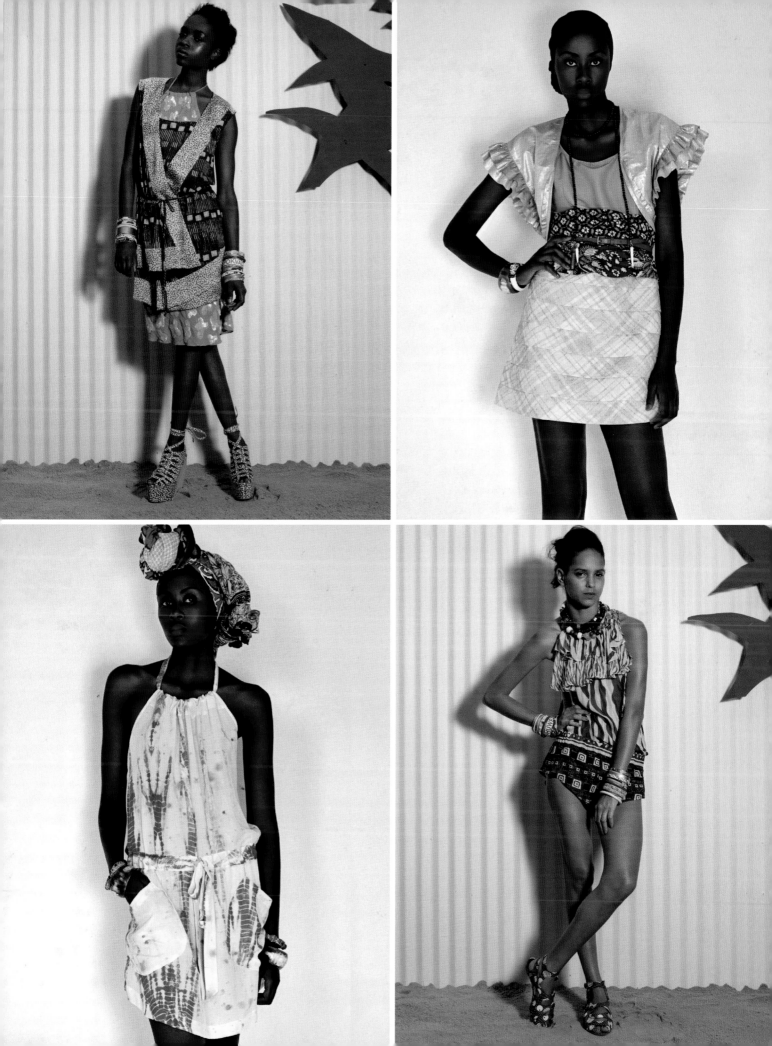

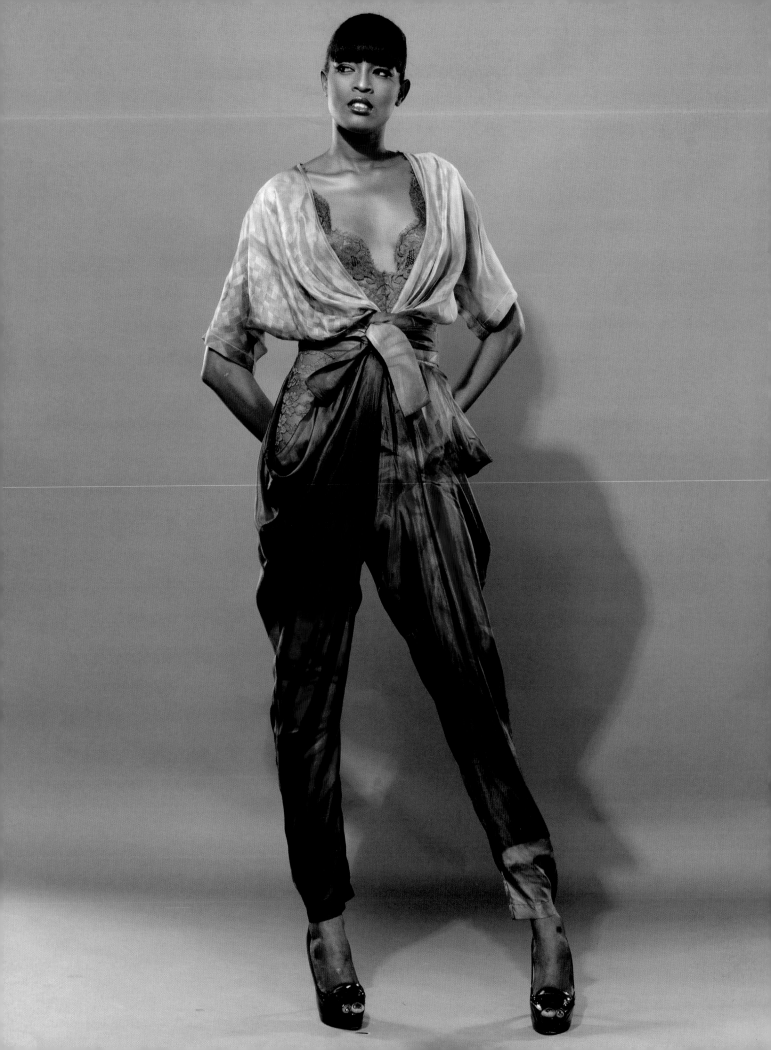

TIFFANY AMBER

FACT FILE

LOCATED LAGOS, NIGERIA

WEBSITE WWW.TIFFANYAMBERNG.COM.

FOUNDED 1998

TIFFANY AMBER was lauched in 1998 by founder Folake Folarin-Coker, and it is considered to have revolutionised the fashion industry in Nigeria. Her vision is for Tiffany Amber to be the first label to transcend the whole of Africa and to become the premier African lifestyle brand.

Folake Folarin-Coker, recipient of the WIE Enterprise Award 2013, believes that her exposure to so many different nationalities at a young age made her somewhat of a global nomad in terms of style. She has successfully translated her love for different cultures into an iconic fashion brand in Africa. Every collection shows the designer's love for luxurious fabric and intricate embellishment from all over the world whilst at the same time instilling her African heritage to produce timeless, feminine and effortlessly stylish pieces. The silhouettes remains elegant and feminine, yet the brand has evolved in terms of design with the method becoming more elaborate and intricate. In terms of fabrication, in the past eight years, this has become mostly luxurious fabric such as silks and lace, and at present, soft and floaty dresses remain staple pieces of TIFFANY AMBER.

"My vision is for Tiffany Amber to be the first label to transcend the whole of Africa. To become the premier African lifestyle brand".

❮ *Tiffany Amber AW2010 collection* ❯ *Illustration Tiffany Amber AW2010 collection* (BY ARSIDA SMAJLI)

What do you see as the pros & cons of producing in Africa? The Nigerian fashion industry is fast evolving, but not yet thriving. The strengths are in the natural talent of potential designers and the weaknesses are the lack of infrastructure, technical know-how and adequate support from the government.

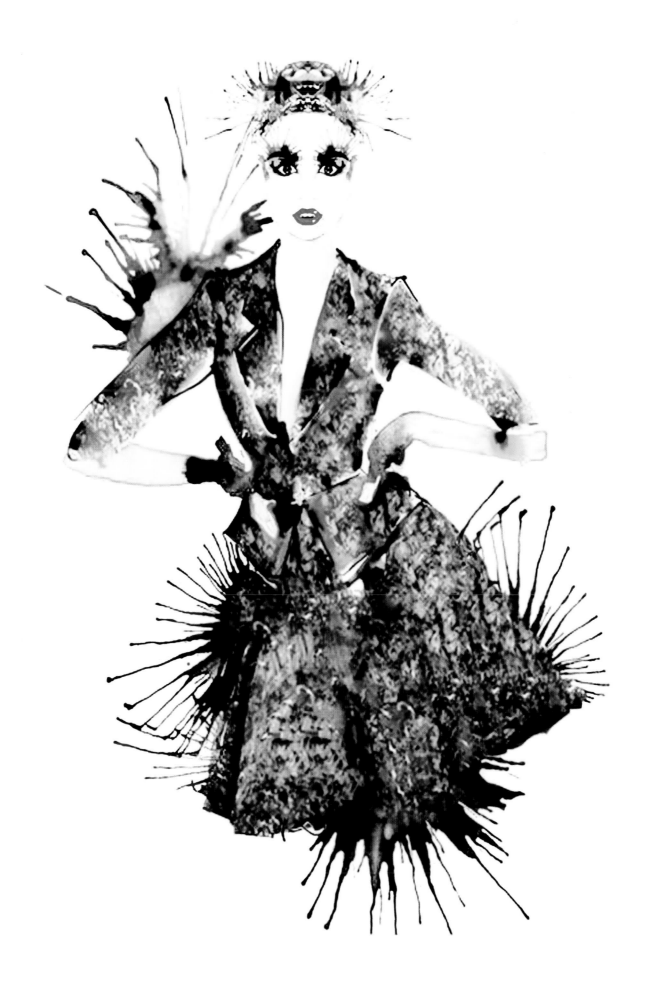

'They need to visit Africa and see how Africa has evolved rather than relying on the internet and history books as their points of reference!'

How do you think fashion made in Africa is regarded internationally? African fashion does not get the attention it deserves; especially considering many International designers and heritage brands are drawing a lot of inspiration from what us African designers have made the trend in Africa. I think they need to visit Africa and see how Africa has evolved rather than relying on the internet and history books as their points of reference!.

What inspires you? I get my inspiration from images from everyday life; films, art and history books. I draw inspiration from different cultures and ethnicities, from places I've lived or visited on holiday. I find both Asian and Far Eastern culture and fashion intriguing and love their ingenious use of colours and embellishment. I realized the importance of fashion when the meaning of the phrase "dress as you wish to be addressed" dawned on me! For me it's important that the clothes do not over-power the wearer, but rather enhance her style. I ask myself three questions after every piece has been created: "Do I like this piece? Will it sell? Is it original?" This keeps me focused and in line with my fashion principles.

How does Africa relate to your company brand and why Africa? After my post-graduate degree, I came back to qualify at the law school in Abuja as I knew I wanted to live in Nigeria. The weather in Abuja was so different to what I had been used to for the past fifteen years that I decided to make my own clothes that

> *Tiffany Amber SS13 collection at Arise Magazine Icons Fashion Collective, New York Fashion Week (©THANASSI KARAGEORGIOU (PHOTOGRAPHER, WWW. NASKARAS.COM)*

were more suitable for the weather. Every time I wore something of mine, I received lots of compliments. Very quickly, people started asking me to make clothes for them.

For me it's important to be seen as an African fashion ambassador until African fashion is put on the same level as our European counterparts. It would be unrealistic for me to see fashion without borders as the world has not fully recognised the industry in Africa. Until that happens, it is important for me to be seen as an African brand and to act as an ambassador.

Is Africa the future? No. The future of fashion lies in great designers. Even though the industry is still in its infancy as there is so much room for growth, there is a lot more structure on ground, especially in the last five or six years. Twelve years ago when I started, the ready-to-wear by an indigenous designer was non-existant. Everybody was used to either buying ready-made clothes from abroad, or making them with their local tailor. However, the more up-market designers then concentrated more on the bespoke pieces. In that sense there was a huge gap in the market for a ready-to-wear label. This I believe has been part of the fast success of the brand Tiffany Amber. We definitely need more fashion schools with lecturers properly trained by real fashion experts. And after this, I guess it's a domino effect. With that we'd have more trained fashion designers, leading to more established fashion houses. Its still a long process, but I believe one day sooner rather than later, we'll get there.

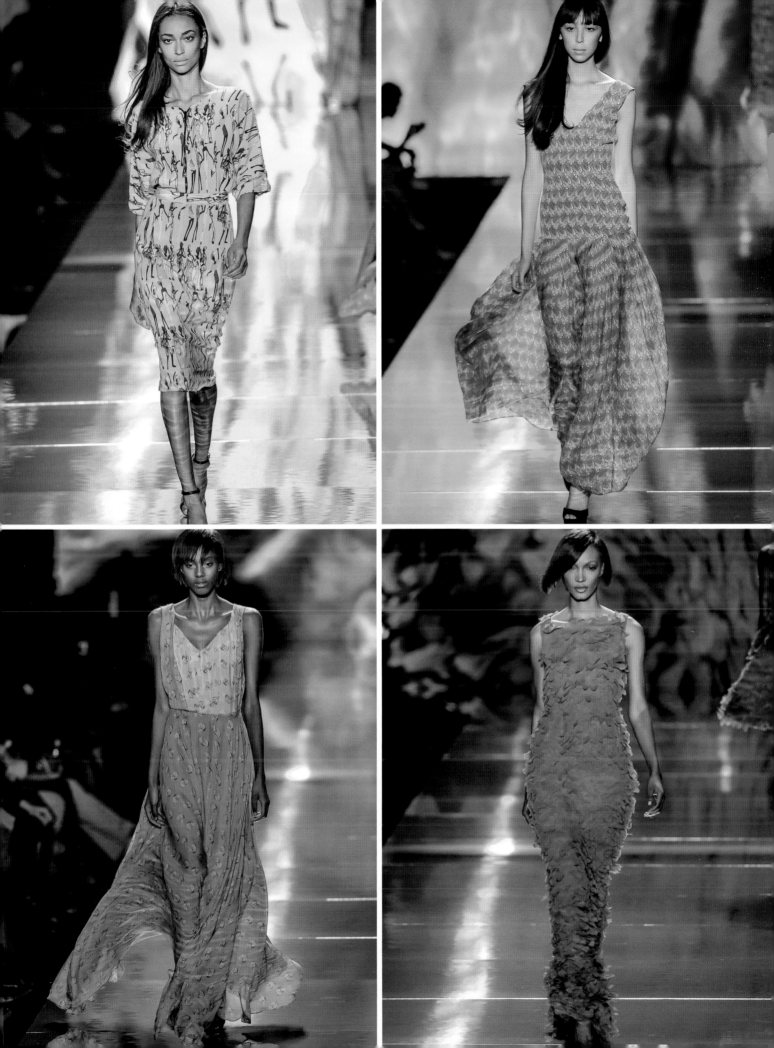

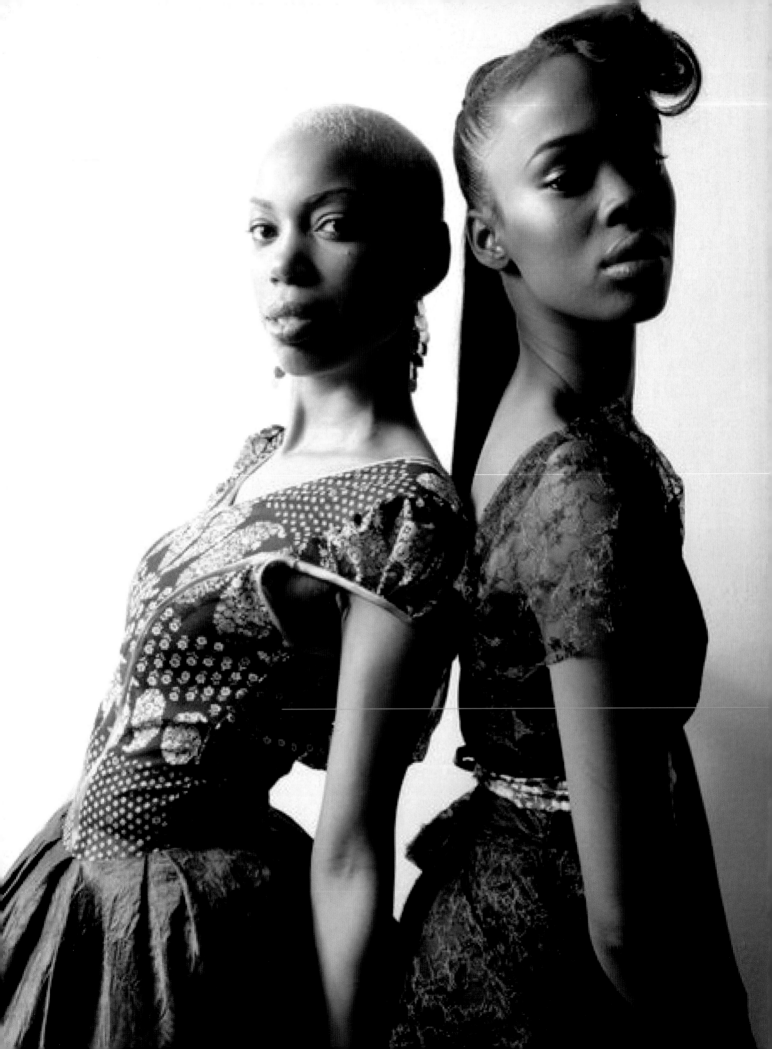

ZED-EYE

FACT FILE
LOCATED LONDON, ENGLAND
WEBSITE WWW.ZEDEYE.COM
FOUNDED 2000

Uber -talented designer Ngozi Pere-Okorotie, hails from the Igbo tribe in Nigeria and is the creative head behind ZED-EYE, which launched in 2006. Inspired by Vivienne Westwood, Ngozi believes learning how to use a measuring tape at the tender age of six changed her life.

Her passion for designing beautiful garments stems from sweet childhood memories of her mother's fashion academy, where Ngozi was constantly surrounded by clothes, and steeped in the world of fashion long before she embarked on her own successful career as a fashion designer. Famed for her three-quarter sleeve floral print summer jacket, has become a favourite in the wardrobes of top celebrities including Kelis, Shingai (The Noisettes), celebrity hairdresser Tara Smith and renowned British designer Henry Holland. Mainly producing women's clothing designs ZED-EYE sometimes dabbles in bespoke tailored garments for their increasing male clientele. Due to this demand to design men's clothing, Ngozi will be launching her men's clothing line under the ZED-EYE brand sometime in the near future.

In which countries do you source and produce? I source most of my fabrics in Africa and England. Sometimes I order some of them from India through my UK wholesalers.

How do you think fashion made in Africa is regarded internationally? From the views and observations I get from international market, fashion made in Africa is highly regarded. Africa to me is one of the most inspiring and resourceful parts of

❬ *Zedeye 2010 collection*
(MODEL SAMIRA HASHI,
PHOTOGRAPHER BUMI THOMAS)
❭ *Illustration, Zedeye
collection* (BY ERICA SHARP)

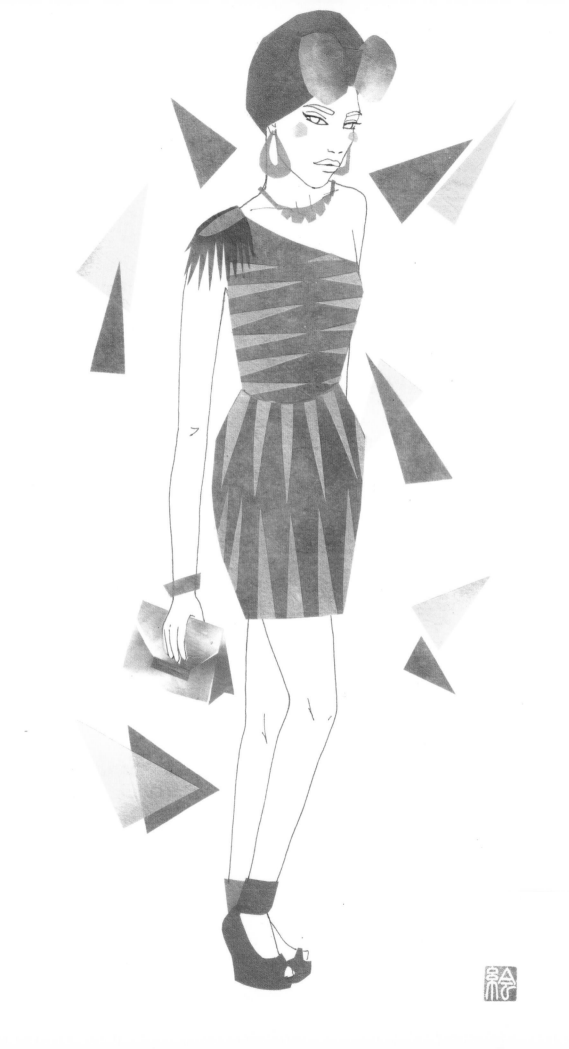

'Africa to me is one of the most inspiring and resourceful parts of the world because it has been blessed with culture'

the world because it has been blessed with culture, and that is what you need as a foundation of any creativity.

What do you see as the pros and cons of producing/sourcing in Africa? The positives are that the labour is cheaper and being African (Nigerian) makes it easier because of the sense of familiarity; I feel at home and good within myself that I am helping to create jobs and promote creative talents in my country.

‹ › Zedeye ss11 collection - Tribal Romance Revisited (STYLING BY ZI; MAKE UP BY STACY OKAFOR; PHOTOGRAPHY BY JOSEPH SINCLAIR; POST PRODUCTION BY SIMON BLAKE; MODEL SAMIRA HASHI)

Unfortunately there are still some aspects of life here that are not as straightforward. Shortcomings such as lack of time and attention to detail is a problem if you are not there to supervise the production. Often creative's are not recognised or regarded with value for their craft and talent but are often taken for granted and in turn that discourages workers from appreciating their own craft. Also the governments are not funding the creative industries which if they did would allow more gifted creative people to turn their craft to a means of making a living.

What inspires you? My inspirations come from everything going on around me. For example the tribal Romance Vol2 collection, is my charity collection whereby 10% of

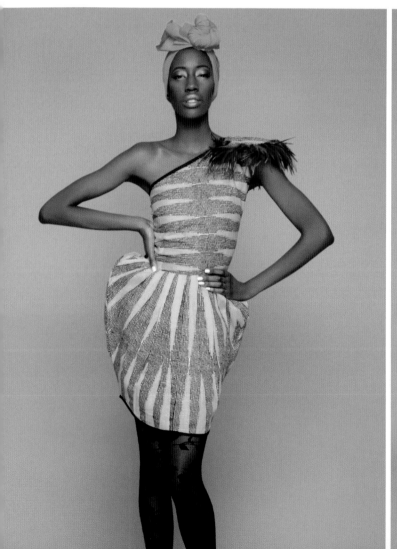

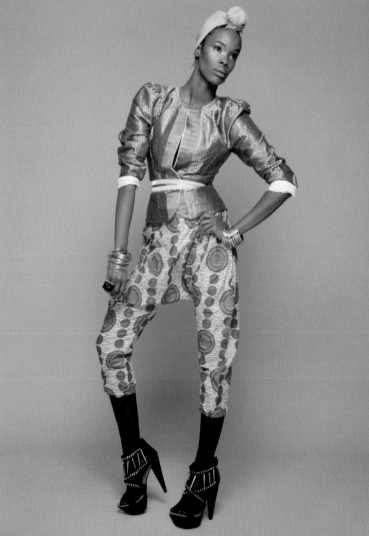

each item sold goes to the Alzheimers Foundation. This is close to my heart because I lost my grandmother two years ago to this illness. My culture inspires me, the colours, the people, the morals and beliefs too. I grew up as a Nigerian of the Igbo tribe. That inspires me to do what I do. Adding to that I put a bit of the western Victorian era into it and so stamp my signature on it. This is influenced by the designers I love such as like Vivienne Westwood and the late Alexander McQueen.

Is Africa the future? Africa will always be one of the futures in the fashion and textile industry because there is room for more improvement. It's increasing recognition worldwide offers the stepping stone to Africa making history in the global fashion and textile industry.

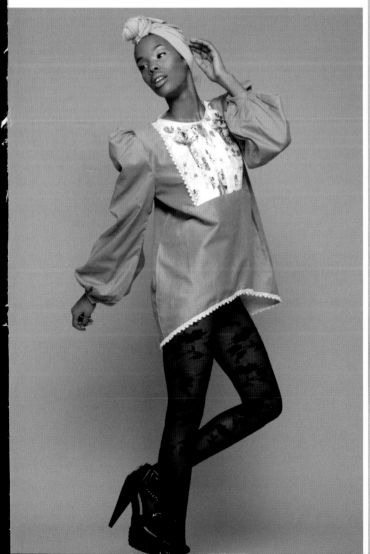

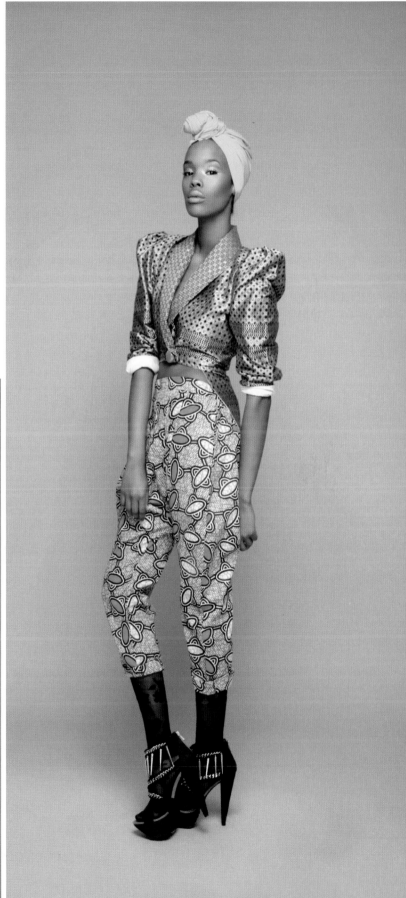

ACKNOWLEDGEMENTS

The completion of this book could not have been achieved without the love and support of my family and close friends.

Above all I thank God for giving me the vision, entrepreneurial spirit and strength needed; my supportive family (especially my Mother who has never stopped believing in and encouraging me); my friends old and new who helped me to stay excited about this project; my university tutors for their direction and ongoing corrections, enabling me to get the best out of my work; my industry network who believed strongly in my vision; my publisher and agent who saw this project and decided straightaway to take it on board and give the book the full promotion it needed; and of course my thanks to the wonderful designers who gave their time to answer questions and send beautiful images. This book is about you and for you.

Separately I give big thanks to all the talented illustrators who were extremely hardworking and without whom this book would not have the visual aesthetic I envisioned.

And finally for everyone else who has supported me and who has purchased this book, I thank you. I pray that you enjoy it for many years to come and that you gain a wider perspective of the wonderful, beautiful continent of Africa, its fashion industry, and the incredible potential it possesses.

Me da ase, Asante Sana, amesege'nallo', Dankie, Zikomo, Enkosi, eh-sheh-wuh, Merci, Obrigado... Thank You!

❯ *Illustration by Filiz Tunali*